The StarMakers

On Set with Hollywood's Greatest Directors

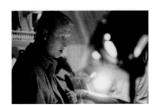

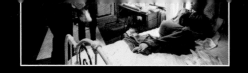

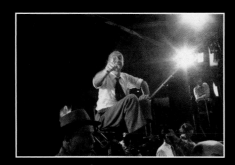

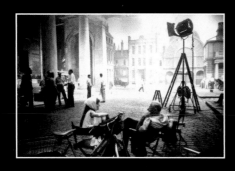

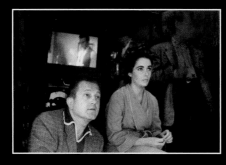

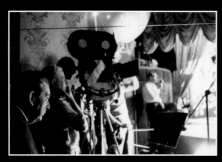

The StarMakers

On Set with Hollywood's Greatest Directors

Bob Willoughby

Foreword by Sydney Pollack

MERRELL

LONDON · NEW YORK

First published 2003 by Merrell Publishers Limited

Head office
42 Southwark Street
London SE1 1UN

New York office
49 West 24th Street
New York, NY 10010

www.merrellpublishers.com

Publisher Hugh Merrell
Editorial Director Julian Honer
US Director Joan Brookbank
Sales and Marketing Director Emilie Nangle
Managing Editor Anthea Snow
Editor Sam Wythe
Design Manager Kate Ward
Production Manager Michelle Draycott
Editorial and Production Assistant Emily Sanders

British Library Cataloguing-in-Publication Data:
The star makers: on set with Hollywood's greatest
directors
1.Portrait photography 2.Photography, artistic
3.Motion picture industry – California – Los Angeles –
Pictorial works 4.Motion picture producers and
directors – Portraits 5.Motion picture actors and
actresses – Portraits
1. Title
779.9'79143

ISBN 1 85894 233 0

Produced by Merrell Publishers Limited
Edited by Kirsty Seymour-Ure
Designed by John Grain
Indexed by Hilary Bird
Printed and bound in Hong Kong

Jacket front: George Cukor and Marilyn Monroe, 1960
Jacket back: Alfred Hitchcock, 1964

A note about dates
Where a film is mentioned in captions or text, the date
given is the date the photograph was taken. The date
of the film's release is given in the film listing for
each director.

Contents

Foreword

Sometimes a film-maker gets a look at a photograph taken on his own set and sees the "soul" of his film in one still photograph. It's rare, but it happens. It happened to me in 1969, the first time I looked at the work of Bob Willoughby during the filming of *They Shoot Horses, Don't They?* He so understood what the film was about that he'd been able to get directly to the heart of it. There was never any of the "behind the scenes" kitsch that is the staple of most movie-set photographs.

Early in our meetings Bob began to talk to me about the film and what I wanted to do with it. He had not only read the script, but had read the book upon which it was based, and something was bothering him. Some connection that hadn't been made—an image, a scene, something that would close the circle that, for him, wasn't yet closed in the screenplay. I was unused to this kind of discussion with anyone at all outside of a screenwriter, with whom I work very closely, and so was perhaps a bit reluctant to discuss these matters with him. But he was persistent, and my curiosity got the better of me. So we began to talk. For him, the title of the film and its metaphorical meaning had not been clearly enough related to the character played by Jane Fonda. He wanted the opening image of the horse falling in the meadow to relate clearly and directly to Jane's getting shot by Michael Sarrazin. He was clear and he was convincing, and it was at his urging that I decided to photograph Jane falling in slow motion in the open field instead of merely showing her drop on to the dark pier where she was shot.

This kind of understanding of the material he was photographing, coupled with his extraordinary technical skill and his instinct for sensing the right moments, has made his photographs extremely specific and powerful. As you look through them, there is an immediacy and an evocative power that is very, very specific to each of the films he is documenting.

I've had the pleasure of meeting many gifted photographers on the sets of films I've directed, and I have admired their photographs enormously. Each of the good ones has taught me something about the mysterious art of photography—but from Willoughby, I truly learned something about telling the story of my own film. He is a true visual stylist, one who understands how to communicate the most complicated ideas in the simplest, most arresting form.

Sydney Pollack
Los Angeles

SYDNEY POLLACK

Vincente Minelli

Lester Anthony Minelli; born Chicago, Illinois, February 28, 1903; died Beverly Hills, California, July 25, 1986

Minelli *was* the MGM musical. He brought taste and visual flair to almost everything he did, and with Gene Kelly created an unequaled body of film work, the like of which we'll never see again. He was also a charming man, and every time I met him with his wife at various occasions, he would always stop to chat.

BELOW *Vincent Minelli and Gene Kelly, on* Brigadoon, *MGM, 1954 (in the background the girl with the glasses is Carole Haney, well-known dancer from Broadway).*

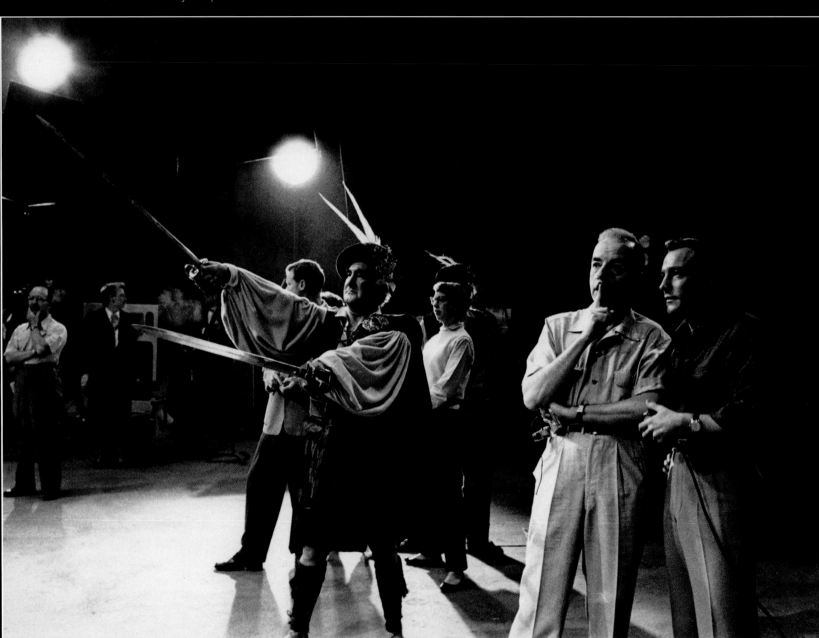

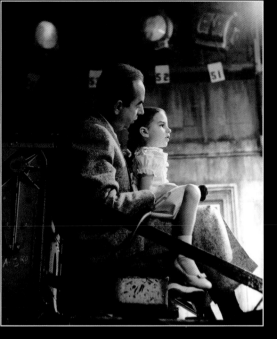

FILMS

ABOVE LEFT *Vincente Minelli takes his little daughter Liza for a ride on the MGM camera crane on the set of Lovely to Look At. MGM, 1952. This was one of my first film assignments, and to gain entry to MGM was a little awe-inspiring. I was there to photograph Marge and Gower Champion, but could not resist this lovely father-and-daughter image.*

ABOVE *Gene Kelly directs the dancers as they rehearse the number for Vincente Minelli on Brigadoon. In the foreground is Jeanne Coyne, whom Kelly later married.*

worked briefly with Fred Zinnemann on three of his films. Happily for me, two of them—*From Here to Eternity* and *A Man For All Seasons*—turned out to be the ones for which he won his two feature-film Academy Awards.

My impression was that Zinnemann was always a gentleman—easily approachable if I needed information, and gentle with his actors. I never saw any theatrics. Standing by the camera smoking his pipe, he became almost invisible at times, unlike a Polanski or a Preminger, who were always center stage. I recall one interesting quirk of his: on *Oklahoma!* he kept Shirley Jones (in her first film) out of bounds to all of the men on the location. He said this was so she would keep that fresh innocent look she had for her role as Laurey in the film. I wonder if any director could do that now?

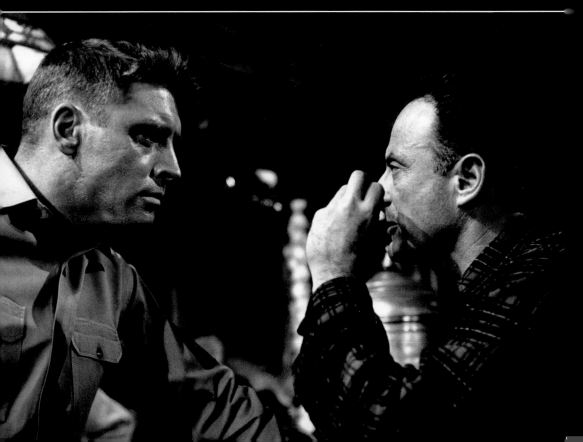

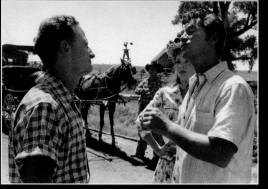

FILMS

Redes/The Wave *(documentary co-directed with Em... Muriel; 1936)*
A Friend Indeed *(short; 1938)*
The Story of Dr. Carver *(short; 1938)*
That Mothers Might Live *(short; 1938)*
Tracking the Sleeping Death *(short; 1938)*
They Live Again *(short; 1938)*
Weather Wizards *(short; 1939)*
While America Sleeps *(short; 1939)*
Help Wanted *(short; 1939)*
One Against the World *(short; 1939)*
The Ash-Can Fleet *(short; 1939)*
Forgotten Victory *(short; 1939)*
The Old South *(short; 1940)*
Stuffie *(short; 1940)*
A Way in the Wilderness *(short; 1940)*
The Great Meddler *(short; 1940)*
Forbidden Passage *(short; 1941)*
Your Last Act *(short; 1941)*
The Lady or the Tiger? *(short; 1941)*
Kid Glove Killer *(1942)*
Eyes in the Night *(1942)*
The Seventh Cross *(1944)*
Little Mister Jim/Army Brat *(1946)*
My Brother Talks to Horses *(1946)*
The Search *(1948)*
Act of Violence *(1949)*
The Men *(1950)*
Benjy *(short; documentary for Orthopedic Foundatio...*
Teresa *(1951)*
High Noon *(1952)*
The Member of the Wedding *(1952)*
From Here to Eternity *(1953)*
Oklahoma! *(1955)*
Miracle in Soho *(1957)*
A Hatful of Rain *(1957)*
The Old Man and the Sea *(production taken over by ... who received director's credit; 1958)*
The Nun's Story *(1959)*
The Sundowners *(1960)*
Behold a Pale Horse *(also produced; 1964)*
A Man for All Seasons *(also produced; 1966)*
The Day of the Jackal *(1973)*
Julie *(1977)*
Five Days One Summer *(also produced; 1982)*

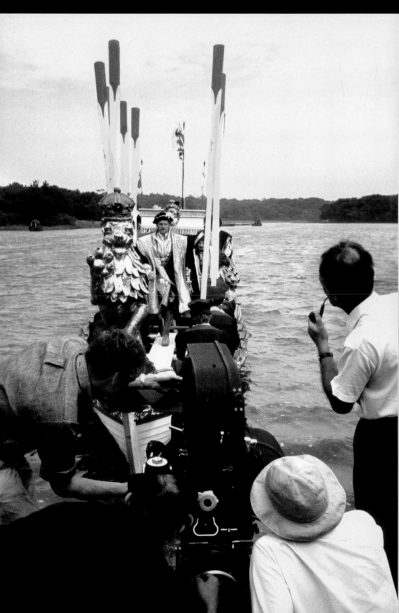

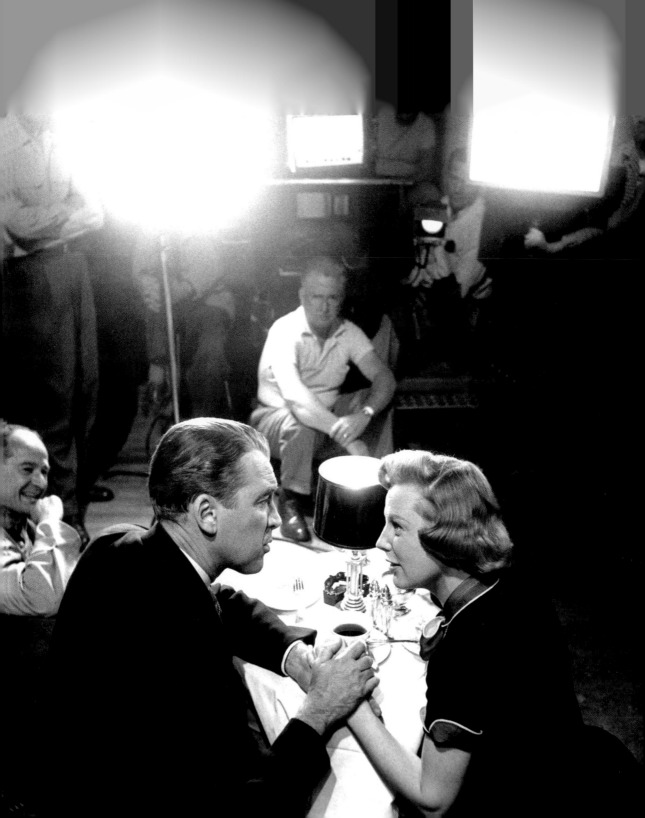

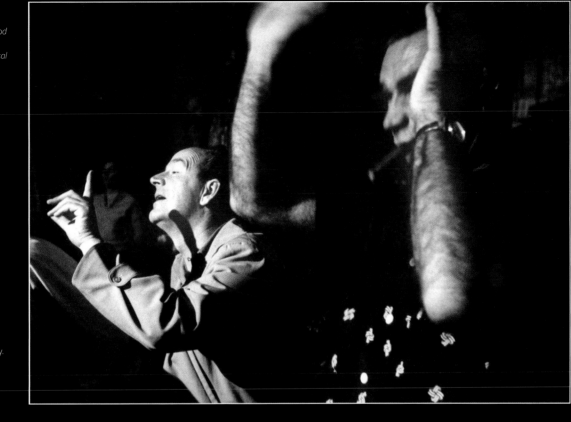

FILMS

Dr. Broadway *(1942)*
Moonlight in Havana *(1942)*
Nobody's Darling *(1943)*
My Best Gal *(1944)*
Strangers in the Night *(1944)*
The Great Flamarion *(1945)*
Two O'Clock Courage *(1945)*
Sing Your Way Home *(1945)*
Strange Impersonation *(1946)*
The Bamboo Blonde *(1946)*
Desperate *(also co-story; 1947)*
Railroaded! *(1947)*
T-Men *(1948)*
Raw Deal *(1948)*
He Walked by Night *(uncredited; 1948)*
The Black Book/Reign of Terror *(1949)*
Border Incident *(1949)*
Side Street *(1950)*
Winchester '73 *(1950)*
The Furies *(1950)*
Devil's Doorway *(1950)*

The Tall Target *(1951)*
Bend of the River *(1952)*
The Naked Spur *(1953)*
Thunder Bay *(1953)*
The Glenn Miller Story (1954)*
The Far Country *(1955)*
Strategic Air Command *(1955)*
The Man from Laramie *(1955)*
The Last Frontier *(1955)*
Serenade *(1956)*
Men in War *(1957)*
The Tin Star *(1957)*
God's Little Acre *(1958)*
Man of the West *(1958)*
Cimarron *(1960)*
El Cid *(1961)*
The Fall of the Roman Empire *(1964)*
The Heroes of Telemark *(UK; 1965)*
A Dandy in Aspic *(also produced; Mann died during production; film completed by Laurence Harvey; 1968)*

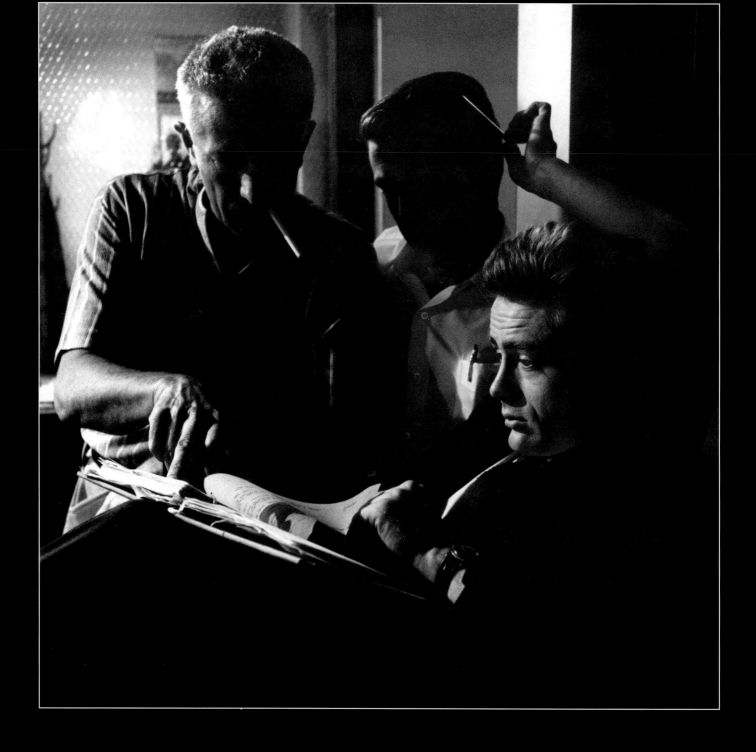

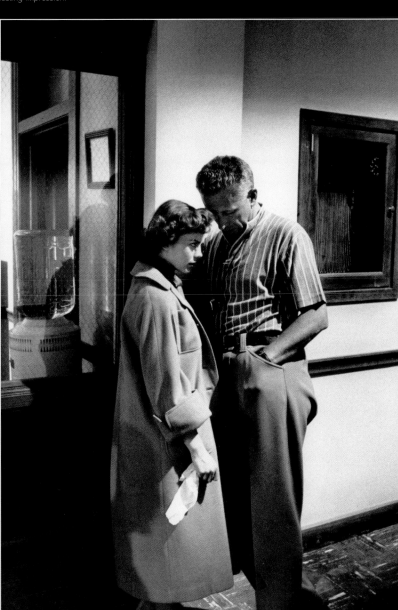

LEFT *Director Nicholas Ray,
photographer Dennis Stock, and
James Dean go over the script on
Rebel Without a Cause. It has
become a cult film, not because
it was a particularly good movie
but because Dean made such a
lasting impression.*

BELOW *Director Ray has a
private word with young Natalie
Wood, away from the filming.*

In 1954 I was working at Warner Brothers on *A Star Is
Born*, and my agent at the time suggested that I go
over to an adjoining set to photograph a young actor
named James Dean. Warner Brothers had tested him
after rave reviews of his performance in the Broadway
play *The Immoralist*. He was in his first film, "a little flick
directed by Nick Ray, and I should shoot a few photo-
graphs for the files." No one could have guessed then
what an amazing box-office success *Rebel Without a
Cause* would be.

FILMS

They Live by Night/The Twisted Road *(also adapted script; 1949)*
A Woman's Secret *(1949)*
Knock on Any Door *(1949)*
Roseanna McCoy *(uncredited; 1949)*
In a Lonely Place *(1950)*
Born to Be Bad *(1950)*
Flying Leathernecks *(1951)*
The Racket *(uncredited; 1951)*
On Dangerous Ground *(1952)*
The Lusty Men *(1952)*
Macao *(uncredited; 1952)*
Androcles and the Lion *(uncredited; 1952)*
Johnny Guitar *(also associate-produced; 1954)*
Run for Cover *(1955)*
Rebel Without a Cause *(also story; 1955)*
Hot Blood *(1956)*
Bigger Than Life *(1956)*
The True Story of Jesse James *(1957)*
Amère Victoire/Bitter Victory *(also co-scripted; 1957)*
Wind across the Everglades *(1958)*
Party Girl *(1958)*
The Savage Innocents/Ombre bianche/Les Dents du diable *(also
scripted; 1960)*
King of Kings *(1961)*
55 Days at Peking *(also acted; 1963)*
We Can't Go Home Again *(made over several years with the students
of NY State University; 1973–76)*
Dreams of 13 *("The Janitor" episode; 1974)*
Lightning over Water/Nick's Film *(co-directed with Wim Wenders;
also acted; 1980)*

Otto Preminger

born Vienna, Austria, December 5, 1905; died New York City, April 23, 1986

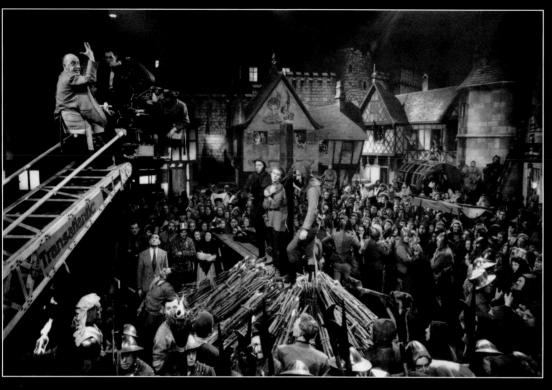

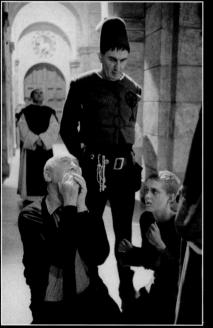

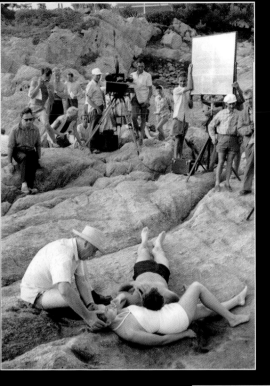

FILMS

Die Grosse Liebe/The Great Love *(1931)*
Under Your Spell *(1936)*
Danger – Love at Work *(1937)*
The Pied Piper *(acted; 1942)*
Margin for Error *(also acted; 1943)*
They Got Me Covered *(acted; 1943)*
In the Meantime, Darling *(1944)*
Laura *(also produced; 1944)*
A Royal Scandal *(1945)*
Fallen Angel *(also produced; 1945)*
Centennial Summer *(also produced; 1946)*
Forever Amber *(1947)*
Daisy Kenyon *(also produced; 1947)*
That Lady in Ermine *(begun by and credited to Ernst Lubitsch; 19*
The Fan *(also produced; 1949)*
Whirlpool *(also produced; 1950)*
Where the Sidewalk Ends *(also produced; 1950)*
The Thirteenth Letter *(also produced; 1951)*
Angel Face *(also produced; 1953)*
The Moon Is Blue *(also produced; 1953)*
Stalag 17 *(acted; 1953)*
River of No Return *(1954)*
Carmen Jones *(also produced; 1954)*
The Man with the Golden Arm *(also produced; 1955)*
The Court-Martial of Billy Mitchell *(1955)*
Saint Joan *(also produced; 1957)*
Bonjour Tristesse *(also produced; 1958)*
Porgy and Bess *(1959)*
Anatomy of a Murder *(also produced; 1959)*
Exodus *(also produced; 1960)*
Advise and Consent *(also produced; 1962)*
The Cardinal *(also produced; 1963)*
In Harm's Way *(also produced; 1965)*
Bunny Lake Is Missing *(also produced; 1965)*
Hurry Sundown *(also produced; 1967)*
Skidoo! *(also produced; 1968)*
Tell Me That You Love Me, Junie Moon *(also produced; 1970)*
Such Good Friends *(also produced; 1971)*
Rosebud *(also produced; 1975)*
The Human Factor *(also produced; 1980)*

LEFT AND BELOW *Otto places Deborah Kerr's head for the camera; and Otto with David Niven.* Bonjour Tristesse *(Wheel Productions), France, 1958.*

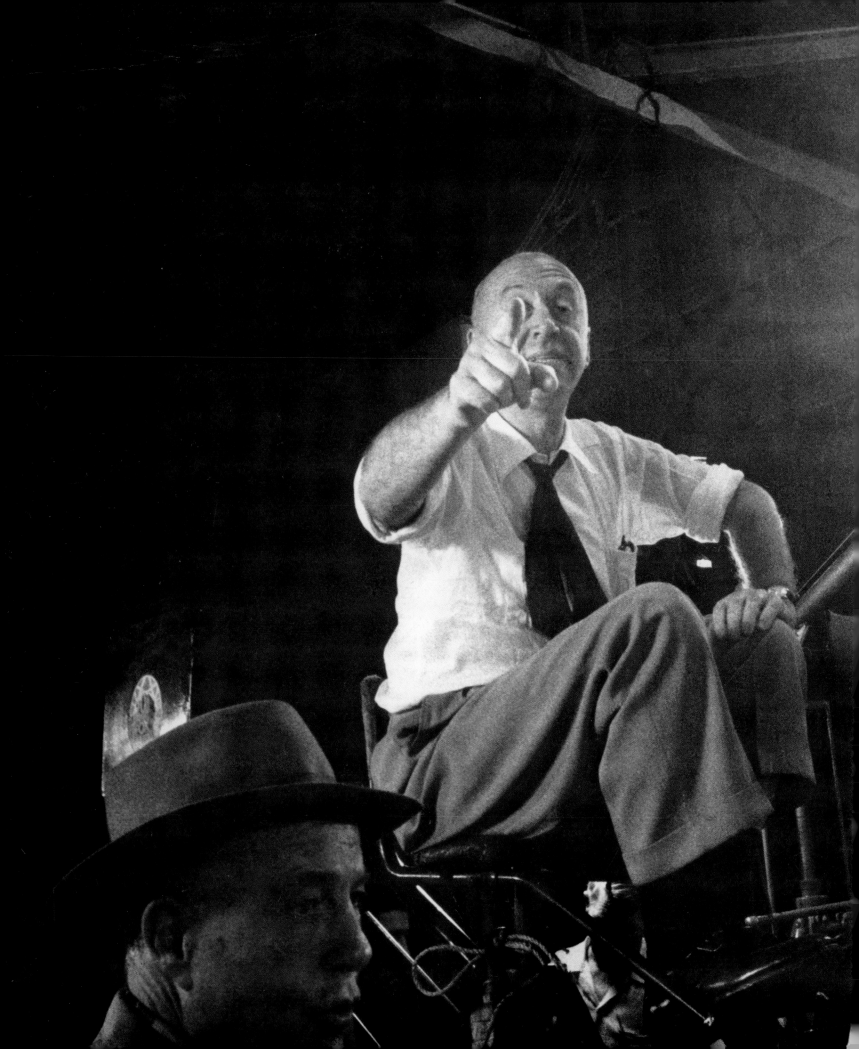

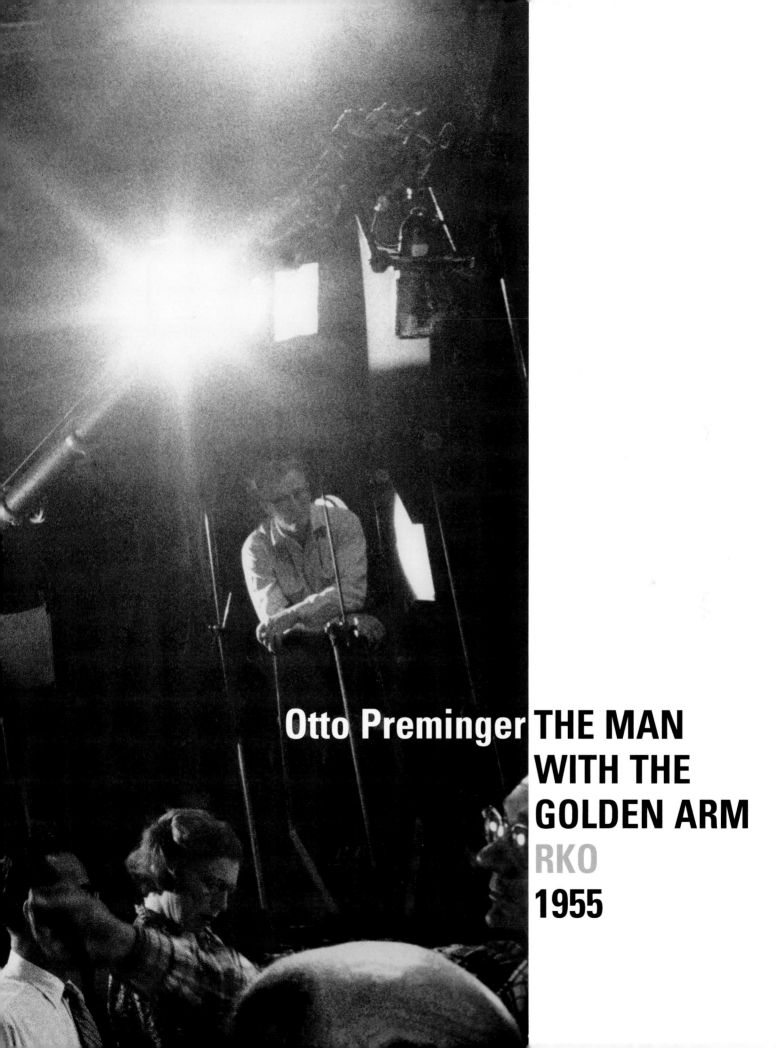

Otto Preminger THE MAN
WITH THE
GOLDEN ARM
RKO
1955

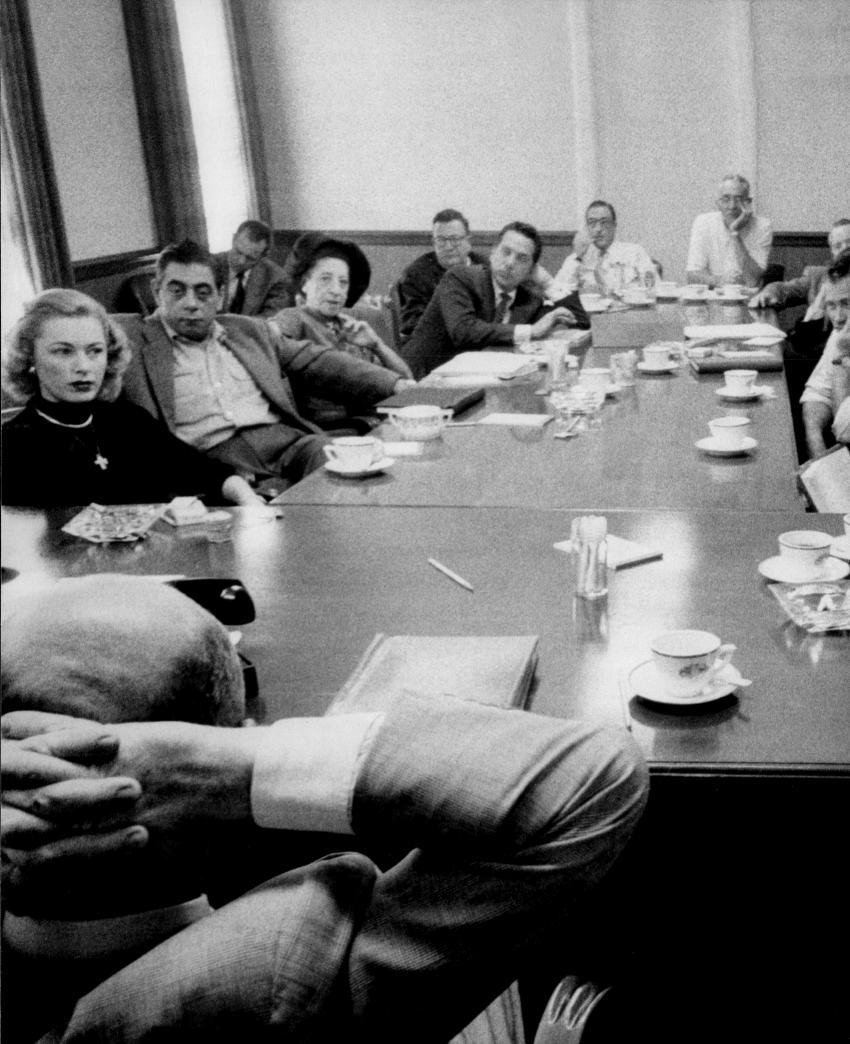

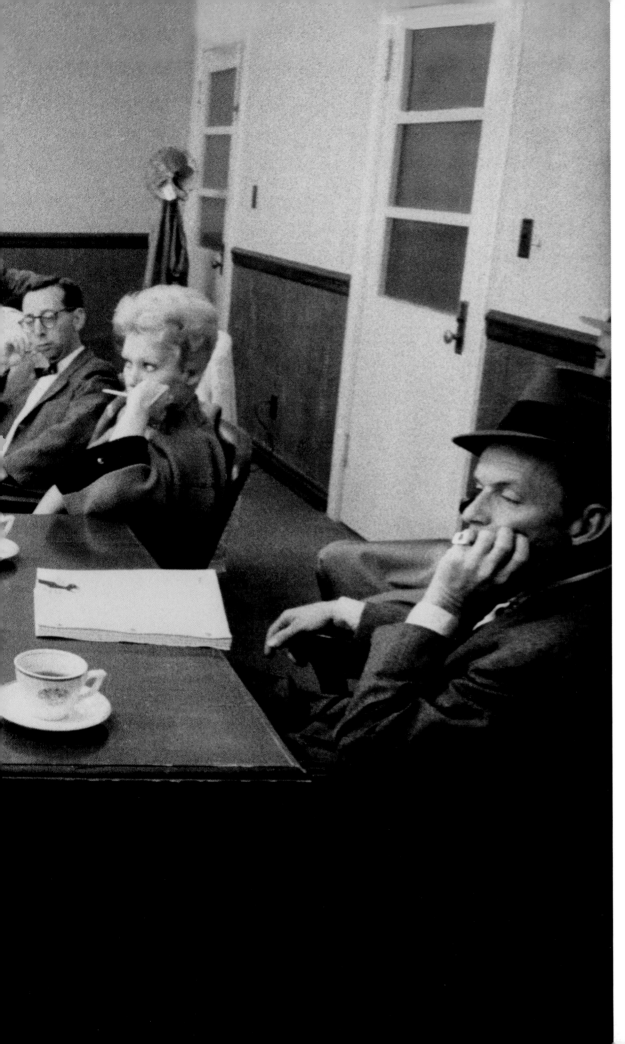

Otto Preminger

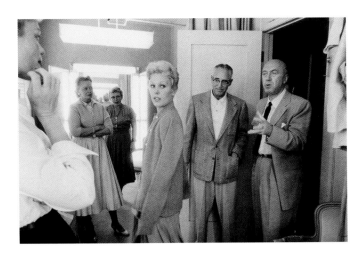

LEFT *Preminger was called in by his costume designer, Mary Ann Nyberg (far left), to see the wardrobe she had selected for Kim Novak. Then it was time for rehearsal and the serious business of making a film from Nelson Algren's downbeat novel. (Otto is seen here with production manager Jack McEdwards.)*

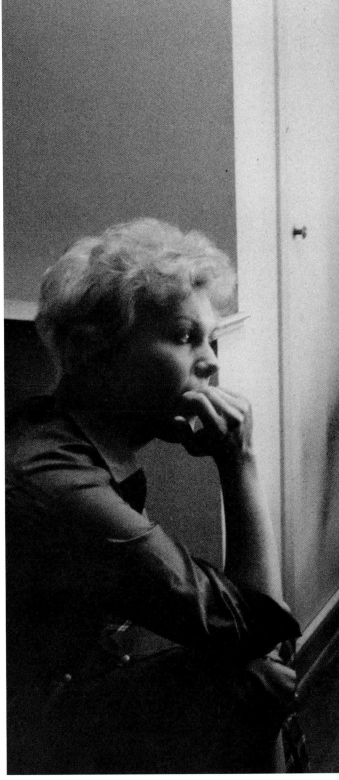

Preminger was the first producer I knew of who rented a sound stage from a major studio at a flat rate, instead of taking the production to the studio itself. He told me that the film studios regularly charged the production costs and overheads of the entire studio when he produced a film with them. So he became one of the first independent producers in Hollywood, mainly to avoid these excessive charges. It didn't take long for other film-makers to see the wisdom in this approach, and a new era in Hollywood was in the making.

BELOW *Preminger watches Frank Sinatra as Frankie Machine, a drummer lost to the world of drugs, rehearsing with Eleanor Parker, who plays his wheelchair-bound wife, Zosch, in the film.*

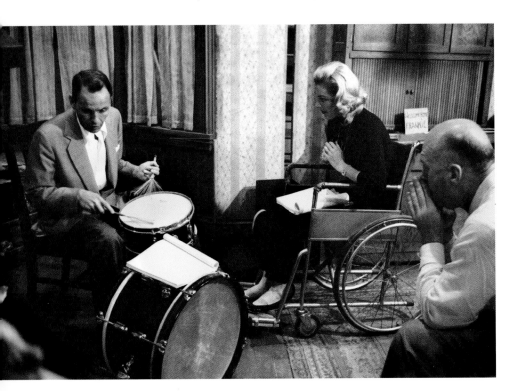

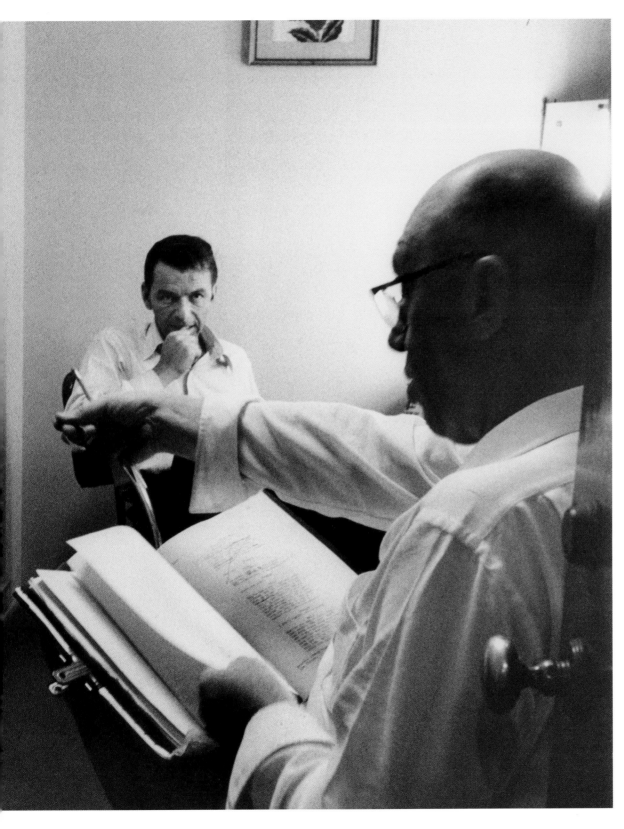

Otto rehearses with Sinatra and Novak in his dressing room before filming begins. Frank's concentration was very intense in his role. Novak was another matter; she worked very hard, but it was easy to see that she was really out of her depth when it came to the emotional scenes. Kim was a very attractive earthy blonde whom I had photographed a year before for Glamour magazine. She was an up-and-coming starlet then, living at the Hollywood Studio Club. This film would give her career a real shot in the arm (no pun intended).

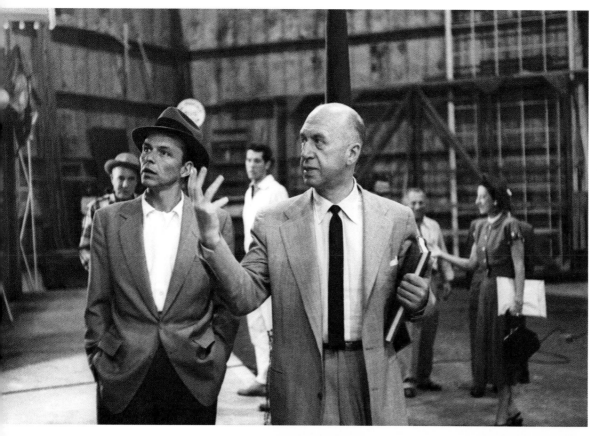

ABOVE *Preminger shows an amazed Frank Sinatra the set he will be working in. It was amazingly realistic, and I remember that it was the first time I had seen the way the craftsmen made an impression of an entire wall of bricks in plaster. Preminger was a very good producer, and while he cut corners wherever he could, his production values never suffered. He also understood how to exploit and get publicity better than any producer I've ever worked with.*

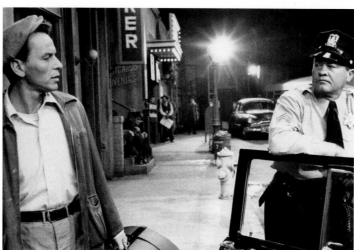

ABOVE *The world in which Frankie lives is revealed to the audience as he heads home to his apartment and his wife, Zosch.*

RIGHT *The beginning of Preminger's opening tracking shot, which follows Frankie as he gets off the bus on his return from prison and tracks him down the street, past neighbors and the cop on the beat. Other directors have told me how much they admired it.*

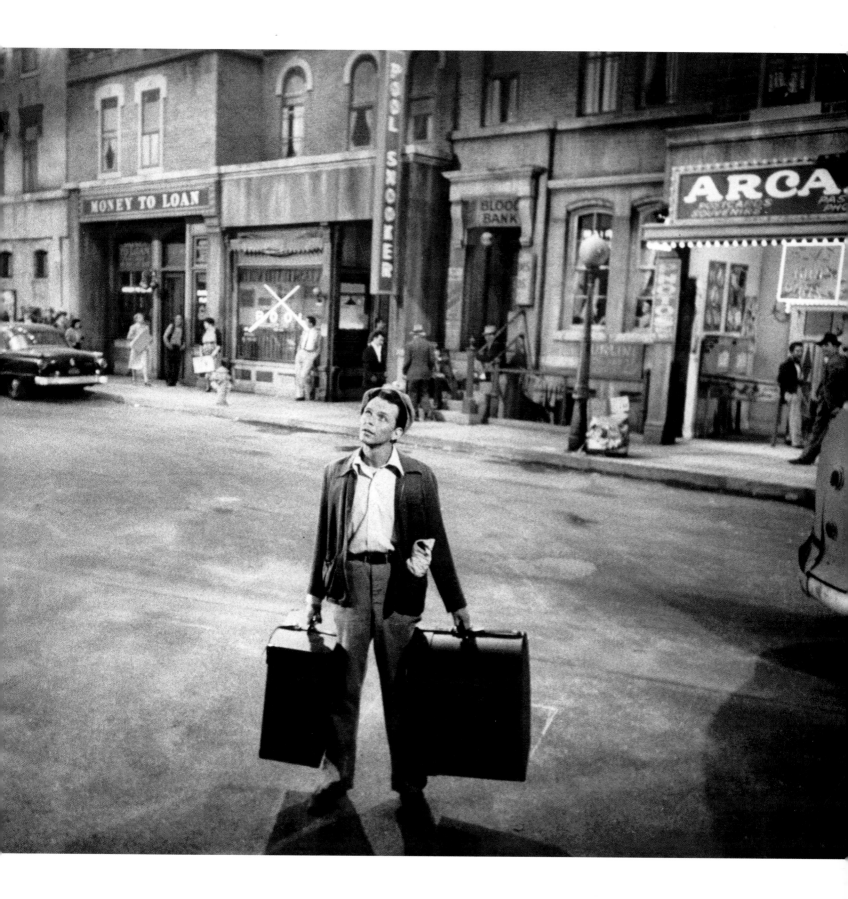

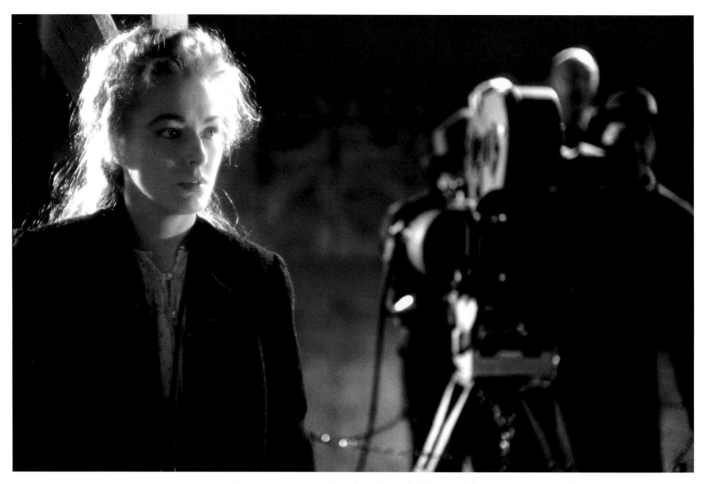

Over and over again, Frankie has told Zosch that he's through with drugs. Then one day when he's not home, his former drug-dealer, Louie (Darren McGavin), comes to their apartment and tells Zosch he wants the money that Frankie owes him. She's so angry, knowing this sleazy dealer has her husband hooked again, that somehow she finds her feet, and as she struggles with him she falls over the balcony.

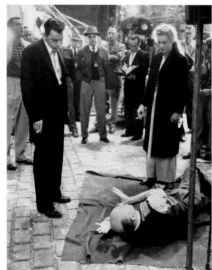

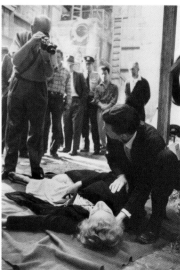

ABOVE *Eleanor Parker, with cinematographer Sam Leavitt and Preminger on the crane behind her, about to start rehearsals.*

RIGHT AND FAR RIGHT *Preminger shows Parker how he wants her to lie after her fall, and then watches the actors rehearse.*

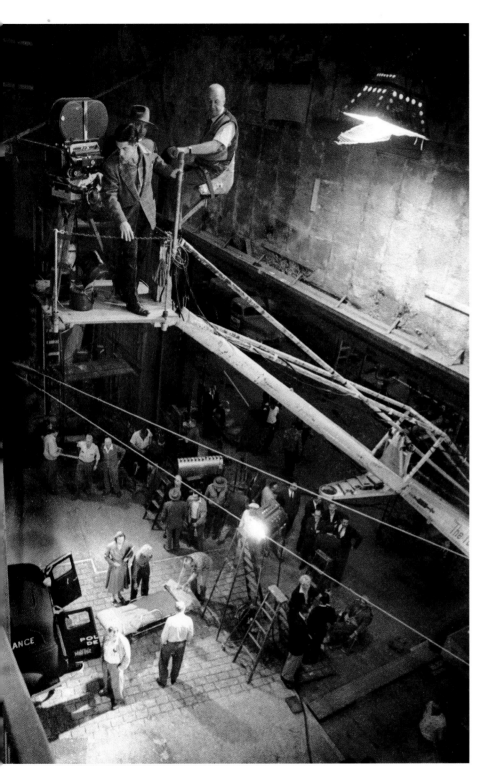

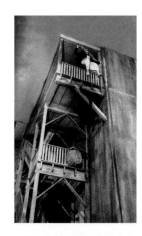

LEFT *Preminger and Leavitt on a tall, very rickety-looking camera crane, which will follow the action above and as Zosch (Parker) falls to the ground.*

RIGHT *A stuntwoman makes the real fall.*

BELOW *This is how the final shot looked in the film, with Eleanor Parker and Frank Sinatra.*

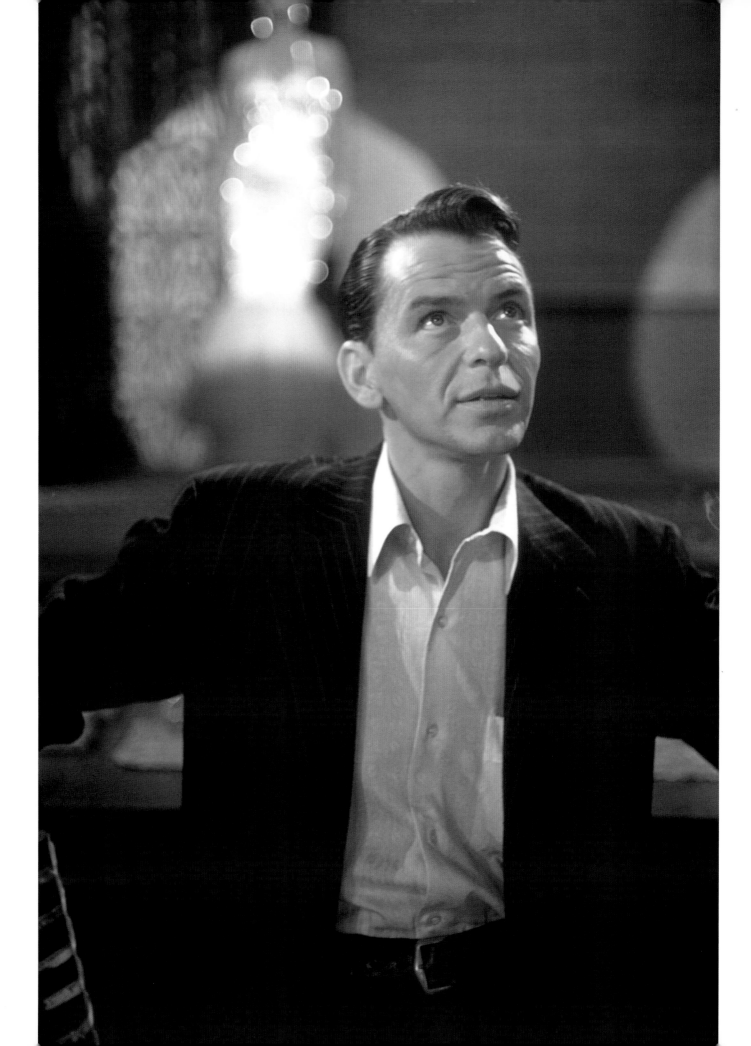

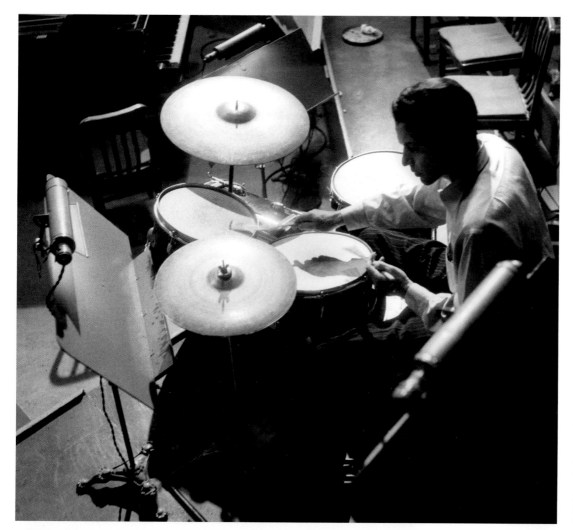

LEFT *Sinatra rehearses with the drums for the coming scene. He was coached by the terrific drummer Shelly Manne, who also had a small part in the film.*

BELOW LEFT *In the scene, Frankie tries out with an orchestra, but he's too spaced out and doesn't get the job. In the rehearsal shown here, Preminger indicates to the camera to move slowly as it tracks in for a close-up. Shorty Rogers, whose great group supplied the jazz, is standing at the back. Elmer Bernstein, who wrote the film's score, leans on the piano, and Lou Levy is at the keyboard.*

BELOW *Preminger watches the rehearsal for the scene in which Frankie needs a fix.*

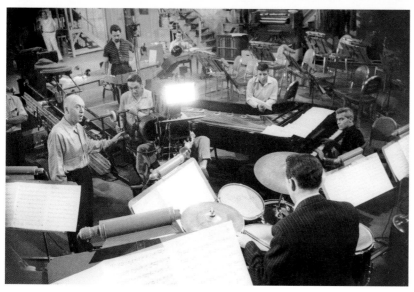

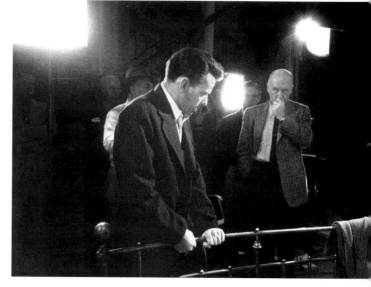

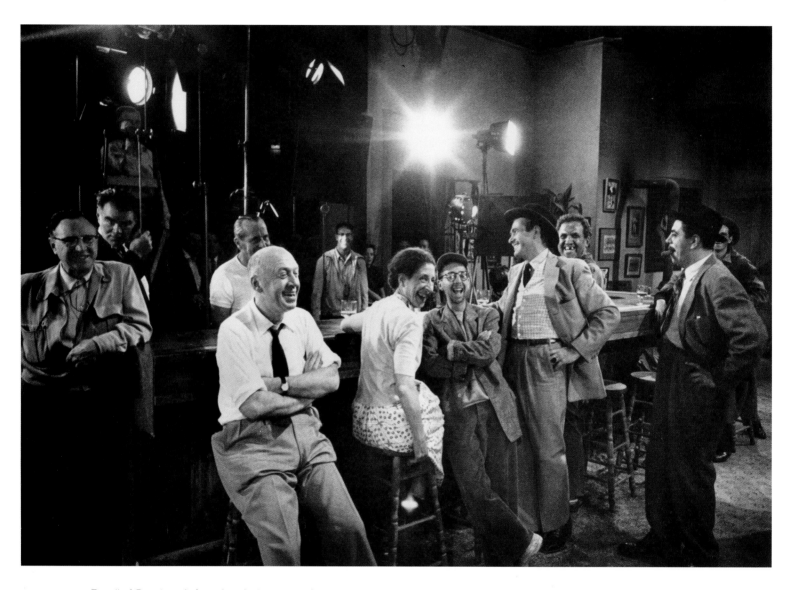

For all of Preminger's famed explosive temper, he never directed it Sinatra's way. There was a sort of mutual regard between them. Frank would call Otto "Ludwig" and—when he was happy with him—Otto called Frank "Francis Albert."

ABOVE *As this picture shows, at times there was laughter on the set (left to right: lighting gaffer Jack Almond, George Mathews, Otto Preminger, Doro Merande, Arnold Stang, Darren McGavin, and Robert Strauss). Otto could be charming and witty, and could then just as easily start screaming. Otto told me that his psychiatrist said it was good to let it all out.*

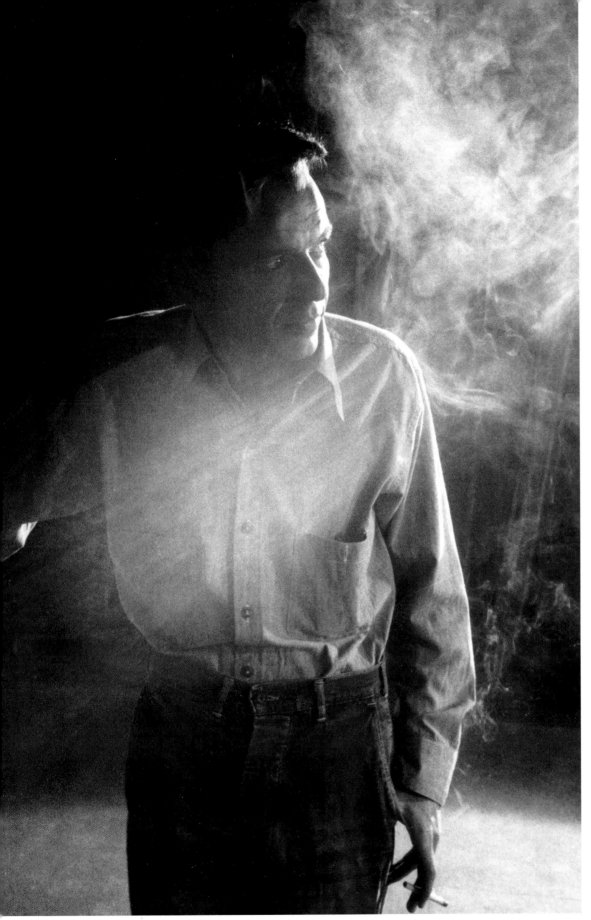

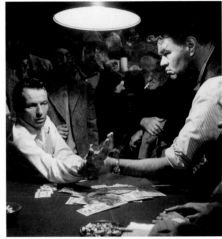

ABOVE *Frankie, strapped for cash to pay for his drugs, is caught cheating at cards and is beaten up by Williams (George Mathews). Molly the bar girl (Kim Novak) takes pity on him. She helps him back to her place and tells him that if he wants to stay he must give up the drugs. Of course he wants to stay, but when the withdrawal symptoms start to hit him, he is physically and mentally weak.*

LEFT *Sinatra, enveloped in smoke, edgily waits for rehearsals to begin.*

Kim Novak was very attractive, and that fact wasn't lost on either Otto or Frank.

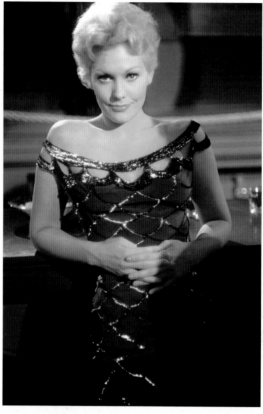

ABOVE AND RIGHT *Kim comes on to the set to show Otto one of the dresses she wears in the bar sequence, eliciting an appreciative whistle from him, and a "wow" from Yul Brynner, in the background, who was visiting that day.*

RIGHT *Frank gives Kim a melting look, which I don't think was part of the film script.*

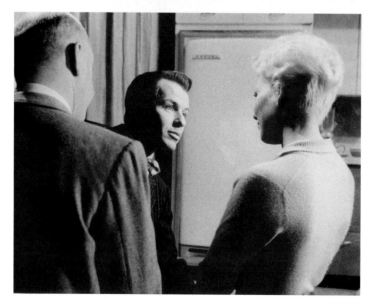

FAR RIGHT *Otto takes Kim away from the set during a break, for a private tutorial.*

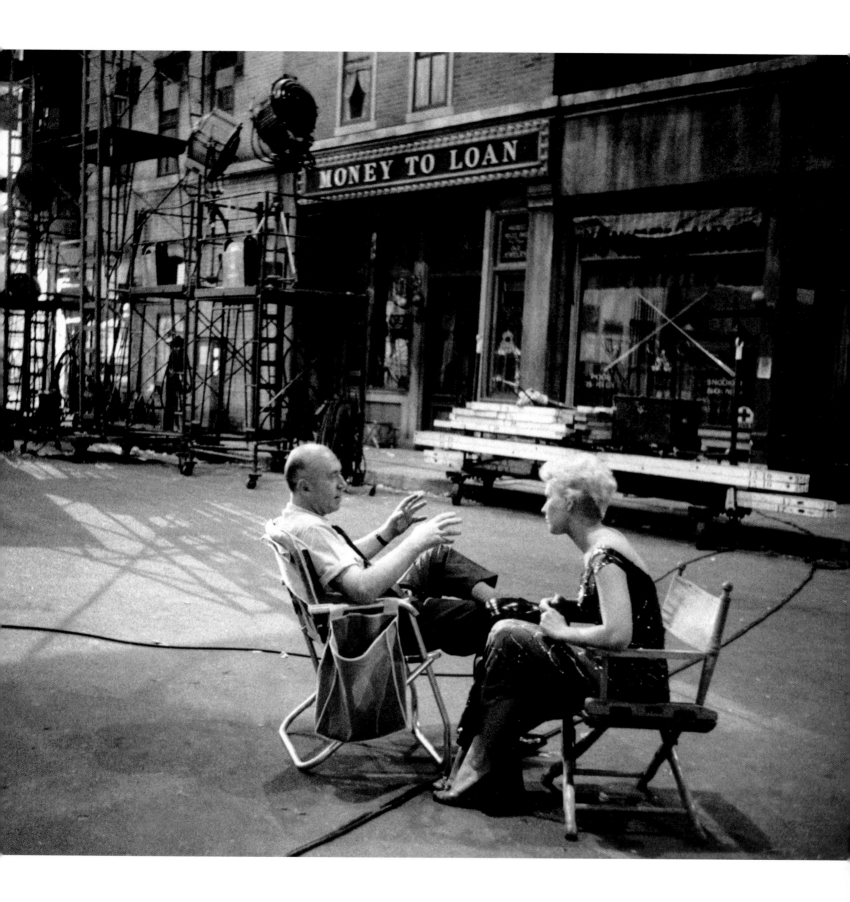

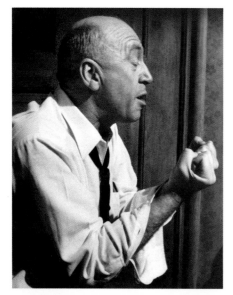

Otto pulls out all the stops to indicate to Kim the level of intensity he wants from her. This is the scene in which Molly pleads with Frankie to be brave and see this withdrawal period through.

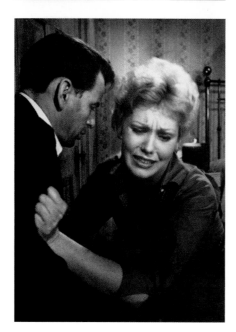

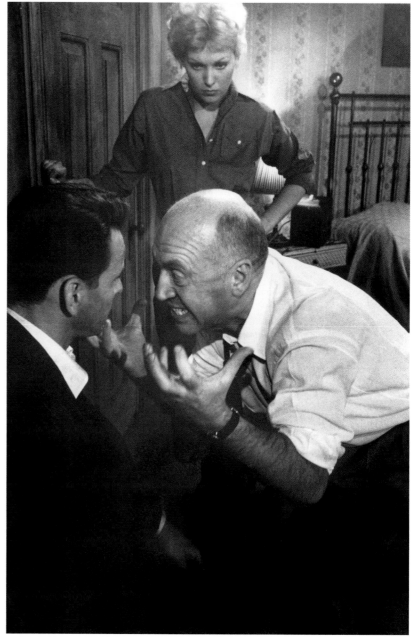

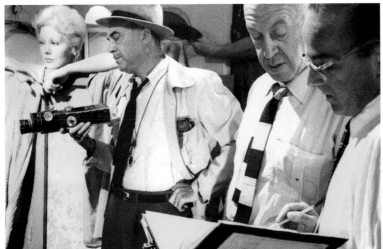

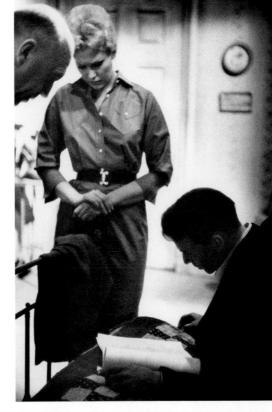

ABOVE Kim, peeking over the top of the screen, waits with cinematographer Sam Leavitt (holding viewfinder) for the rehearsal to begin, while Otto checks the script with his assistant, Max Slater.

ABOVE RIGHT Sinatra goes through the first rehearsal reading from the script.

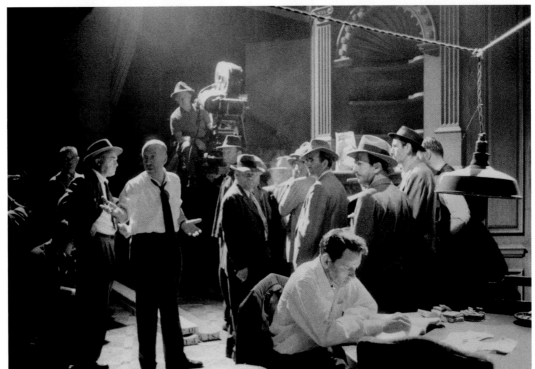

RIGHT While Otto sorts out his troops, Frank takes one last look at the script.

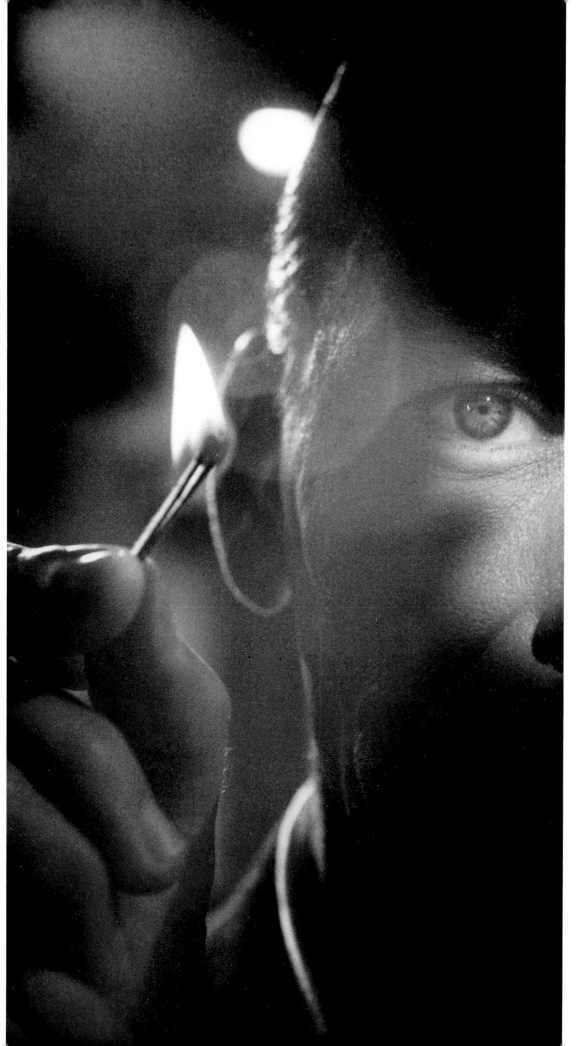

LEFT *Otto had chemical solution put into Sinatra's eyes for one shot, to make the pupils contract, as if he really were a junky. I'm told the police at one time would light a match to look into the eyes of a suspect, to see if he had taken drugs.*

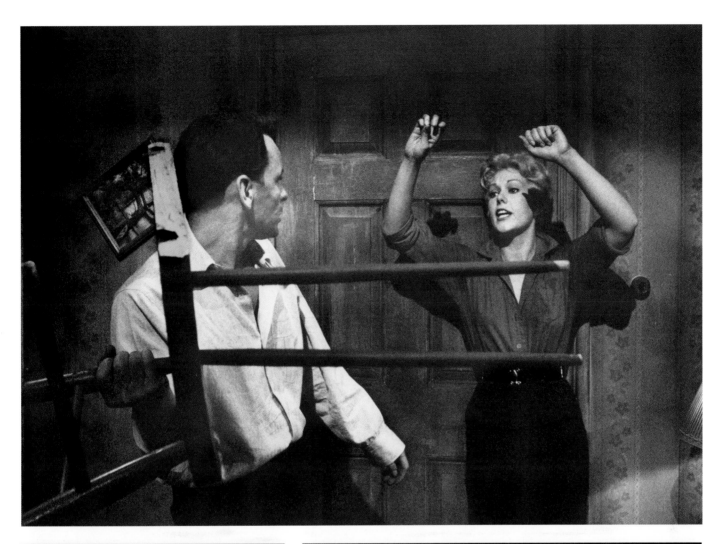

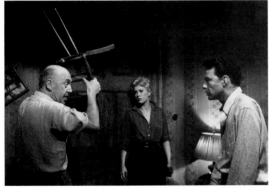

THIS PAGE *No more Mr. Nice Guy: Otto must get the scene where Molly helps Frankie dry out—cold turkey. It was hard for Kim to match Otto's intensity, and he was at full steam sometimes trying to get her mad.*

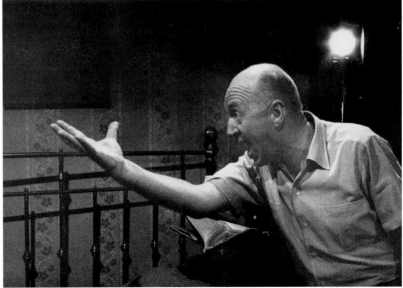

Frank Sinatra was nominated in the best actor category by the Motion Picture Academy for his work on this film. He had already won an Oscar as the best supporting actor in *From Here to Eternity* a few years before. This film proved again what a fine actor Frank could be.

These images were made during the withdrawal sequence, and Frank gave it everything he had. When Otto yelled "Cut!" and said something about doing another take, Frank looked up at Al Myers, the camera operator, and asked him if he'd got it. Al quietly nodded, and Frank walked back to his dressing room. There would be no retakes on this scene.

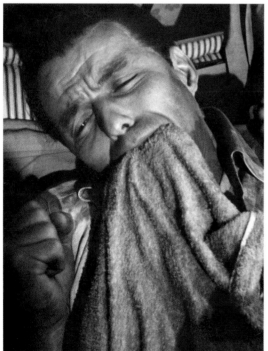

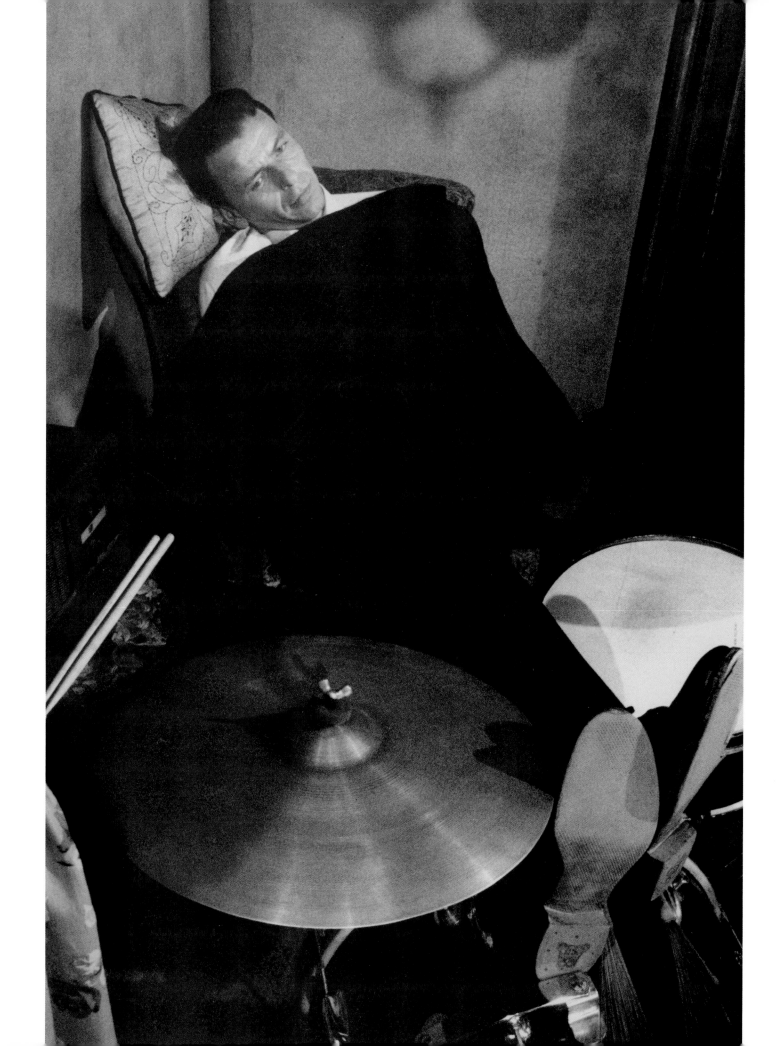

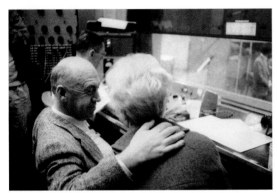

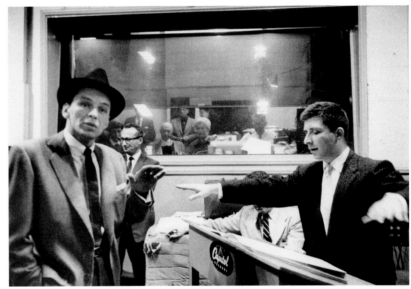

TOP *Otto is still directing, this time in the sound booth at the recording session of the film's soundtrack.*

ABOVE AND ABOVE RIGHT *Otto with his arm around Kim Novak, as they prepare to listen to Frank sing with the terrific score that Elmer Bernstein has written and is directing.*

LEFT *Sinatra is photographed alone in a quiet corner of the set, I'm sure exhausted from the weeks of emotional scenes in this film.*

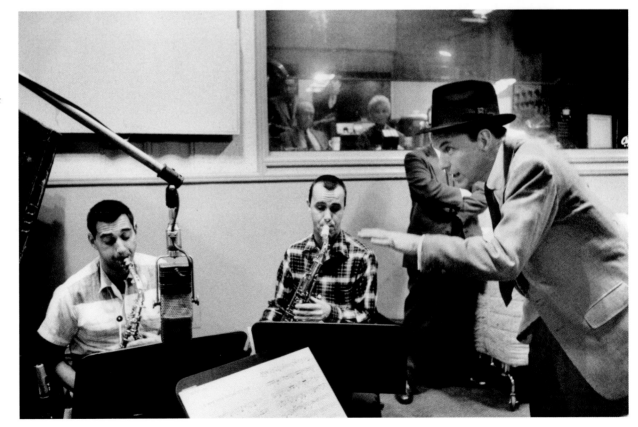

RIGHT *Frank now becomes the director. This is what he does, and where he lives.*

ABOVE *Otto gives Kim a farewell squeeze at the end of the film. One could see there was definitely some close bond between them.*

RIGHT *Otto has just seen the first rough cut of the film, and he sits back in the screening room as his film editor, Lou Loeffler, wonders what he thinks. The film was critically acclaimed, especially Sinatra's performance and the exciting Elmer Bernstein score played by Shorty Rogers.*

Bill Wellman won the first best picture Academy Award for his film *Wings* in 1927. He had been a decorated pilot in World War I, and put his flying experiences to use in creating the realism of air warfare of the time. His bad temper and reputation as being very demanding of his actors won him the apparently well-deserved nickname of "Wild Bill."

We are all in his debt for the legacy of films that he's left us. You can read the credits on the facing page and judge for yourself. *The Ox-Bow Incident*, *A Star Is Born*, *Nothing Sacred* … He was a real film-maker of an era now long gone. I met him only briefly, on the location of *Blood Alley* (Warner Brothers), in 1955, just below San Francisco (*see the pictures on these pages*). He and John Wayne seemed to hit it off very well, and there were no fist fights with the actors while I was there.

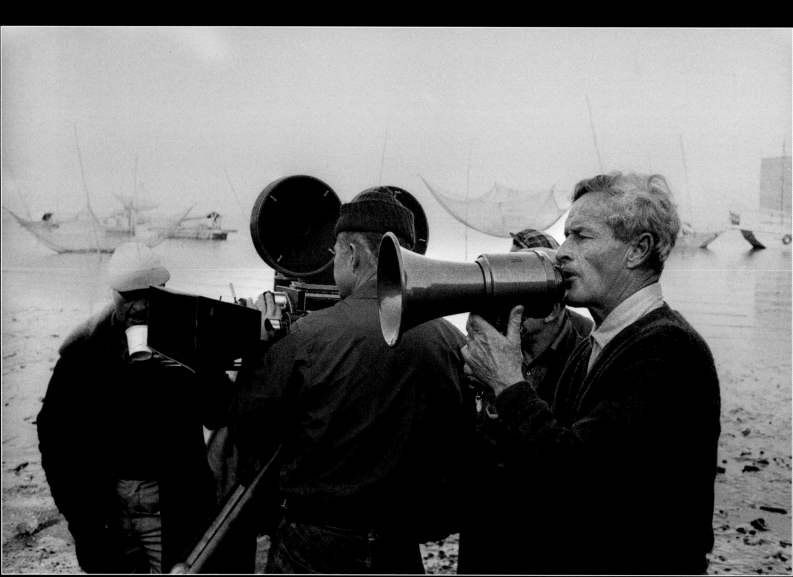

FILMS

The Man Who Won *(1923)*
Second Hand Love *(1923)*
Big Dan *(1923)*
Cupid's Fireman *(1923)*
The Vagabond Trail *(1924)*
Not A Drum Was Heard *(1924)*
The Circus Cowboy *(1924)*
When Husbands Flirt *(1925)*
The Boob *(1926)*
The Cat's Pajamas *(1926)*
You Never Know Women *(1926)*
Wings *(1927)*
The Legion of the Condemned *(1928)*
Ladies of the Mob *(1928)*
Beggars of Life *(1928)*
Wings *(re-released with sound; 1929)*
Chinatown Nights *(1929)*
The Man I Love *(1929)*
Woman Trap *(1929)*
Dangerous Paradise *(1930)*
Young Eagles *(1930)*
Maybe It's Love *(1930)*
Other Men's Women/The Steel Highway *(1931)*
The Public Enemy *(1931)*
Night Nurse *(1931)*
The Star Witness *(1931)*
Safe in Hell *(1931)*
The Hatchet Man *(1932)*
So Big *(1932)*
Love Is a Racket *(1932)*
The Purchase Price *(1932)*
The Conquerors *(1932)*
Frisco Jenny *(1933)*
Central Airport *(1933)*
Lilly Turner *(1933)*
Midnight Mary *(1933)*
Heroes for Sale *(1933)*
Wild Boys of the Road *(1933)*
College Coach *(1933)*
Looking for Trouble *(1934)*
Stingaree *(1934)*
The President Vanishes *(1934)*
Call of the Wild *(1935)*
The Robin Hood of El Dorado *(also co-scripted; 1936)*
Small Town Girl *(1936)*
A Star Is Born *(also co-story; 1937)*
Nothing Sacred *(1937)*
Men with Wings *(also produced; 1938)*
Beau Geste *(also produced; 1939)*
The Light that Failed *(also produced; 1939)*
Reaching for the Sun *(also produced; 1941)*
Roxie Hart *(1942)*
The Great Man's Lady *(also produced; 1942)*
Thunder Birds *(1942)*
The Ox-Bow Incident *(1943)*
Lady of Burlesque *(1943)*
Buffalo Bill *(1944)*

This Man's Navy *(1945)*
The Story of G.I. Joe *(1945)*
Gallant Journey *(also produced and co-scripted; 1946)*
Magic Town *(1947)*
The Iron Curtain *(1948)*
Yellow Sky *(1948)*
Battleground *(1949)*
The Happy Years *(1950)*
The Next Voice You Hear *(1950)*
Across the Wide Missouri *(1951)*
It's a Big Country *(co-directed; 1952)*
Westward the Women *(1952)*
My Man and I *(1952)*
Island in the Sky *(1953)*
The High and the Mighty *(1954)*
Track of the Cat *(1954)*
Ring of Fear *(uncredited; 1954)*
Blood Alley *(1955)*
Goodbye My Lady *(1956)*
Darby's Rangers *(1958)*
Lafayette Escadrille *(also story; 1958)*

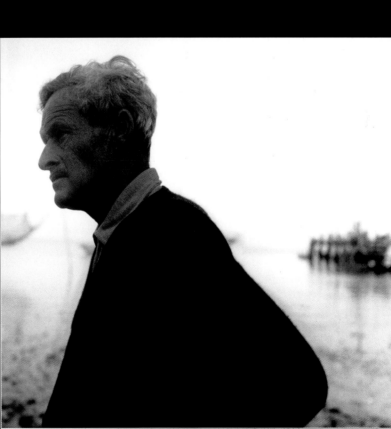

Henry King

born Christiansburg, Virginia, June 24, 1888; died Toluca Lake, California, June 29, 1982

When Henry King made his last film, *Tender Is the Night*, he was seventy-six years old and had made more than a hundred films, yet he was still bouncing around the set making sure of every detail. An amazing man!

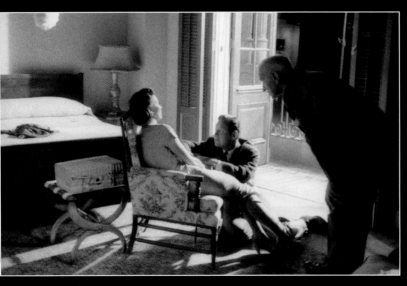

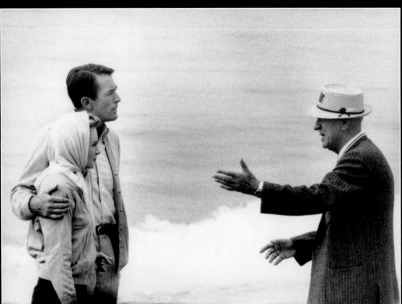

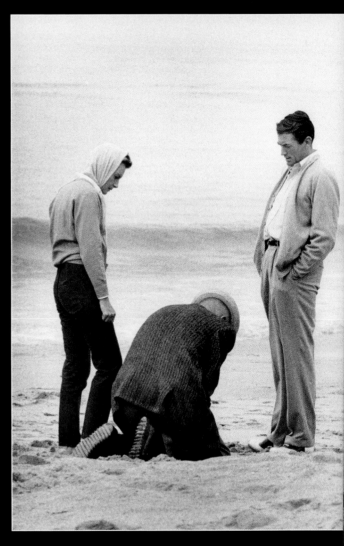

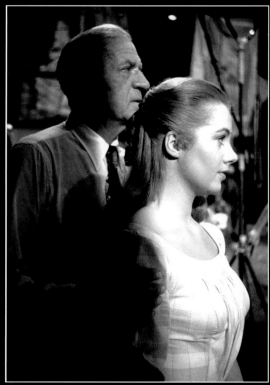

BELOW AND BOTTOM *King with (top picture) Gordon MacRae, Barbara Ruick, and Shirley Jones; and (bottom) with Shirley Jones.* Carousel, *20th Century Fox, 1955.*

FILMS

Who Pays? *(serial; credit uncertain; 1915)*
Should a Wife Forgive?/Lady of Perfume *(1915)*
Nemesis/The Brand of Man *(short; also acted; 1915)*
Little Mary Sunshine *(also acted; 1916)*
The Oath of Hate *(short; also acted; 1916)*
Pay Dirt *(also acted; 1916)*
Shadows and Sunshine *(1916)*
Joy and the Dragon *(1916)*
Faith's Reward *(1916)*
Twin Kiddies *(also acted; 1917)*
Told at Twilight *(also acted; 1917)*
Sunshine and Gold *(also scripted and acted; 1917)*
The Mainspring *(also acted; 1917)*
Souls in Pawn *(1917)*
The Bride's Silence *(1917)*
Vengeance of the Dead *(1917)*
The Climber *(1917)*
A Game of Wits *(1917)*
The Mate of Sally Ann *(1917)*
New York Luck *(credit doubtful; 1917)*
Scepter of Suspicion *(short; 1917)*
Beauty and the Rogue *(1918)*
Powers That Prey *(1918)*
Hearts or Diamonds? *(1918)*
Social Briars *(1918)*
Up Romance Road *(1918)*
The Ghost of Rosy Taylor *(credit doubtful; 1918)*
The Locked Heart *(also acted; 1918)*
No Children Wanted *(credit doubtful; 1918)*
Hobbs in a Hurry *(1918)*
All the World to Nothing *(1918)*
When a Man Rides Alone *(1919)*
Where the West Begins *(1919)*
Brass Buttons *(1919)*
Some Liar *(1919)*
A Sporting Chance *(1919)*
This Hero Stuff *(1919)*
Six Feet Four *(1919)*
23½ Hours Leave *(1919)*
A Fugitive from Matrimony *(1919)*
Haunting Shadows *(1920)*
The White Dove/Judge Not Thy Wife *(1920)*
Uncharted Channels *(1920)*
One Hour before Dawn *(1920)*
Help Wanted – Male *(also acted; 1920)*
Dice of Destiny *(1920)*
When We Were 21 *(1921)*
The Mistress of Shenstone *(1921)*
Salvage *(1921)*
The Sting of the Lash *(1921)*
Tol'able David *(also produced and co-scripted; 1921)*
The Seventh Day *(also produced; 1922)*
Sonny *(also produced and co-scripted; 1922)*
The Bond Boy *(also produced; 1922)*
Fury *(also produced; 1923)*
The White Sister *(also produced; 1923)*
Romola *(also produced; 1924)*
Sackcloth and Scarlet *(also produced; 1925)*

Any Woman *(also produced; 1925)*
Stella Dallas *(1925)*
Partners Again *(1926)*
The Winning of Barbara Worth *(1926)*
The Magic Flame *(1927)*
The Woman Disputed *(co-directed with Sam Taylor; also produced; 1928)*
She Goes to War *(also executive-produced; 1929)*
Hell Harbor *(also executive-produced; 1930)*
The Eyes of the World *(also executive-produced; 1930)*
Lightnin' *(1930)*
Merely Mary Ann *(1931)*
Over the Hill *(1931)*
The Woman in Room 13 *(1932)*
State Fair *(1933)*
I Loved You Wednesday *(co-directed with William Cameron Menzies; 1933)*
Carolina *(1934)*
Marie Galante *(1934)*
One More Spring *(1935)*
Way Down East *(1935)*
The Country Doctor *(1936)*
Ramona *(1936)*
Lloyds of London *(1936)*
Seventh Heaven *(1937)*
In Old Chicago *(1938)*
Alexander's Rag Time Band *(1938)*
Jesse James *(1939)*
Stanley and Livingstone *(1939)*
Little Old New York *(1940)*
Maryland *(1940)*
Chad Hanna *(1940)*
A Yank in the R.A.F. *(1941)*
Remember the Day *(1941)*
The Black Swan *(1942)*
The Song of Bernadette *(1943)*
Wilson *(1944)*
A Bell for Adano *(1945)*
Margie *(1946)*
Captain from Castile *(1947)*
Deep Waters *(1948)*
Prince of Foxes *(1949)*
Twelve O'Clock High *(1949)*
The Gun Fighter *(1950)*
I'd Climb the Highest Mountain *(1951)*
David and Bathsheba *(1951)*
Wait Till the Sun Shines Nellie *(1952)*
The Snows of Kilimanjaro *(1952)*
O. Henry's Full House *("The Gift of the Magi" episode; 1952)*
King of the Khyber Rifles *(1953)*
Untamed *(1955)*
Love Is a Many-Splendored Thing *(1955)*
Carousel *(1956)*
The Sun Also Rises *(1957)*
The Bravados *(1958)*
This Earth Is Mine *(1959)*
Beloved Infidel *(1959)*
Tender Is the Night *(1962)*

Charles Vidor

Karoly Vidor; born Budapest, Hungary, July 27, 1900; died Vienna, Austria, June 4, 1959

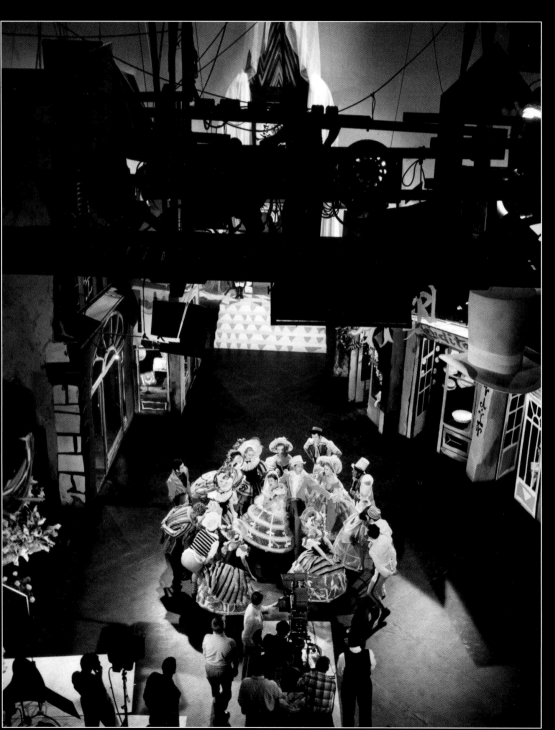

LEFT *We are looking down on the* Hans Christian Andersen *set with Danny Kaye and Zizi Jeanmaire (middle of group). The camera and Charles Vidor are at the bottom.*

RIGHT TOP *Charles Vidor directing. This was literally my first film assignment and it was all magic to me. Vidor was very sweet to this new kid on the block.* Hans Christian Andersen, *Goldwyn Studios, 1952.*

RIGHT BOTTOM *Vidor with Rock Hudson on the northern Italian location of* A Farewell to Arms *in 1957 (20th Century Fox). This was Vidor's last completed film, and he was constantly harassed by producer David O. Selznick. (It was Selznick's last film as well.) It became embarrassing to the actors. Rock told me he was glad to get away the time I took him off to photograph him for a* Look *cover. Consequently the film looked like it had been directed by a committee.*

FILMS

The Bridge *(short; 1931)*
The Mask of Fu Manchu *(uncredited; co-directed with Charles Bralin; 1932)*
Sensation Hunters *(1933)*
Double Door *(1934)*
Strangers All *(1935)*
The Arizonian *(1935)*
His Family Tree *(1935)*
Muss 'Em Up *(1936)*
A Doctor's Diary *(1937)*
The Great Gambini *(1937)*
She's No Lady *(1937)*
Romance of the Redwoods *(1939)*
Blind Alley *(1939)*
Those High Grey Walls *(1939)*
My Son, My Son! *(1940)*
The Lady in Question *(1940)*
Ladies in Retirement *(1941)*
New York Town *(1941)*
The Tuttles of Tahiti *(1942)*
Desperadoes *(1943)*
Cover Girl *(1944)*
Together Again *(1944)*
A Song to Remember *(1945)*
Over 21 *(1945)*
Gilda *(1946)*
The Loves of Carmen *(also produced; 1948)*
It's a Big Country *(co-directed with six others; 1952)*
Hans Christian Andersen *(1952)*
Thunder in the East *(1953)*
Rhapsody *(1954)*
Love Me or Leave Me *(1955)*
The Swan *(1956)*
The Joker Is Wild/All the Way *(1957)*
A Farewell to Arms *(1958)*
Song Without End *(completed by George Cukor; 1960)*

Edward Dmytryk

born Grand Forks, British Columbia, September 4, 1908; died Encino, California, July 1, 1999

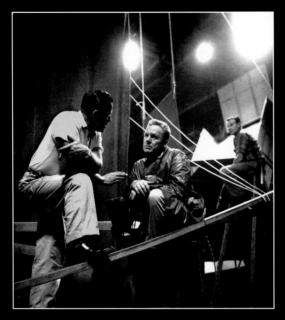

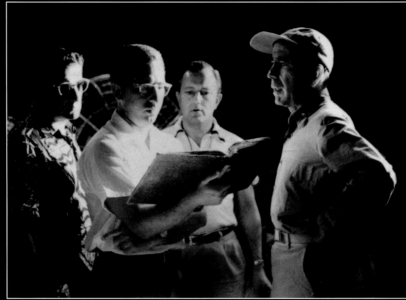

ABOVE *On the set of* The Caine Mutiny *with Van Johnson.*

ABOVE RIGHT *Stanley Kramer, the script supervisor, Dmytryk, and Humphrey Bogart.* The Caine Mutiny, *Columbia, 1954.*

RIGHT *On the film* The Mountain *(Paramount, 1956): Spencer Tracy in the foreground and Dmytryk above on the camera crane (center).*

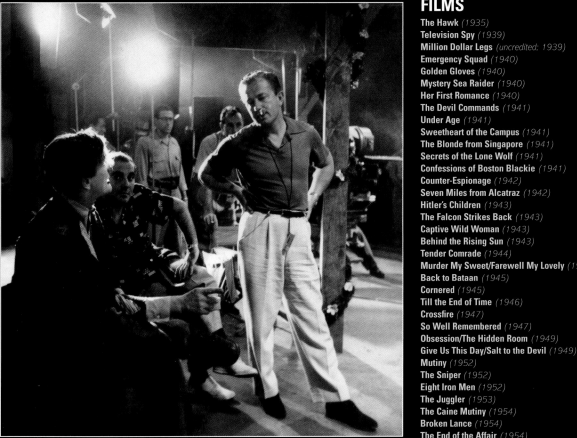

FILMS

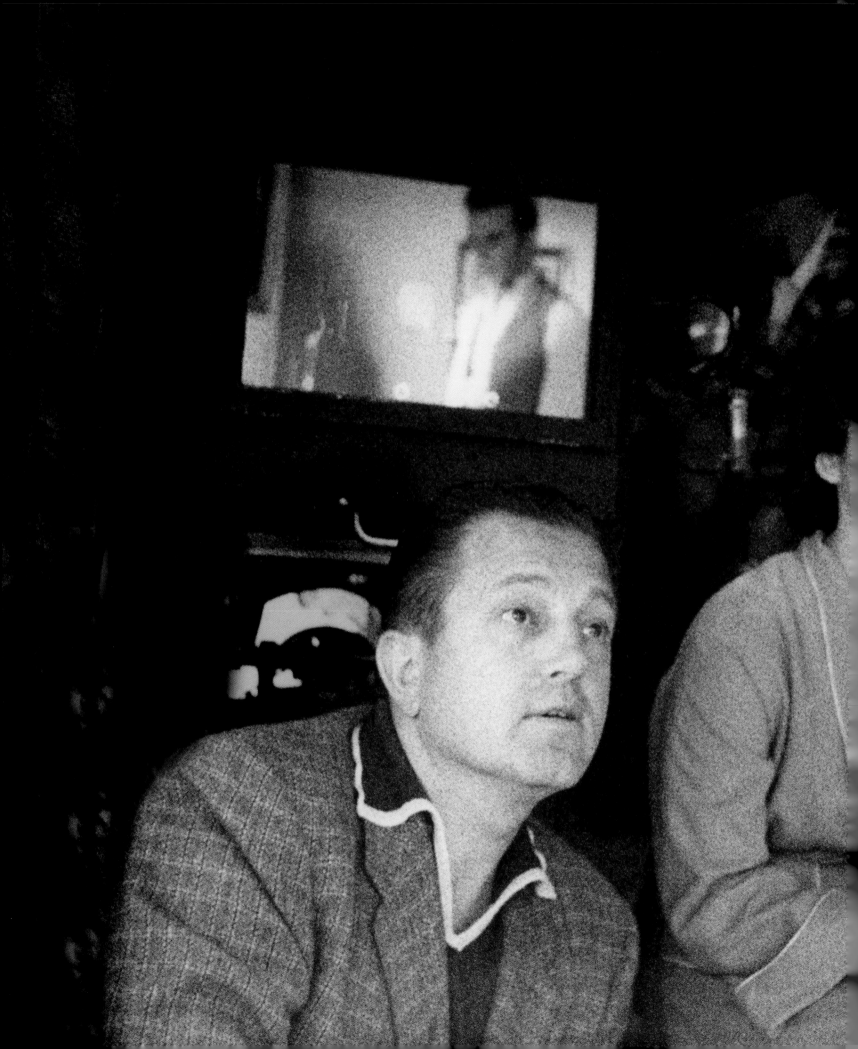

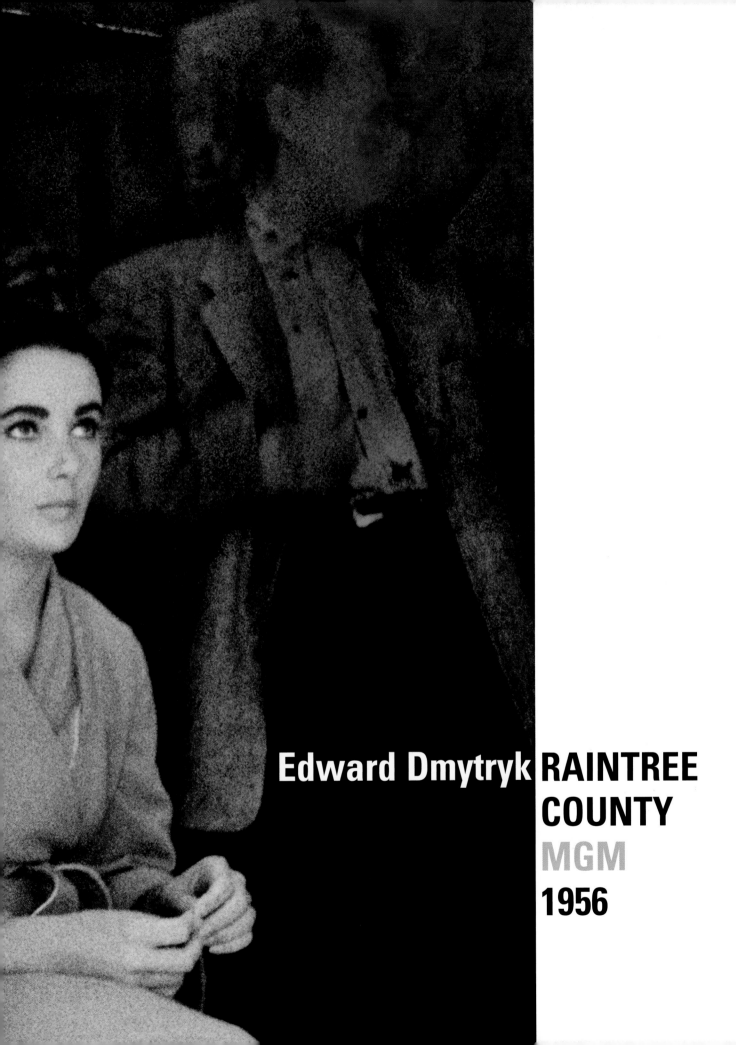

Edward Dmytryk RAINTREE
COUNTY
MGM
1956

I was given a wonderful assignment by MGM to do the special magazine photography on their film of *Raintree County*. The film would star Montgomery Clift and Elizabeth Taylor. Dore Schary was then head of production, and his publicity man told me he had dreams that this would rival *Gone with the Wind*.

Besides Clift and Taylor, the cast included Eva Marie Saint, Rod Taylor, Lee Marvin, Nigel Patrick, Agnes Moorehead, Tom Drake, and Walter Abel. The director was Edward Dmytryk, whom I had worked with briefly before, but never really got to know. In time I would discover that he was basically a dry, humorless, detached man, interested in doing a good job but without a lot of warmth for or rapport with his actors.

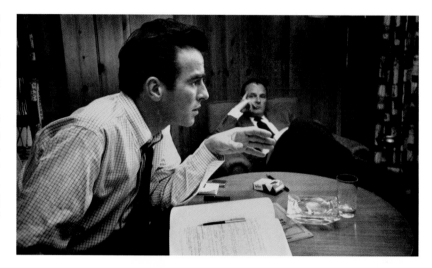

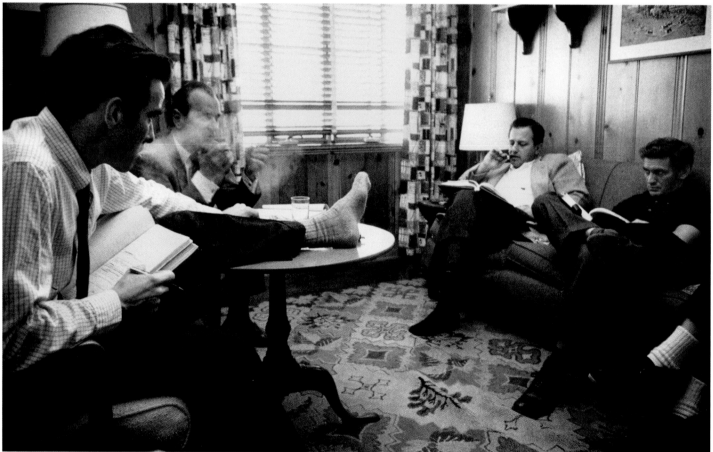

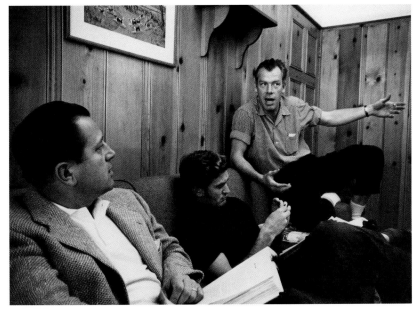

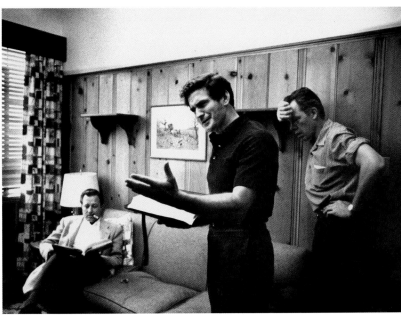

LEFT TOP *Montgomery Clift and Nigel Patrick.*

LEFT *Montgomery Clift, Nigel Patrick, Edward Dmytryk, and Rod Taylor work through the first read-through.*

THIS PAGE *Rod Taylor and Lee Marvin at the first reading of the script, with Edward Dmytryk acting out the parts of the missing actors.*

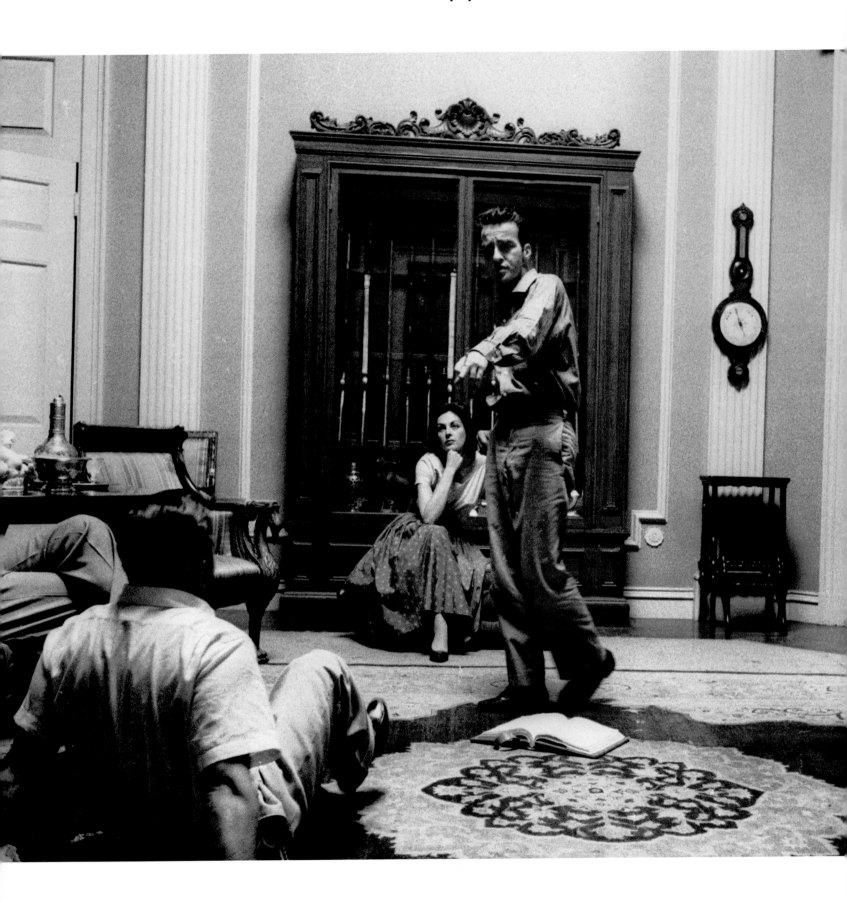

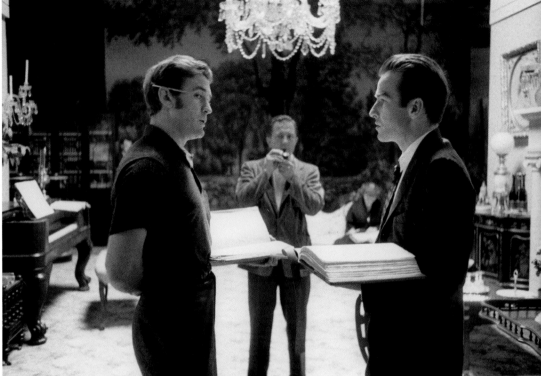

ABOVE *Rod Taylor and Montgomery Clift rehearse from their scripts.*

LEFT *Montgomery Clift was so very serious about his work that he seemed to agonize over every word of the script. During this early rehearsal he seems worried about where he should move to. The other actors look bored waiting for his concerns to be resolved by the director (left to right: Dmytryk seated on floor, Jarma Lewis, Montgomery Clift, and Elizabeth Taylor).*

Montgomery Clift took all his concerns about his role to Dmytryk, who would quietly listen to him, and I think that is basically what he seemed to need. With such reassurance Clift was doing really well until his terrible auto accident after a party at Elizabeth's. The studio had to completely revise the shooting schedule, and eventually close the film down until the plastic surgery on Clift's face had healed. Monty told me that they had to wire his jaw shut for weeks.

Clift really never looked or acted the same after that. The effect on him psychologically was telling. I also felt that afterwards Dmytryk didn't behave in quite the same way toward him; either he lost patience with him because he had become more eccentric, or else he secretly felt that the cause was lost. Not so Elizabeth Taylor (*far right*), who really supported Clift, mothering him through day after day. She was a true friend to him.

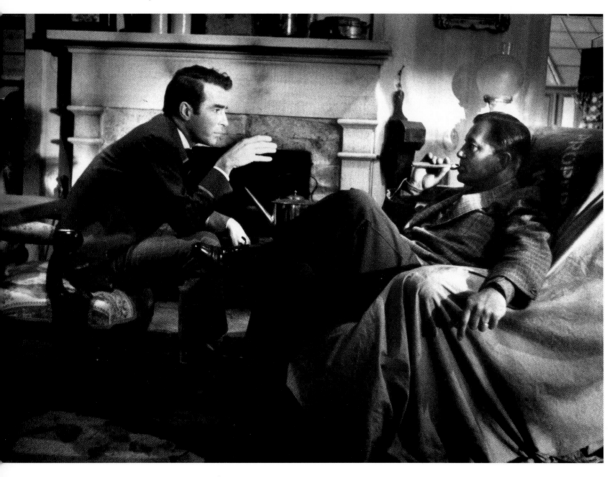

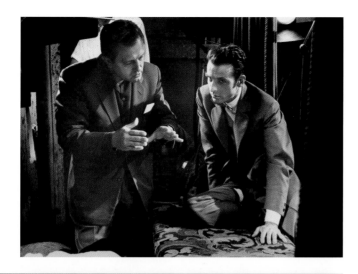

Edward Dmytryk

There seem to be certain truisms that hold when you are making a film. If you want sun you'll surely get an overcast sky, or more often rain. If you go someplace for the rain, you'll get sun. Every location I've ever been on, the locals would tell me: "You should have been here last week!"

Raintree County was no exception. Dmytryk, trying to match shots, was frustrated from the very beginning by what turned out to be an omen of things to come. Here you see him looking up to heaven while the production costs and overheads pour down the drain. This is a real concern on a feature film, for if the production gets behind schedule it is usually the director that gets the blame.

Edward Dmytryk

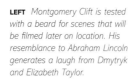

LEFT Montgomery Clift is tested with a beard for scenes that will be filmed later on location. His resemblance to Abraham Lincoln generates a laugh from Dmytryk and Elizabeth Taylor.

LEFT BELOW In the MGM makeup room, Dmytryk forgets to look at Clift's new mustache for the moment, and turns his gaze toward Elizabeth as she fusses with her hair.

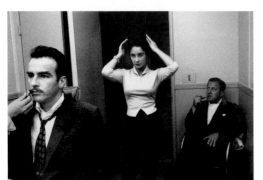

BELOW Clift was no dancer, but he was very game. Here you see him struggling with the waltz, counting as he stepped: one, two, three. Behind him, ostensibly to show him how it's done, Dmytryk dances with Taylor, while Clift is too occupied to notice.

RIGHT Clift, still counting, dances in rehearsal with Jarma Lewis. Dmytryk holds the camera's viewfinder; to his right is Academy Award-winning cinematographer Robert Surtees.

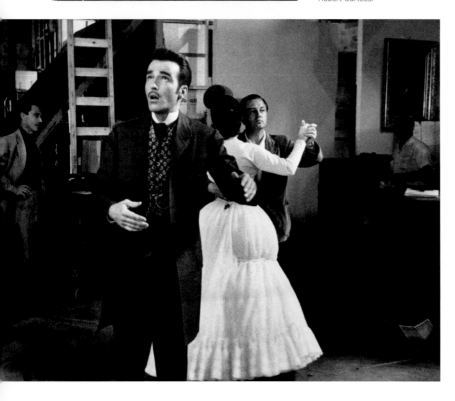

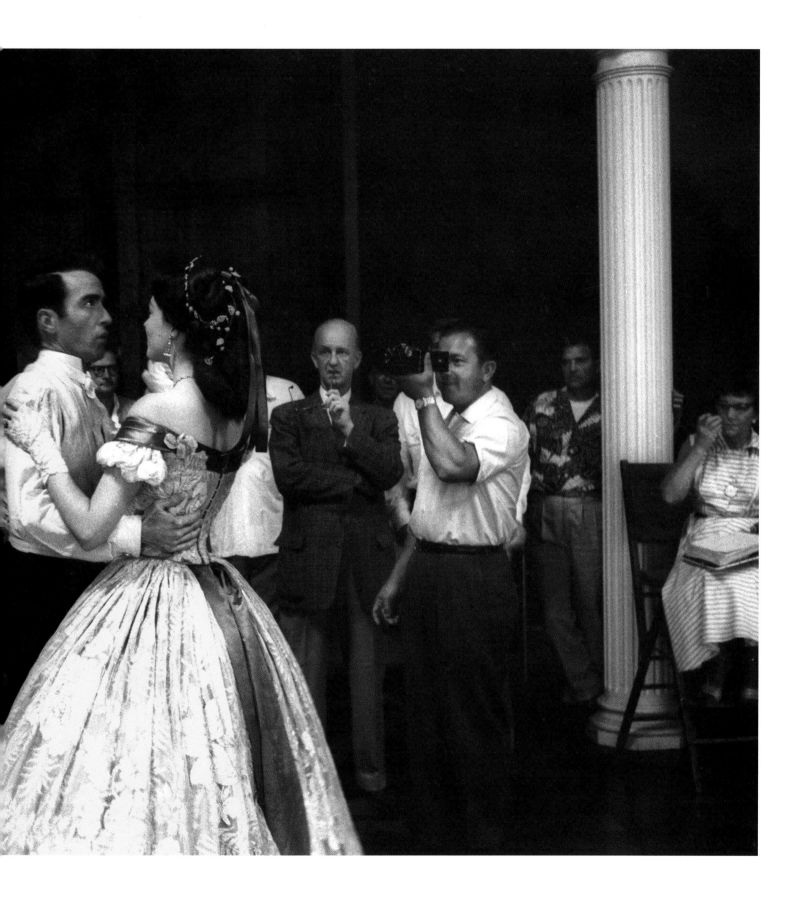

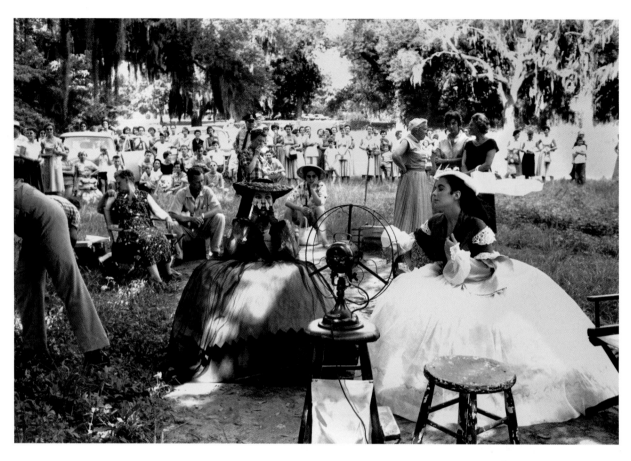

The production flew south to Natchez, Mississippi, for exteriors. It was steamy and hot, and the ladies' period costumes were so uncomfortable that the electricians kept a fan going on them the entire time (Elizabeth had already fainted once from this heat). Weather continued to be one of Dmytryk's major problems.

ABOVE *Jarma Lewis and Elizabeth Taylor suffer the Natchez heat.*

BELOW LEFT *Sidelined once again for lack of sun: (left to right) screenwriter Millard Kaufman, Edward Dmytryk, Montgomery Clift, Elizabeth Taylor, and Marguerite Lamkin (the southern speech advisor).*

BELOW RIGHT *The final straw. A major storm hits Natchez and knocks out all the electricity. Here in their candlelit hotel room, Dmytryk, shaking his head, looks out of the window wondering what else might go wrong. Montgomery Clift lights Tom Drake's cigarette, while Elizabeth seems to enjoy the adventure.*

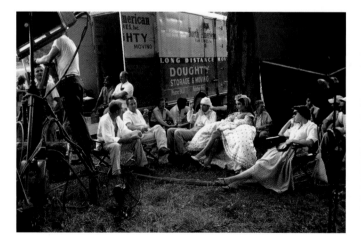

RIGHT *Dmytryk is at the far left looking to heaven. Kentucky, their next location, beckons.*

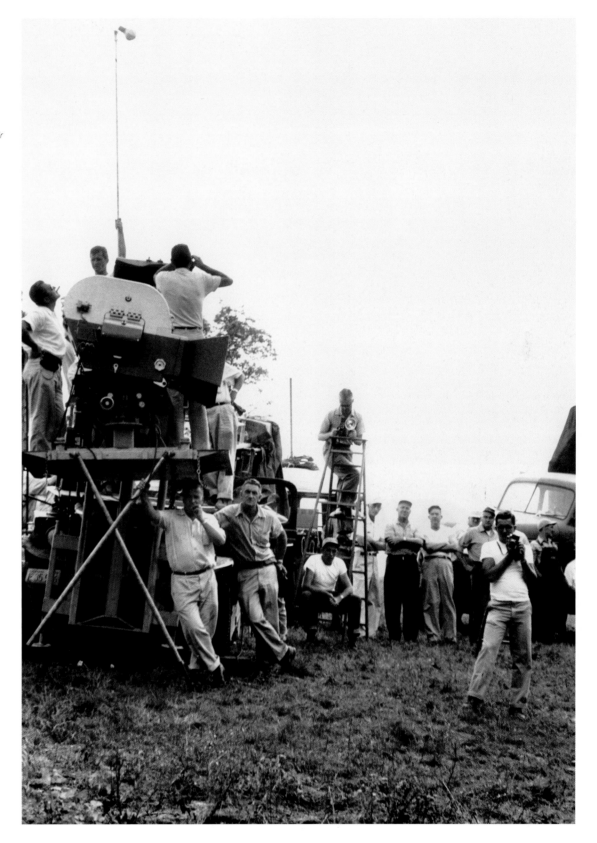

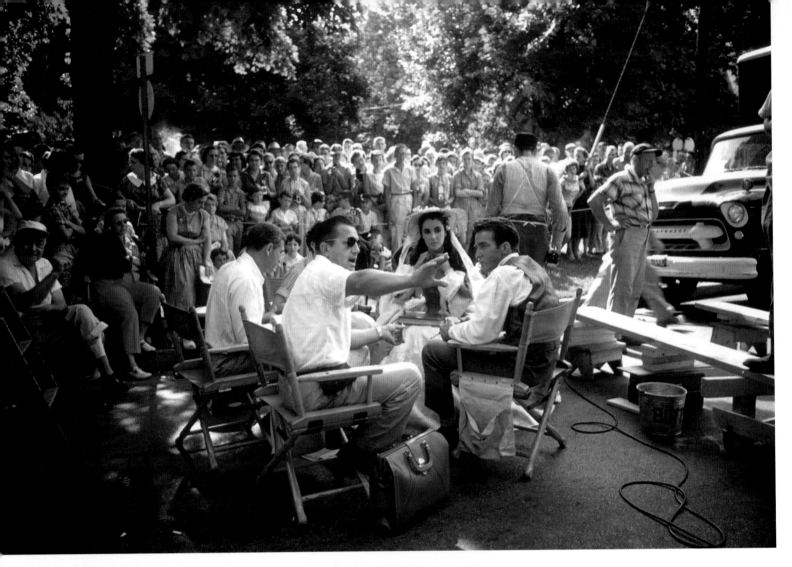

Danville, Kentucky, created yet another problem for Dmytryk: crowds. Everywhere they set up camera, there were hundreds and hundreds of really nice, interested, well-behaved townsfolk, who had never seen a film made and didn't wish to miss a thing. After a few weeks of shooting, there were times MGM couldn't get their equipment in for the crush of cars and people.

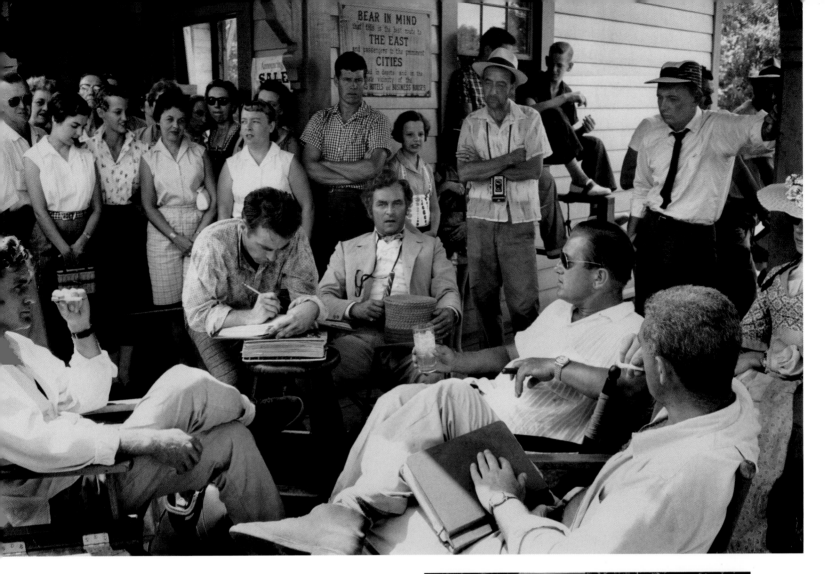

ABOVE *Even when they are just sitting talking, the locals crowd around them. Clift keeps his concentration, writing down every script change.*

RIGHT *Director Dmytryk watches the final rehearsal between Montgomery Clift and Elizabeth Taylor before filming begins.*

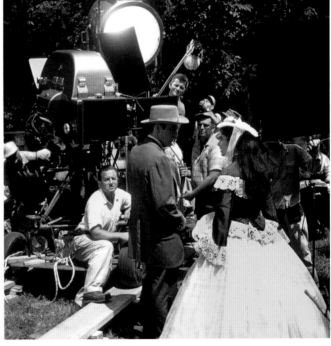

The crowds in Danville were one thing; worse was the lack of sun. I never saw Dmytryk blow his cool: he just chomped on his cigar, and looked (maybe pleadingly) toward heaven.

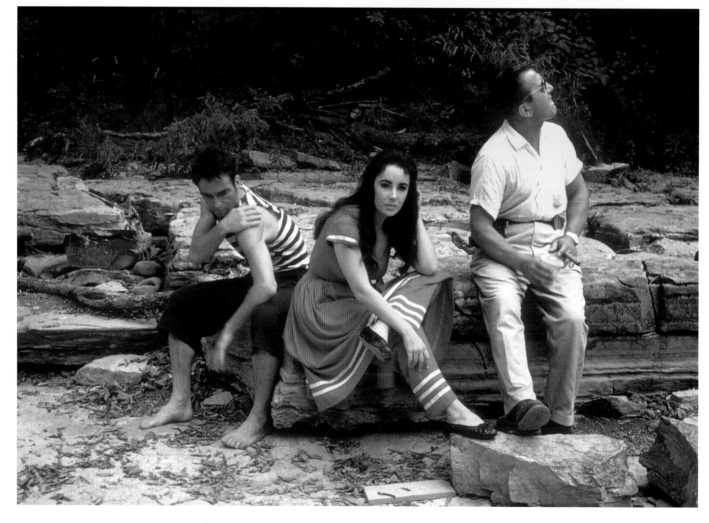

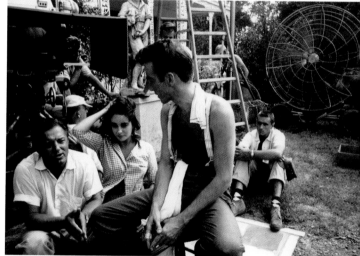

LEFT AND ABOVE *Not only did
the sun not come out but the
rain started, and, while it was
fun watching Elizabeth enjoy its
cooling effects, the production
department were tearing their
hair out.*

LEFT, BELOW LEFT, AND BELOW
The rain now really pours down, and some of the crew shelter under the camera umbrella, while the director and his stars wait it out in his trailer. (Below left, left to right: Montgomery Clift, Eva Marie Saint, screenwriter Millard Kaufman, and Edward Dmytryk.)

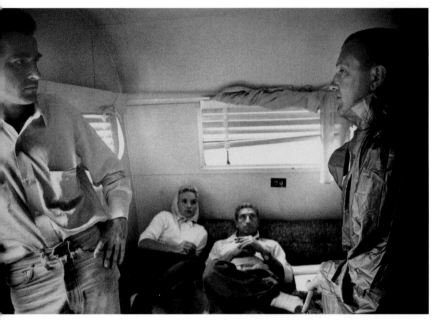

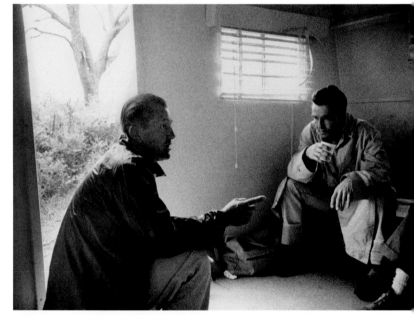

LEFT *They sit, they stand, they run out of jokes, and finally they just sit staring at the walls, keeping to themselves, waiting out the rain.*

RIGHT *Dmytryk wonders whether the sun will ever come out again.*

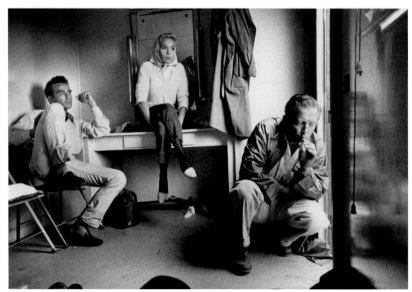

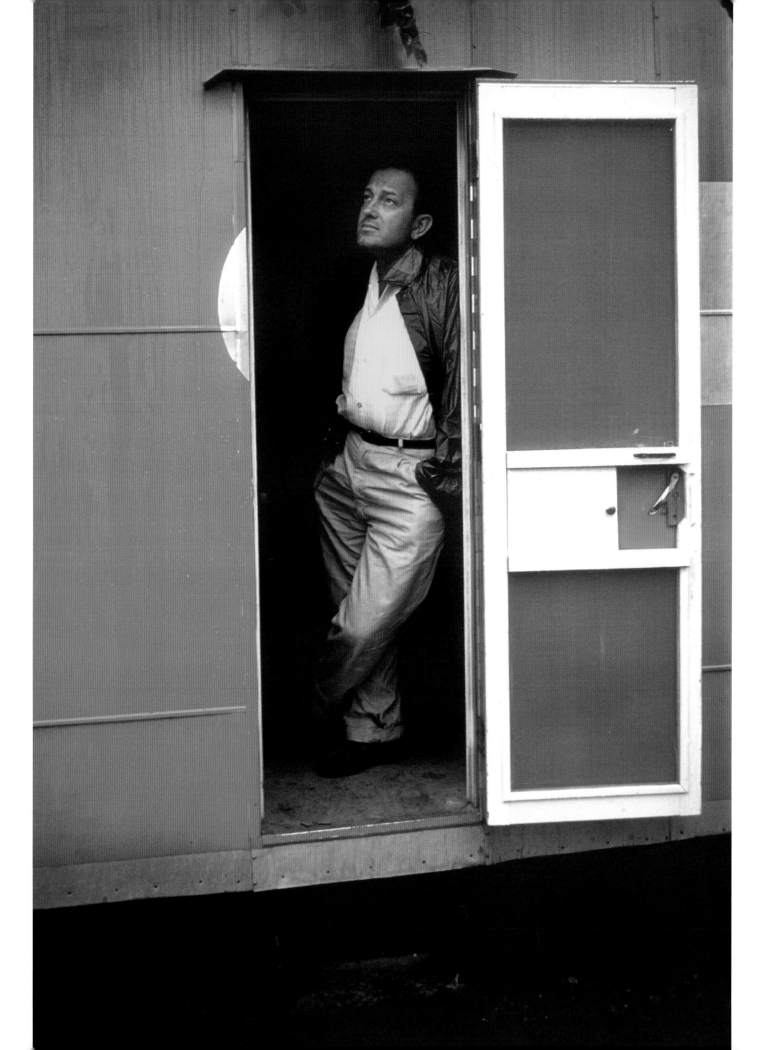

The rain didn't take on biblical proportions, but when the trucks got stuck in the mud, the people back at the studio decided to pull the plug. Dmytryk and a few key men flew back to MGM and literally stranded the rest of the crew, who had to make their own way on commercial airlines. Mike Todd, soon to be Elizabeth Taylor's third husband, sent his private plane down from Chicago to rescue Elizabeth, and Marguerite Lamkin and I were lucky enough to escape with her, but it took weeks for some of the crew driving the equipment to return.

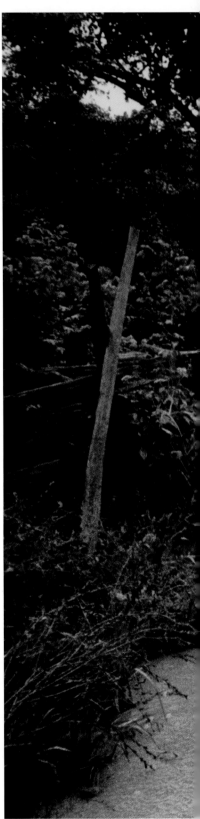

RIGHT *They shot the rest of the film on the back lot, where Montgomery Clift in the finale finds the magic raintree in the swamp. Unfortunately for Dore Schary the magic didn't extend to his getting his* Gone with the Wind.

Joshua Logan

Joshua Lockwood Logan III; born Texarkana, Texas, October 5, 1908; died New York City, July 12, 1988

Josh Logan was famous for the many Broadway plays and musicals that he directed and also co-authored. It's a marvelous list of credits, inlcuding *Annie, Get Your Gun*, *Mister Roberts*, *South Pacific*, *Picnic*, and *Fanny*. He began directing films seriously only in 1955. *Paint Your Wagon* (Paramount, 1969), illustrated here on location near Baker, Oregon, was his last film.

FILMS

I Met My Love Again *(co-directed with Arthur Ripley; 1938)*
Mister Roberts *(uncredited; co-scripted; co-authored play; 1955)*
Picnic *(1955)*
Bus Stop *(1956)*
Sayonara *(1957)*
South Pacific *(1958)*
Tall Story *(also produced; 1960)*
Fanny *(also produced; 1961)*
Ensign Pulver *(also produced and co-scripted; 1964)*
Camelot *(1967)*
Paint Your Wagon *(1969)*

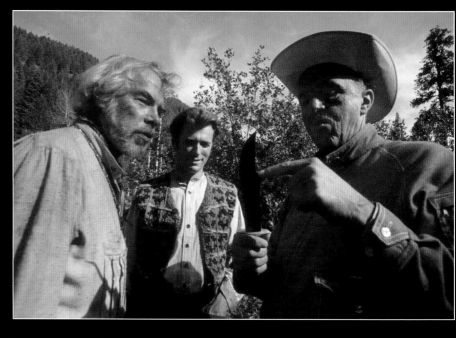

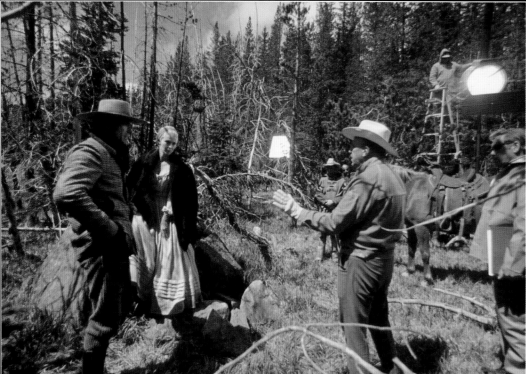

ABOVE *Josh tests Lee Marvin's knife, with Clint Eastwood looking on.*

LEFT *Logan is seen here directing Clint Eastwood and Jean Seberg.*

RIGHT *From left to right: Clint Eastwood, Alan Jay Lerner, Joshua Logan, and Lee Marvin; Jean Seberg seated in front.*

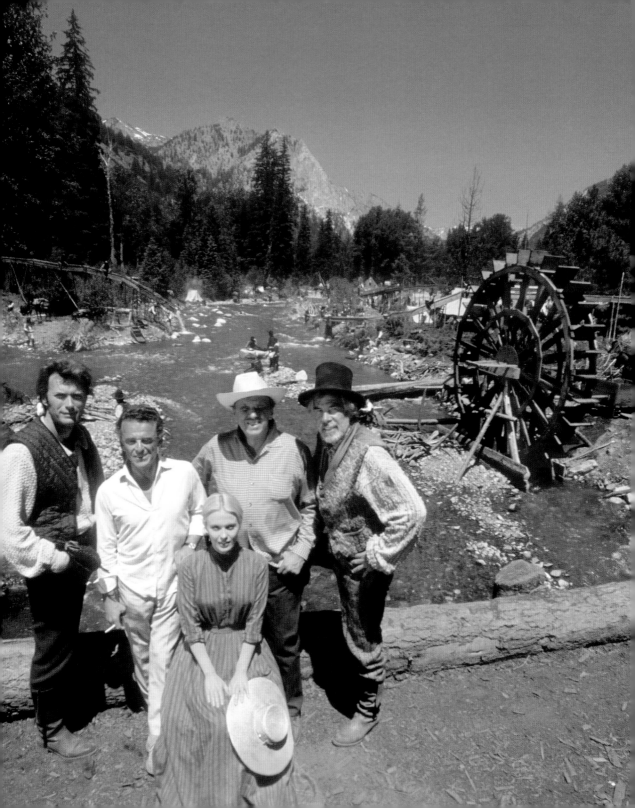

Joshua Logan **SOUTH PACIFIC**
20th CENTURY FOX
1958

Joshua Logan

I was assigned to photograph some of the initial dance rehearsals for *South Pacific* at 20th Century Fox Studios in 1958, with Mitzi Gaynor and France Nuyen. It was a pleasant assignment since I had previously photographed them both. Mitzi was an effervescent personality whom I enjoyed very much, and France was a delicious beauty.

BELOW *When I arrived, the rehearsals were on an empty sound stage, and to my surprise Josh Logan was there too. He had co-authored the stage play, which was one of the longest-running Broadway shows of all time. He was a great, outgoing character, and when he interrupted the choreographer to show Mitzi the moves for her "Honey Bun" number I think she could hardly believe it.*

RIGHT *Mitzi started as a dancer, so the choreographer to her was the boss. What she probably didn't remember was that Josh had been with the Broadway show from the beginning, and after so many years he knew everyone's part by heart. It then became sort of a dare, that Josh could show her the dance number … and he did!*

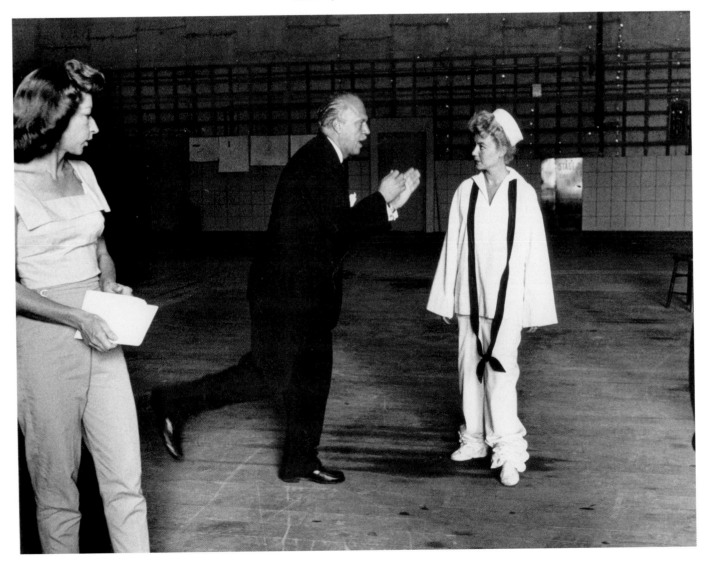

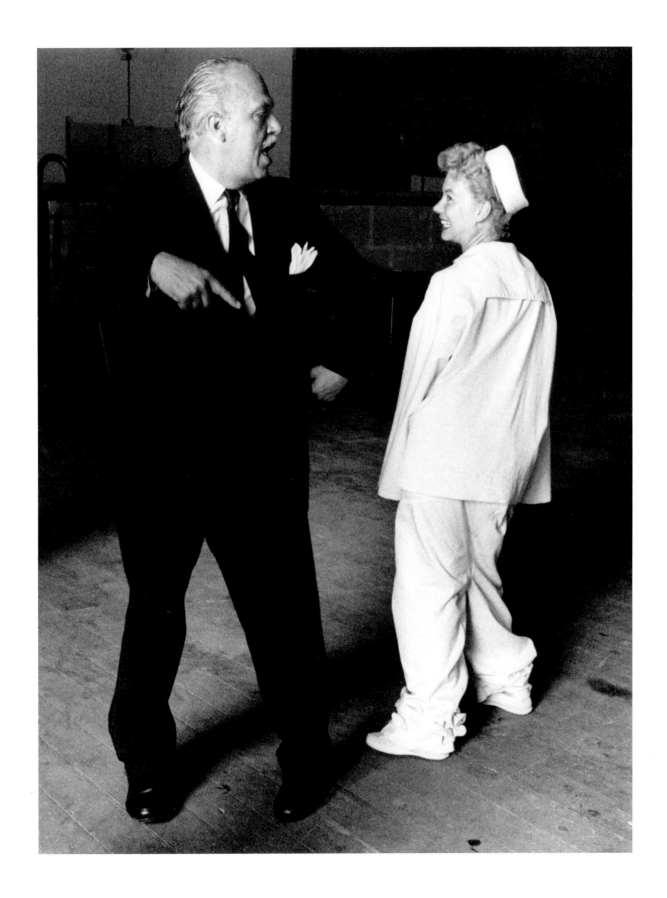

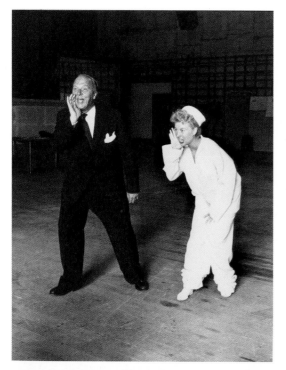

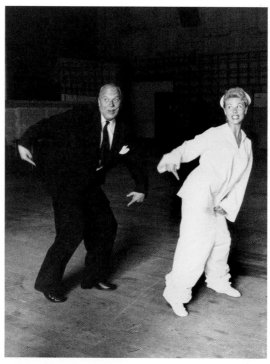

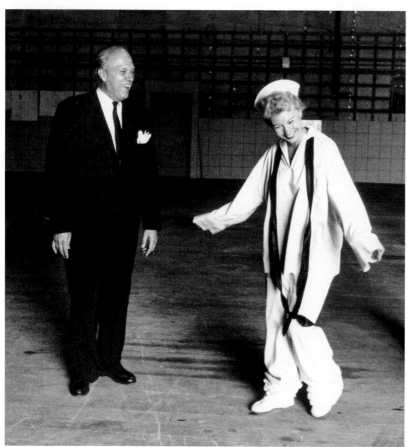

THIS PAGE *And how Josh danced! With Mitzi echoing every move, he went through the entire routine singing every line … and he was terrific! It was a great performance.*

RIGHT *Everyone then settled down to the serious business at hand: to watch Mitzi Gaynor become nurse Nellie Forbush.*

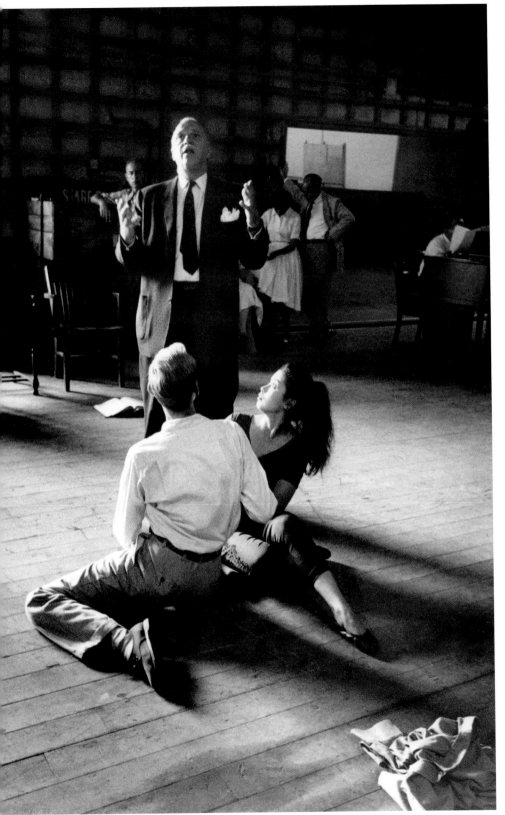

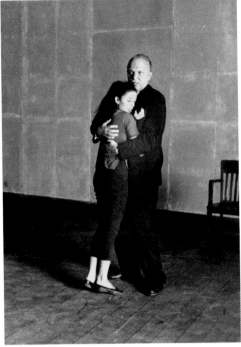

LEFT AND ABOVE *This was supposedly only a dance rehearsal, but when it came to France Nuyen's turn, Logan participated in that as well.*

RIGHT *France, sitting alone on her stool, can finally rehearse the number.*

BELOW *France shows Mitzi Gaynor and Josh Logan how to hold their hands for "Happy Talk."*

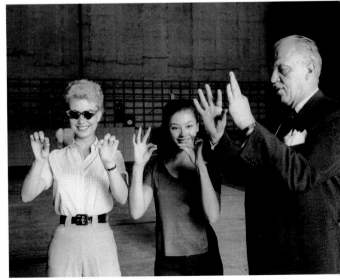

René Clément

born Bordeaux, France, March 18, 1913; died Monte Carlo, March 17, 1996

This Angry Age (Columbia/de Laurentiis) was filming in Rome, in 1957, and it was my first multi-language film (*see photographs on these pages*). I confess I was lost trying to communicate or make my needs understood. Happily for me, Anthony Perkins was part of the cast. I had worked with him before on *Friendly Persuasion* and we had become good friends. He introduced me around, and that was a big help, especially with René Clément, who then understood what I was doing there.

Clément had an air of whimsy, and he seemed to float through this film unaffected by the hurricane spinning about him. He would sit down and play the piano on the set while the crew was lighting around him.

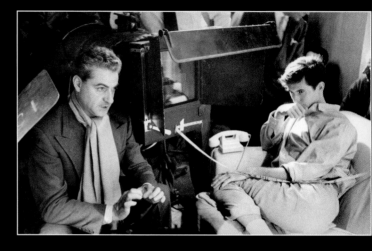

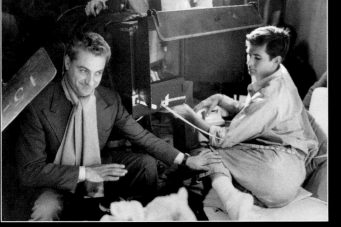

FILMS

Soigne ton gauche *(short; 1936)*
L'Arabie interdite *(short; also scripted and photography; 1937)*
La Grande Chartreuse *(short; 1938)*
Paris la nuit *(short; 1939)*
La Bièvre, fille perdue *(short; 1939)*
Le Triage *(short; 1940)*
Ceux du rail *(short; 1942)*
La Grande Pastorale *(short; 1943)*
Chefs de demain *(short; 1944)*
La Bataille du rail/The Battle of the Rails *(also scripted; 1946)*
Le Père tranquille/Mr. Orchid *(1946)*
Les Maudaits/The Dammed *(also co-adapted; 1947)*
Au-delà des Grilles/Le Mura di Malapaga/The Walls of Malapaga *(1949)*
Le Chateau de verre/L'amante di una notte *(also co-scripted; 1950)*
Jeux interdits/Forbidden Games *(also co-adapted; 1952)*
Monsieur Ripois/Knave of Hearts/Lovers Happy Lovers *(also co-scripted; 1954)*
Gervaise *(1956)*
This Angry Age/La diga sul Pacifico/The Sea Wall *(also co-scripted; 1958)*
Plein Soleil/Purple Noon *(also co-scripted; 1959)*
Che gioia vivere/Quelle joie de vivre/The Joy of Living *(also co-scripted; 1961)*
Le Jour et l'heure/The Day and the Hour *(also co-scripted; 1963)*
Les Félins/Joy House/The Love Cage *(also co-scripted; 1964)*
Paris brûle-t-il?/Is Paris Burning? *(1966)*
Le Passager de la pluie/Rider on the Rain *(1970)*
La Maison sous les arbres/The Deadly Trap *(1971)*
La Course du lièvre à travers les champs/And Hope to Die *(1972)*
Jeune fille libre le soir/The Babysitter *(1975)*

ABOVE AND ABOVE LEFT *Clément directs, while Anthony Perkins keeps a close watch.*

LEFT *Clément demonstrates emotion to Silvana Mangano; her husband Dino de Laurentiis, the producer of the film, is seen in the background at far right of frame.*

Martin Ritt

born New York City, March 2, 1914; died Santa Monica, California, December 8, 1990

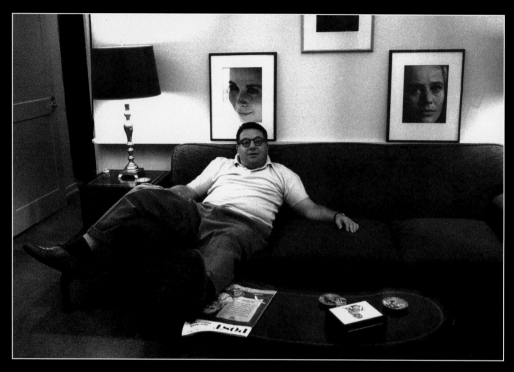

FILMS

Somerset Maugham TV Theatre *(TV series; 1950)*
Edge of the City *(1957)*
No Down Payment *(1957)*
The Long Hot Summer *(1958)*
The Black Orchid *(1958)*
The Sound and the Fury *(1959)*
Five Branded Women *(1960)*
Paris Blues *(1961)*
Hemingway's Adventures of a Young Man *(1962)*
Hud *(also co-produced; 1963)*
The Outrage *(also executive-produced; 1964)*
The Spy Who Came in from the Cold *(also produced; 1965)*
Hombre *(also co-produced; 1967)*
The Brotherhood *(also executive-produced; 1968)*
The Molly Maguires *(also co-produced; 1970)*
The Great White Hope *(also co-executive-produced; 1970)*
Sounder *(1972)*
Pete 'n' Tillie *(1972)*
Conrack *(also co-produced; 1974)*
The Front *(also produced; 1976)*
Casey's Shadow *(1978)*
Norma Rae *(also co-produced; 1979)*
Back Roads *(1981)*
Cross Creek *(1983)*
Murphy's Romance *(also co-executive-produced; 1985)*
Nuts *(1987)*
Stanley and Iris *(1990)*

ABOVE *Martin Ritt plops himself down in Yul Brynner's Paramount Studios dressing room (those are Yul's photographs on the wall); 1958.*

RIGHT *Martin Ritt, in Sophia Loren's dressing room, gets himself revved up to the Sinatra records Sophia is playing. Ritt was directing Sophia's film The Black Orchid at the time. Paramount Studios, 1958.*

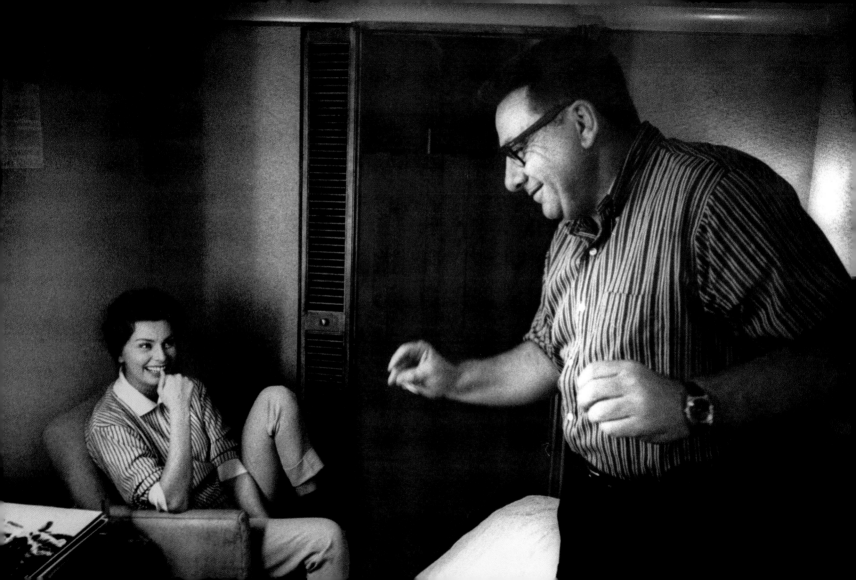

Martin Ritt THE BLACK
ORCHID
PARAMOUNT
1958

Martin Ritt

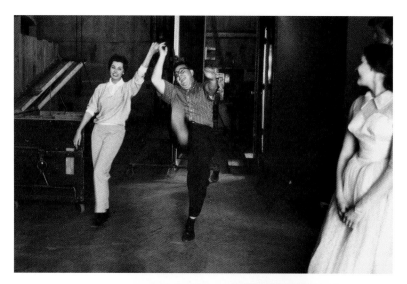

I had an assignment to photograph Sophia Loren at Paramount Studios when she was filming *The Black Orchid*. We were in her dressing room, and she was telling me how much she adored Frank Sinatra's singing: she had him playing softly in the background, and I agreed he was terrific. Her director, Martin Ritt, walked in and sat down with us just as one of those great Nelson Riddle arrangements began. Ritt leaned over, put the music on very loud, took Sophia by the hand, and started to do the Lindy. The dressing room was too small, so they ended up outside on this empty sound stage. It was one of those wonderful moments. Midsummer madness if you will, but it was so much fun. Everyone was laughing so hard that Ina Balin and some of the wardrobe ladies came out to see what was happening.

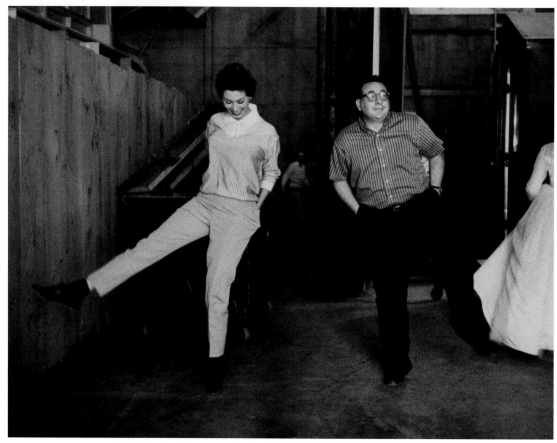

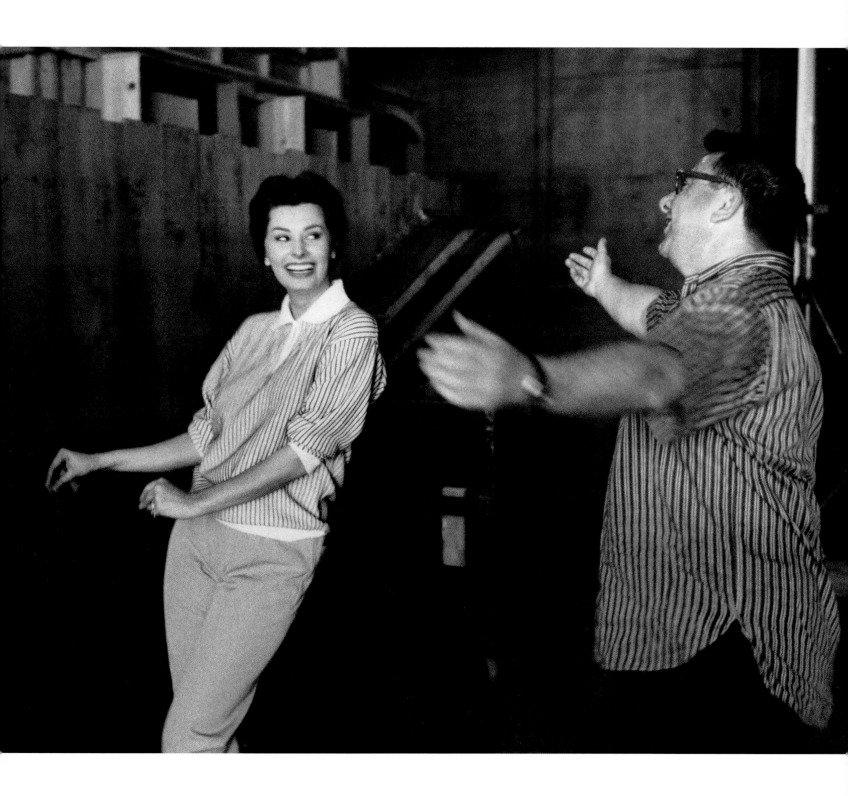

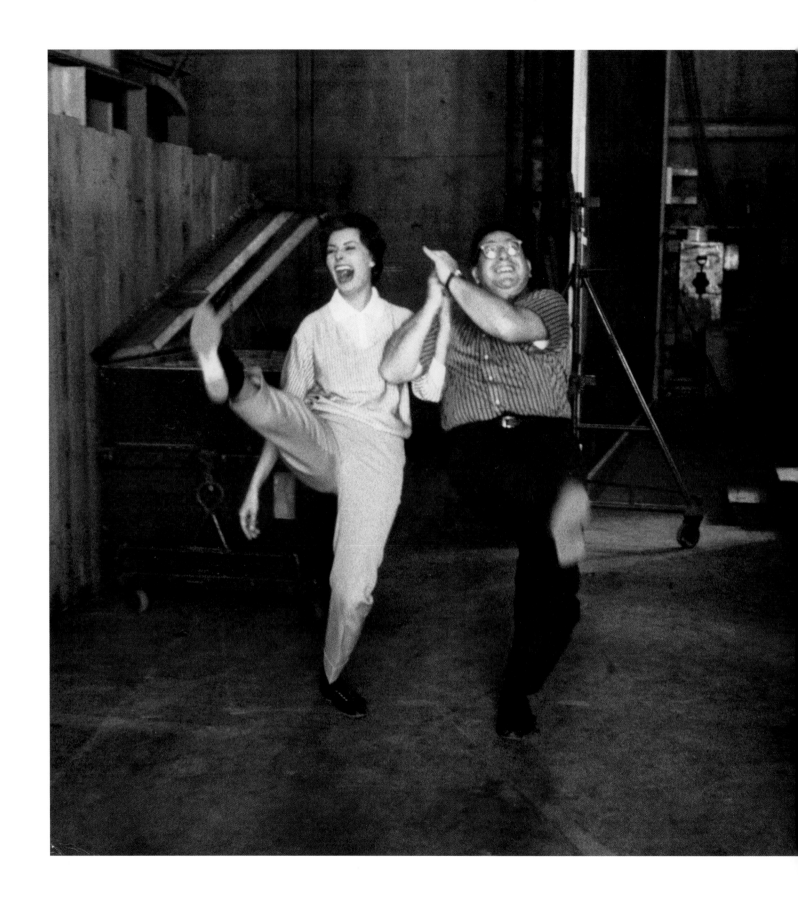

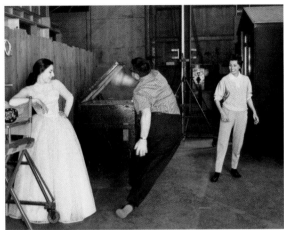

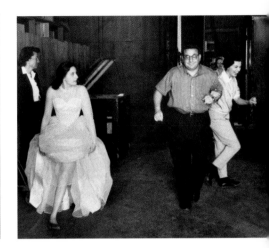

Ina tried to compete, but Martin and Sophia were the dancing champions, without a doubt! It was a heady few minutes, and then Sinatra's track was finished. Martin kissed Sophia and went back to the set, and I had photographed a charming moment in the day of a director.

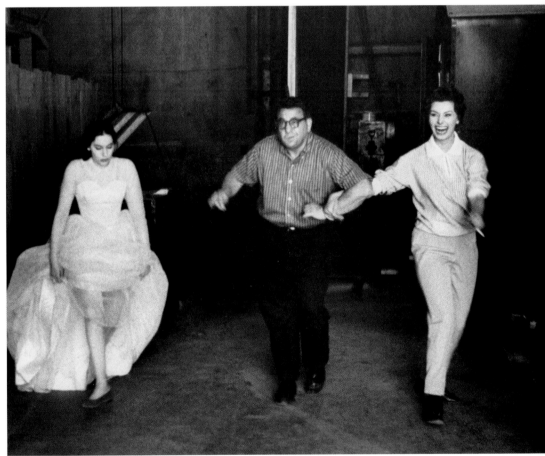

Mel Ferrer

Melchior Gaston Ferrer; born Elberon, New Jersey, August 25, 1917

Mel Ferrer is mostly known as an actor, and appeared in an amazing number of films over the years. He did, however, produce several films, and directed a few others. When he directed *Green Mansions* at MGM in 1958 (released 1959; *pictured on these pages*) he was married to Audrey Hepburn. Theirs was a really nice relationship.

BELOW LEFT *Audrey Hepburn wishes Mel Ferrer well in the morning before they start filming.*

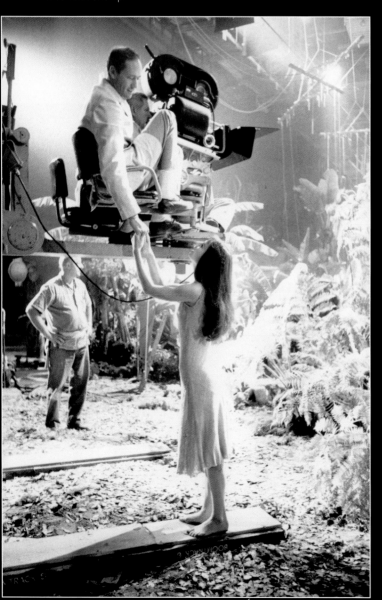

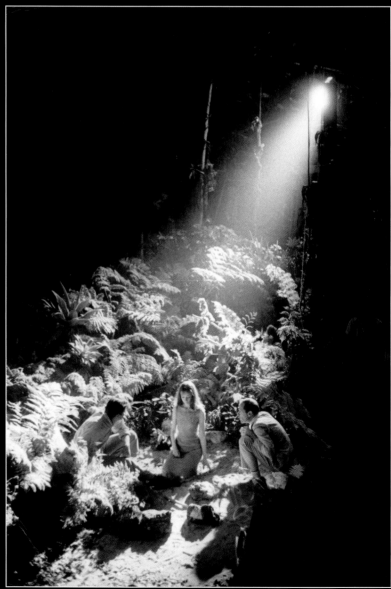

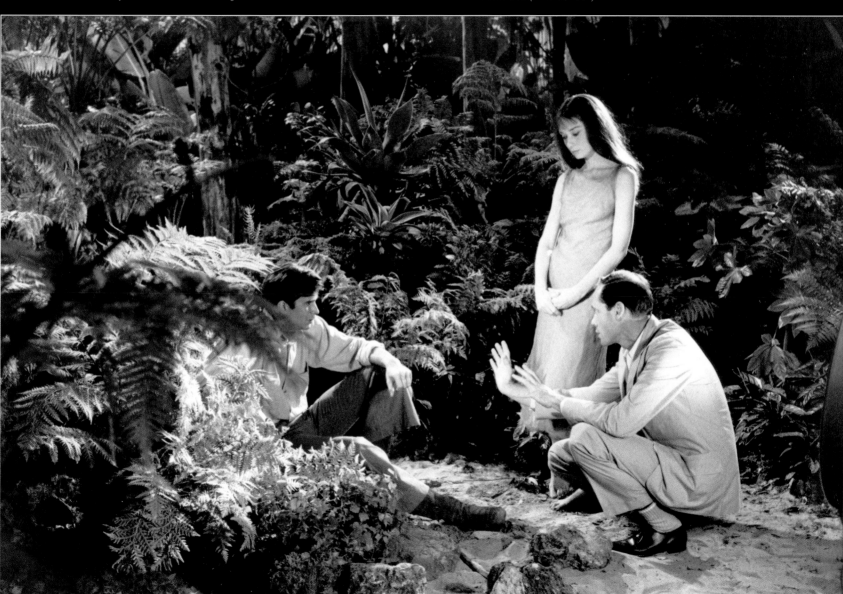

BELOW LEFT AND BELOW *Mel quietly directs Anthony Perkins and Audrey Hepburn in MGM's version of the rainforest in which Hugh Hudson's romantic novel is set. It was pleasant to come to work each day, Mel and Audrey were lovely to work with, and there were lots of exotic birds and animals, but Mel's style of directing lacked the energy, the magic, to make Audrey come alive as Rima the bird-girl.*

FILMS

(as director)

The Girl of the Limberlost *(1945)*
The Secret Fury *(1950)*
Vendetta *(co-directed with several uncredited directors; 1950)*
Green Mansions *(1959)*
Cabriola/Every Day Is a Holiday *(also executive-produced, story, and co-scripted; 1965)*
Falcon Crest *(TV series; 1981)*

George Stevens

born Oakland, California, December 18, 1904; died Lancaster, California, March 8, 1975

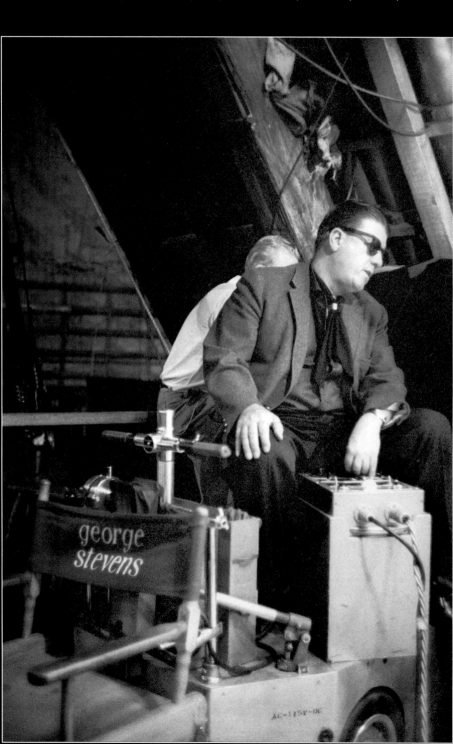

I only worked very briefly one afternoon on *The Diary of Anne Frank* (20th Century Fox), pictured here. I'm sorry my assignments never enabled me to work with George Stevens for longer, since I know I would have enjoyed it. I've heard he shot every scene from every angle, even more than William Wyler. My film-editor friend Bill Cartwright was called in to help on *The Greatest Story Ever Told*, and he said that he and Stevens sat in the screening room eight hours a day for weeks, looking at the incredible amount of footage he had shot.

FILMS

Ladies Last *(1930)*
Blood and Thunder *(1931)*
Air-Tight *(1931)*
Mama Loves Papa *(1931)*
The Kickoff *(1931)*
Call a Cop! *(1931)*
Who, Me? *(1932)*
The Finishing Touch *(1932)*
Boys Will Be Boys *(1932)*
Family Troubles *(1932)*
Rock-a-Bye Cowboy *(1933)*
Room Mates *(1933)*
The Cohens and Kellys in Trouble *(1933)*
Should Crooners Marry *(1933)*
Quiet, Please *(1933)*
Grin and Bear It *(1933)*
Flirting in the Park *(1933)*
Divorce Courtship *(1933)*
Bachelor Bait *(1934)*
Kentucky Kernels *(1934)*
Hollywood Party *(1934)*
Ocean Swells *(1934)*
Laddie *(1935)*
The Nitwits *(1935)*
Alice Adams *(1935)*
Annie Oakley *(1935)*
Pickled Peppers *(1935)*
Hunger Pains *(1935)*
Swing Time *(1936)*
Quality Street *(1937)*
A Damsel in Distress *(1937)*
Having Wonderful Time *(uncredited; 1938)*
Vivacious Lady *(also produced; 1938)*
Gunga Din *(also produced; 1939)*
Vigil in the Night *(also produced; 1940)*
Penny Serenade *(also produced; 1941)*
Woman of the Year *(1942)*
The Talk of the Town *(also produced; 1942)*
The More the Merrier *(also produced; 1943)*
1945: Stevens directed several films of the Nazi concentration camps etc. for the US Army Signal Corps
On Our Merry Way *(uncredited; 1948)*
I Remember Mama *(also executive-produced; 1948)*
A Place in the Sun *(also produced; 1951)*
Something to Live For *(also produced; 1952)*
Shane *(also produced; 1953)*
Giant *(also co-produced; 1956)*
The Diary of Anne Frank *(also produced; 1959)*
The Greatest Story Ever Told *(also produced; 1965)*
The Only Game in Town *(1970)*

Clifford Odets

born Philadelphia, Pennsylvania, July 18, 1906; died Los Angeles, California, August 18, 1963

Clifford Odets was one of America's most famous play-wrights in the 1930s: his *Waiting For Lefty*, *Till the Day I Die*, and *The Golden Boy* were huge successes. Hollywood called to him, and he wrote many original screenplays such as *The Sweet Smell of Success*, *The Big Knife*, and *The General Died at Dawn*. I first met him when he was directing *The Flowering Peach* on Broadway in 1954. When 20th Century Fox hired me to do the ads on *The Story on Page One* in 1959, I was able to direct him for a change.

FILMS

None But the Lonely Heart *(1944)*
The Story on Page One *(1959)*

RIGHT *This portrait was taken during the filming of* The Story on Page One *(1959).*

BELOW *Odets visits with Shirley MacLaine, sitting just behind director Walter Lang on the* Can Can *set, 20th Century Fox Studios, 1959.*

Jean Negulesco

born Craiova, Romania, February 26, 1900; died Marbella, Spain, July 18, 1993

In 1959, 20th Century Fox called me in to work on *The Best of Everything*. They told me that they were going to make Suzy Parker and Louis Jourdan the new romantic couple à la Greta Garbo and John Gilbert (if you can believe that!). Suzy Parker was a very famous fashion model. She had great bones, but not much sex appeal, and Louis Jourdan had even less, so although I could take pictures, Jean Negulesco had to get performances out of them, which meant a lot of pull and tug.

Negulesco and I hit it right off, since we were both passionate about art; and he invited me back to his home to see his collection and to meet his lovely wife, Dusty. Jean had this great facility for drawing a nude with one continuous line, which was phenomenal. He had started out as a painter, and brought this taste of design to his films.

FILMS

Singapore Woman *(1941)*
The Mask of Dimitrios *(1944)*
The Conspirators *(1944)*
Three Strangers *(1946)*
Nobody Lives Forever *(1946)*
Humoresque *(1946)*
Deep Valley *(1947)*
Johnny Belinda *(1948)*
Road House *(1948)*
Britannia Mews/The Forbidden Street *(1949)*
Under My Skin *(1950)*
Three Came Home *(1950)*
The Mudlark *(1950)*
Take Care of My Little Girl *(1951)*
Phone Call from a Stranger *(1952)*
Lydia Bailey *(1952)*
Lure of the Wilderness *(1952)*
O. Henry's Full House *("The Last Leaf" episode; 1952)*
Titanic *(1953)*
How to Marry a Millionaire *(1953)*
Scandal at Scourie *(1953)*
Three Coins in the Fountain *(1954)*
Woman's World *(1954)*
Daddy Long Legs *(1955)*
The Rains of Ranchipur *(1955)*
Gay Parisian *(1955)*
At the Stroke of 12 *(1955)*
The Dark Wave *(1956)*
Boy on a Dolphin *(1957)*
The Gift of Love *(1958)*
A Certain Smile *(1958)*
Count Your Blessings *(1959)*
The Best of Everything *(1959)*
Jessica *(also produced, 1962)*
The Pleasure Seekers *(1964)*
The Heroes/The Invincible Six *(1969)*
Hello Goodbye *(1970)*

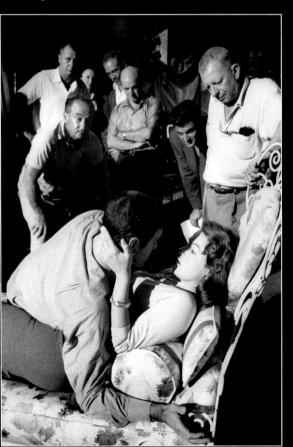

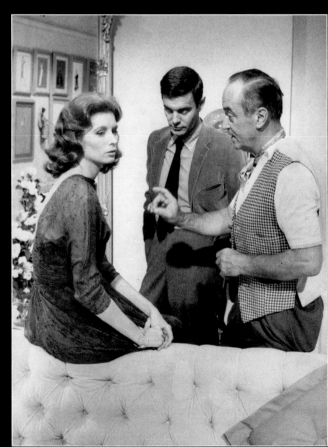

BELOW LEFT *Negulesco lines up the shot with Louis Jourdan and Suzy Parker in the foreground*

BELOW *Suzy Parker tries to understand her character's motivation for the coming scene as Louis Jourdan wills her on.*

RIGHT *Negulesco gently explains to his actors that what they are doing is quite simple, and they musn't think too much about it. Costume designer Donfeld is just behind Jean on the left.*

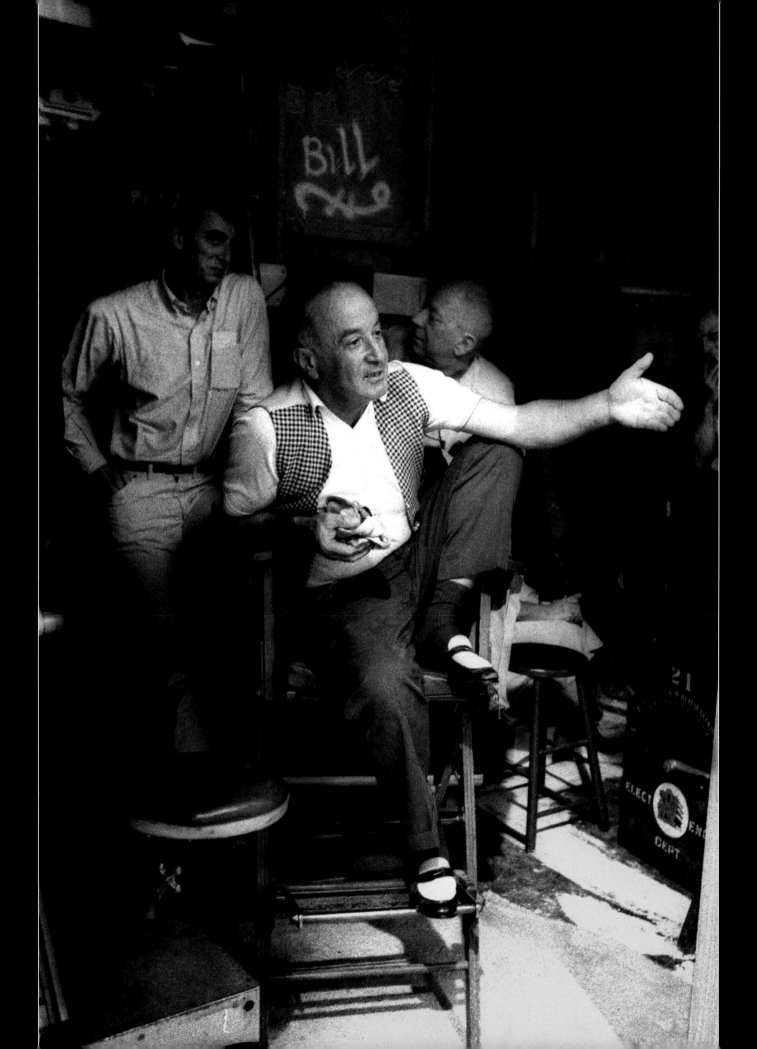

Walter Lang was something of an enigma to me. He seemed perpetually dour and crusty on the set of *Can Can* (20th Century Fox, 1960, *pictured on these pages*). I knew he had directed funny films, such as *Sitting Pretty*, and fine musicals, such as *The King and I*, but here there wasn't a lot of excitement or energy coming from him to stimulate the actors. We had great music and choreography from the stage play, and Frank Sinatra and Shirley MacLaine for him to work with; Irene Sharaff made terrific costumes; there were pretty dancing girls … I was amazed that he didn't seem to have a bit more enthusiasm for the project.

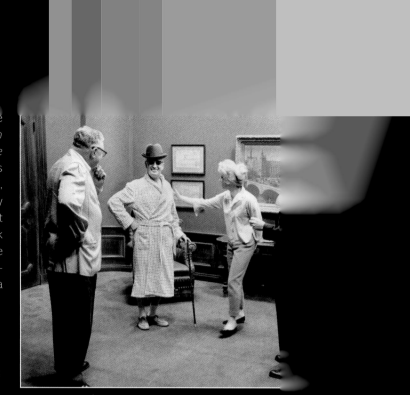

BELOW *Lang watches rehearsals with dancer Juliet Prowse.*

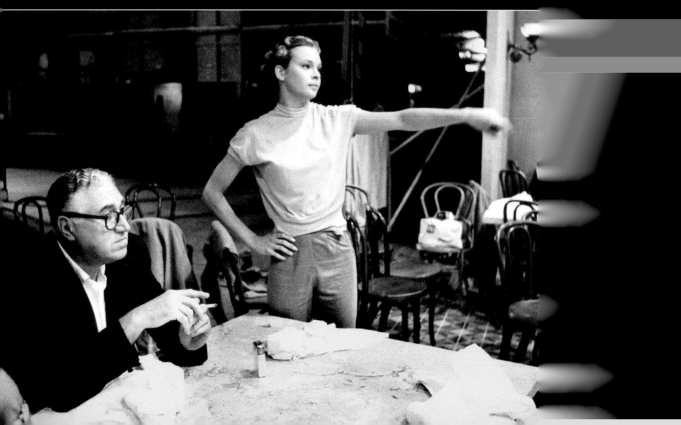

FILMS

Red Kimono *(1925)*
The Earth Woman *(1926)*
The Golden Web *(1926)*
Money to Burn *(1926)*
The Ladybird *(1927)*
The Satin Woman *(also scripted; 1927)*
Sally in Our Alley *(1927)*
By Whose Hand? *(1927)*
The College Hero *(1927)*
The Night Flyer *(1928)*

Shadows of the Past *(1928)*
The Desert Bride *(1928)*
Alice through the Looking Glass *(1928)*
The Spirit of Youth *(1929)*
Hello Sister *(1930)*
Cock o' the Walk *(co-directed with Roy Williams*
The Big Fight *(1930)*
The Costello Case *(1930)*
Brothers *(1930)*
Command Performance *(1931)*
Hell Bound *(1931)*
Women Go On Forever *(1931)*
No More Orchids *(1932)*
The Warrior's Husband *(also co-scripted; 1933*
Meet the Baron *(1933)*
The Party's Over *(1934)*
Whom the Gods Destroy *(1934)*
The Mighty Barnum *(1934)*
Carnival *(1935)*
Hooray for Love *(1935)*
Love before Breakfast *(1936)*
Wife, Doctor and Nurse *(1937)*
Second Honeymoon *(1937)*
The Baroness and the Butler *(1938)*
I'll Give a Million *(1938)*
The Little Princess *(1939)*
Susannah of the Mounties *(1939)*
The Blue Bird *(1940)*
Star Dust *(1940)*
The Great Profile *(1940)*
Tin Pan Alley *(1940)*
Moon over Miami *(1941)*
Weekend in Havana *(1941)*
Song of the Islands *(1942)*
The Magnificent Dope *(1942)*
Coney Island *(1943)*
Greenwich Village *(1944)*
State Fair *(1945)*
Sentimental Journey *(1946)*
Claudia and David *(1946)*
Mother Wore Tights *(1947)*
Sitting Pretty *(1947)*
When My Baby Smiles at Me *(1948)*
You're My Everything *(1949)*
Cheaper by the Dozen *(1950)*
The Jackpot *(1950)*
On the Riviera *(1951)*
With a Song in My Heart *(1952)*
Call Me Madam *(1953)*
There's No Business Like Show Business *(195*
The King and I *(1956)*
Desk Set *(1957)*
But Not for Me *(1959)*
Can Can *(1960)*
The Marriage-Go-Round *(1961)*
Snow White and the Three Stooges *(1961)*

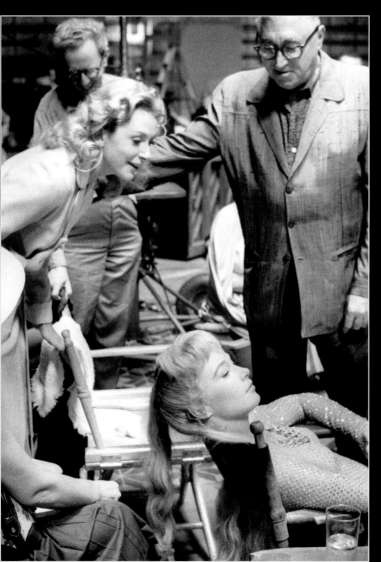

Lewis Milestone

Lev Milstein; born Kishinev, Ukraine, September 30, 1895; died Los Angeles, California, September 25, 1980

Lewis Milestone will always be remembered for his great classic film *All Quiet On The Western Front*. In 1960, when I got to the location of *Ocean's Eleven*—The Sands Hotel, Las Vegas—I was very pleased to have the opportunity to work with him. However, Milestone really didn't have the sole attention of the famous "rat pack." They were not only doing a stage show every night at The Sands, but director George Sidney was in Las Vegas making another film at the same time, in which Frank Sinatra and his cronies were making guest appearances. Add the all-night excesses they were prone to at the time and, even with their amazing stamina, one could see that Milestone didn't get 100% when they were in front of the cameras.

LEFT *Lewis Milestone (center) gives Red Skelton (left) and Frank Sinatra a laugh*

RIGHT *Milestone (left) with Sammy Davis Jr (right)*

RIGHT BOTTOM *Frank Sinatra (left) goes over the script with his director (center)*

BELOW *Lewis Milestone (left) watches the rehearsals of Ocean's Eleven, cinematographer William Daniels to his left.*

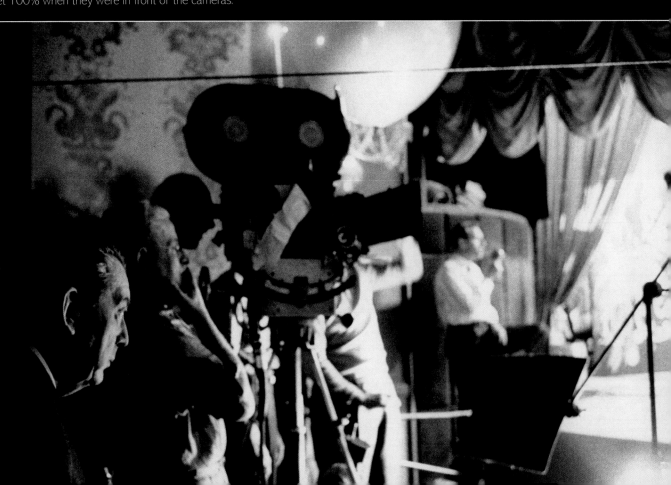

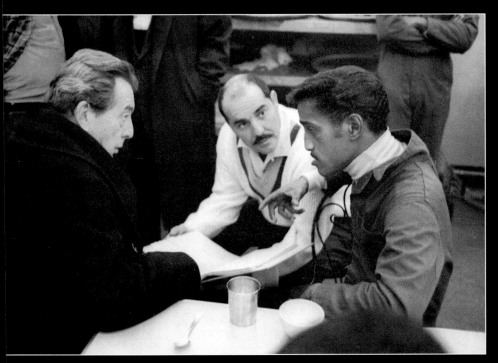

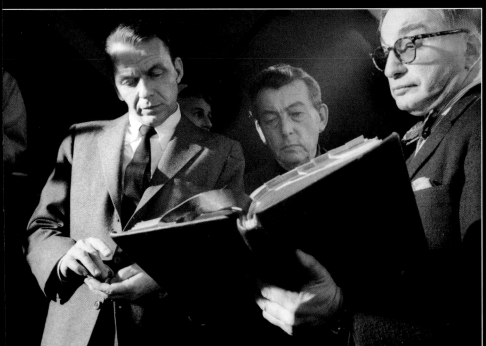

FILMS

Seven Sinners *(also co-story, co-scripted; 1925)*
The Caveman *(1926)*
The New Klondike *(1926)*
Two Arabian Nights *(1927)*
The Garden of Eden *(1928)*
The Tempest *(uncredited; 1928)*
The Racket *(1928)*
Betrayal *(1929)*
New York Nights *(1929)*
Hell's Angels *(co-directed with Howard Hughes; uncredited; 1930)*
All Quiet on the Western Front *(1930)*
The Front Page *(1931)*
Rain *(also produced; 1932)*
Hallelujah, I'm a Bum *(1933)*
The Captain Hates the Sea *(1934)*
Paris in Spring *(1935)*
Anything Goes/Tops is the Limit *(1936)*
The General Died at Dawn *(1936)*
The Night of Nights *(1939)*
Of Mice and Men *(also produced; 1939)*
Lucky Partners *(1940)*
My Life with Caroline *(also produced; 1941)*
Our Russian Front *(documentary; co-produced; co-directed with Joris Ivens; 1942)*
Edge of Darkness *(1943)*
The North Star/Armored Attack *(1943)*
A Guest in the House *(replaced John Brahm, uncredited; 1944)*
The Purple Heart *(1944)*
A Walk in the Sun *(also produced; 1945)*
The Strange Love of Martha Ivers *(1946)*
Arch of Triumph *(also co-scripted; 1948)*
No Minor Vices *(also produced; 1948)*
The Red Pony *(also produced; 1949)*
The Halls of Montezuma *(1950)*
Kangaroo *(1952)*
Les Misérables *(1952)*
Melba *(1953)*
They Who Dare *(1953)*
The Widow *(also adapted; 1955)*
King Kelly *(unfinished; 1957)*
Have Gun Will Travel *(TV Series; 1957)*
Pork Chop Hill *(1959)*
Ocean's Eleven *(1960)*
Mutiny on the Bounty *(1962)*
PT 109 *(replaced by Leslie Martinson, uncredited; 1963)*
Arrest and Trial *(TV series; 1963)*
The Dirty Game *(replaced by Terence Young; uncredited; 1965)*

found David Miller very easy to work with, and I felt that this was true for the actors as well. He did things quietly: in the photograph below, Miller has taken Doris Day to a quiet place away from the filming of *Midnight Lace* (Universal Studios, 1960). Sitting at her feet he reassures her, psyching her up for the dramatic scene to come. Doris, while a wonderful singer, was never quite as relaxed in the acting department, and needed the encouragement she received from her directors.

LEFT *David Miller (left) reassures Rex Harrison.*

BELOW *A moment that must come to all directors: Miller questions what he's done and what is yet to come.*

Midnight Lace, *Universal Studios, 1960.*

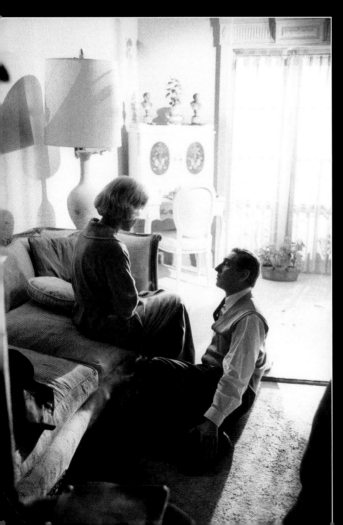

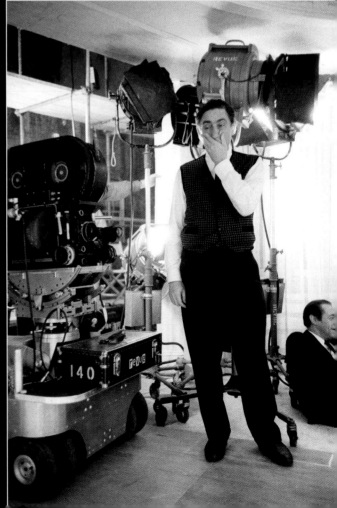

FILMS

Billy the Kid *(1941)*
Sunday Punch *(1942)*
Flying Tigers *(1942)*
Top o' the Morning *(1949)*
Love Happy *(1950)*
Our Very Own *(1950)*
Saturday's Hero *(1951)*
Sudden Fear *(1952)*
The Beautiful Stranger/Twist of Fate *(also story; 1954)*
Diane *(1956)*
The Opposite Sex *(1956)*
The Story of Esther Costello *(1957)*
Happy Anniversary *(1959)*
Midnight Lace *(1960)*
Back Street *(1961)*
Lonely Are the Brave *(1962)*
Captain Newman M.D. *(1964)*
Hammerhead *(1968)*
Hail Hero! *(1969)*
Executive Action *(1973)*
Bittersweet Love *(1976)*
Goldie and the Boxer *(TV; 1979)*
Love For Rent *(TV; 1979)*
The Best Place to Be *(TV; 1979)*
Goldie and the Boxer Go to Hollywood *(TV; 1981)*

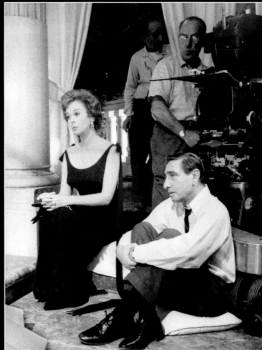

ABOVE *David Miller explains the action to (left to right) Tammy Marihugh, Susan Hayward, John Gavin, and Vera Miles.*

BELOW *Susan Hayward and Miller sit watching rehearsals.*

Back Street, Universal Studios, 1961.

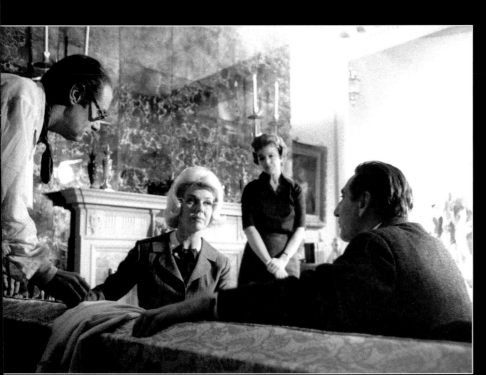

BELOW *On the set of Midnight Lace, Miller is seen with Rex Harrison (left), Myrna Loy (second from right), and Doris Day.*

William Wyler

born Mulhouse, France, July 1, 1902; died Los Angeles, California, July 27, 1981

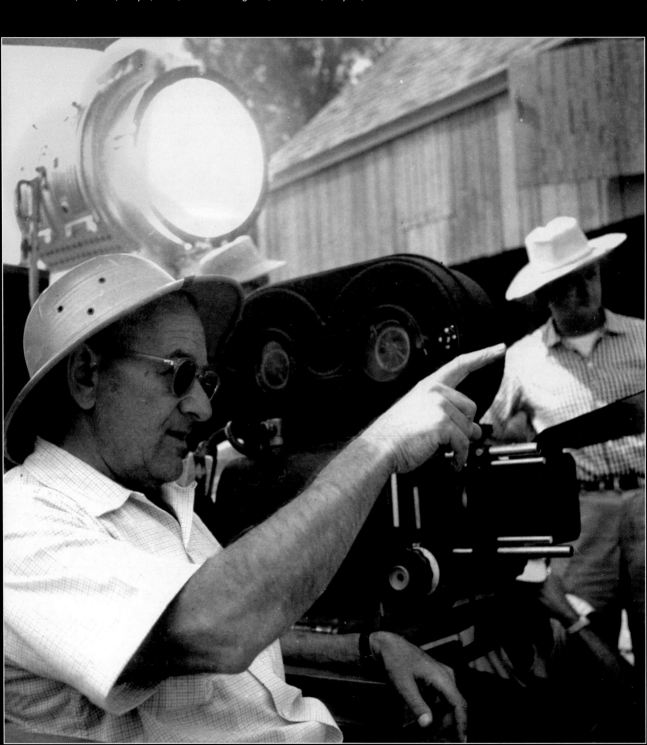

FILMS

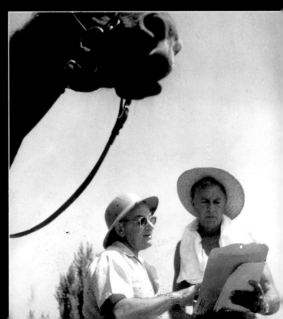

LEFT AND ABOVE RIGHT
William Wyler

RIGHT William Wyler and Gary Cooper on location

Friendly Persuasion, Warner
Brothers, 1956

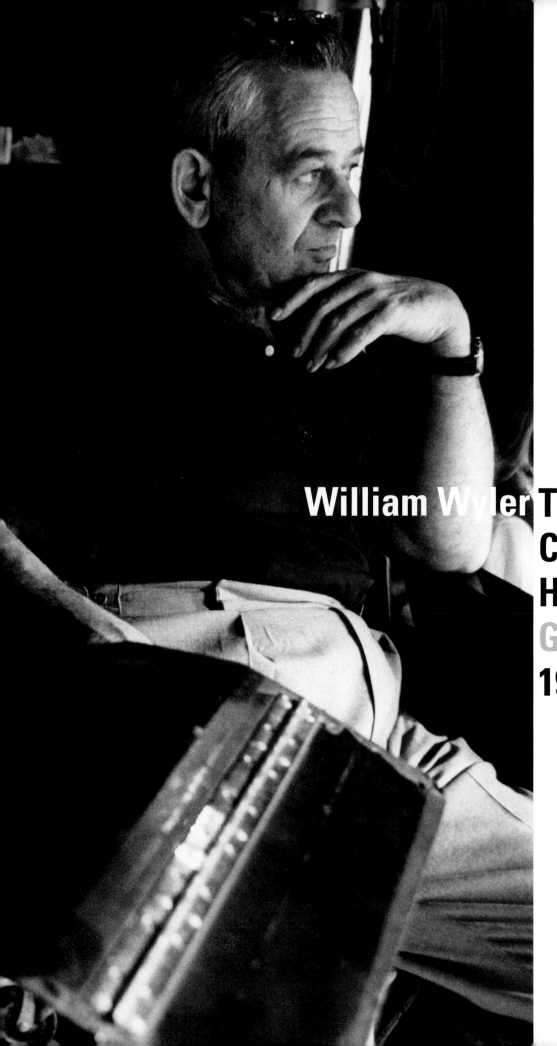

William Wyler THE CHILDREN'S HOUR GOLDWYN 1961

William Wyler

Long before I started to work on films, three-time Academy Award-winner William Wyler was a legend. So when I received the assignment to cover *The Children's Hour*, I really looked forward to the opportunity.

The film was starring Audrey Hepburn (who won the Oscar under Wyler's direction in *Roman Holiday*), Shirley MacLaine, and James Garner, all of them people whom I had worked with before and liked very much.

This was the second time Wyler was to film Lillian Hellman's controversial play with a plot concerning lesbianism. In 1936 he had filmed it as *These Three*, but I was told that he was never happy with the result because of the strictures of the censor at the time.

Years before, I had worked briefly on Wyler's film *Friendly Persuasion*. It was there that Gary Cooper told me he had walked down a flight of stairs fifty, maybe sixty times, and Wyler kept asking him to do it over and over again. In the end, Cooper said, he never knew what it was that he finally did differently, or what it was that Wyler wanted him to do.

I guess that should have prepared me for Wyler's style of directing. I had been working for more than six years on feature films, creating layouts for magazines. My job was to get space in the major magazines, especially *Life* and *Look*, and anywhere else I could manage. I would read the script, consult the shooting schedule, and work out the best days for me to cover the key scenes. Wyler's style of filming made me change the way I worked. Normally I could get the material I needed candidly as the film progressed, but on this film the only way to get the story line I needed for the magazines was to restage the scene after his final take. I had to distill the script down to a few images in order easily to convey what the film was about.

What was interesting was that Wyler stayed on when I was shooting to watch what I did. At first I was a little apprehensive with the director looking over my shoulder, but he never interfered or offered suggestions. He just took the time to see what I was doing, giving me a smile or nodding his head, then headed back to his dressing room, puffing on his cigar.

He would do a master shot, and explore it from every possible angle, over and over again, and there seemed no end to this. Once when I returned after a week, Audrey said that they had worked on the same scene the entire time I was gone. It is very hard on actors to sustain the level of their acting, especially with such very emotional scenes.

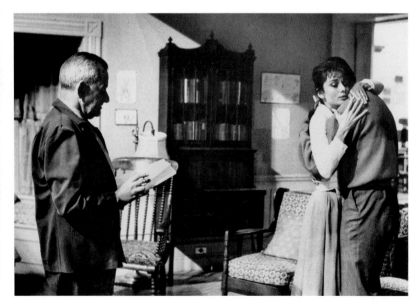

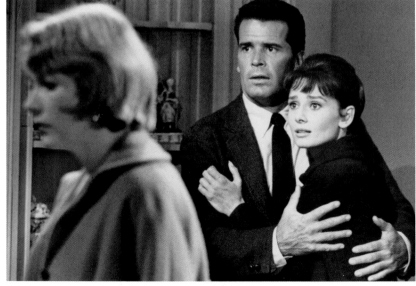

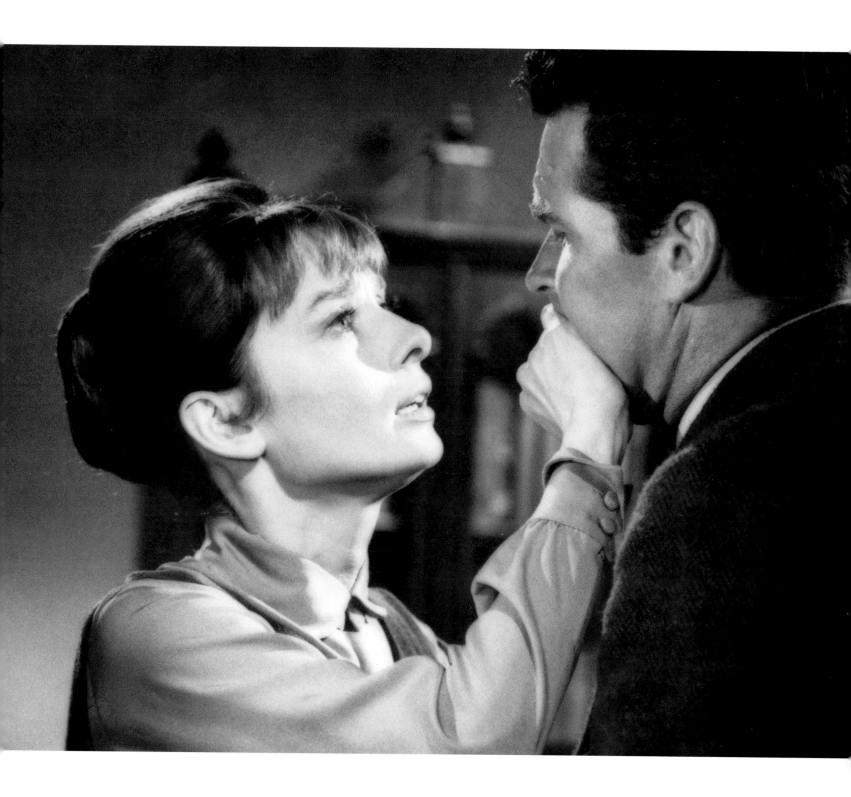

William Wyler

 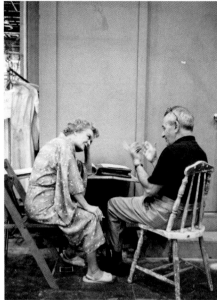 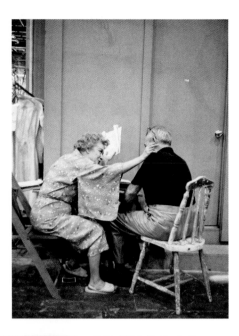

THIS PAGE *Miriam Hopkins starred in the original film* These Three, *and Wyler brought her back for a part in this remake. Here she tries to beguile Wyler into (I assume) enlarging her part, or doing it differently; in the last frame (right) she tries everything, but to no avail. Wyler wouldn't budge.*

RIGHT *Miriam Hopkins holds a photograph of herself when she was a beautiful Hollywood star.*

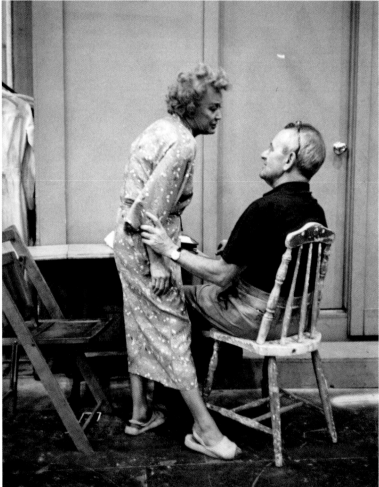

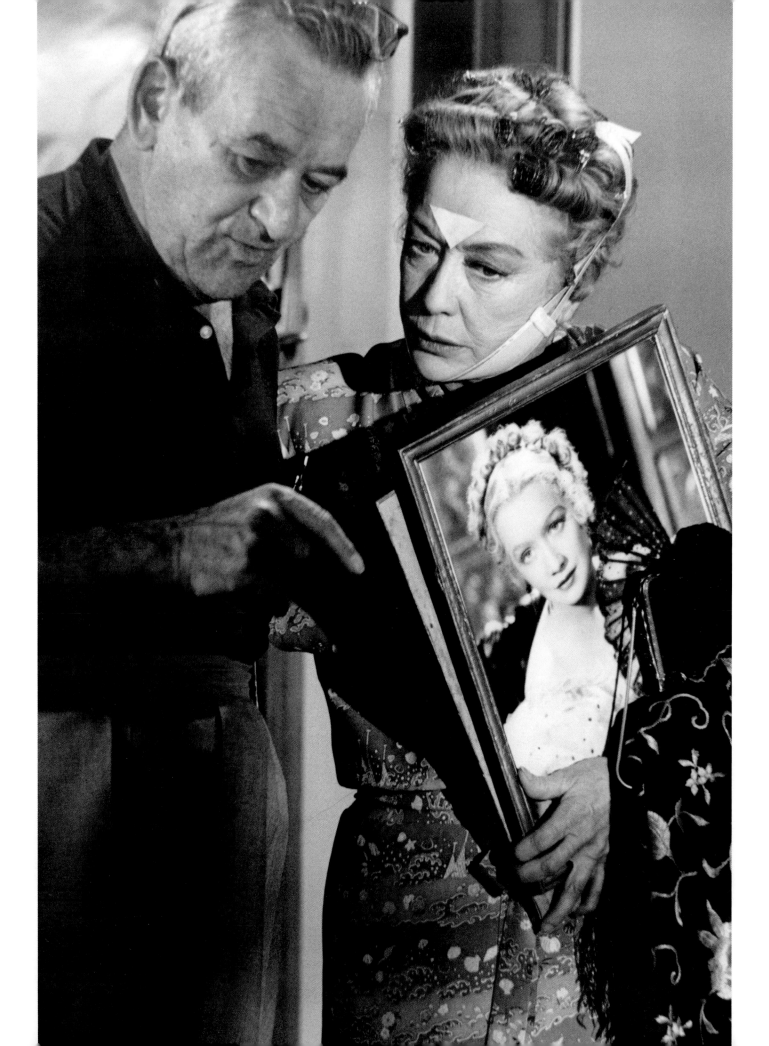

William Wyler

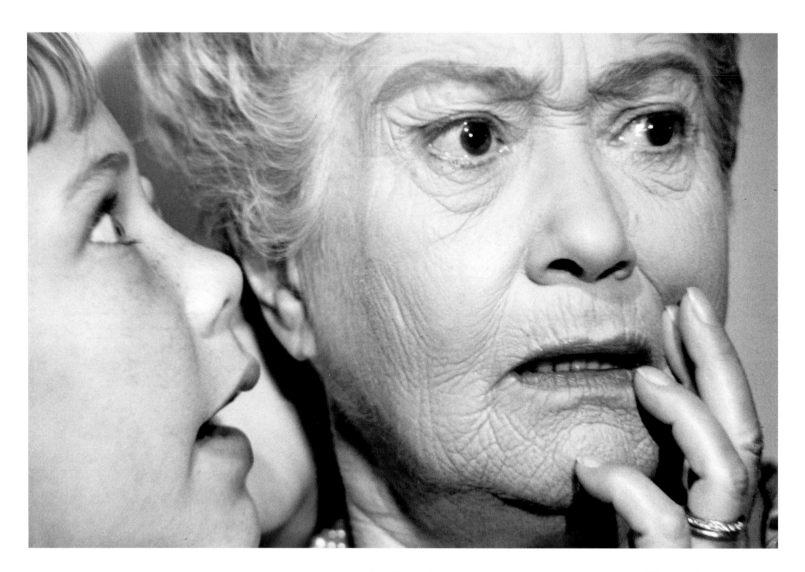

ABOVE *Karen Balkin as the little girl who tells the lie about her two teachers (Hepburn and MacLaine) to the headmistress (played by Fay Bainter), and in effect destroys their lives. The film was released in the UK as* The Loudest Whisper. Life *magazine used this as their lead shot in reviewing the film.*

RIGHT *William Wyler intently watches the filming.*

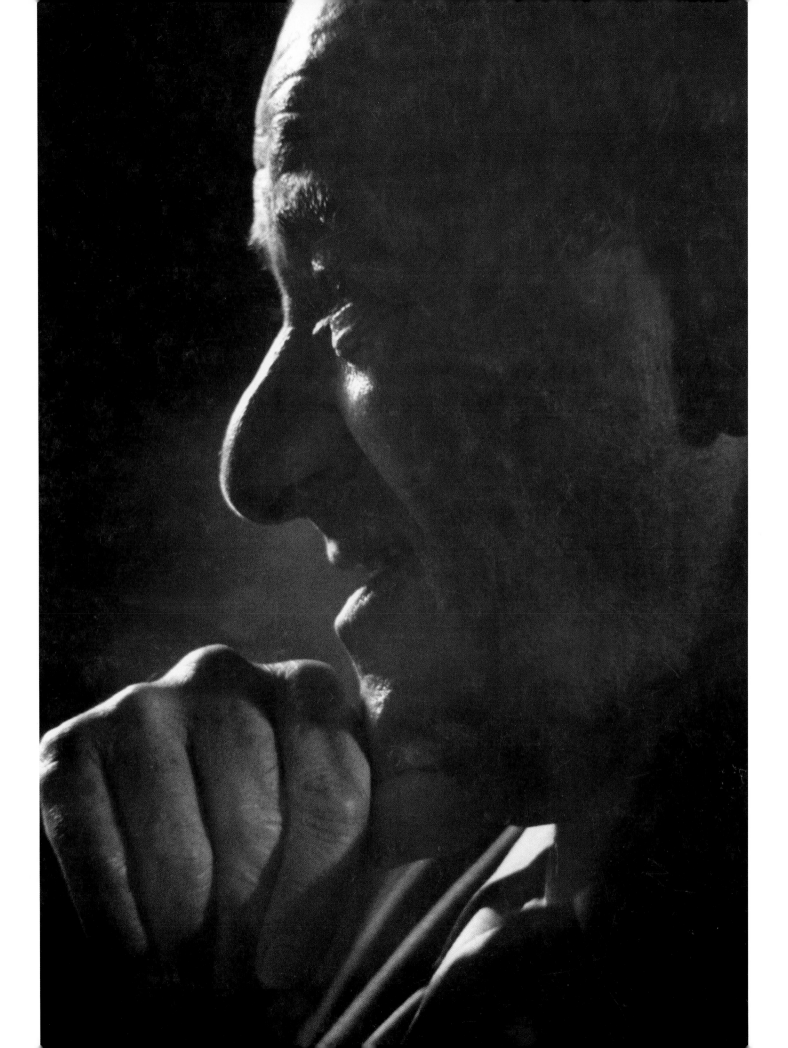

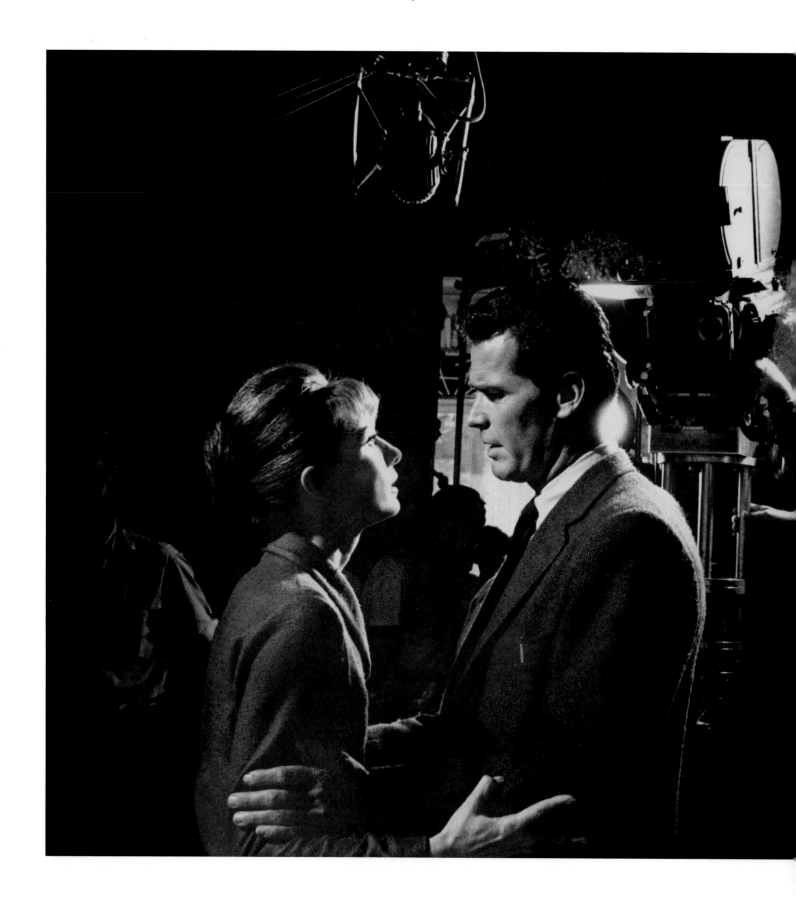

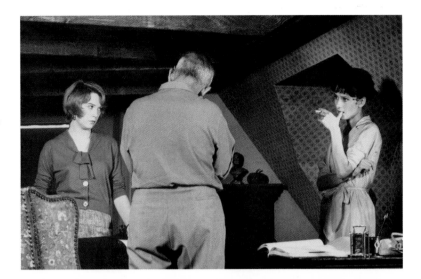

LEFT *Audrey Hepburn rehearses with James Garner.*

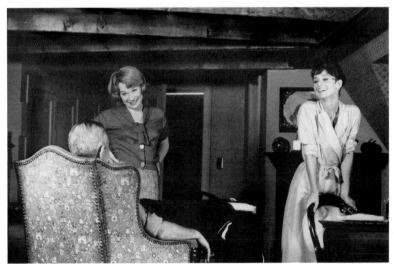

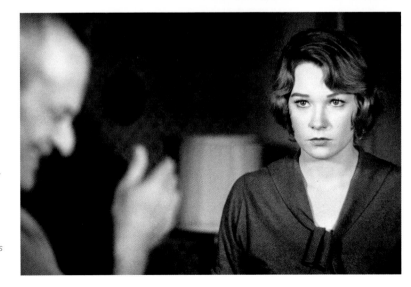

RIGHT *Shirley MacLaine and Audrey Hepburn gang up on Wyler, as they both seem to feel that the characters they are playing are not going where they think they should. They take a page out of Miriam Hopkins's book and try to charm him, and meet with the same brick wall. Wyler is locked into his idea of the characters (and after all, he's been thinking about this play since 1936).*

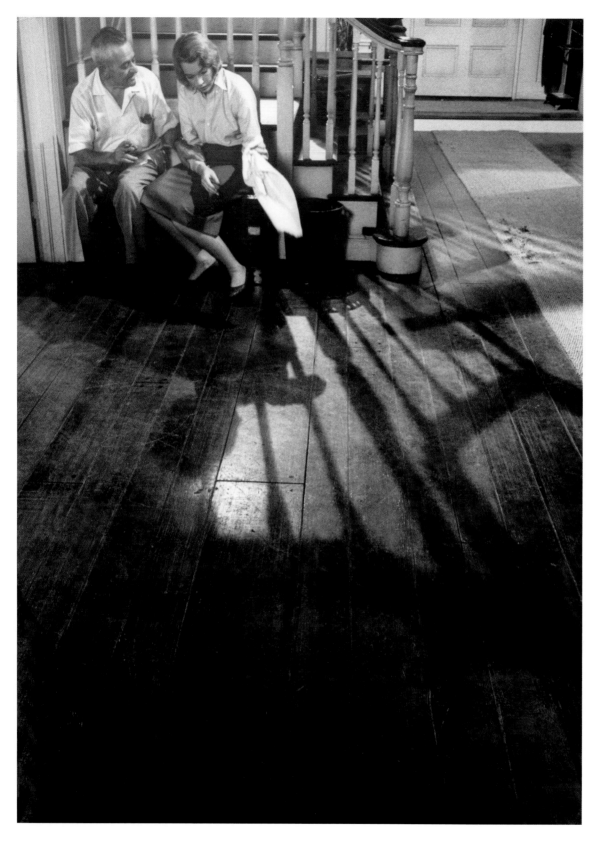

LEFT *Wyler takes Shirley MacLaine away from the filming for a private word.*

The days of a director making so many takes (in effect so unsure of what he will need, or could possibly use) are dead and gone. It's just not economically viable. I've heard that George Stevens did the same thing. By contrast, Alfred Hitchcock would never be guilty of this excess, as he had the film in his head, cut for cut, long before he started.

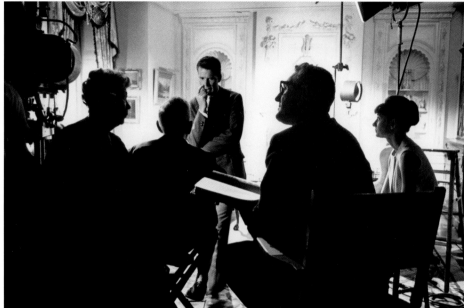

ABOVE *Wyler's copy of the script, with all of his revisions and stage directions, and of course his ever-present cigar.*

ABOVE RIGHT *James Garner listens to Wyler just before a take.*

RIGHT *The end of the film, when the character MacLaine plays has been buried and Audrey Hepburn sadly leaves the grave. James Garner watches her from afar, his life, too, affected by that child's terrible lie.*

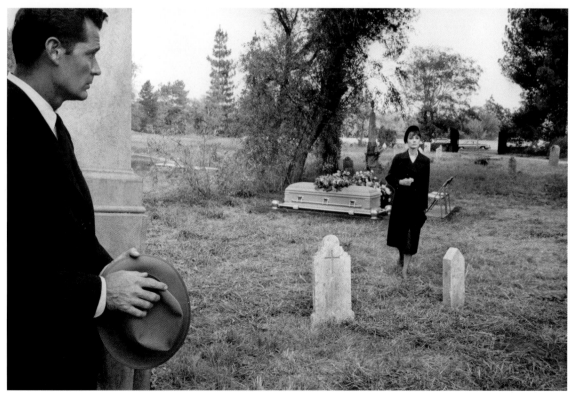

Henry Koster

Herman Kosterlitz; born Berlin, Germany, May 1, 1905; died Camarillo, California, September 21, 1988

Henry Koster was a very charming man. While some directors are demanding and bulldoze a performance from the actors, I feel in retrospect that Henry was more like a tuning fork. He gave the actors the tone and hoped they would resonate to that, letting them do their thing and then correcting them if they went off key.

These photographs were made on the Universal Pictures musical *Flower Drum Song*, 1961.

BELOW LEFT *Producer Ross Hunter, who always seemed to be omnipresent, pushes Henry a little.*

BELOW *Henry directs, while Miyoshi Umeki and Benson Fong (top right) wait for the rehearsals to begin.*

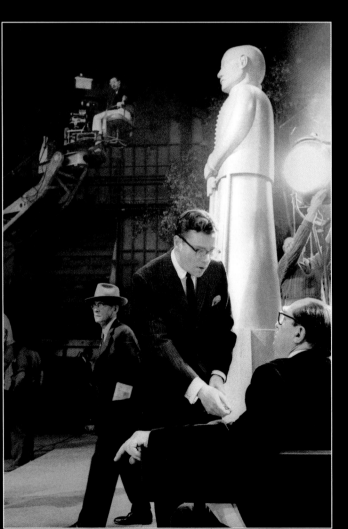

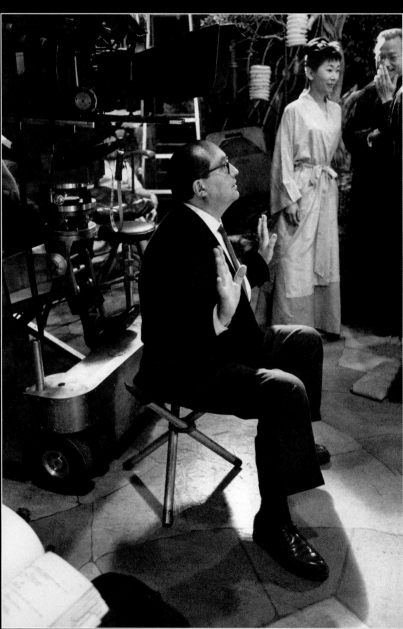

FILMS

(as Herman Kosterlitz)

Das Abenteuer der Thea Roland/The Adventure of Thea Roland *(1932)*
Das Hässliche Mädchen *(also co-scripted; 1933)*
Peter *(1934)*
Kleine Mutti/Little Mother *(1934)*
De Kribbebijter/The Cross-Patch *(1935)*
A Csúnya lány/The Homely Girl *(1935)*
Katharina, die Letzte/Catherine the Last *(1936)*
Il diario di una amata/Affairs of Maupassant *(1936)*

(as Henry Koster)

Three Smart Girls *(1936)*
One Hundred Men and a Girl *(1937)*
The Rage of Paris *(1938)*
Three Smart Girls Grow Up *(1939)*
First Love *(1939)*
Spring Parade *(1940)*

It Started with Eve *(1941)*
Between Us Girls *(also produced; 1942)*
Music for Millions *(1944)*
Two Sisters from Boston *(1946)*
The Unfinished Dance *(1947)*
The Bishop's Wife *(1947)*
The Luck of the Irish *(1948)*
Come to the Stable *(1949)*
The Inspector General *(1949)*
Wabash Avenue *(1950)*
My Blue Heaven *(1950)*
Harvey *(1950)*
No Highway/No Highway in the Sky *(1950)*
Mr. Belvedere Rings the Bell *(1951)*
Elopement *(1951)*
O. Henry's Full House *("The Cop and the Anthem" episode; 1952)*
Stars and Stripes Forever *(1952)*
My Cousin Rachel *(1953)*
The Rope *(1953)*

Desirée *(1954)*
A Man Called Peter *(1955)*
The Virgin Queen *(1955)*
Good Morning, Miss Dove *(1955)*
D-Day the Sixth of June *(1956)*
The Power and the Prize *(1956)*
My Man Godfrey *(1957)*
Fraülein (1958)
The Naked Maja *(1959)*
The Story of Ruth *(1960)*
Flower Drum Song *(1961)*
Mr. Hobbs Takes a Vacation *(1963)*
Take Her She's Mine *(also produced; 1963)*
Dear Brigitte *(also produced; 1965)*
The Singing Nun *(1966)*

BELOW *Ross confers with Henry on the studio's wonderful Grant Avenue set, modeled after the real street in San Francisco.*

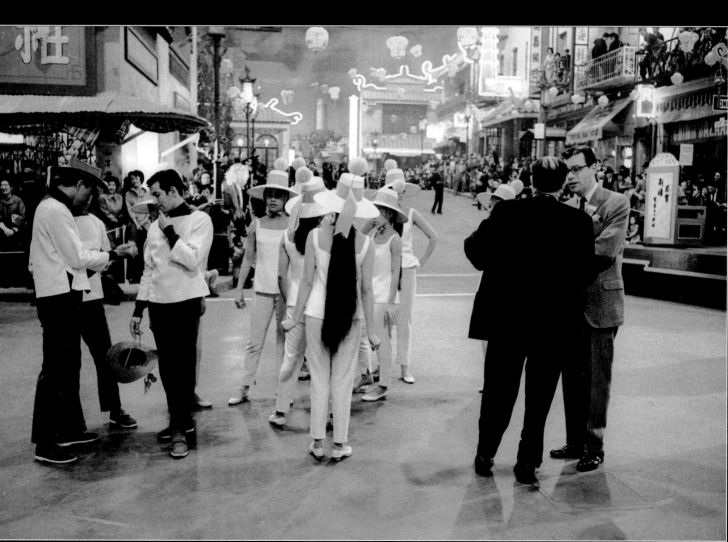

J. Lee Thompson

John Lee Thompson; born Bristol, England, August 1, 1914; died Sooke, British Columbia, August 30, 2002

When I worked briefly on *Cape Fear* at Universal Studios in 1961, what struck me most about Thompson was how nervous he was when working. He would tear off little pieces of his script, I'm sure unconsciously, and chew them into little balls (*far right*). He was very sensitive to whatever emotions the actors were going through in the scene, and you could see this reflected in his face. He was right there living it with them, chewing furiously all the time, caught up in the excitement of the moment.

FILMS

Murder Without Crime *(also story and scripted; 1950)*
The Yellow Balloon *(also scripted; 1952)*
The Weak and the Wicked *(also co-scripted; 1954)*
For Better, For Worse *(also scripted; 1954)*
As Long as They're Happy *(1955)*
An Alligator Named Daisy *(1955)*
Yield to the Night/Blonde Sinner *(1956)*
The Good Companions *(also co-produced; 1957)*
Woman in a Dressing Gown *(also co-produced; 1957)*
Ice Cold in Alex/Desert Attack *(1958)*
No Trees in the Street *(also co-executive-produced; 1959)*
Tiger Bay *(1959)*
North West Frontier/Flame over India *(1959)*
Wernher von Braun/I Aim at the Stars *(1960)*
The Guns of Navarone *(1961)*
Cape Fear *(1962)*
Taras Bulba *(1962)*
Kings of the Sun *(1963)*
What a Way to Go! *(1964)*
John Goldfarb Please Come Home! *(also executive-produced; 1965)*
Return from the Ashes *(also produced; 1965)*
Eye of the Devil *(1967)*
Before Winter Comes *(1969)*
The Chairman/The Most Dangerous Man in the World *(1969)*
Mackenna's Gold *(1969)*
Country Dance/Brotherly Love *(1970)*
Conquest of the Planet of the Apes *(1972)*
Battle for the Planet of the Apes *(1973)*
Huckleberry Finn *(1974)*
The Reincarnation of Peter Proud *(1975)*
St. Ives *(1976)*
The White Buffalo *(1977)*
The Greek Tycoon *(1978)*
The Passage *(1979)*
Caboblanco *(1980)*
Happy Birthday to Me *(1981)*
10 to Midnight *(1983)*
The Evil That Men Do *(1984)*
The Ambassador *(1984)*
King Solomon's Mines *(1985)*
Murphy's Law *(1986)*
Firewalker *(1986)*
Death Wish 4: The Crackdown *(1987)*
Messenger of Death *(1988)*
Kinjite: Forbidden Subjects *(1989)*

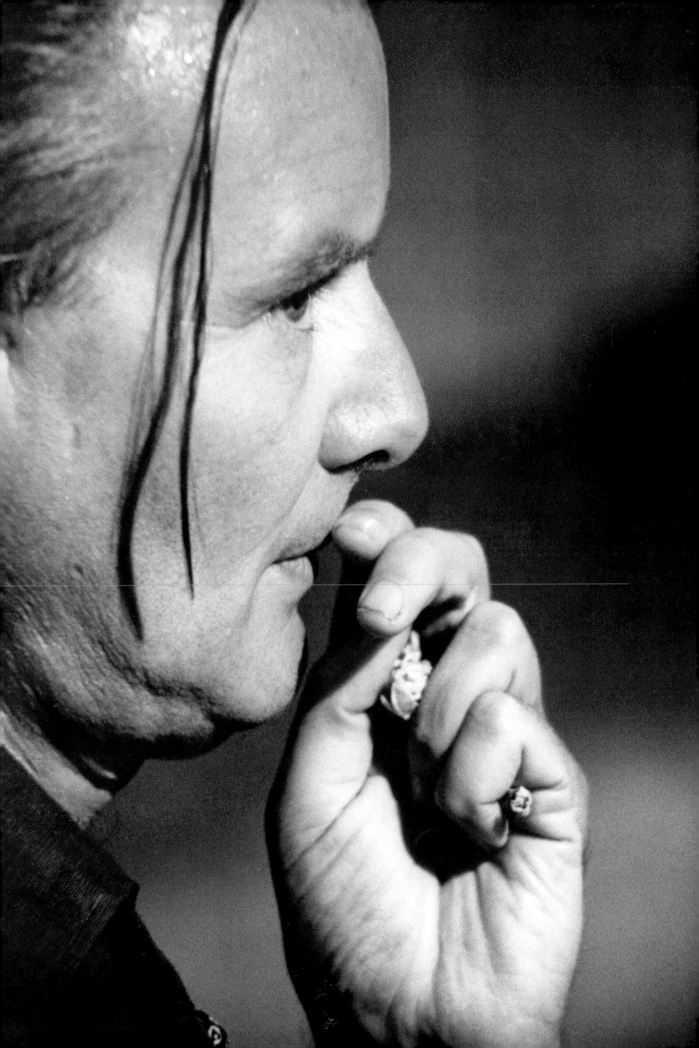

Richard Quine

born Detroit, Michigan, November 12, 1920; died Los Angeles, California, June 10, 1989

Director Richard Quine had an ongoing romance with the actress Kim Novak for years. It is generally not a good thing for the director and an actress to be involved during filming—either the film or the relationship has to suffer. Kim seemed always to be looking for "motivation," and the times I worked with the two of them, Quine seemed always to be pleading with her (*see the two photographs on facing page, top*), trying to make it simple for her.

I've worked with Jack Lemmon on many films, and I have never seen him angry or say an unkind word to anyone. So the image at bottom right, taken on the Big Sur location of *The Notorious Landlady*, is truly a rare photograph. It shows Jack walking away from the filming in total frustration, muttering to himself about Novak's wanting motivation—"I'll give her motivation!" The hapless Dick Quine is left below, pleading once again with his lady love to get on with the filming.

BELOW *Dick Quine behind the camera (with mustache, to make him look older) on the set of* My Sister Eileen, *Columbia Studios, 1955.*

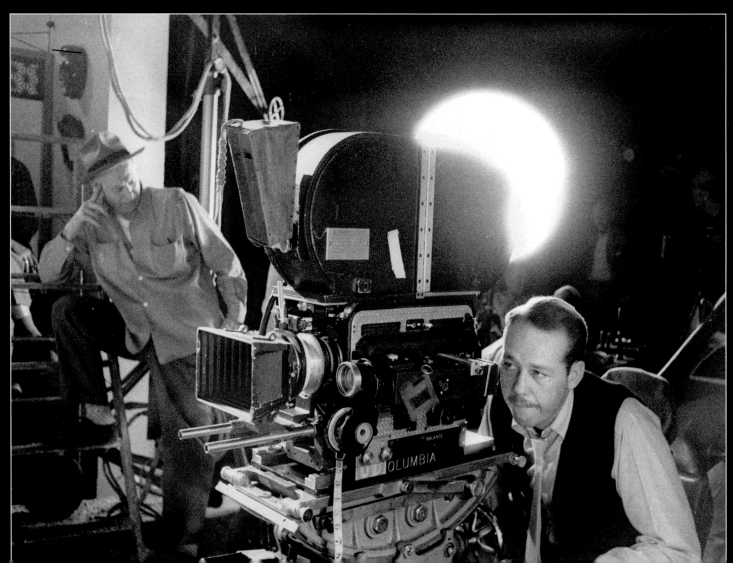

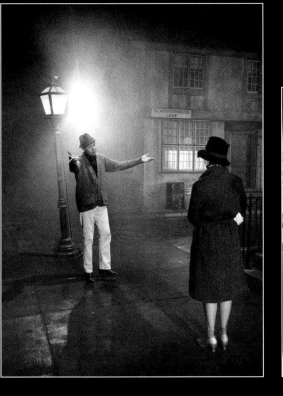

FILMS

(excluding TV series)

Leather Gloves *(co-directed and co-produced with William Asher; 1948)*
Sunny Side of the Street *(1951)*
Purple Heart Diary *(1951)*
Sound Off *(also co-scripted; 1952)*
Rainbow 'Round My Shoulder *(also co-scripted; 1952)*
All Ashore *(1953)*
Siren of Baghdad *(1953)*
Cruisin' Down the River *(also co-scripted; 1953)*
Drive a Crooked Road *(also co-scripted; 1954)*
My Sister Eileen *(also co-scripted; 1955)*
The Solid Gold Cadillac *(1956)*
Full of Life *(1957)*
Operation Mad Ball *(1957)*
Bell Book and Candle *(1958)*
It Happened to Jane *(also produced; 1959)*
Strangers When We Meet *(also co-produced; 1960)*
The World of Suzie Wong *(1960)*
The Notorious Landlady *(1962)*
Paris When It Sizzles *(also co-produced; 1964)*
Sex and the Single Girl *(1964)*
How to Murder Your Wife *(1965)*
Synanon *(also produced; 1965)*
**Oh Dad, Poor Dad, Mama's Hung You in the Closet and I'm Feelin'
So Sad** *(1967)*
Hotel *(1967)*
A Talent for Loving *(1969)*
The Moonshine War *(1970)*
W *(1974)*
The Prisoner of Zenda *(1978)*
Double Take *(1979)*

ABOVE LEFT *Quine and Novak on* The Notorious Landlady *(Columbia), photographed in 1961.*

ABOVE *Quine and Novak on* Bell Book and Candle. *Columbia/Phoenix Productions, 1958.*

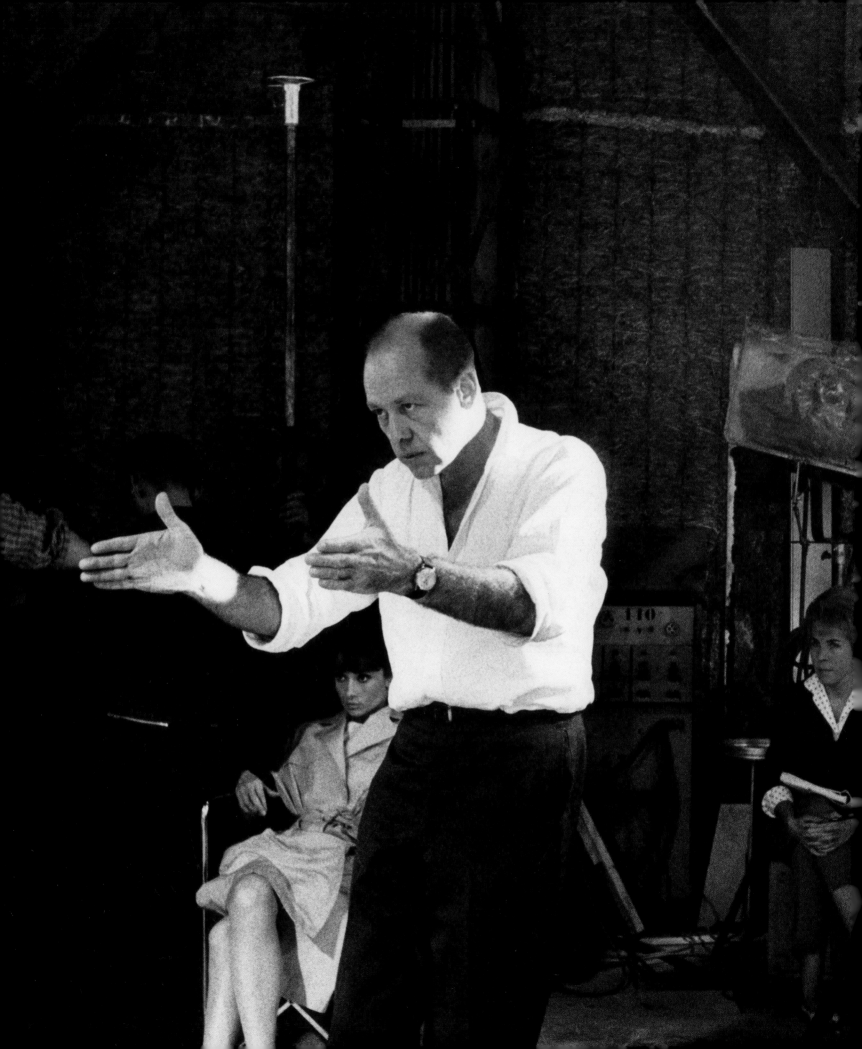

Richard Quine **PARIS WHEN IT SIZZLES**

PARAMOUNT

1962

Richard Quine

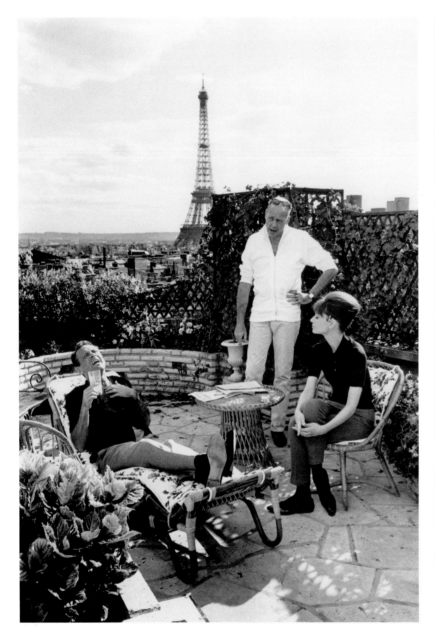

Richard Quine was such a pleasure to work with. There was always a lighthearted character to his sets and *Paris When It Sizzles* was no exception. Audrey Hepburn and William Holden were the stars of the film—two special people whom I liked very much, and frankly I miss them.

The script was another thing. A remake of a French film, *Holiday for Henrietta* (*La Fête à Henriette*), it was too convoluted to make much sense of. From start to finish, it was hard to know where we were.

ABOVE *William Holden (left), Quine, and Audrey Hepburn.*

RIGHT *Richard Quine stands on the empty set in the Boulogne Studios before filming begins, probably trying to put together in his mind the pieces of this jigsaw of a film.*

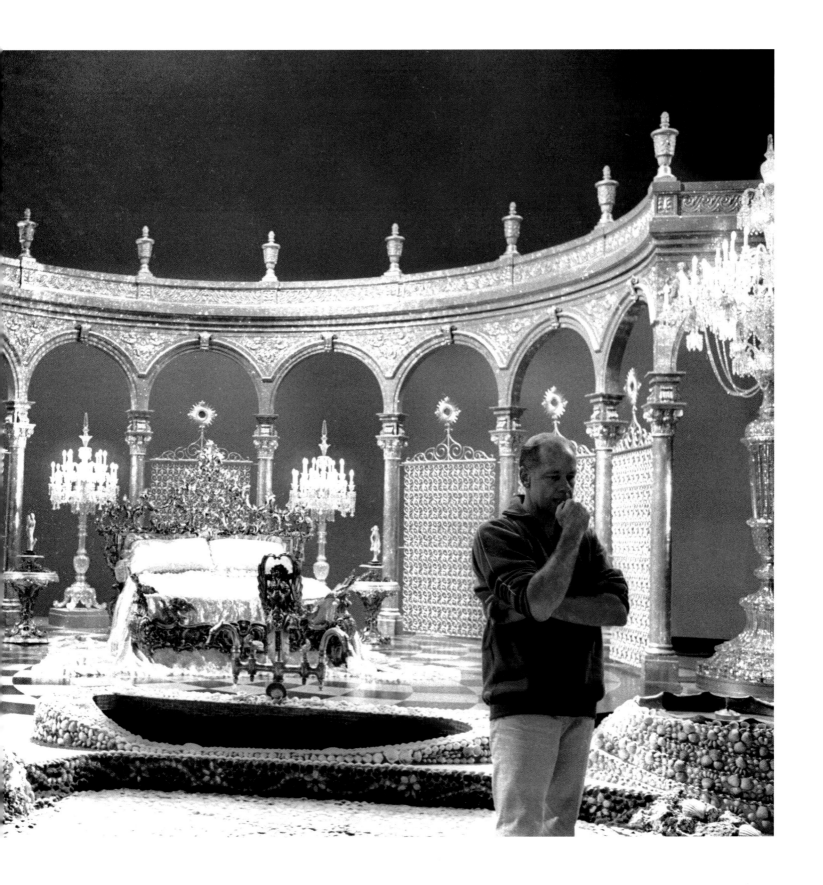

Richard Quine

There is a film lore adage that says that if you laugh too much while filming, the film is bound not to be funny. We should have remembered this, as we laughed a lot on this set. We shot it in 1962, though it wasn't released until 1964.

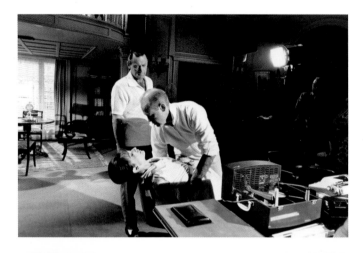

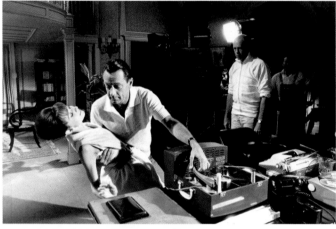

THIS PAGE *Richard Quine demonstrates to William Holden how to hold Audrey Hepburn, and then watches Bill and Audrey rehearse the scene.*

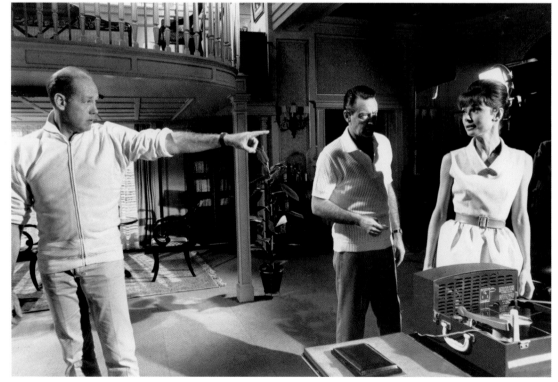

RIGHT *Quine watches the rehearsal through the camera, while Audrey Hepburn stands waiting to enter the scene in her little Givenchy suit.*

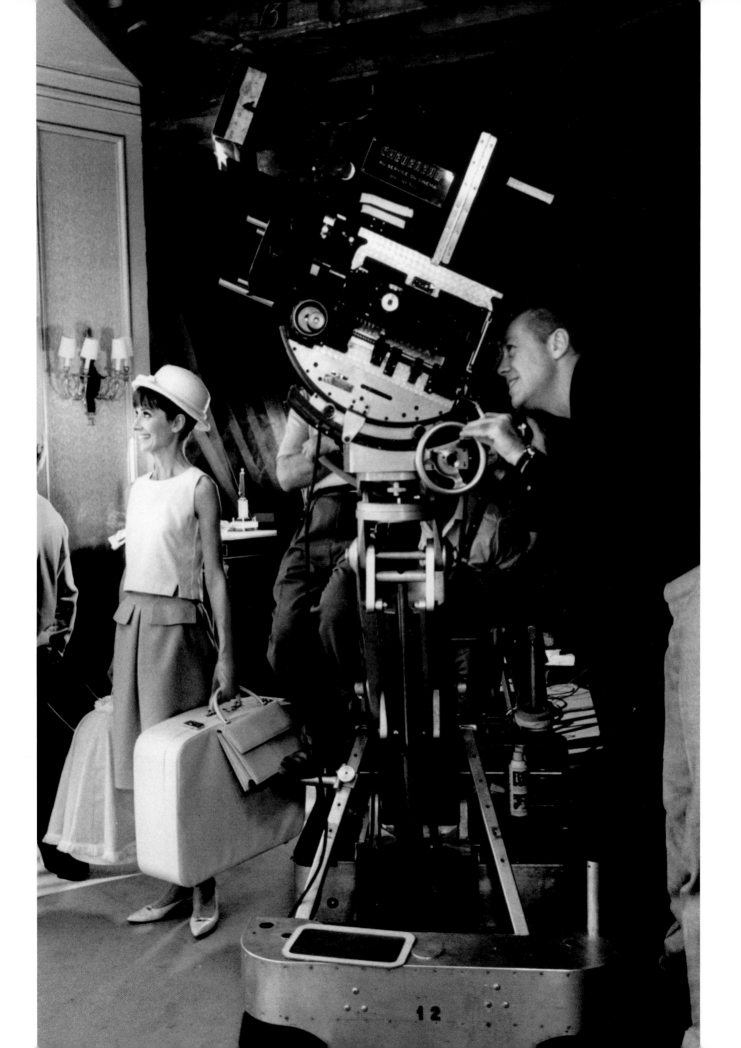

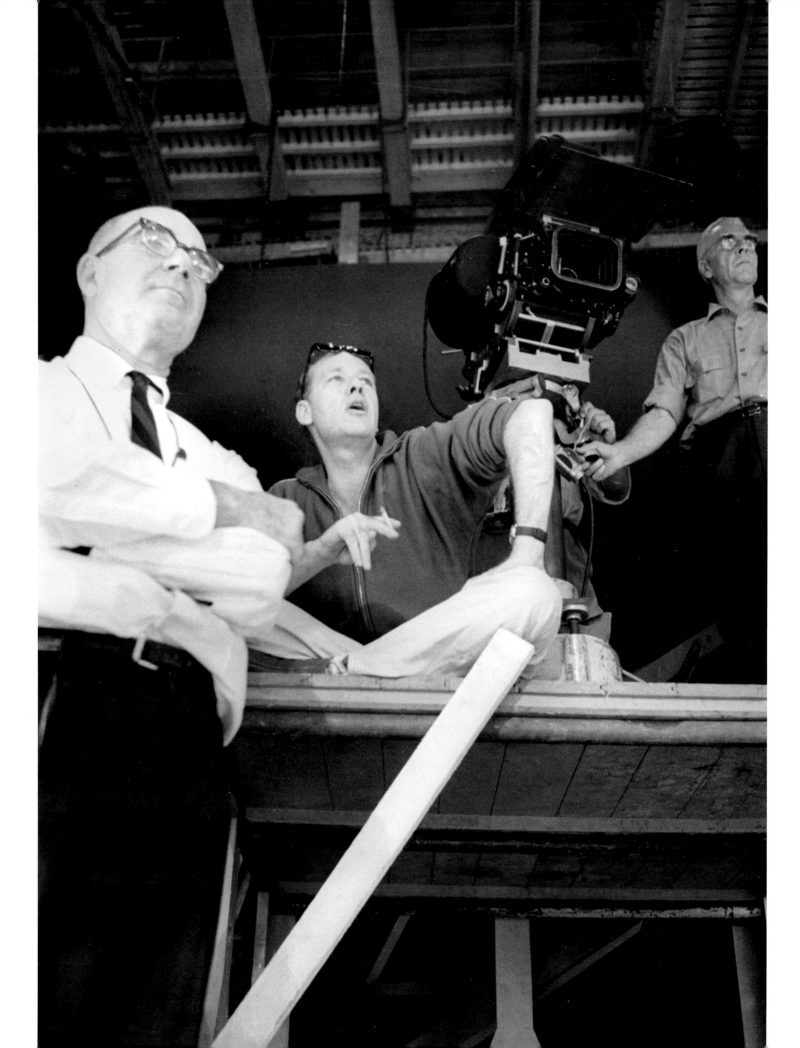

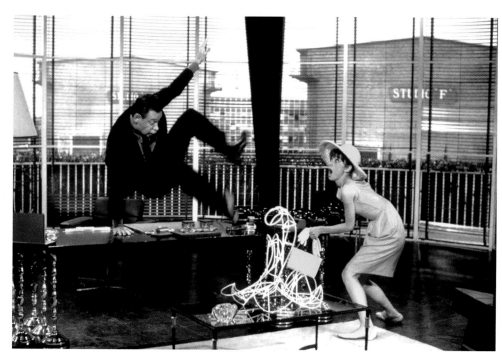

LEFT *Richard Quine with the much-honored cinematographer Charles Lang. Lang has had eighteen Academy Award nominations, more than any other artist in a single category.*

RIGHT *In one of the film's zany scenes, Bill Holden (as Richard Benson) leaps over the desk to reach the quaking Audrey Hepburn (as Gabrielle Simpson) and starts chasing her around his office.*

RIGHT *In another sequence, it's Audrey's turn to be the seductress. Gabrielle lies back on her glamorous bed, enticing Richard with her charms.*

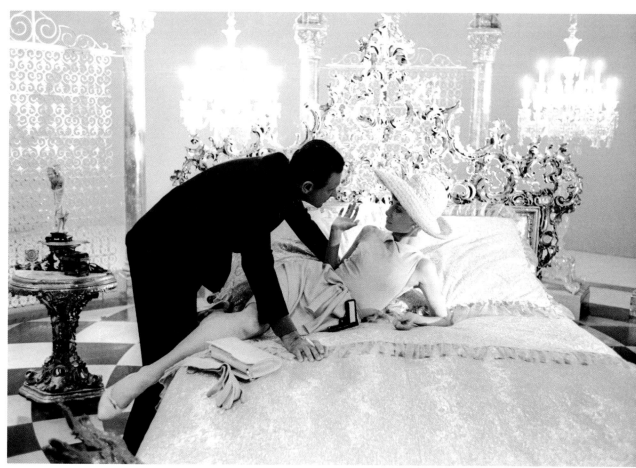

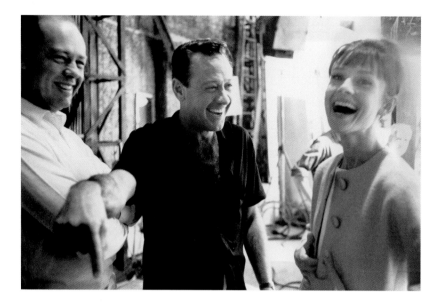

I was almost sorry when this film ended: Paris in the fall, and such nice people to work with.

THIS PAGE *These photographs offer some idea of the happy feeling on the set: Bill Holden telling one of his many long tales, Dick Quine swinging Audrey around after a take. It was a special time!*

RIGHT *I even did some fashion shots for French Vogue on the film set, and included our director, with Audrey perched on the camera crane.*

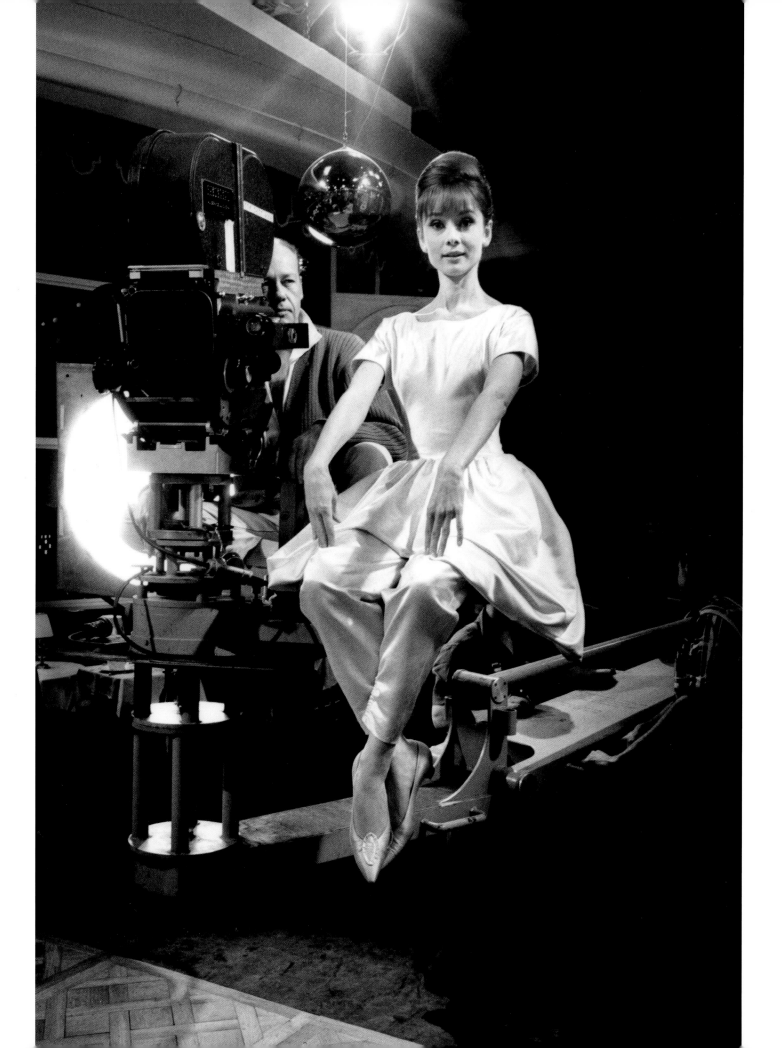

Ronald Neame

born London, England, April 23, 1911

I worked with Ronald Neame on *Gambit* at Universal Studios in 1966. It starred Shirley MacLaine and Michael Caine. It was good to see Neame in such fine form, without the problems that were ever-present during *I Could Go On Singing* (pages 140–49).

FILMS

Take My Life *(1947)*
The Golden Salamander *(1950)*
The Card/The Promoter *(1952)*
The Million Pound Note/The Man with a Million *(1953)*
The Man Who Never Was *(1956)*
The Seventh Sin *(1957)*
Windom's Way *(1957)*
The Horse's Mouth *(also produced; 1958)*
Tunes of Glory *(1960)*
Escape from Zahrain *(also produced; 1962)*
I Could Go On Singing *(1963)*
The Chalk Garden *(1964)*
Mister Moses *(1965)*
A Man Could Get Killed/Welcome, Mr. Beddoes *(co-directed with Cliff Owen; 1966)*
Gambit *(1966)*
Prudence and the Pill *(co-directed with Fielder Cook; 1968)*
The Prime of Miss Jean Brodie *(1969)*
Hello-Goodbye *(uncredited; replaced by Jean Negulesco; 1970)*
Scrooge *(1970)*
The Poseidon Adventure *(1972)*
The Odessa File *(1974)*
Meteor *(1979)*
Hopscotch *(1980)*
First Monday in October *(1981)*
Foreign Body *(1986)*
The Magic Balloon *(also wrote; 1990)*

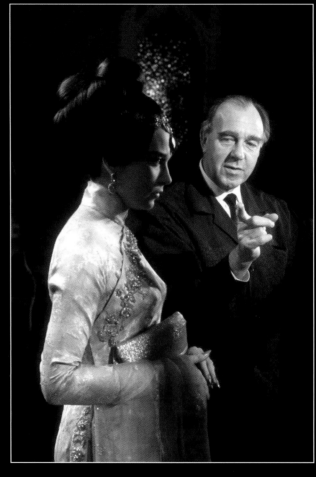

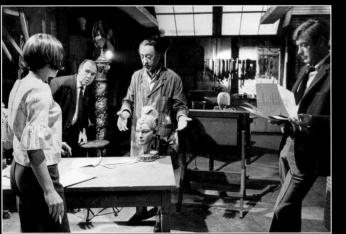

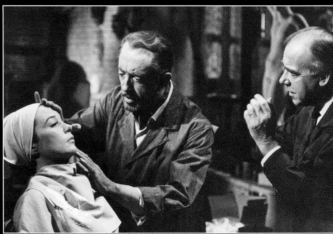

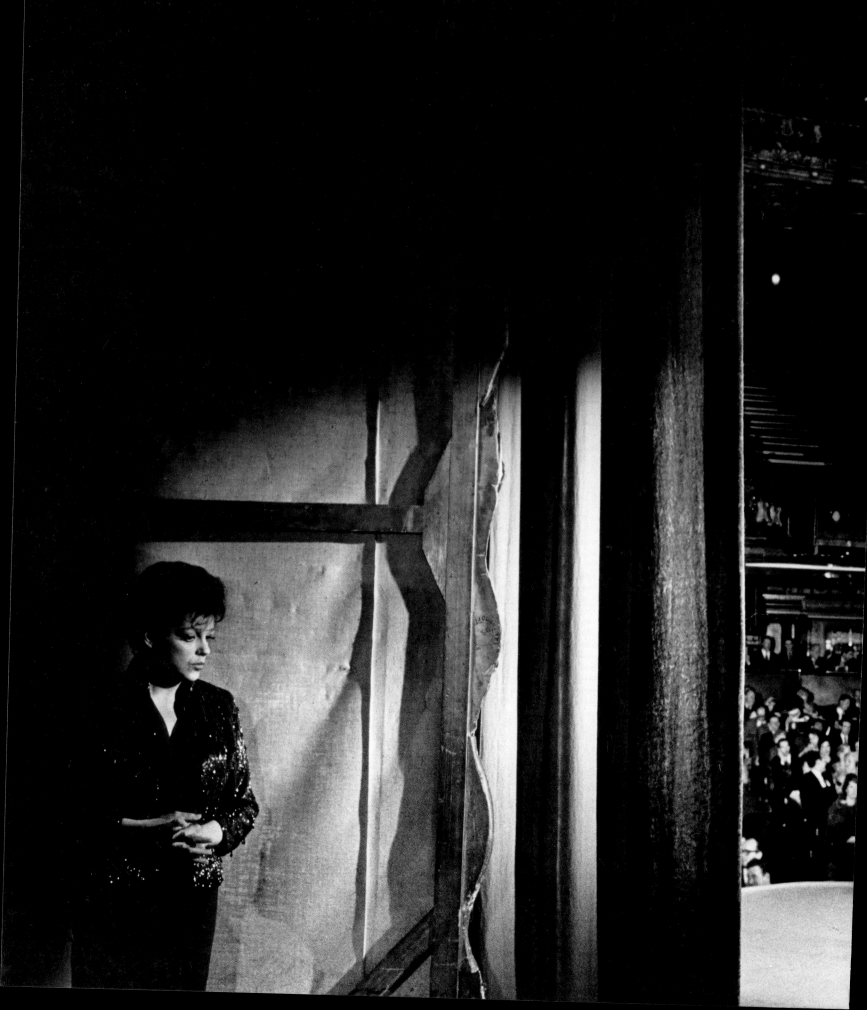

Ronald Neame | **I COULD GO ON SINGING** UNITED ARTISTS **1962**

Ronald Neame

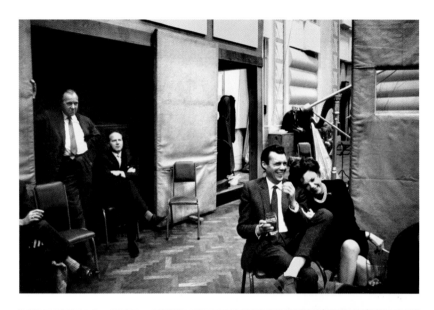

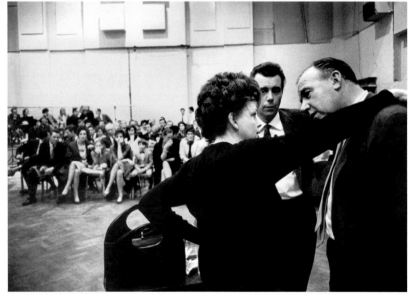

Director Ronald Neame's credits as a cinematographer in the 1930s and 1940s included a dazzling collection of such fine films as *Pygmalion*, *Major Barbara*, *In Which We Serve*, and *Blithe Spirit*. As a producer he also struck gold with *Brief Encounter*, *Great Expectations*, and *Oliver Twist*. However, I don't think anything in his long career could have quite prepared him for *I Could Go On Singing*, Judy Garland's last film.

I had worked with Judy several times; in fact *A Star Is Born* was the first film on which a studio had ever hired an outside photographer. We knew each other, and got along very well. Sadly Judy was more insecure on this film than I had ever seen her.

I could see how necessary it was for her to be reassured all the time. Neame, who was always a gentleman, always patient with his actors, was very frustrated by her ups and downs. Her co-star Dirk Bogarde was the one who kept her on an even keel for the longest periods. When he wound up his work on the film, Neame asked the producers to call him back as Judy just wasn't showing up regularly on the Shepperton sound stage in London.

LEFT AND ABOVE LEFT *The recording session. Producers Larry Turman and Stuart Millar wisely invited Dirk Bogarde, who had such a calming effect on Judy; and the small audience included her children. In the front row you can see Lorna, Liza, and Joey. There was a lot of "stroking" of Judy that night, and her recordings were electric. The expression on Neame's face, as he watches Judy with Dirk, says a lot about his concerns for the weeks ahead.*

RIGHT *Ronald Neame gives Judy Garland the OK sign for a fine performance after a take.*

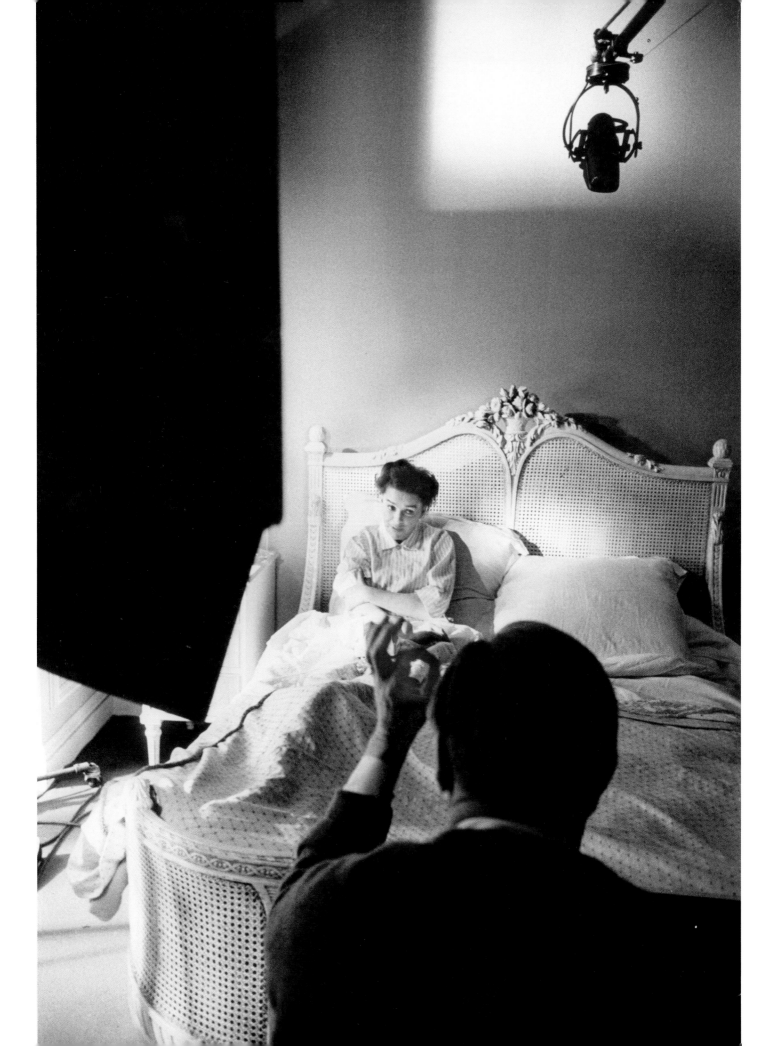

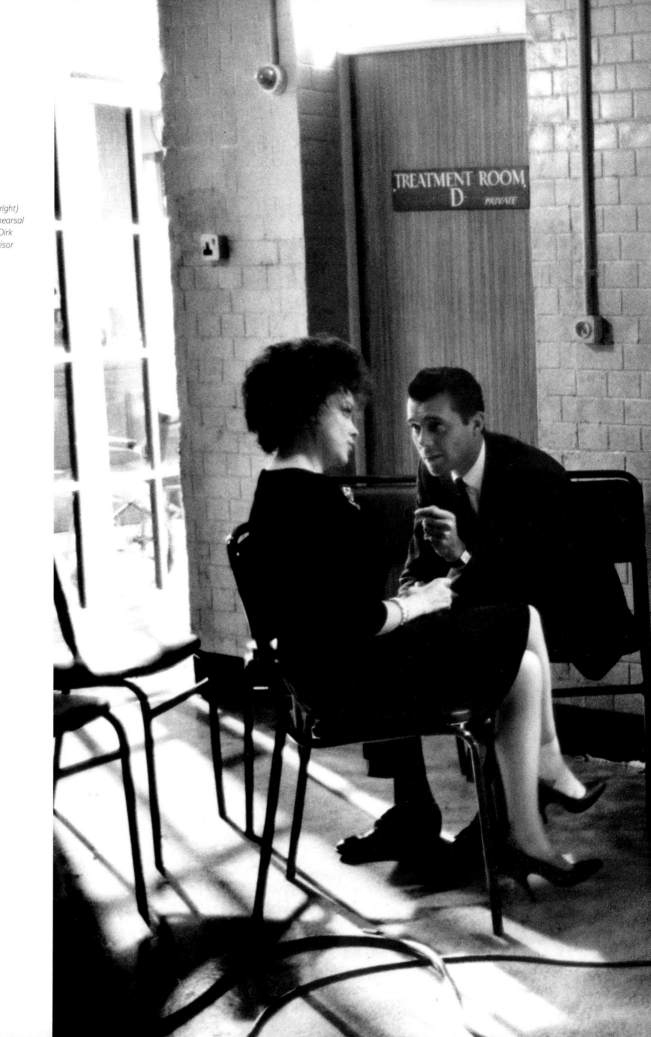

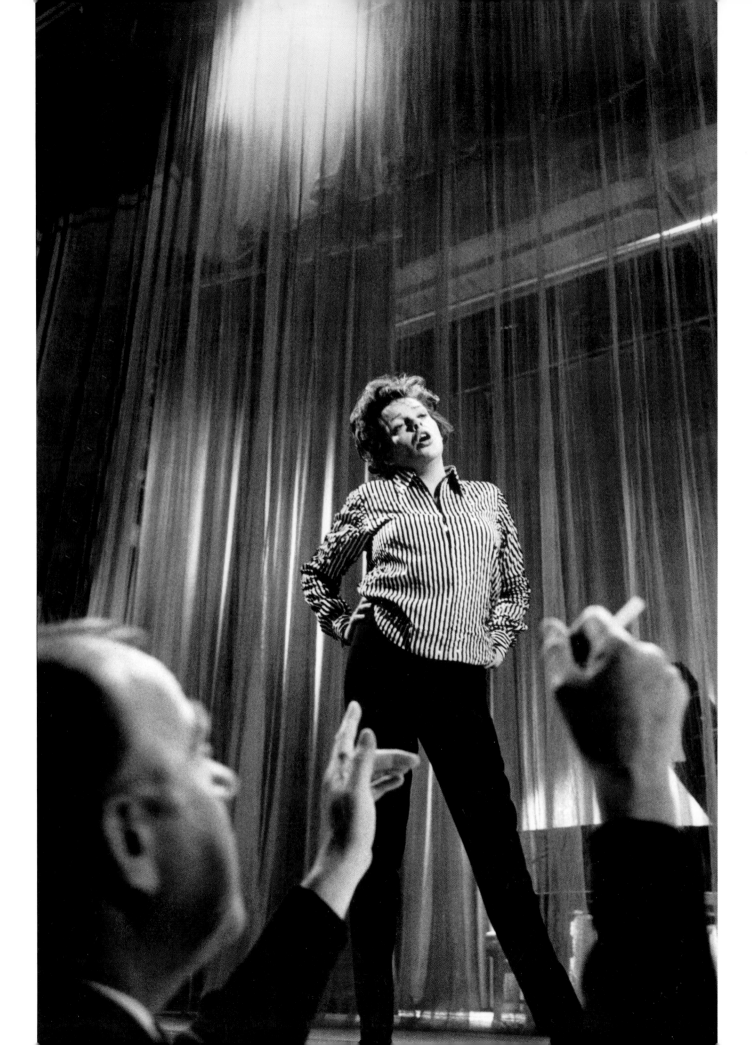

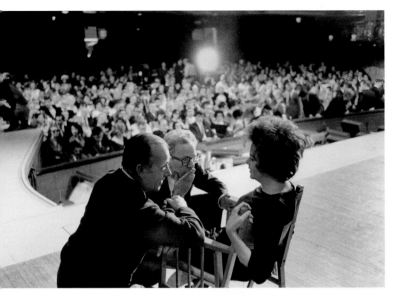

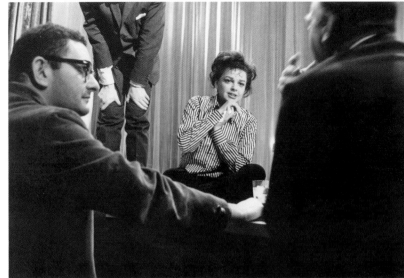

ABOVE AND RIGHT *Neame and musical director Saul Chaplin confer with Judy as the film audience waits. Chaplin was a dynamo with Judy, and always kept her laughing when he was around. Neame just didn't have that kind of personality, or the energy to try to keep Judy in constant high spirits.*

LEFT *Judy Garland sings to the music playback on the stage of the London Palladium.*

ABOVE *Producer Stuart Millar listens to Neame as he reassures Judy just how wonderful it will all be—and by the way, it was! No one could sing like Judy, she was just amazing.*

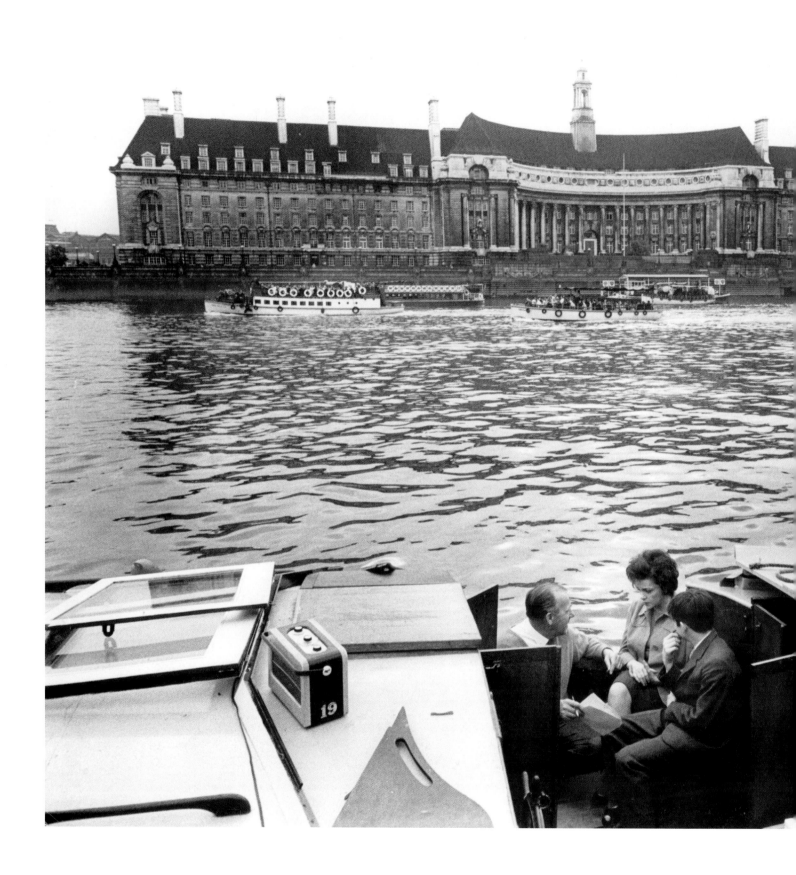

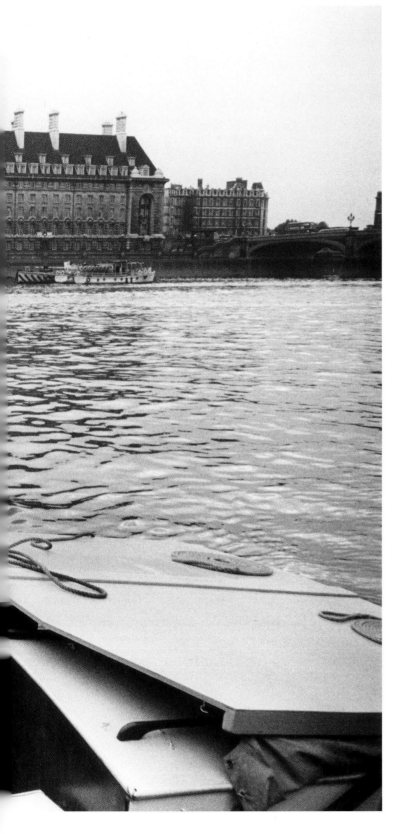

Even on the last day, Judy was down. It was a relief for the crew that the film was completed, but I did feel so sorry for Judy.

LEFT *The last day of filming, on a barge on the River Thames in London: Judy Garland and Greg Phillips (her son in the film) confer with Neame.*

ABOVE *Ronald Neame, the filming finished, must wonder if the final movie will be worth all of the aggravation and sleepless nights. His next film was a little lighter—*The Chalk Garden *with Deborah Kerr, who was a pure delight to work with—and I'm sure he was looking forward to the change of pace.*

Norman Jewison

born Toronto, Canada, July 21, 1926

Before Norman Jewison began his successful film career, he directed many TV specials, including the one here for Judy Garland in 1962. Her dear pals Frank Sinatra and Dean Martin were there, and you can see how Norman kept the energy going and how he stirred things up. His enthusiasm for what he does, and his ear for comedy, have kept him busy over the last thirty-five years. If *Moonstruck* were the only film he'd ever made, he would be a winner in my book. It had such charming touches, and the characters were so well defined, that it stands high in my book of favorites.

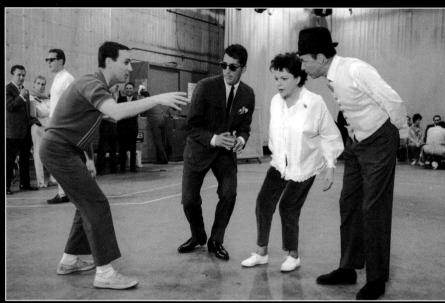

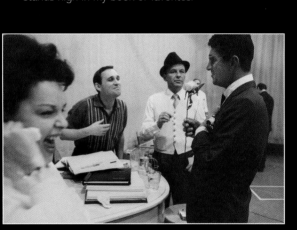

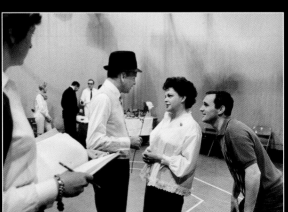

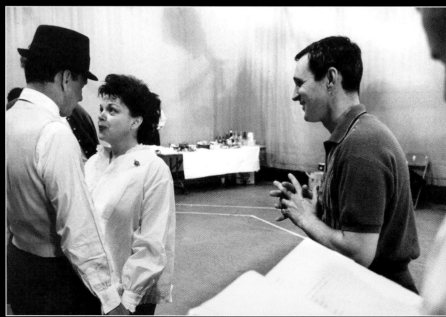

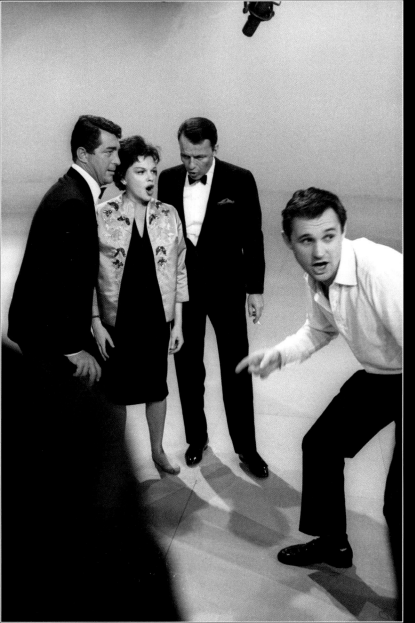

FILMS

40 Pounds of Trouble *(1963)*
The Thrill of It All *(1963)*
Send Me No Flowers *(1964)*
The Art of Love *(1965)*
The Cincinnati Kid *(1965)*
The Russians Are Coming, The Russians Are Coming *(also produced; 1966)*
In the Heat of the Night *(1967)*
The Thomas Crown Affair *(also produced; 1968)*
Gaily, Gaily *(also produced; 1969)*
Fiddler on the Roof *(also produced; 1971)*
Jesus Christ Superstar *(also co-produced; 1973)*
Rollerball *(also produced; 1975)*
F.I.S.T. *(also produced; 1978)*
And Justice for All *(also co-produced; 1979)*
Best Friends *(also co-produced; 1982)*
A Soldier's Story *(also co-produced; 1984)*
Agnes of God *(also co-produced; 1985)*
Moonstruck *(also co-produced; 1987)*
In Country *(also co-produced; 1989)*
Other People's Money *(also produced; 1991)*
Only You *(also produced; 1994)*
Bogus *(also co-produced; 1996)*
The Hurricane *(also co-produced; 1999)*
The 20th Century: Funny is Money *(TV; 1999)*
Dinner With Friends *(TV; also executive-produced; 2001)*

George Cukor

born New York City, July 7, 1899; died Los Angeles, California, January 24, 1983

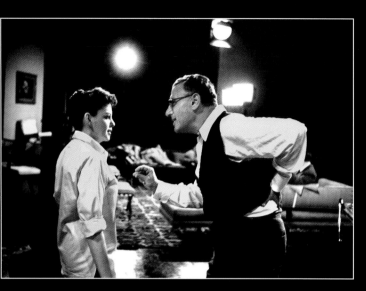

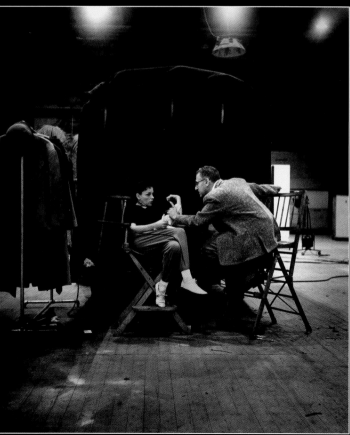

FILMS

Grumpy *(co-directed with Cyril Gardner; 1930)*
The Virtuous Sin *(co-directed with Louis Gasnier; 1930)*
The Royal Family of Broadway *(co-directed with Cyril Gardner; 1930)*
Tarnished Lady *(1931)*
Girls About Town *(1931)*
One Hour with You *(co-directed with Ernst Lubitsch; 1932)*
What Price Hollywood *(1932)*
A Bill of Divorcement *(1932)*
Rockabye *(1932)*
Our Betters *(1933)*
Dinner at Eight *(1933)*
Little Women *(1933)*
David Copperfield *(1935)*
Sylvia Scarlet *(1936)*
Romeo and Juliet *(1936)*
Camille *(1937)*
Holiday *(1938)*
Zaza *(1938)*
Gone With the Wind *(replaced by Victor Fleming; uncredited; 1939)*
The Women *(1939)*
The Philadelphia Story *(1940)*
Susan and God *(1940)*
A Woman's Face *(1941)*
Two-Faced Woman *(1941)*
Her Cardboard Lover *(1942)*
Keeper of the Flame *(1943)*
Resistance and Ohm's Law *(documentary for the Army Signal Corps; 1944)*
Gaslight *(1944)*
Winged Victory *(1944)*
Desire Me *(co-directed with Mervin LeRoy; neither credited; 1947)*
A Double Life *(1947)*
Edward My Son *(1949)*
Adam's Rib *(1949)*
Born Yesterday *(1950)*
A Life of Her Own *(1950)*
The Model and the Marriage Broker *(1952)*
The Marrying Kind *(1952)*
Pat and Mike *(1952)*
The Actress *(1953)*
It Should Happen to You *(1954)*
A Star Is Born *(1954)*
Bhowani Junction *(1956)*
Les Girls *(1957)*
Wild is the Wind *(1957)*
Heller in Pink Tights *(1960)*
Song Without End *(completed for the deceased Charles Vidor; declined screen credit; 1960)*
Let's Make Love *(1960)*
The Chapman Report *(1962)*
My Fair Lady *(1964)*
Justine *(replaced Joseph Strick; 1969)*
Travels With my Aunt *(also co-produced; 1973)*
The Blue Bird *(1976)*
The Corn Is Green *(TV movie; 1979)*
Rich and Famous *(1981)*

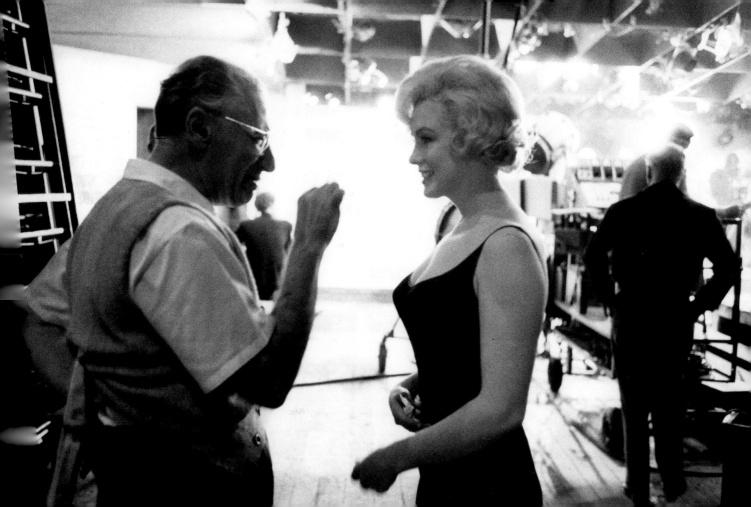

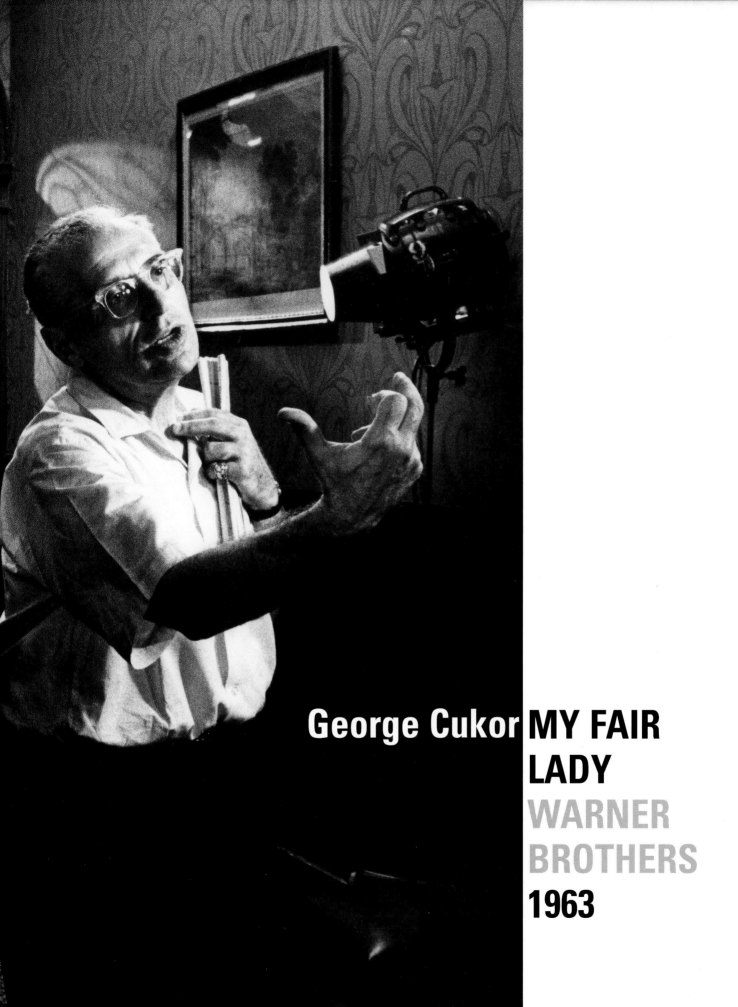

George Cukor MY FAIR LADY WARNER BROTHERS 1963

George Cukor

Veteran director George Cukor was a great character. He had directed just about everyone, including Garbo, Kate Hepburn, and Norma Shearer. He was known in Hollywood as a "woman's director." It was terrific to photograph him emoting as he acted out the parts for the actors. I had worked with him several times before this, and we always had a great funny exchange verbally, or by letter, when I sent him some prints.

You can see in these opening scenes of *My Fair Lady*, with Audrey Hepburn and Rex Harrison, what I mean about his emoting to convey the idea of the part. The actors had to do their own interpreting of what he meant. He was from another era, not only in his style on the floor—a time when the director was king, and no one questioned his authority.

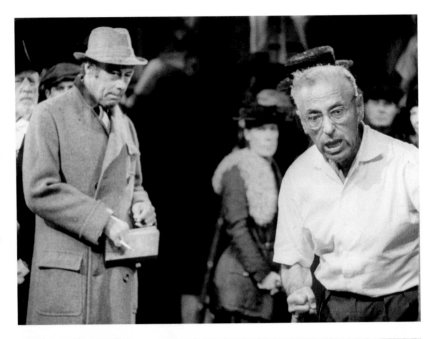

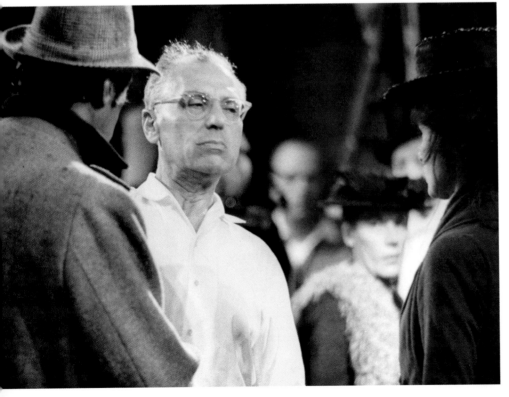

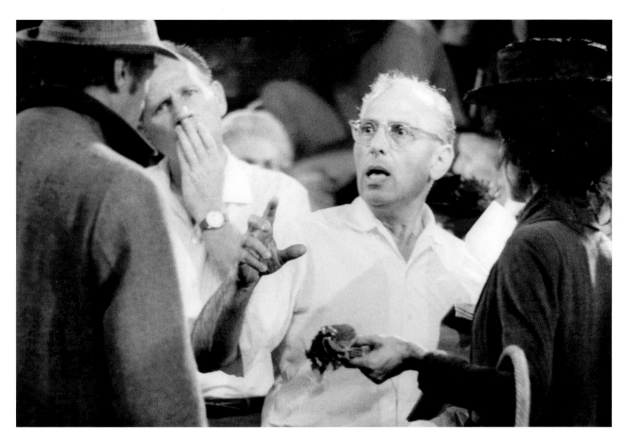

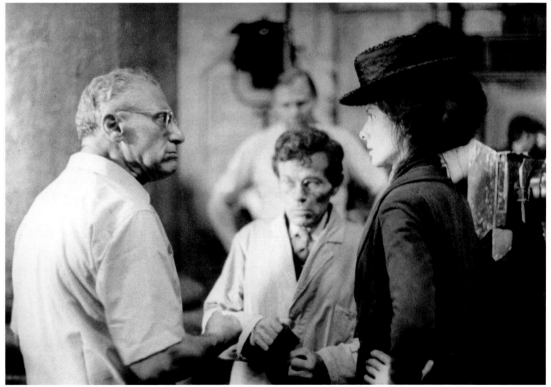

LEFT *Cukor listens to cinematographer Harry Stradling (who won an Academy Award for his photography) as he describes to Cukor where he feels the camera should go (left to right: Cukor, art director Gene Allen, assistant director Buck Hall, Stradling, and assistant to Allen, Ed Graves).*

My Fair Lady was shot in sequence in order to maintain the sense of the progression of Eliza (Hepburn) from dirty flower girl to lovely lady to win a bet for Professor Higgins (Harrison): the *Pygmalion* story set to music. The Warner Brothers Art Department's reproduction of London's Covent Garden was marvelous, and this is where filming began. The biggest problem (to me) was that it was almost impossible to disguise Audrey Hepburn's natural ladylike quality, which came through no matter how dirty they made her.

BELOW AND RIGHT *Cukor took a lot of time with Audrey. One never knew what he was telling her, but she took it all very seriously.*

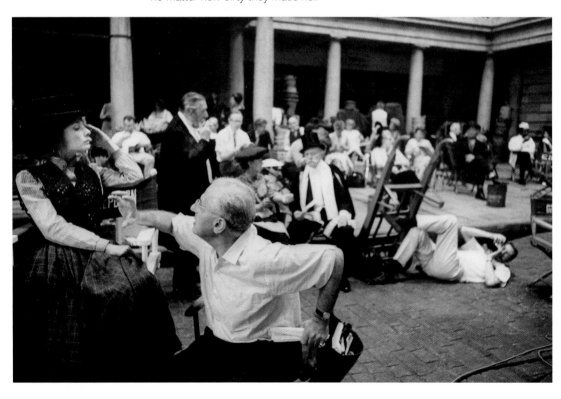

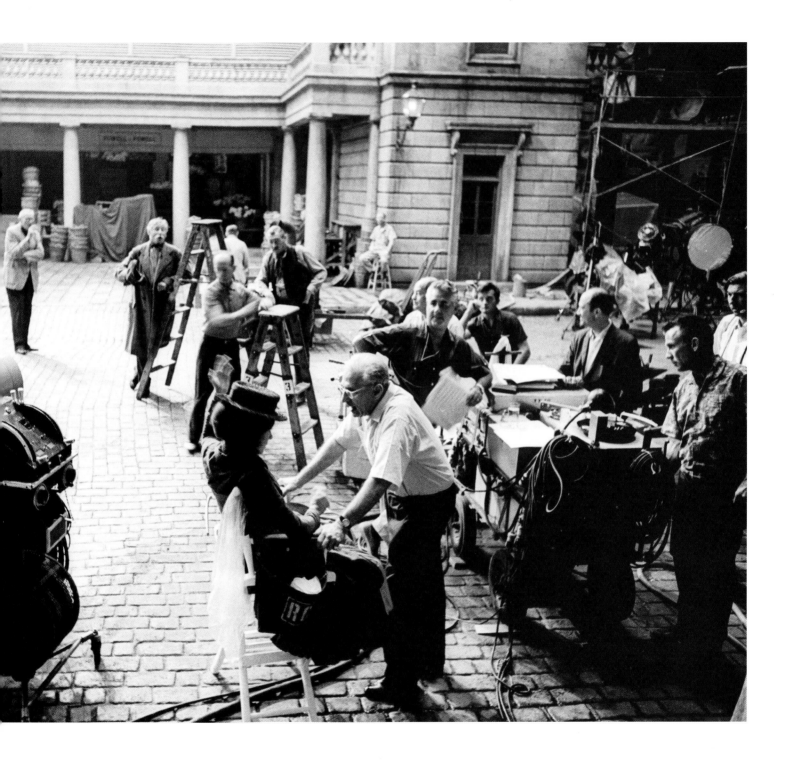

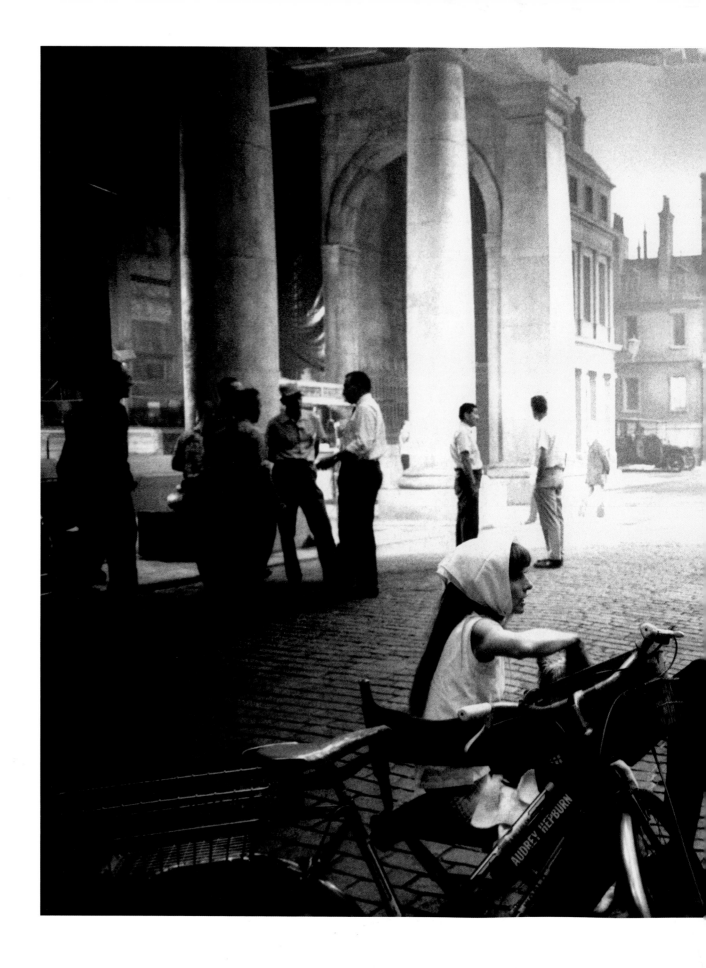

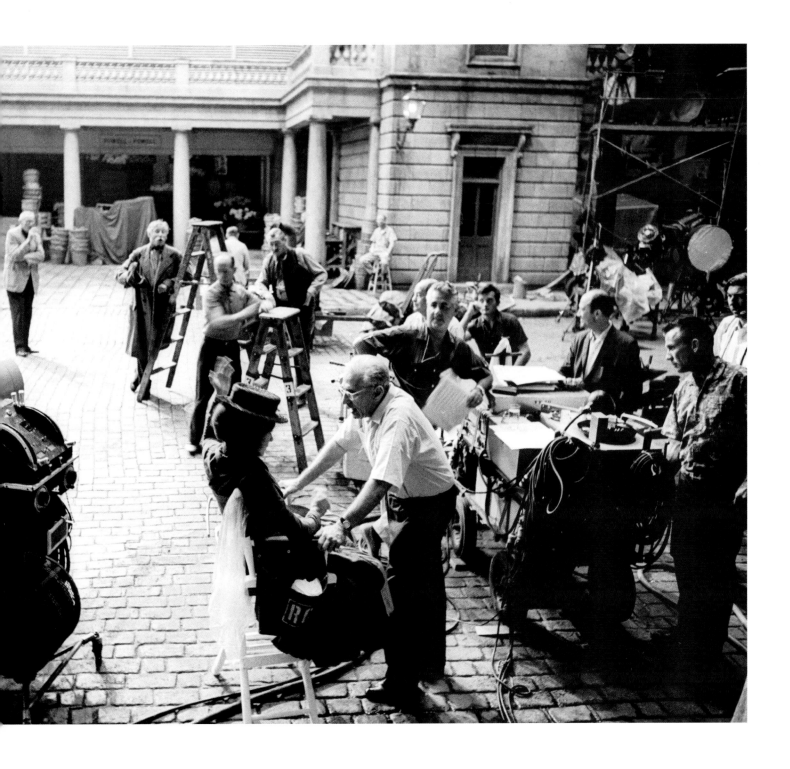

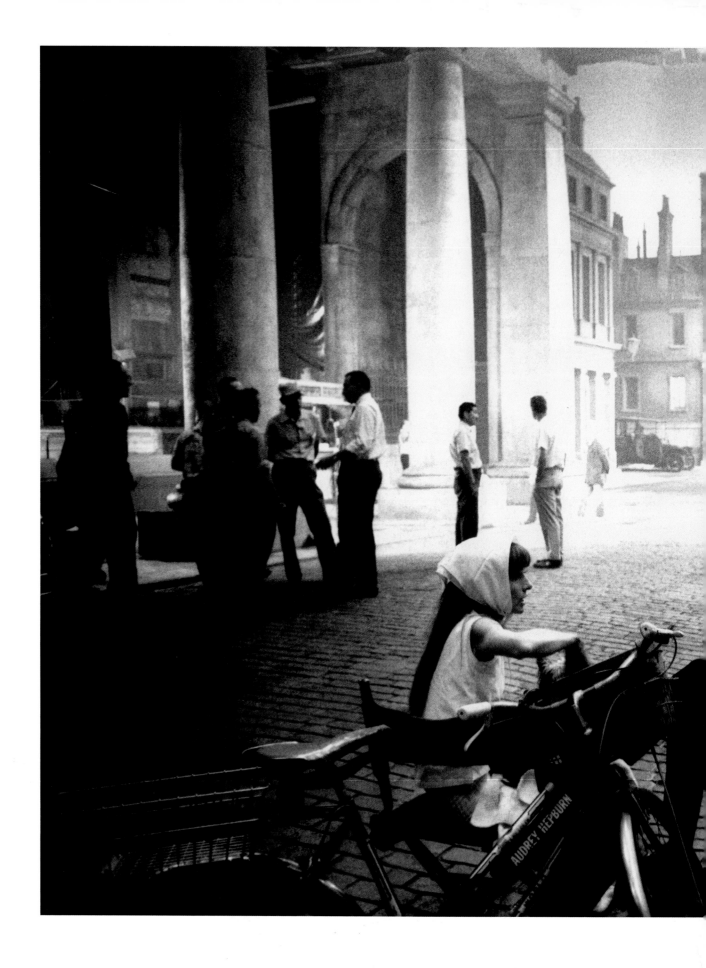

The first day of filming completed, I packed up my camera gear, and as I was heading out I noticed director George Cukor sitting alone on the Covent Garden set—I assume thinking about what had been filmed that day, and what was in store for the next. Just then Audrey Hepburn interrupted his musing, riding her bike over from makeup, where they had scrubbed the fuller's earth (dirt) out of her hair and from under her nails; she, too, apparently had second thoughts about Cukor's direction of her character, Eliza. I unpacked my camera and captured this quiet moment between the actress and her director.

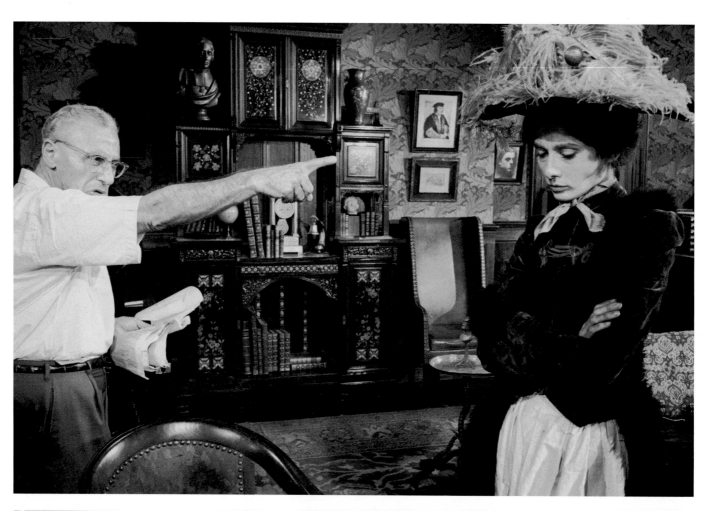

The days spent on this film were really an unusual photographic treat. The wonderful sets and costumes; the magical music by Lerner and Loewe; Rex Harrison, Stanley Holloway, Wilfrid Hyde-White, and, of course, Audrey Hepburn—it was all terrific. Another asset for still photographers was that the music numbers were all pre-recorded, so that meant we could photograph during the takes.

The assistant director, probably with orders from on high, shut down the lights when my comrade in arms, Mel Traxel, and I were trying to get photographs after a print. This was really the only down side. It frustrated me so much that it gave me the impetus to find an engineer who would make me a silent camera blimp for my Nikon so I could photograph while they were filming. Cukor continued with his operatic direction. Rex was a marvel to listen to with the patter songs he had become famous for. I guess he had played this part so long on Broadway, I'm sure he could do it in his sleep.

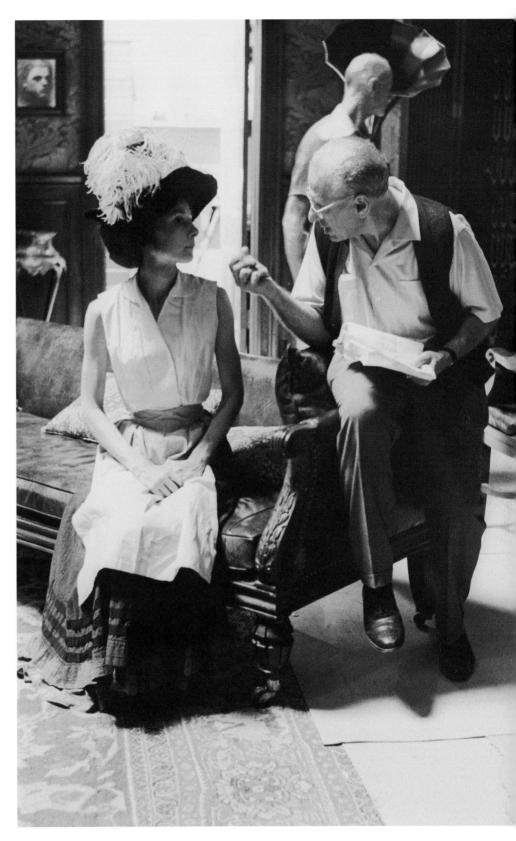

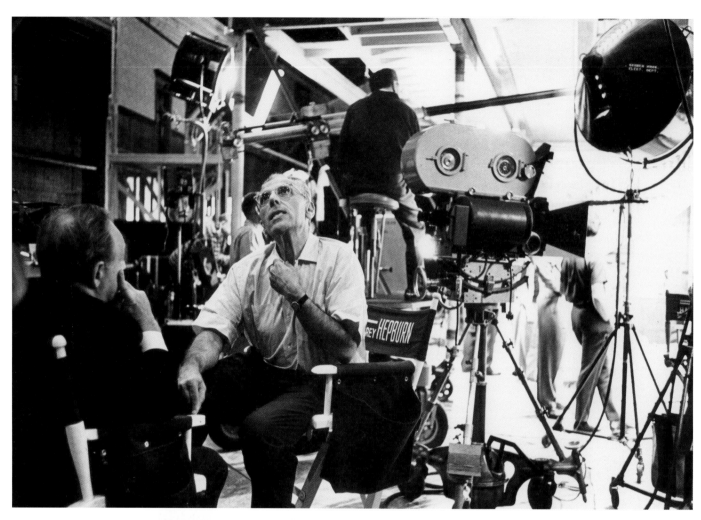

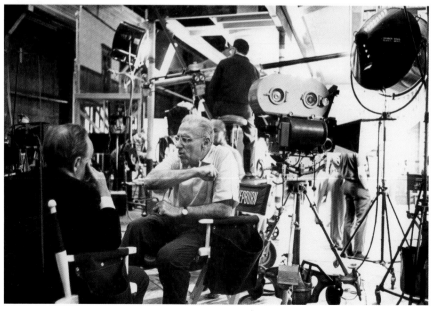

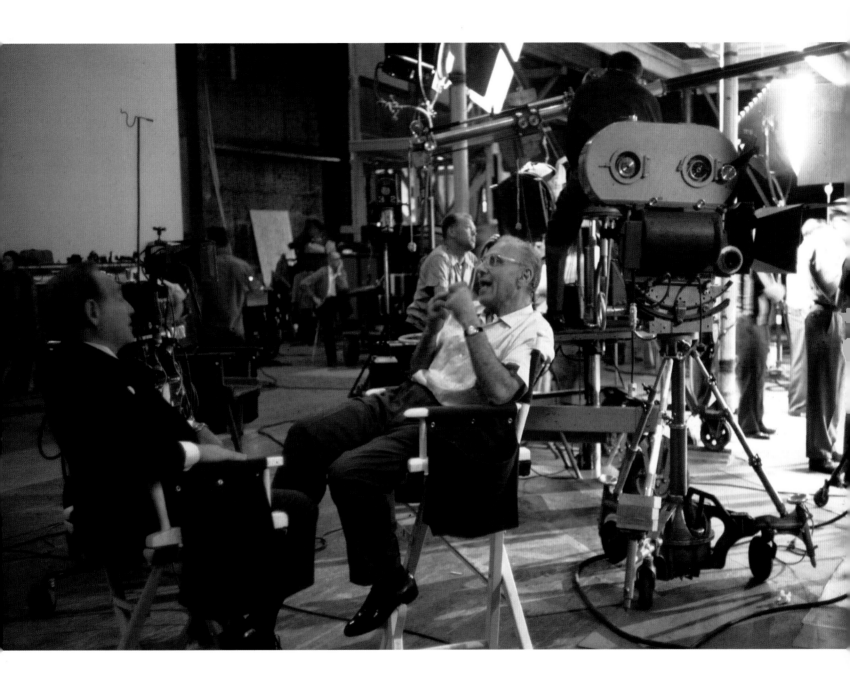

My Fair Lady was probably the most expensive film Warner Brothers had ever produced. They had a big investment with CBS, plus the very high (for the time) star salaries and huge production costs: it was a major financial gamble. The day that Jack Warner sent his right-hand man, Steve Trilling, down to the set to see if he could speed up the tempo, and consequently to put the pressure on the director, was telling. Whenever Trilling appeared on a set the crew knew this was trouble for the director and would look the other way.

Cukor had only one way of working, and it often didn't suit the front office. For some directors a visit from Trilling might be the trumpet of doom, but Cukor was up to the task, describing to him his vision of what was coming, acting out each part in a private performance (*see pictures on these pages*). It seemed to work, as there were smiles at the end, and the crisis for the moment seemed averted. This wasn't the only visit he was to receive, and the gnashing of teeth could be heard in the land.

George Cukor

RIGHT My Fair Lady *was a closed set. That sign is often posted, but this time they meant it, and kept one of the studio policeman always at the door to be certain it was maintained.*

BELOW *There seemed to be some major tiff between Cukor and Cecil Beaton. Not only was Beaton a famous photographer, but he also designed the fabulous costumes and the sets for the film. He won an Academy Award for the costumes, as well as for the art direction (shared with Gene Allen; left, bottom right) … and Cukor would not let him on the set without his specific OK. I don't know how he could keep Beaton off the set when he was so much part of the production. It was amazing.*

LEFT *As Cukor watches, Rex, Audrey, and Mona Washbourne rehearse the scene when Eliza comes to ask Professor Higgins if he could teach her to "talk propa."*

ABOVE *When he wanted—or perhaps I should say, when he needed—to liven up the actors, Cukor could be quite witty. Left to right: Mona Washbourne, Rex Harrison, Wilfrid Hyde-White, Audrey Hepburn, and Cukor.*

George Cukor

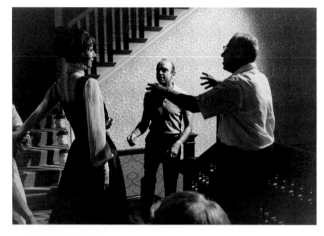

The choreographer Hermes Pan was a Hollywood mainstay, having worked closely with Fred Astaire on seventeen of his films, and on dozens of others. He was a perfect gentleman. It was always such a pleasure to work with him. Warner Brothers hired him to choreograph all the film's musical numbers.

ABOVE LEFT, LEFT, AND BELOW LEFT *Here you see Hermes Pan rehearsing with Audrey Hepburn in the "I Could Have Danced All Night" sequence. Cukor watched every move, and then sat down with Pan and discussed what he wanted.*

BELOW *The man from on high, Steve Trilling, once again pays Cukor a visit. He pulled him aside, away from the production, and while I don't know what was said, one could see that Cukor wasn't very happy when he returned to the set.*

RIGHT *Cukor became anxious about the actors being distracted, and built this series of baffles around the area that was being filmed. He would shout "I can see someone walking!" and another series of baffles would be put in place. The easy atmosphere that we started with on the film became a little more stressful. One of the crew told me that he had heard of these baffles being put around the set only once before: when Cukor was directing Garbo at MGM. Whether all of this change was due to the "message from above" or to Cukor's becoming tired with the long shooting schedule it is hard to know. He was only sixty-four at the time, but the pressure was showing.*

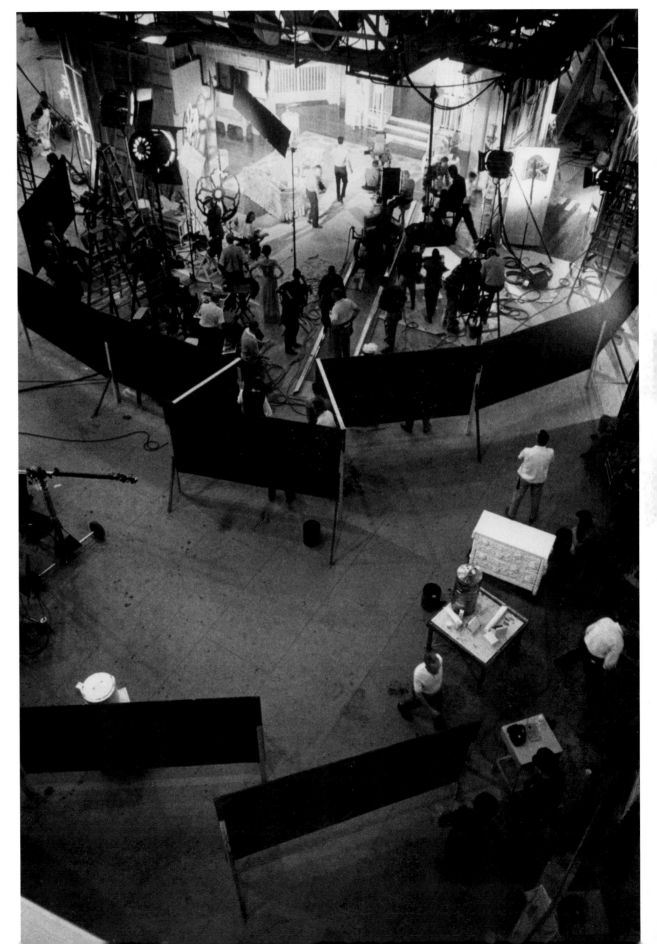

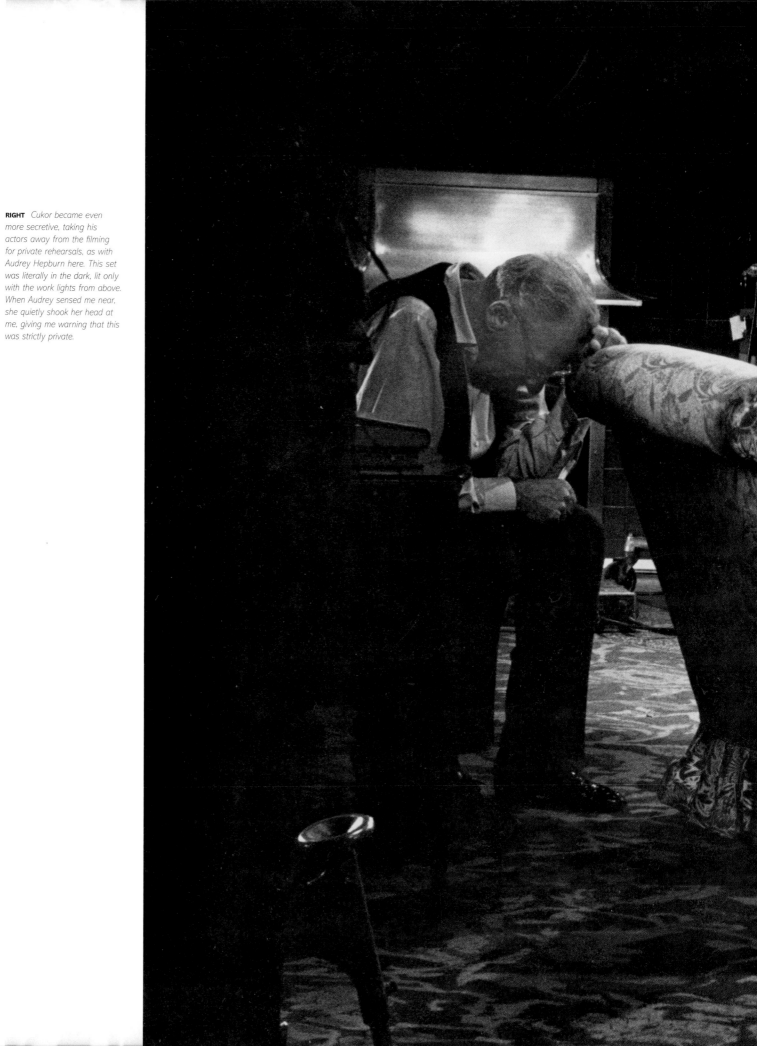

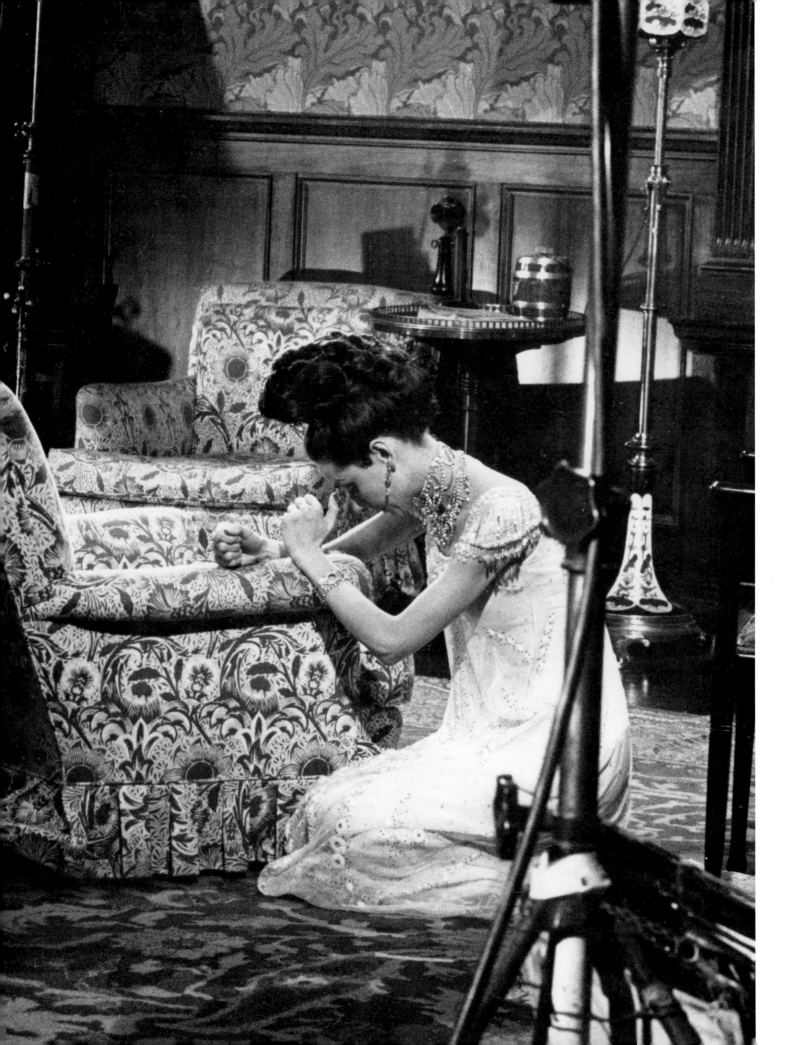

George Cukor

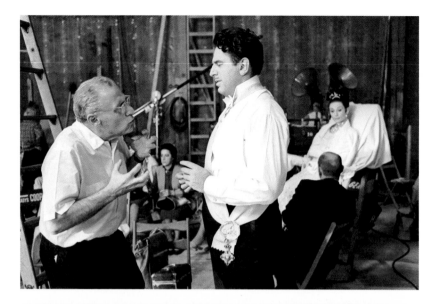

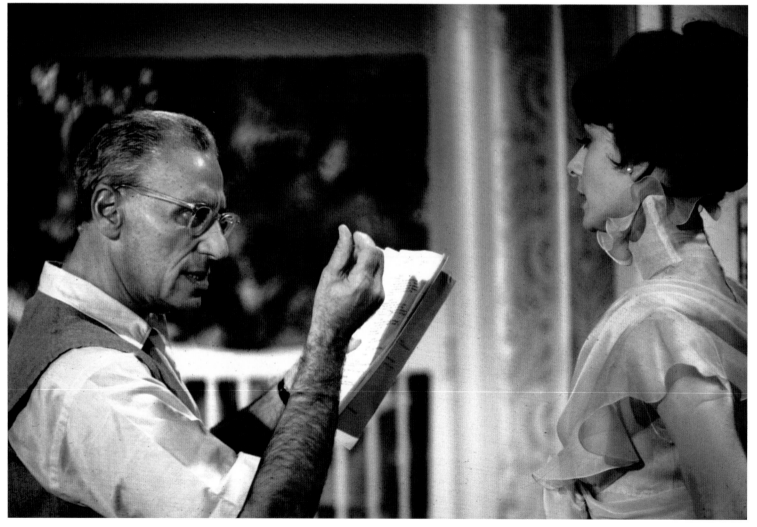

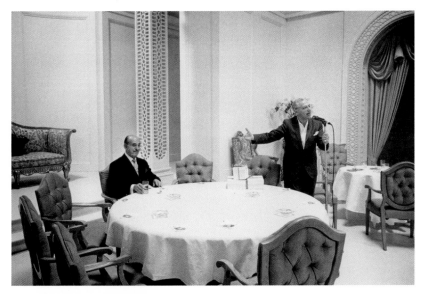

LEFT *Cukor is seen here introducing the production head, Jack Warner, to the cast and crew at the end-of-film party, thanking him for his contribution —this must have galled Cukor no end.*

ABOVE *He is seen fussing at the party while Warner kisses his star, Audrey Hepburn (her husband Mel Ferrer just behind).*

BELOW *The Ferrers give Cukor a warm farewell and thank you.*

Some months later, when the film was in its final cut, George Cukor came alone to watch the music score being recorded for the film by André Previn. There for the first time he could see his vision combined with the sumptuous score, for which André won an Academy Award. It was exciting for me, but for Cukor, sitting alone with only Previn and the orchestra in the big recording stage, it must have been one of the most rewarding moments in his long career.

Billy Wilder

Samuel Wilder; born Sucha, Austria-Hungary (now Poland), June 22, 1906; died Beverly Hills, California, March 27, 2002

While I regret never having worked with Billy Wilder, I could not leave him out of this collection, for his films have given me, and so many, such pleasure. Admittedly some of his films, such as *The Apartment*, have a very acid tinge to them; but when one thinks of, for example, *Some Like It Hot* and *Sunset Boulevard*, one can only be grateful for his great talent. This photograph was made in Wilder's office at Goldwyn Studios in 1964.

FILMS

Mauvaise graine/Bad Blood (co-directed with Alexander Esway, and story; 1934)
The Major and the Minor (1942)
Five Graves to Cairo (1943)
Double Indemnity (1944)
The Lost Weekend (1945)
The Emperor Waltz (1948)
A Foreign Affair (1948)
Sunset Boulevard (1950)
(as producer, director, and screenwriter)
Ace in the Hole/The Big Carnival (1951)
Stalag 17 (1953)
Sabrina (1954)
The Seven Year Itch (1955)
The Spirit of St. Louis (directed and co-scripted only; 1957)
Love in the Afternoon (1957)
Witness for the Prosecution (directed and co-scripted only; 1958)
Some Like It Hot (1959)
The Apartment (1960)
One, Two, Three (1961)
Irma la Douce (1963)
Kiss Me Stupid (1964)
The Fortune Cookie (1966)
The Private Life of Sherlock Holmes (1970)
Avanti! (1972)
The Front Page (directed and co-scripted only; 1974)
Fedora (1978)
Buddy Buddy (1981)

Alfred Hitchcock

born London, England, August 13, 1899; died Los Angeles, California, April 29, 1980

FILMS

(as director)
(in UK)
Number Thirteen *(unfinished; 1922)*
Always Tell Your Wife *(in collaboration with Seymour Hicks; 1922)*
The Pleasure Garden *(1925)*
The Mountain Eagle/Fear O'God *(1926)*
The Lodger/The Case of Jonathan Drew *(also co-scripted; 1926)*
Downhill/When Boys Leave Home *(1927)*
Easy Virtue *(1927)*
The Ring *(1927)*
The Farmer's Wife *(also co-scripted; 1928)*
Champagne *(1928)*
Harmony Heaven *(co-directed with Eddie Pola and Edward Brandt; 1929)*
The Manxman *(1929)*
Blackmail *(also co-scripted; 1929)*
Elstree Calling *(co-directed with Andre Charlot, Jack Hulbert, and Paul Murray, under the supervision of Adrian Brunel; 1930)*
Juno and the Paycock *(also co-scripted; 1930)*
Murder *(also co-adapted script; 1930)*
The Skin Game *(also co-scripted; 1931)*
Rich and Strange/East of Shanghai *(also adapted; 1932)*
Number Seventeen *(also co-scripted; 1932)*
Waltzes From Vienna/Strauss's Great Waltz *(1933)*
The Man Who Knew Too Much *(1934)*
The 39 Steps *(1935)*
The Secret Agent *(1936)*
Sabotage/The Woman Alone *(1937)*
Young and Innocent/The Girl Was Young *(1937)*
The Lady Vanishes *(1938)*
Jamaica Inn *(1939)*
(in US)
Rebecca *(1940)*

Foreign Correspondent *(1940)*
Mr. & Mrs. Smith *(1941)*
Suspicion *(1941)*
Saboteur *(also story; 1942)*
Shadow of a Doubt *(1943)*
Lifeboat *(1944)*
Bon Voyage *(4-reel documentary for British M.O.I.; 1944)*
Adventure Malagache *(documentary for British M.O.I.; never released; 1944)*
Spellbound *(1945)*
Notorious *(also produced and story; 1946)*
The Paradine Case *(1948)*
Rope *(also co-produced; 1948)*
Under Capricorn *(also co-produced; UK; 1949)*
Stage Fright *(also produced; 1950)*
Strangers on a Train *(also produced; 1951)*
I Confess *(also produced; 1953)*
Dial M for Murder *(also produced; 1954)*
Rear Window *(also produced; 1954)*
To Catch a Thief *(also produced; 1955)*
The Trouble With Harry *(also produced; 1955)*
The Man Who Knew Too Much *(also produced; remake of 1934 film; 1956)*
The Wrong Man *(also produced; 1957)*
Vertigo *(also produced; 1958)*
North By Northwest *(also produced; 1959)*
Psycho *(also produced; 1960)*
The Birds *(also produced; 1963)*
Marnie *(also produced; 1964)*
Torn Curtain *(also produced; 1966)*
Topaz *(also produced; 1969)*
Frenzy *(also produced; UK; 1972)*
Family Plot *(also produced; 1976)*

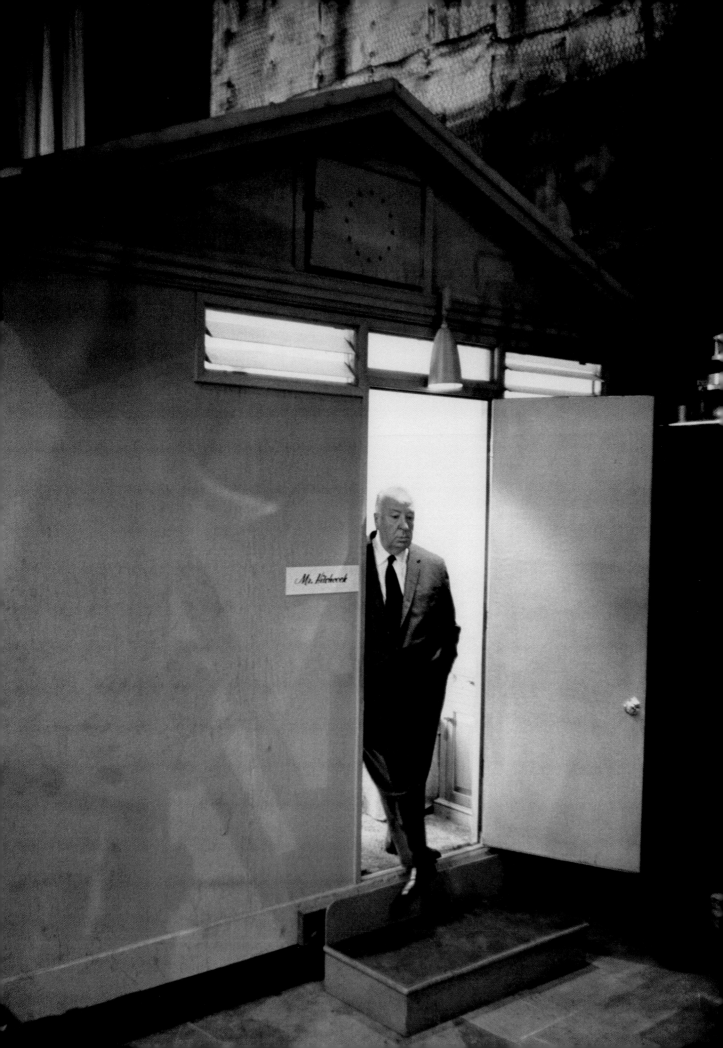

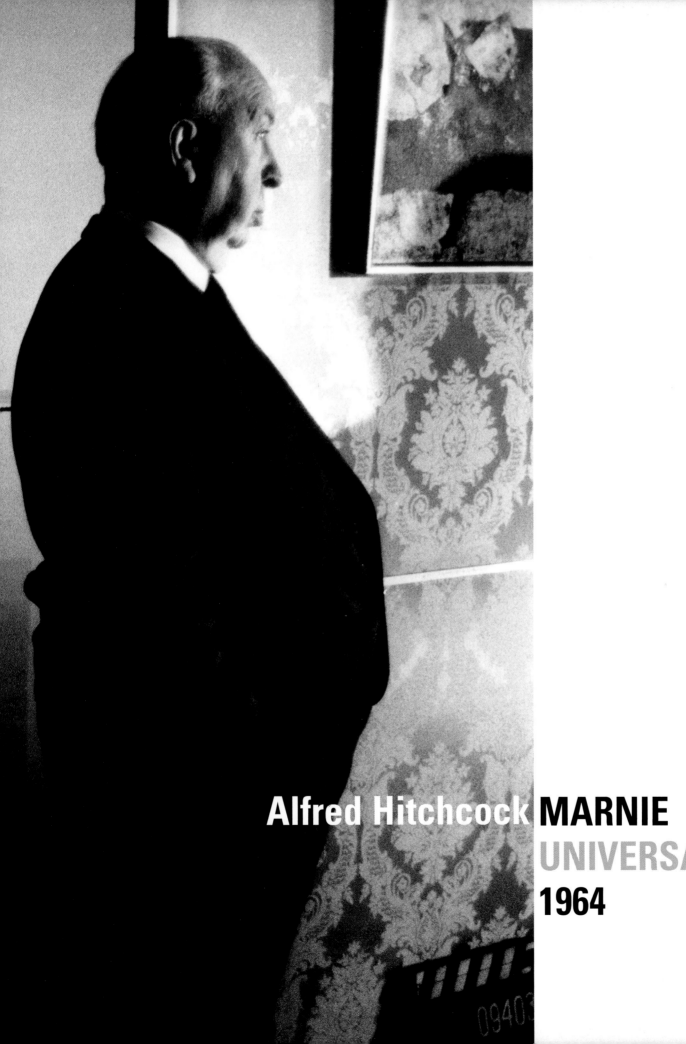

Alfred Hitchcock MARNIE

UNIVERSAL

1964

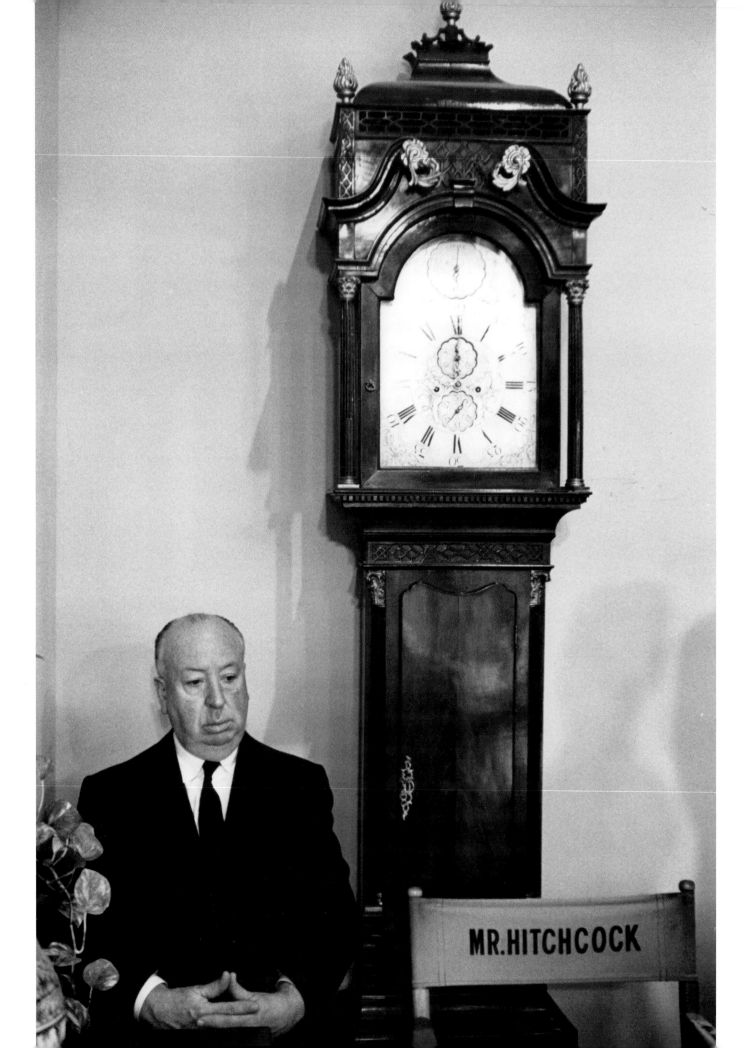

MR.HITCHCOCK

Universal Studios called me in to work on *Marnie* after it had already started filming. I didn't have a chance to read the script, which is not the way I liked to work. The publicity department had given me a little printed synopsis, but in fact I was lost when I arrived and had no idea of where they were in the story. As it happened, there was a break on the set, and I introduced myself to Mr. Hitchcock, explained what I was doing there, and apologized that I had to bother him but I really didn't know enough of the story to function well.

He was really gracious, sitting me down in a handy director's chair, and not only did he tell me what was being filmed then, but he went through the whole film, almost cut for cut. I was amazed that he could have the storyline so detailed. He told me he saw the entire film in his mind, so that filming it was "rather an anticlimax."

What a wonderful treat to have the master storyteller give me a private performance. *Marnie* was a complex psychological film, with many flashbacks, and I was very happy to have it explained so clearly.

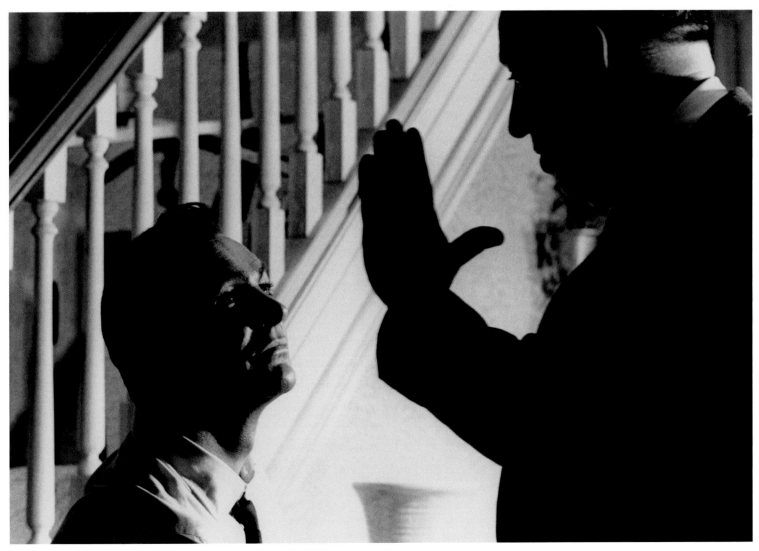

Alfred Hitchcock

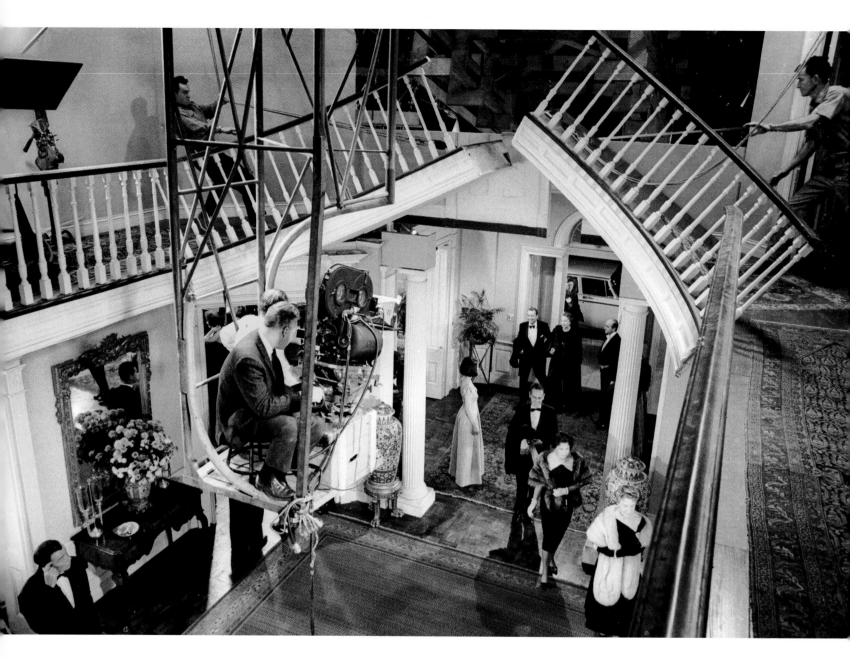

When I was attending the film department at the University of Southern California (USC), the great production designer William Cameron Menzie taught some classes. He told us how Hitchcock often used oversize objects (such as a telephone) in the foreground of the camera, to increase the feeling of depth. *Marnie* was no exception in the way he used special techniques to capture on film the image that was so clear in his mind.

ABOVE *Here you see that they have built a special track in the ceiling to support the camera as it zooms down to the front door. Fold-back balustrades pull up as the camera descends.*

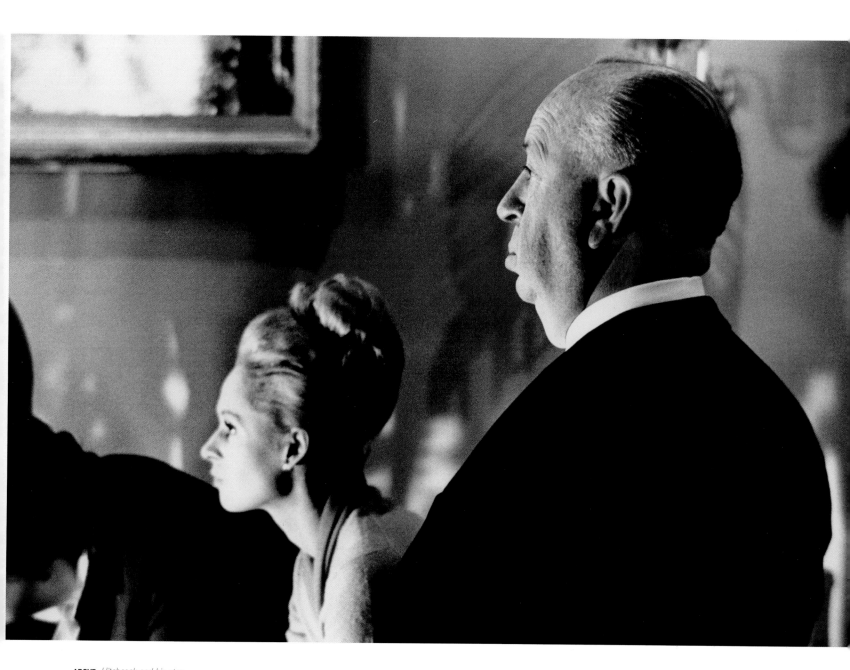

ABOVE *Hitchcock and his star Tippi Hedren watch the camera rehearsal (facing page) from the balcony above.*

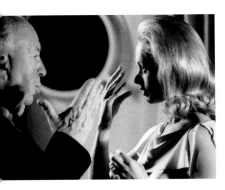

THESE PAGES *Watching Hitchcock directing Tippi Hedren, I could swear he was trying to hypnotize her with his hands.*

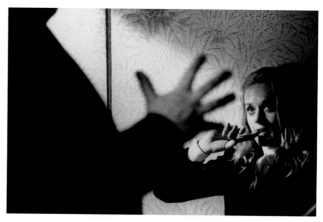

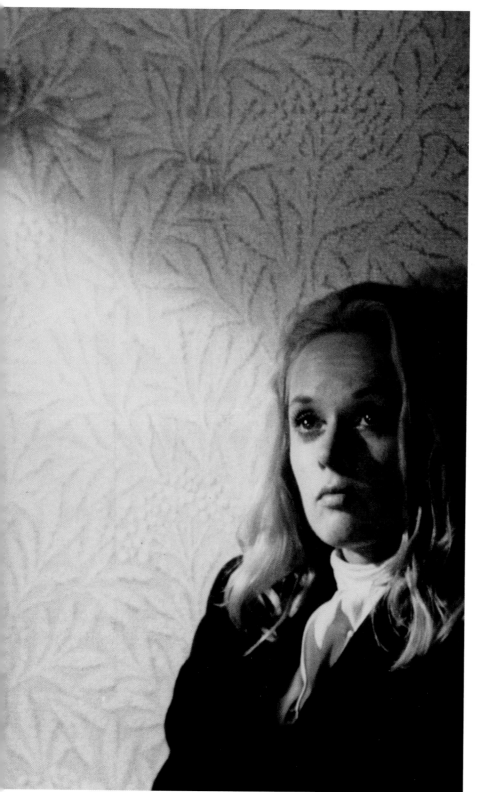

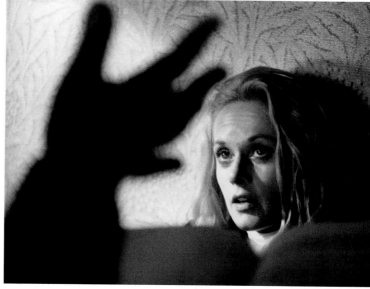

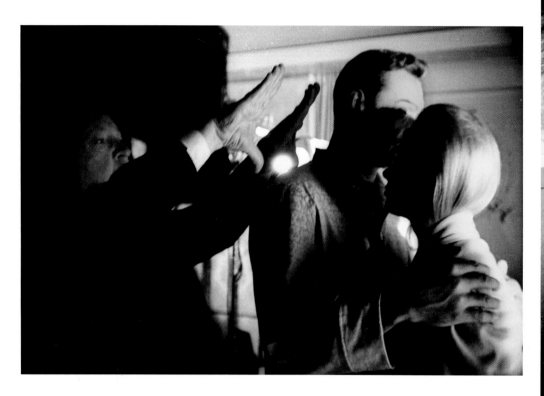

ABOVE *Hitchcock indicates where he wants the camera placed for this shot, as Connery and Hedren rehearse for him. He seemed to have such clear images in his head of each scene, something that I'd rarely encountered before.*

Hitchcock employed another ingenious device when he wished to show Sean Connery and Tippi Hedren kissing and then lying down on the bed in one movement. Hitchcock shows the kiss and then, as the camera moves in, Sean slips out and Tippi is lowered slowly on to the bed with the use of a heavy strap, held on each side of the camera by two crew members.

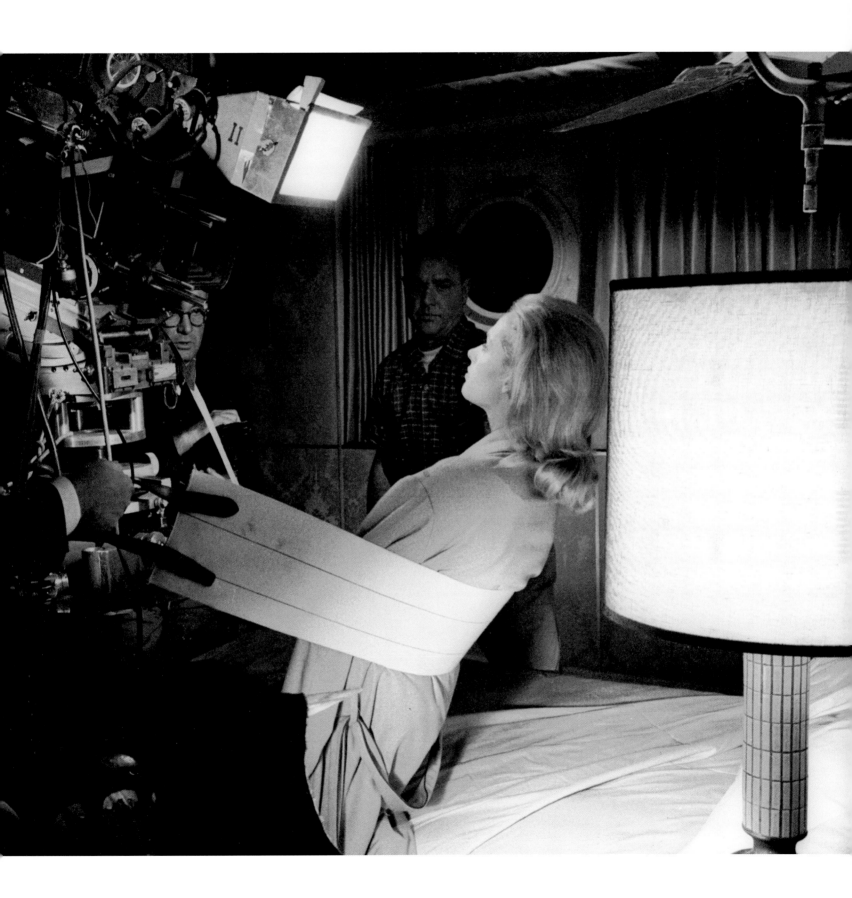

Hitchcock would often take the part of both actors to demonstrate what he wanted. He's seen here wrestling with both Sean Connery and Tippi Hedren, then (*far right*) holding his hands up to show the cinematographer exactly where he wished the camera to go.

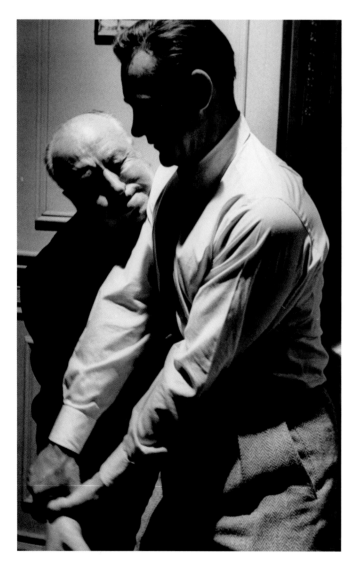

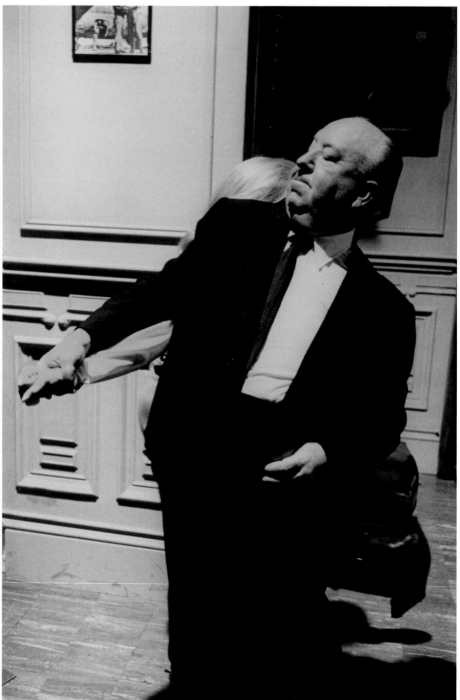

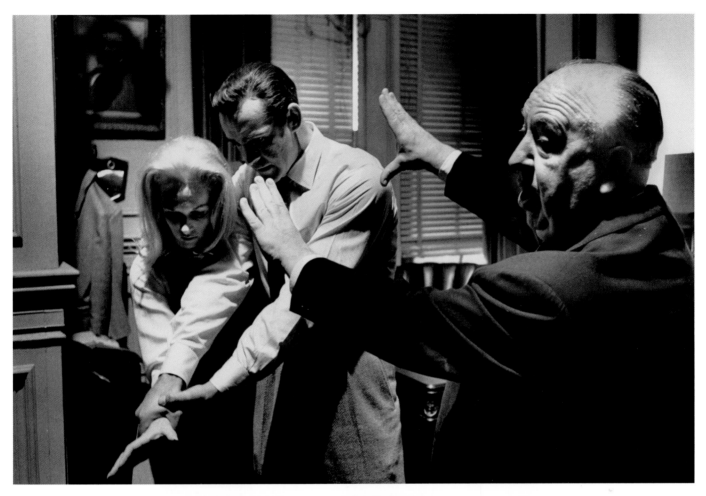

LEFT *While Hitchcock was known for his penchant for using attractive blondes in his films, he wasn't above flirting with attractive brunettes. He is seen here with one of his young stars, Diane Baker.*

BELOW, BOTTOM, AND RIGHT
Sean Connery waylays Hitchcock to tell him about his ideas for a coming scene. I think Hitchcock's expression says it all.

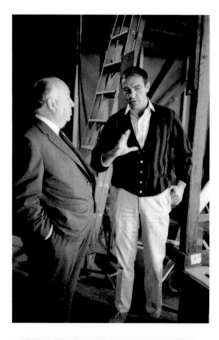

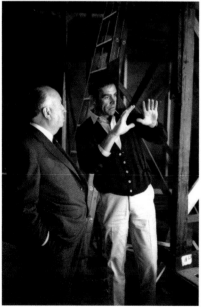

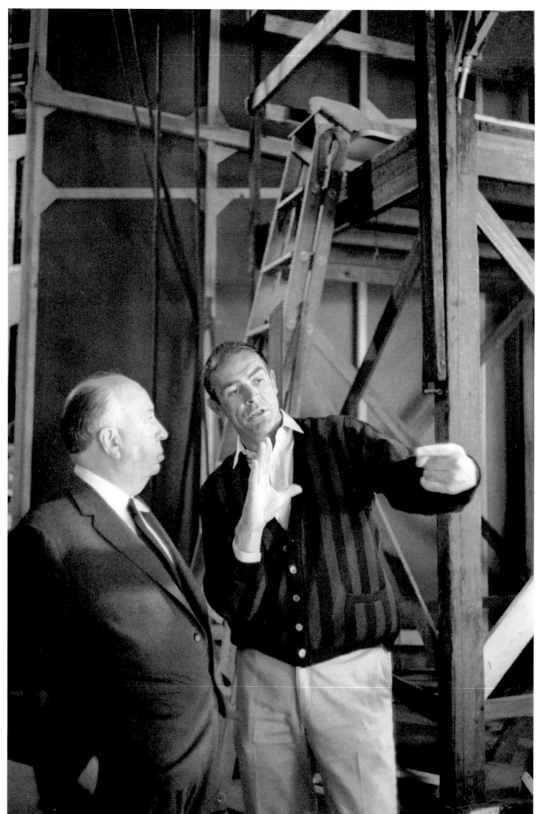

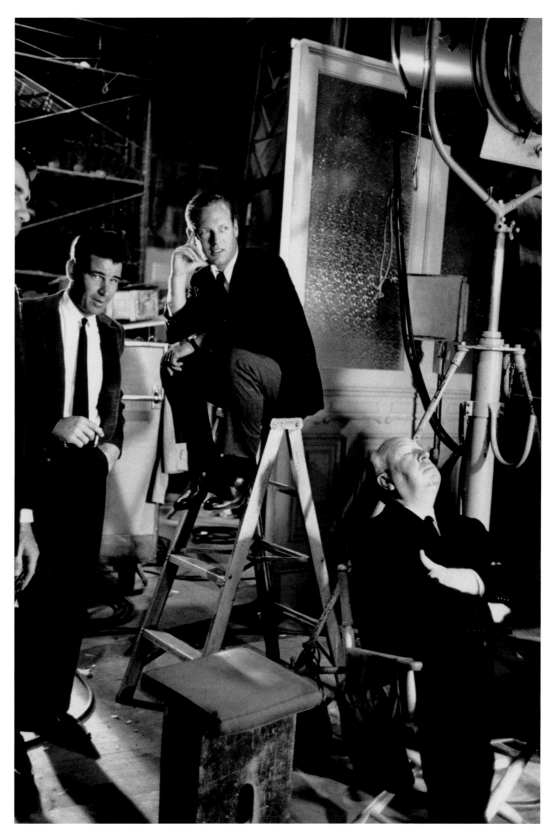

ABOVE AND RIGHT *As Hitchcock had said, filming was an anticlimax; and something that he really disliked doing was all the entrances and exits (these used to be needed to let the audience know where the characters were, but now they are rarely used). He would save them all up to shoot on the last day. Above, you see how bored he is, and finally he just fell fast asleep. Eventually he told the assistant director to tell him when they got a print, and returned to his dressing room. His mental picture of the film was obviously complete; these few "walking through door" shots were just minor details.*

Jack Smight

born Minneapolis, Minnesota, March 9, 1926

Jack Smight was a great laugh and fun to work with. He had a light touch with the cast and crew, which made the day fly by. He started directing in television, and *I'd Rather be Rich* (Universal, 1964), pictured on this pages, was his first film.

BELOW *Director Smight hopped into bed with the marvelous sex symbol Hermione Gingold for the photograph.*

FILMS

I'd Rather be Rich *(1964)*
The Third Day *(also produced; 1965)*
Harper *(1966)*
Kaleidoscope *(1966)*
The Secret War of Harry Frigg *(1968)*
No Way to Treat a Lady *(1968)*
Strategy of Terror *(originally made for TV; 1969)*
The Illustrated Man *(1969)*
The Traveling Executioner *(also produced; 1970)*
Rabbit, Run *(1970)*
Airport 1975 *(1974)*
Midway *(1975)*
Damnation Alley/Survival Run *(1977)*
Fast Break *(1979)*
Loving Couples *(1980)*
Number One with a Bullet *(1987)*
The Favorite/Intimate Power *(1989)*

ABOVE *As Maurice Chevalier rehearses, Jack Smight emotes right along with him.*

LEFT *A very contrite director is reprimanded by Maurice Chevalier, while Robert Goulet watches the encounter (far left).*

RIGHT *Sylva Kocina and Paul Newman have a laugh with their director Jack Smight on the film* The Secret War of Harry Frigg, *Universal, 1968.*

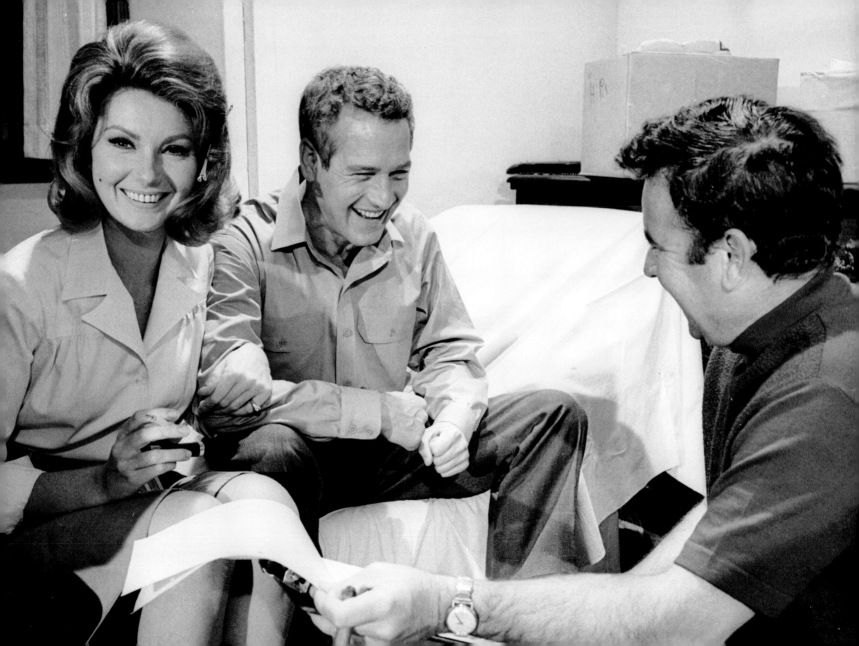

Blake Edwards

William Blake McEdwards; born Tulsa, Oklahoma, July 26, 1922

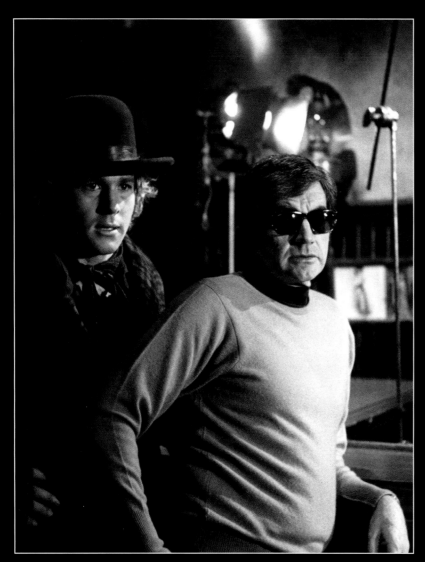

ABOVE *Ryan O'Neil and Blake Edwards on the Warner Brothers set of* Wild Rovers, *1971.*

RIGHT *Edwards with William Holden on the Utah location of* Wild Rovers.*.*

FILMS

Bring Your Smile Along *(1955)*
He Laughed Last *(1956)*
Mister Cory *(1957)*
Peter Gunn *(TV series; 1958)*
The Perfect Furlough *(1958)*
This Happy Feeling *(1958)*
Mr. Lucky *(TV series; 1959)*
Operation Petticoat *(1959)*
High Time *(1960)*
The Dick Powell Show *(TV series; 1961)*
Breakfast at Tiffany's *(1961)*
Experiment in Terror/Grip of Fear *(1962)*
Days of Wine and Roses *(1962)*
The Boston Terrier *(episode in* The Dick Powell Theatre; *1962)*
The Pink Panther *(1963)*
A Shot in the Dark *(1964)*
The Great Race *(1965)*
What Did You Do in the War, Daddy? *(1966)*
Gunn *(1967)*
The Party *(1968)*
Darling Lili *(1970)*
Wild Rovers *(1971)*
The Carey Treatment/Emergency Ward *(1972)*
The Tamarind Seed *(1974)*
The Return of the Pink Panther *(1974)*
The Pink Panther Strikes Again *(1976)*
Revenge of the Pink Panther *(1978)*
10 *(1979)*
S.O.B. *(1981)*
Victor/Victoria *(1982)*
Trail of the Pink Panther *(1982)*
Curse of the Pink Panther *(1983)*
The Man Who Loved Women *(1983)*
Micki + Maude *(1984)*
That's Life! *(1986)*
Blind Date *(1987)*
Justin Case *(TV; 1988)*
Sunset *(1988)*
Peter Gunn *(TV; 1989)*
Skin Deep *(1989)*
Switch *(1991)*
Julie *(TV series; 1992)*
Son of the Pink Panther *(1993)*
The Pink Panther *(TV series; concepts; uncredited; 1993)*
Victor/Victoria *(TV; 1995)*
(most of the above Edwards co-produced and often co-wrote)

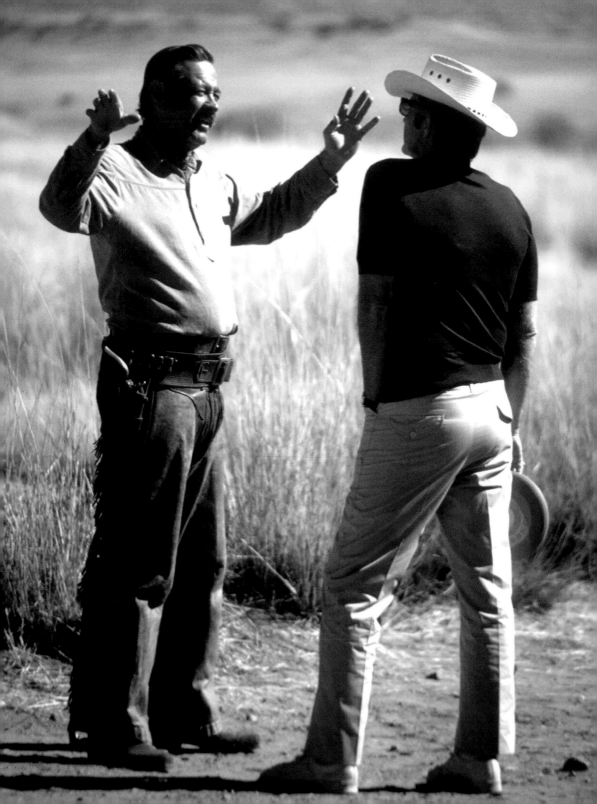

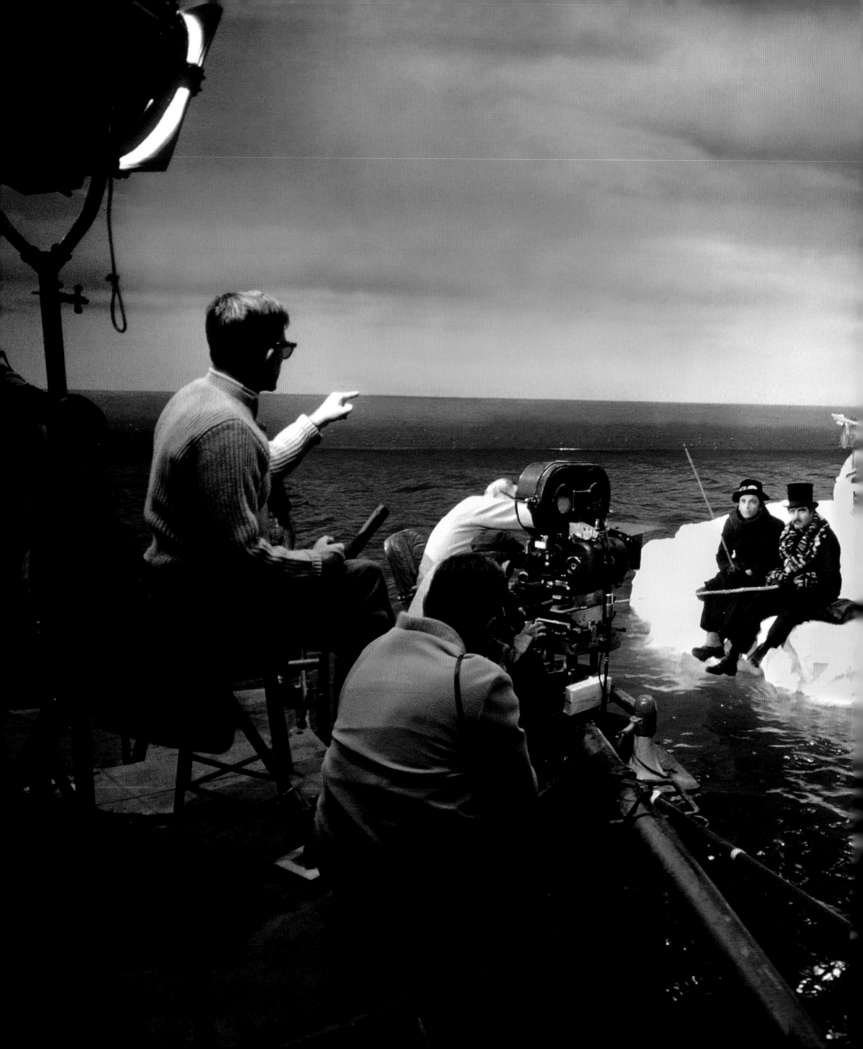

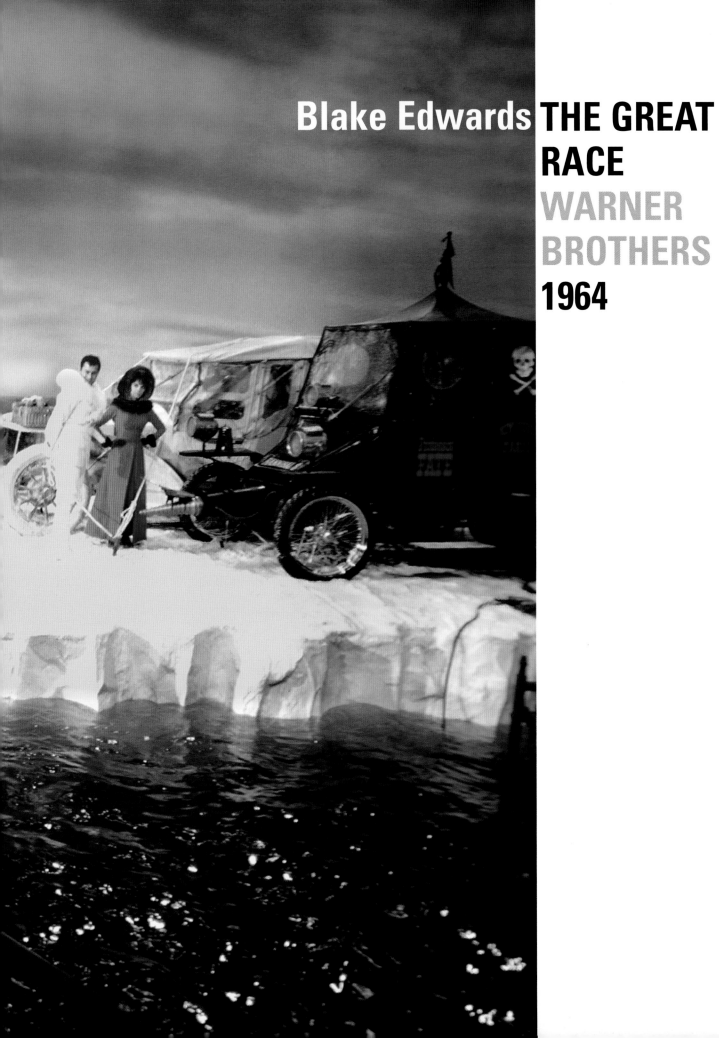

Blake Edwards THE GREAT
RACE
WARNER
BROTHERS
1964

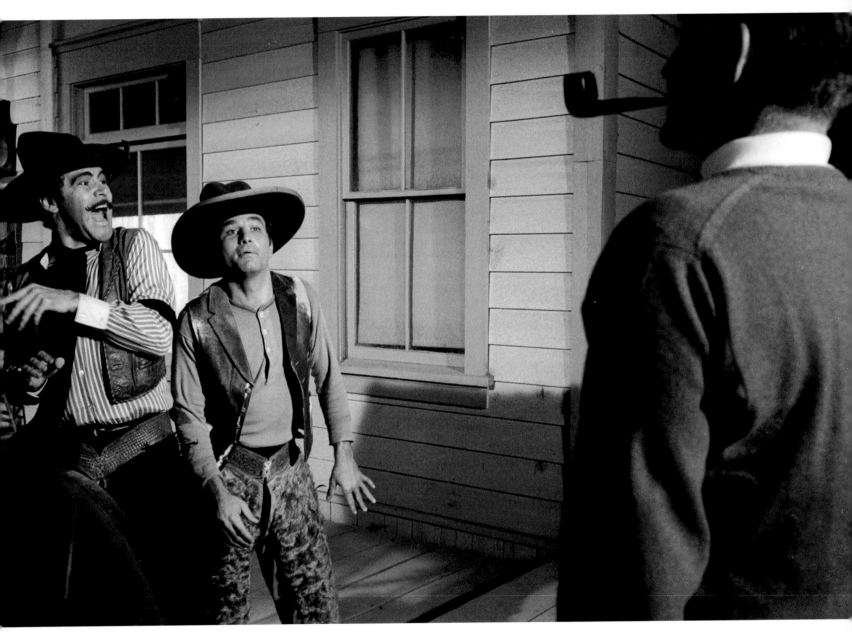

THESE PAGES *The film had a marvelous cast. Here you see Jack Lemmon (with mustache, playing the villainous Professor Fate) and Peter Falk (playing* *Fate's sidekick, Max) rehearsing with Blake just before the big bar-room brawl at the Silver Palace Saloon.*

In his time Blake Edwards was probably the best comedy director in Hollywood (think of all of those marvelous *Pink Panther* films), and he brought *The Great Race* to Warner Brothers to be the biggest "laugh-in" of all time. The basic idea was that of an automobile race from New York to Paris—the hard way. However, I think that Blake, without telling Warners, had the idea that this film should be a tribute to the classic early movies.

It had to be big—the biggest fight scene, the biggest pie fight. There were blizzards; there were scenes on an iceberg; there were scenes in palaces, deserts, rockets,

airplanes, submarines. Anything he could imagine, he wanted to pack in. There was dueling, and derring-do, and a seven-month shooting schedule!

The film went way, way over budget, and I think producer Martin Jurow just finally gave up trying to curb Blake's enthusiasms. Jack Warner, I've been told, was beside himself with the cost overruns. The gossip columnist Louella Parsons reported that Warner (who wanted filming to begin earlier to try to gain time) locked Blake off his own set when he arrived an hour late. (I never personally saw this, however, and I was there almost every day.)

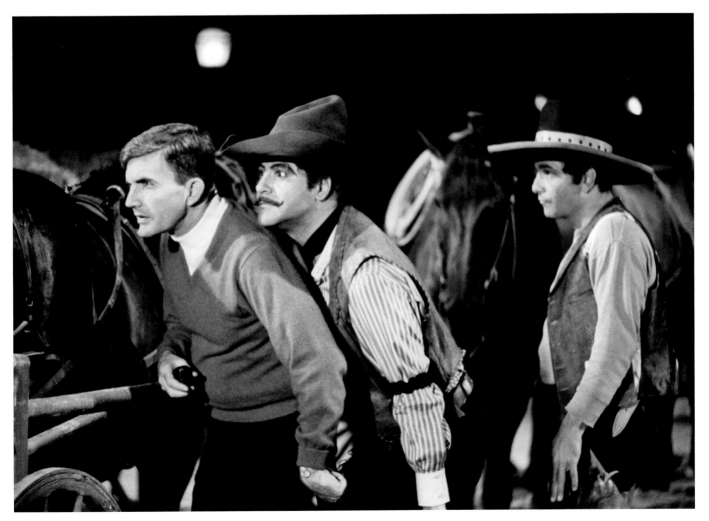

Blake Edwards

BELOW *Producer Martin Jurow has brought word from above that, although the film has only just started, they are already behind schedule.*

Tony Curtis played the Great Leslie III (always dressed in white, *above right*), with his sidekick mechanic Hezikiah played by Keenan Wynn. The evil Professor Fate (played with great panache by Lemmon, and always dressed in black) hates this perfect hero and, with his partner in crime and evil plots, Max (Falk), invents one mad device after another to sabotage everything that Leslie does, invariably without success.

When the race begins they quickly eliminate all of the other competitors except for the Great Leslie and, by some whim, Natalie Wood, who plays an intrepid, liberated reporter with carrier pigeons in her baggage.

At one point they arrive in a little desert town called Boracho, and the mayor insists that the Great Leslie be feted. All goes well until Dorothy Provine's character, Lilly, takes a fancy to him. She sings a marvelously funny song (with lyrics by Johnny Mercer), "He Shouldn't-a, Hadn't-a, Oughtn't-a, Swang On Me!" Her boyfriend, Texas Jack, played by Larry Storch, sees Lilly and the Great Leslie together, and then all hell breaks loose.

The saloon fight was choreographed mayhem. Blake loved every minute of this.

LEFT *Blake was so eager to get into this brawl that he dressed himself as one of the cowboys and punched out his good friend and stunt coordinator Dick Crockett.*

202

By the end of the fight the entire set was destroyed, but the dancing girls carried on as if there was nothing unusual happening.

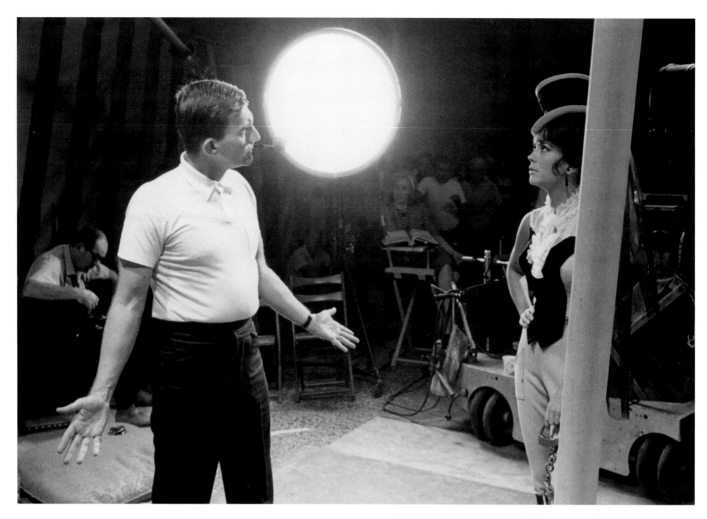

If Jack Warner had problems with this film, Blake had one of his own: Natalie Wood. She could be sweet one minute and a prima donna the next.

These unprofessional confrontations should never take place on the set. This is one of the reasons that the schedule for the film was longer and cost overruns higher than Warner Brothers expected.

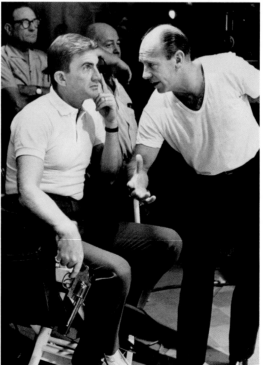

ABOVE *Blake pleads with Natalie to do the scene as it was written. Natalie pretends not to hear his entreaties.*

LEFT *Blake, holding a gun, is consoled by Dick Crockett, who I'm sure would have been happy to help Natalie out.*

RIGHT *Blake is left alone in her wake. While he smoulders, the crew try to look the other way (left to right: camera operator Jack Whitman, Blake, second assistant director Jack Cunningham, and dialogue director Ken Wales).*

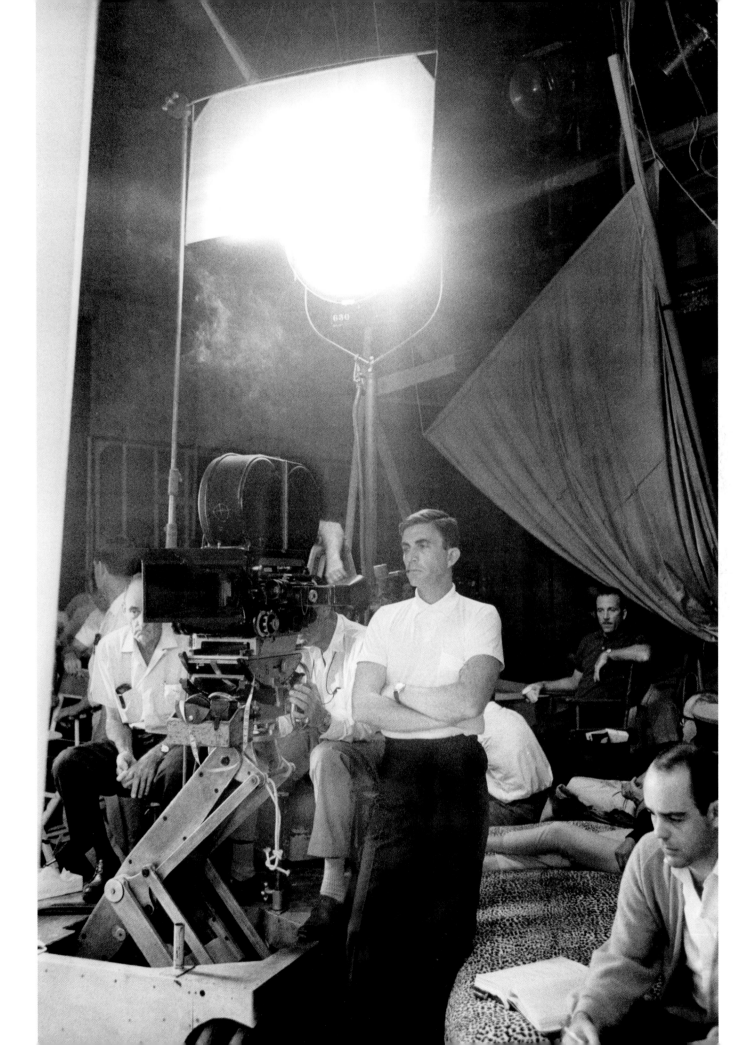

This film was like a great toy to Blake, and he was marvelous to watch as he took control of everything. He moved the film company to Vienna and into the interior of the wonderfully Baroque Karlskirch Cathedral.

BELOW LEFT *Blake luxuriates in his throne with (left to right) script supervisor Betty Abbott, Peter Falk, cinematographer Russ Harlan (kneeling), and producer Martin Jurow.*

BELOW *Jack Lemmon plays a double role as Professor Fate and Prince Hapnik.*

RIGHT *Fate, pretending to be Hapnik, is crowned. (If it gets confusing, just think of* The Prisoner of Zenda, *of which this episode is a spoof.)*

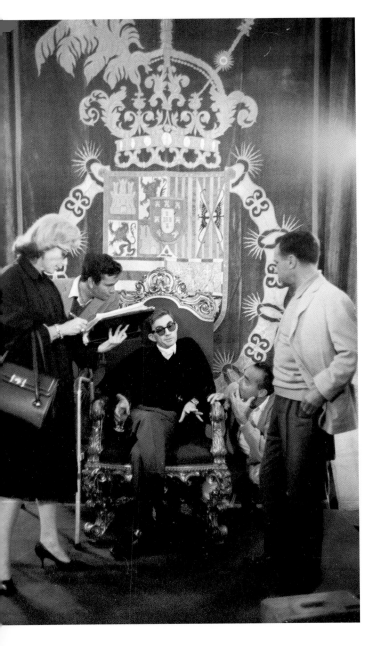

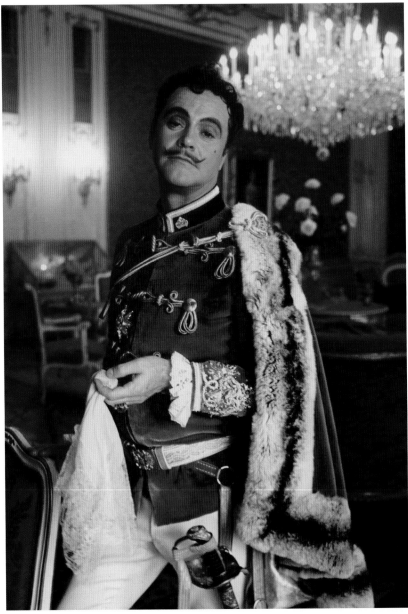

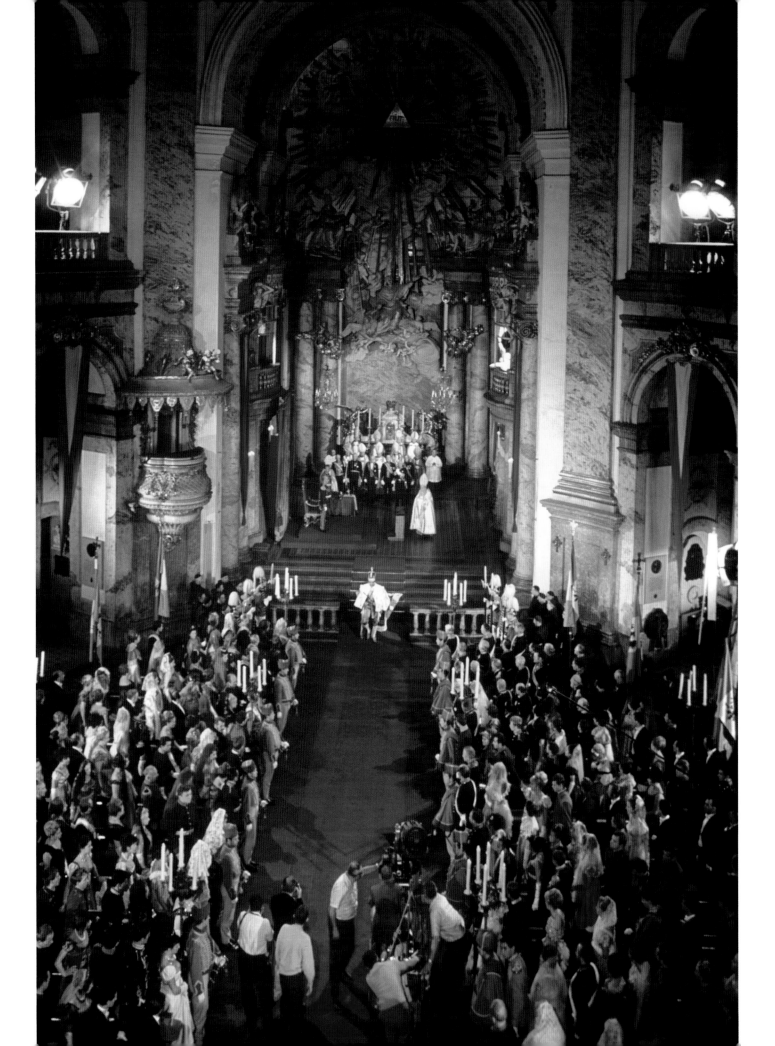

Blake Edwards

Blake Edwards had a great reputation for being a practical joker, and there was plenty of time on the set between shots for his imagination to flower. His whimsy was often directed toward Sherm Clark, one of the Warner Brothers still photographers. Sherm had been with Blake on a number of his films, and had the reputation of being "goosey"—meaning that if you touched his bottom he would jump. Blake thought this very funny and it made him laugh (*below*). After a while, I think Sherm made a point of reacting just because of this. No matter where Sherm was, Blake would find the most ingenious ways to reach him, and it became the daily routine.

On one film location, whenever lunch or dinner was served, when it came to Sherm's plate he would get this very large bone. Sherm may have thought it funny the first time, but day after day the bone would appear whenever he was served. He finally got so mad that he took it and threw it in a nearby lake, and hoped that would be the end of it.

Not so. Blake got a diver to retrieve it, and it ended up on Sherm's plate again that night for dinner.

THIS PAGE *Blake amuses himself by "goosing" Sherm Clark, blowing a claxon horn behind him (left), and reaching him with a fencing foil (above).*

208

LEFT *Mel Traxel, another Warner Brothers still man, is seen lying on the floor as Blake mock-threatens him with a fencing foil. (The still men had to have a good sense of humor when working on Blake's films.)*

ABOVE AND BELOW *Blake always had his toys with him. In Austria he had a customized golf cart; in Frankfort, Kentucky, a miniature scooter.*

European locations always have their production problems, which is normal: feeding and housing a large cast and crew, unpredictable weather, local restrictions, language. The list goes on and on.

The drama with Natalie continued. In Salzburg, Tony and his wife Christine, who had a new baby, asked for a hotel room with a fridge. When Natalie heard, she had to have a room with a fridge as well. In the rented trailers that served as location dressing rooms, it turned out that Tony's trailer had an awning. All hell broke out because Natalie's didn't. Tony thought all this was very funny and played on it, basically to annoy Natalie. Making this film was complicated enough, and Blake didn't need to hear these childish problems.

LEFT *Blake and Jack Lemmon try to resolve a technical problem.*

LEFT *In Paris at the finale, Natalie had some new complaint. Again Blake is seen trying to resolve it, with all of the extras waiting. Producer Martin Jurow stands like a brave soldier in this mini-crisis, his ulcer growing by the minute.*

RIGHT *Our pure, pristine hero, the Great Leslie, played by Tony Curtis, in the palace.*

On the return to Warner Brothers from the European and US locations, the filming of the big pie fight began. This of course had to be the biggest pie fight in history, and I think one of Blake's greatest pleasures was hitting Natalie in the face with a cream pie.

This sequence went on for days, and then we shut down for the weekend, returning the following Monday. By then the cream pies had gone off, and they were encrusted on everything and smelled sickly sweet.

THESE PAGES *My radio-controlled cameras were first used on this film. As I shot Blake throwing the pie, my camera mounted on the motion-picture camera took the shot of Natalie in closeup. Jack Lemmon (far left), already covered in pie, also savors the moment. ("How sweet it was," was more than simply a figure of speech that day!)*

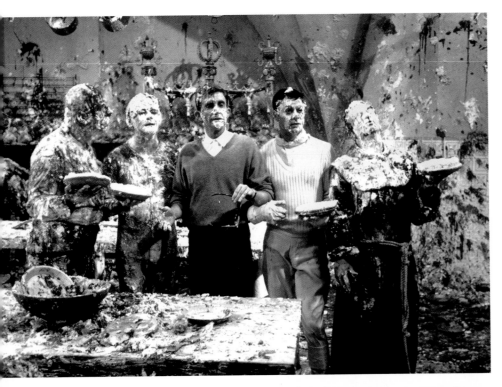

Reports at the time gave the cost of *The Great Race* as an amazing $12 million. It was a very big, funny, and richly produced film, but cost way too much for the time. This was basically because of Blake's excesses, and because Jurow and Jack Warner had been unable to rein him in. Blake is so bright, so creative, and it was always a pleasure to work with him, but I feel he would have done better work if he had had the controlling effect of a very strong producer.

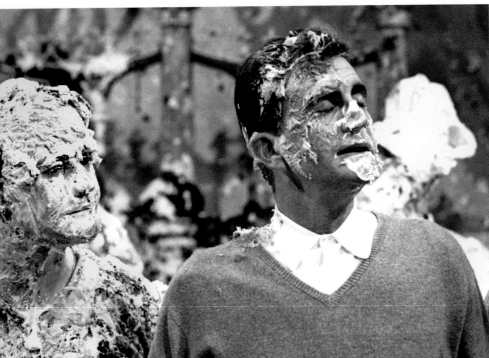

LEFT AND ABOVE LEFT *At the final take, I had all the pastry-covered actors pose with Blake. I figured there would be no way the cast, after getting pies in their faces for five days, would let Blake escape. I just waited, and sure enough Tony got to him, and Blake got his just "desserts."*

ABOVE *Henry Mancini and Johnny Mercer, who wrote the music for the film, visit Blake on the set. Producer Martin Jurow is on the right.*

RIGHT *After the first private screening, Blake and the studio executives stand outside the screening room and discuss what they have.*

Mike Nichols

Michael Igor Peschkowsky; born Berlin, Germany, November 6, 1931

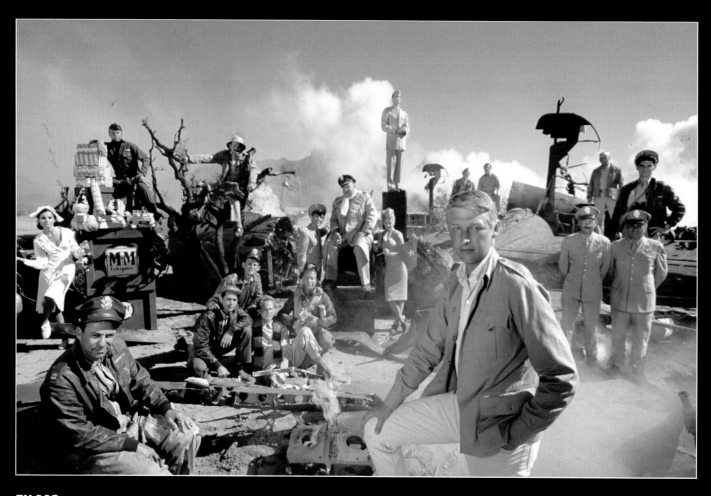

FILMS

Who's Afraid of Virginia Woolf? *(1966)*
The Graduate *(1967)*
Catch 22 *(1970)*
Carnal Knowledge *(also produced; 1971)*
The Day of the Dolphin *(1973)*
The Fortune *(also co-produced; 1975)*
Gilda Live *(filmed Gilda Radner's stage performance; 1980)*
Silkwood *(also co-produced; 1983)*
The Longshot *(executive-produced only; 1986)*
Heartburn *(also co-produced; 1986)*
Biloxi Blues *(1988)*

Working Girl *(1988)*
Postcards From the Edge *(also co-produced; 1990)*
Regarding Henry *(also co-produced; 1991)*
The Remains of the Day *(co-produced only; 1993)*
Wolf *(1994)*
The Birdcage *(1996)*
The Designated Mourner *(acted only; 1997)*
Primary Colors *(1998)*
What Planet Are You From? *(2000)*
Wit *(TV; 2001)*
Angels in America *(TV miniseries; 2003)*

ABOVE *Mike Nichols and the cast of* Catch 22 *(Paramount), Guaymas, Mexico, 1970.*

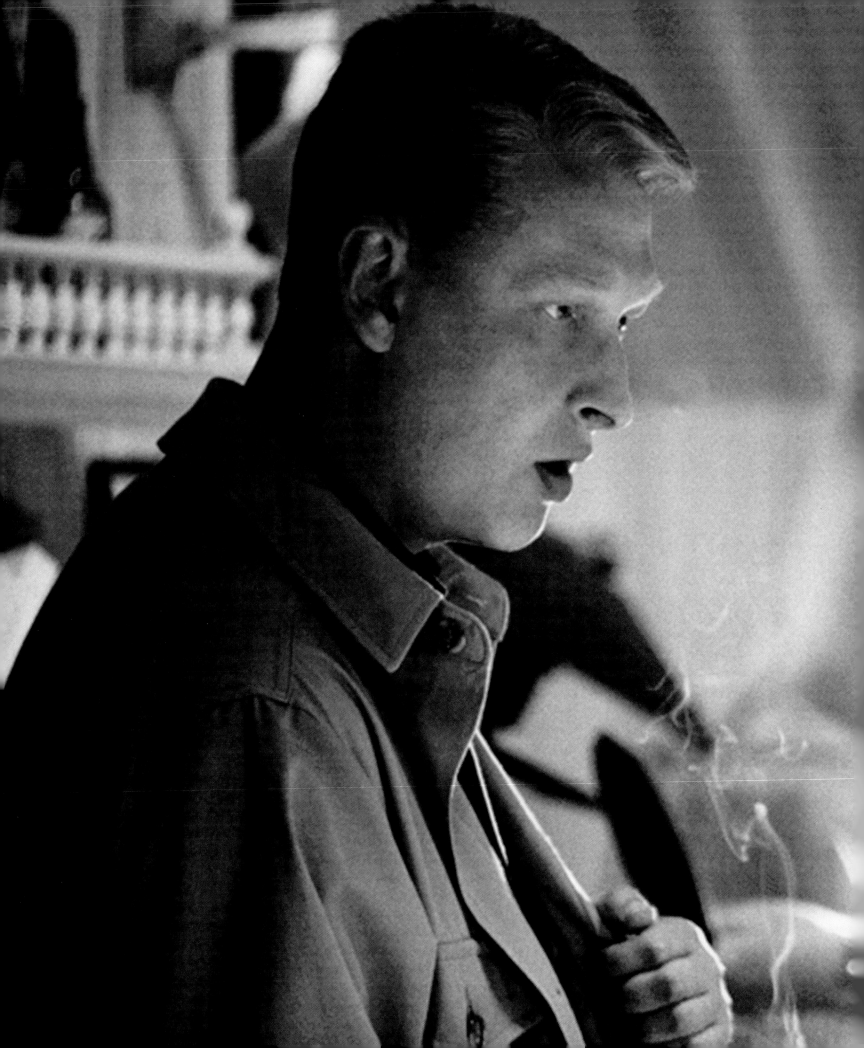

Mike Nichols **WHO'S AFRAID OF VIRGINIA WOOLF?** WARNER BROTHERS 1965

Who's Afraid of Virginia Woolf? was Mike Nichols's first film. Not only was the Edward Albee play very controversial at the time, but he had to deal with such acting luminaries as Elizabeth Taylor and Richard Burton (who were married to one another at the time), Sandy Dennis, and George Segal. Nichols was well known for his comedy routines on and off Broadway (usually paired with Elaine May), but this film was jumping off the deep end with material at the other end of the spectrum.

ABOVE AND RIGHT *Nichols outlines his ideas to the cast (above) and closely watches the rehearsals (right).*

Nichols borrowed veteran film specialist Doane Harrison from Billy Wilder for advice on cutting and shooting, and brought on board other talents, such as cinematographer Haskell Wexler and production designer Richard Sylbert, who both won Academy Awards for this film.

Then came the day to plunge in, and the rehearsals began.

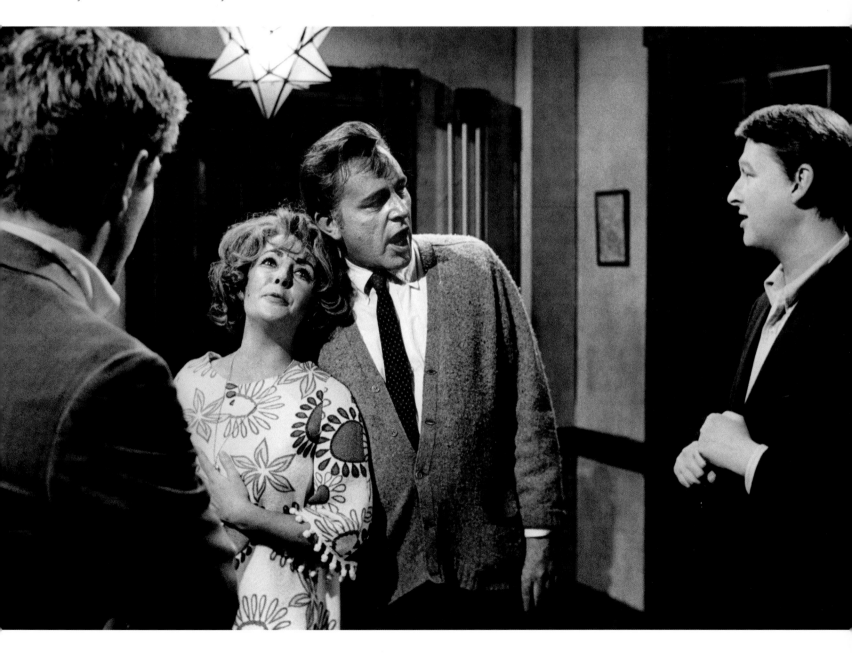

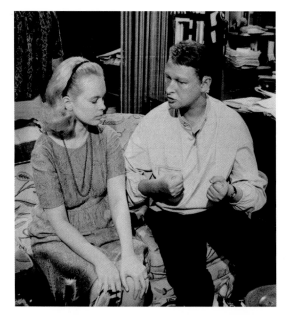

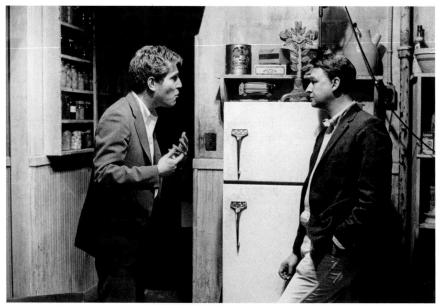

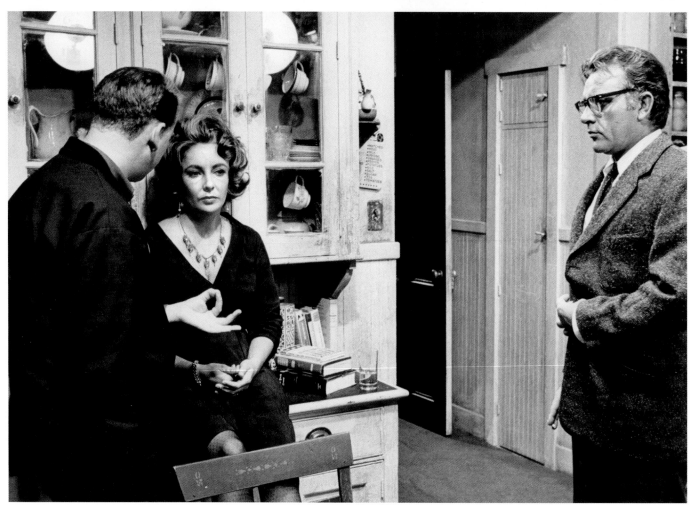

FAR LEFT *Sandy Dennis quietly listens to Nichols.*

LEFT *George Segal pleads his case.*

BELOW LEFT *Nichols explains to Elizabeth Taylor how he sees her character, while Richard Burton listens.*

BELOW *Richard Burton wasn't easy to turn, as Mike would find out during the course of the film.*

The first problem a new director must face is taking control, and this film was no exception. This proved no easy task as the Burtons had so many films under their belts, and they knew film far better than Nichols did.

Nichols, however, is very bright, and had definite ideas of what Albee was saying with the play, and where he was going with it. He had to sell it, and each of the actors had to be convinced that Nichols's idea of Albee's play was the same as theirs. At first it must have been a very daunting task.

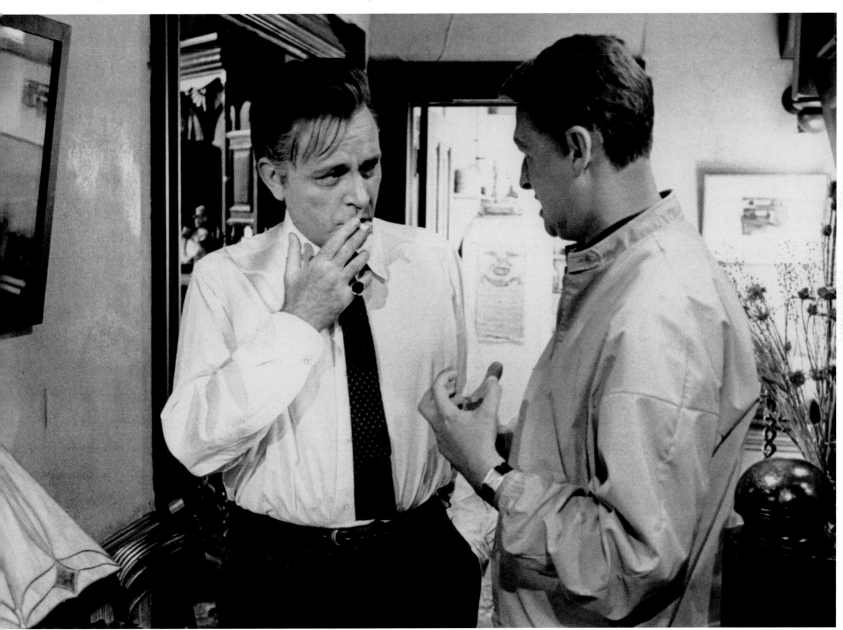

Mike Nichols

An unusual thing happened at the beginning of this film. Albee's dialogue was so acid, so bitter, that a number of the crew members said, no thanks, and left the first week. I had never seen this happen before, nor have I since. It was hard listening to the same invectives hour after hour, day after day, and it wore on everyone. It was even difficult not to take it home with you at night.

LEFT *Nichols takes Elizabeth off the set to a quiet corner to direct her for the coming scene.*

RIGHT *Nichols and Elizabeth Taylor react, off-camera, to Richard Burton in rehearsal.*

RIGHT *Nichols explains the scene, as the crew wait to begin filming. Cinematographer Haskell Wexler is sitting on the camera.*

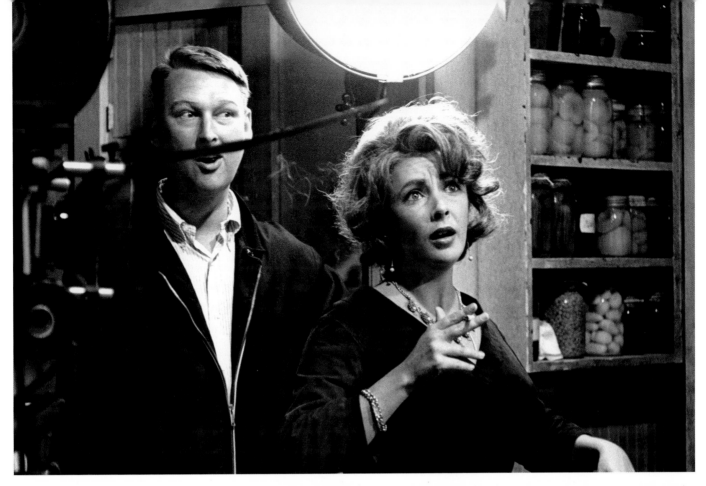

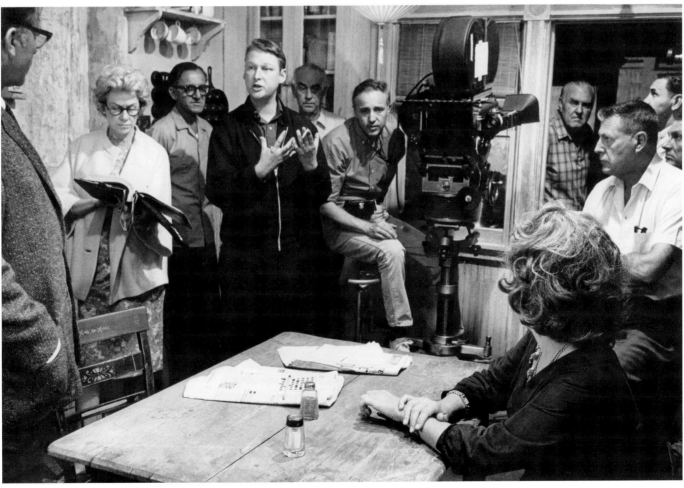

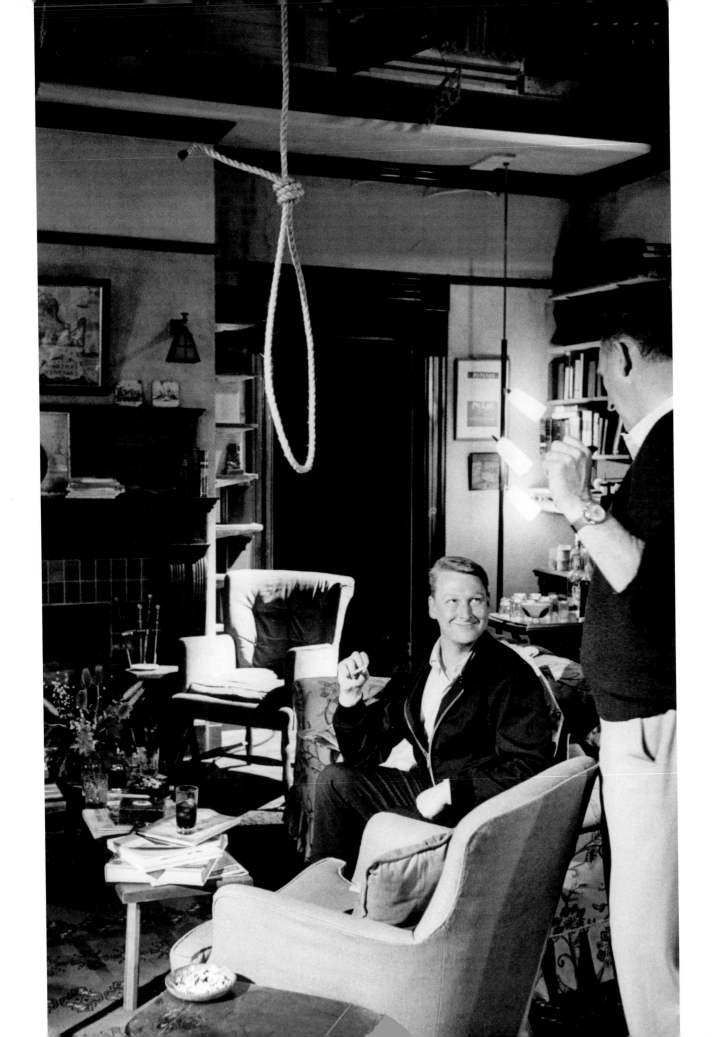

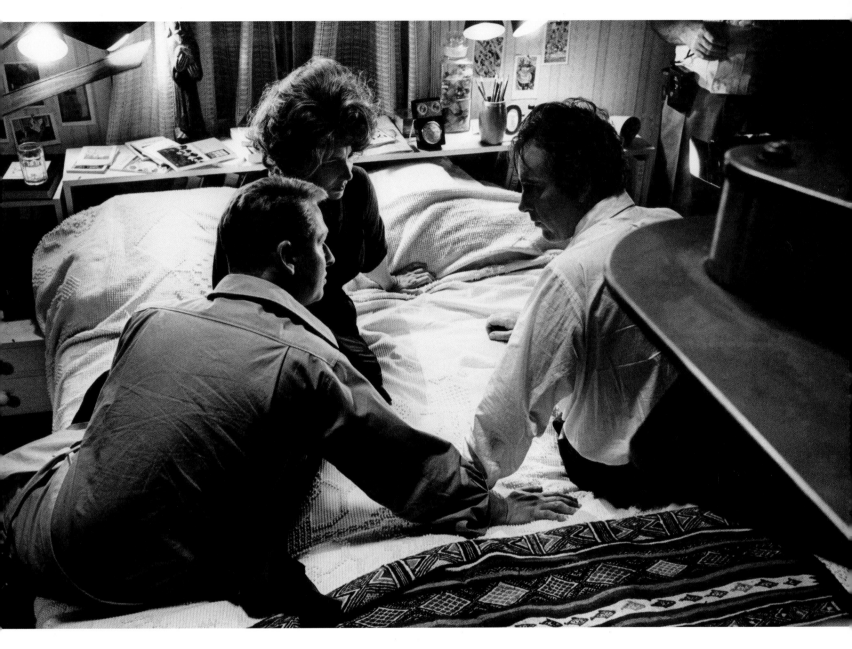

There seemed to be a distracting element on the set that Nichols felt disturbed the rapport he needed to have with his four actors. He narrowed it down to the professional but heavy-handed activities of his assistant director, Buck Hall. One morning Mike waited on the empty set for Buck to arrive, with the hangman's noose hanging from the rafters (*left*), telling him in this black-humored way that his services were no longer required.

Warner Brothers' still photographer and my dear friend, Mel Traxel, and I had had real trouble with Buck Hall when we were working together on *My Fair Lady*—he would arbitrarily have the lights turned out on us when we were trying to photograph the actors and the wonderful production numbers (*see page 163*)—and we were both very happy to see him leave this production.

ABOVE *With the climate now calmer, Nichols could have the time with his stars and to progress the film in his own rhythm, without all of the previous push and shove.*

Mike Nichols

I could see that Nichols hadn't realized before just how many other things there were to think about in this new (to him) film-making process. More than just directing the actors—which he seemed right at home doing—he also had to consider the juxtaposition of images so as either to strengthen the impact of a scene or to make it weaker, and this aspect was only one of the new things to learn.

BELOW *Conference in the screening room after the first rushes (left to right: film editor Sam O'Steen, production designer Richard Sylbert, cinematographer Haskell Wexler; seated: producer/screenwriter Ernest Lehman, and Mike Nichols).*

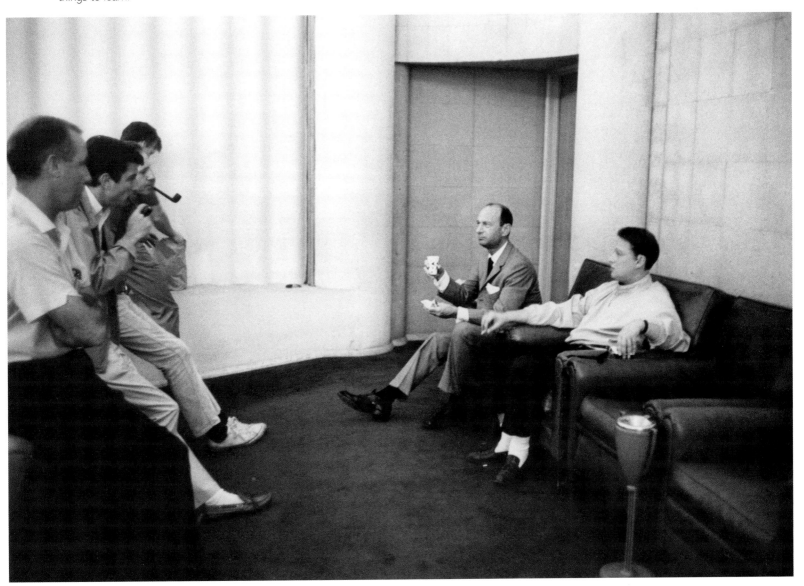

Mike Nichols

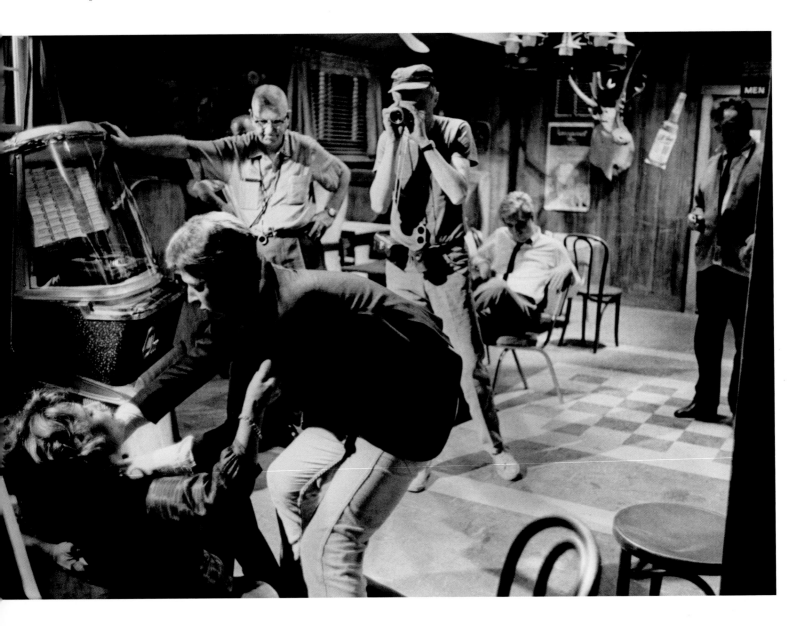

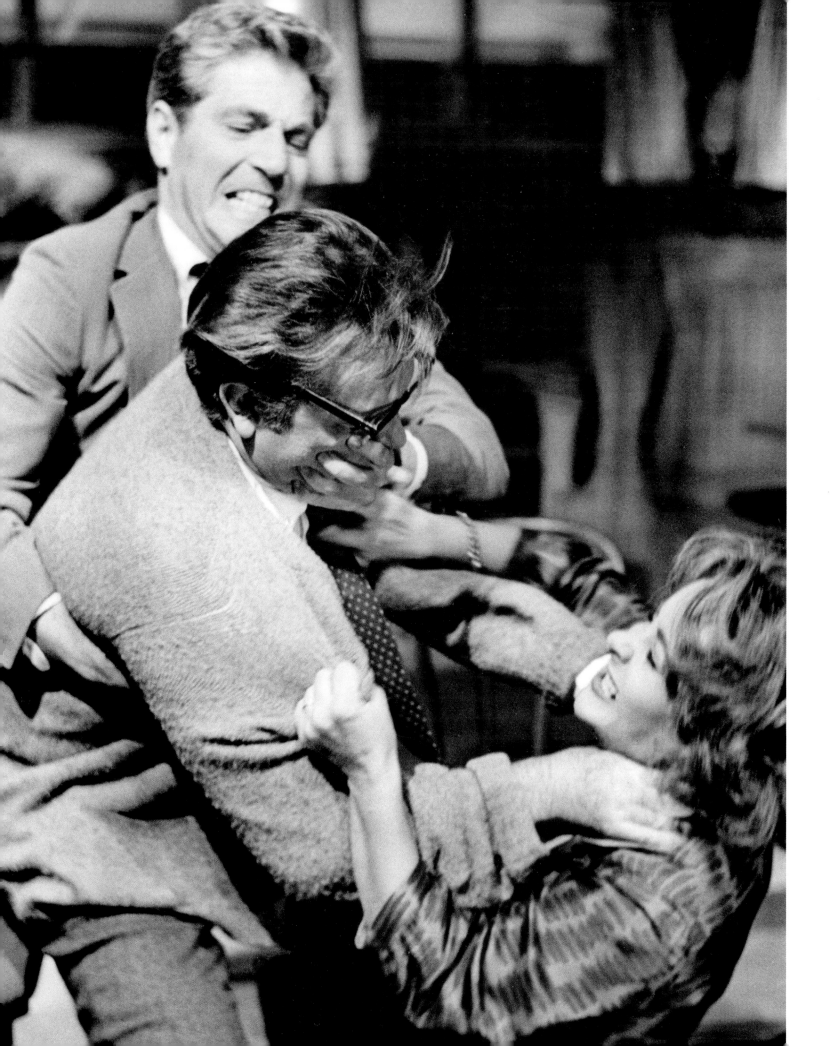

In the beginning, Nichols had to win every scene (*see pictures on this page*), having to convince the actors that they were going in the right direction, for it was their reputations on the line. This eventually seemed to ease off toward the end, when they had seen some of the rushes, but I wonder how many directors would have had the patience and resolve that Nichols had on this film—all the more remarkable since it was his first.

RIGHT *Mike Nichols takes a moment to himself to consider the scenes ahead.*

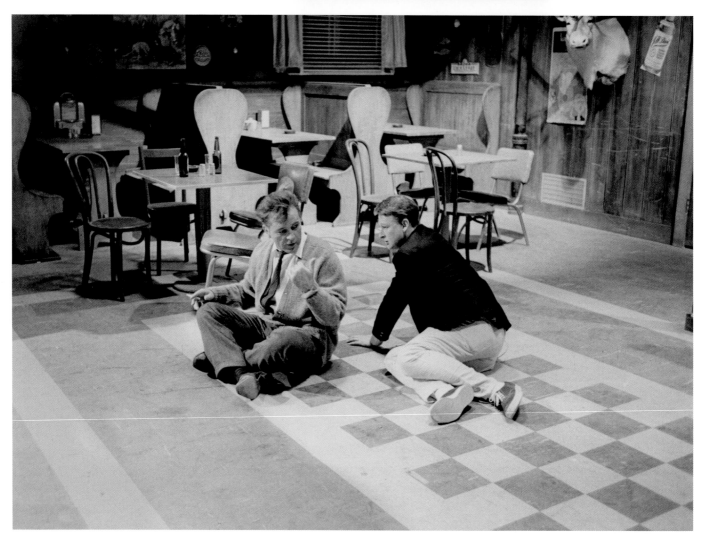

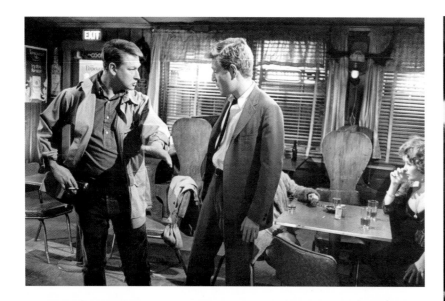

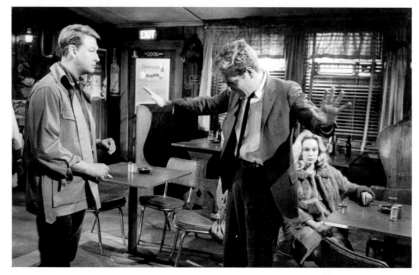

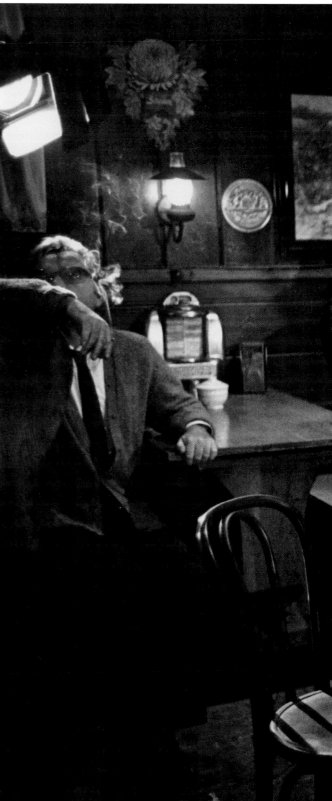

While the actors' confrontations meant a lot to them personally, these challenges destroyed the momentum that Nichols was trying to maintain. Sometimes a challenge was put down immediately, no quarter given, as with George Segal (*above*). Sometimes it was quietly done, with patience, as with Elizabeth Taylor (*right*)

The other actors never seemed to involve themselves in these discussions: each fight with or question to the director was an individual clash, and the others pretended not to notice—except for Richard Burton (note him sitting in the shadows, *right*), who watched every confrontation and every challenge with great interest: I think he was curious to see how Nichols would resolve them.

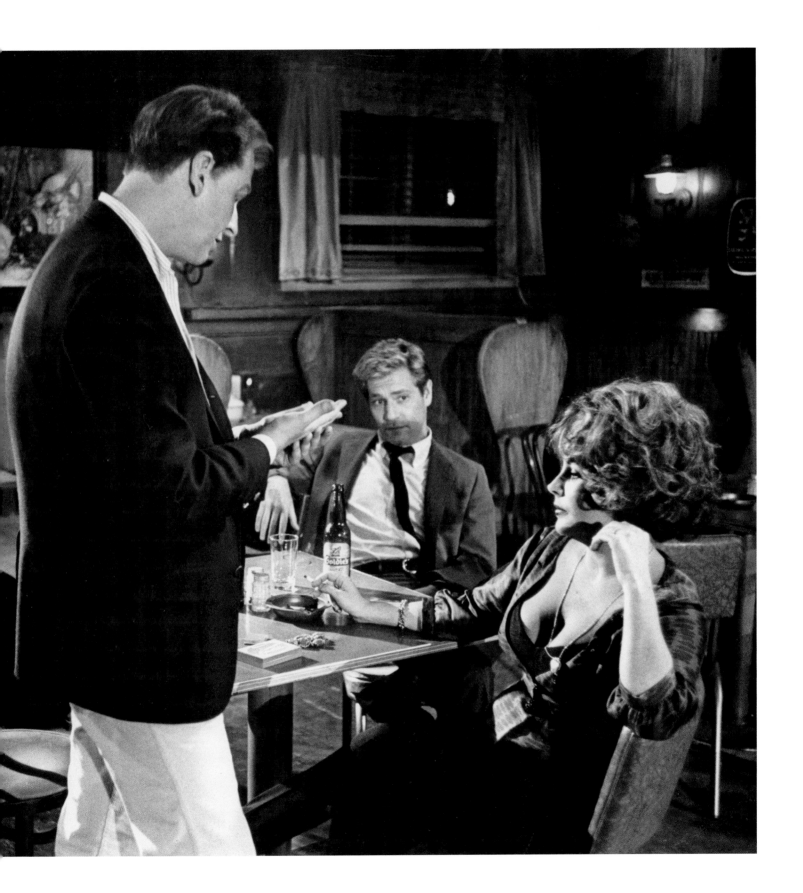

Mike Nichols

Nichols had decided to open the play up to include some exteriors, and to this end the company moved to Northampton, Massachusetts, for filming at Smith College (*see pictures on these pages*). The constant questioning from the actors didn't change for Nichols, only now the location included the damp and bone-chilling nights, which seemed to make the nerve-grating, acid dialogue get under one's skin along with the chill.

LEFT AND BELOW *A conference with Nichols during dinner with production designer Richard Sylbert and cinematographer Haskell Wexler. It seemed to take Wexler forever to be happy with the lighting for these night scenes (below), and the crew became testy with the cold and the endless delays.*

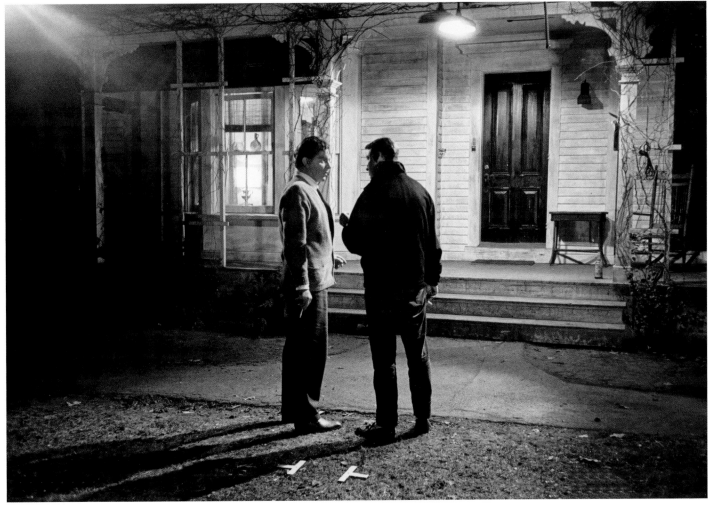

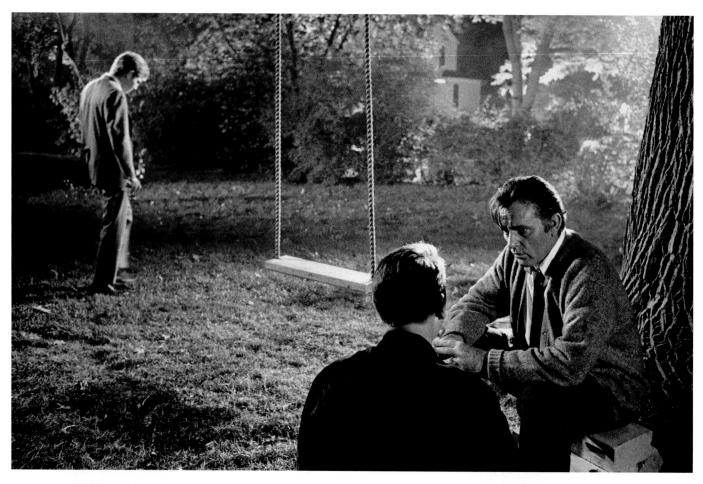

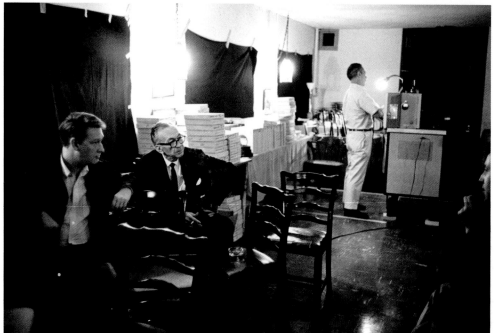

ABOVE *Mike Nichols, Richard Burton, and George Segal on the Northampton location.*

LEFT *Sam O'Steen, the film editor, had moved his equipment to the location, where he made a rough edit of the film as it progressed, and ran the rushes every night for Nichols and editing expert Doane Harrison. These were long days and nights for Nichols.*

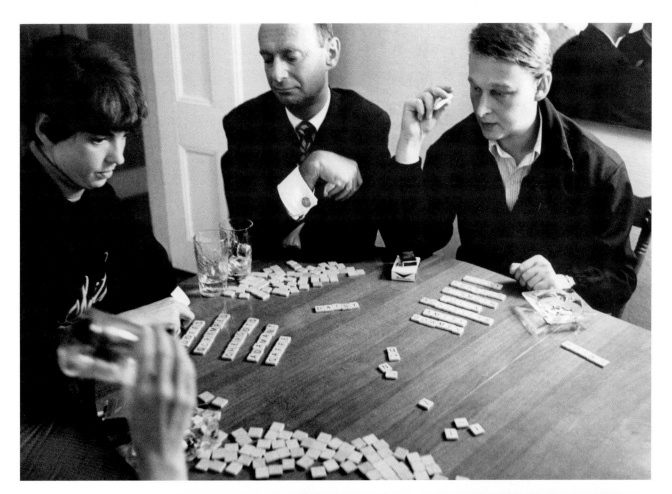

ABOVE *On those cold evenings, waiting for Haskell to finish lighting, some of the lucky few could be found inside playing Scrabble, which Mike was very good at. He is seen here playing with producer Ernest Lehman and friends.*

RIGHT *Not all was fun and games though, and there was a splendid difference of opinion between Lehman, who, after all, had written the script, and Nichols, who had other ideas and would go his own way no matter what Lehman thought.*

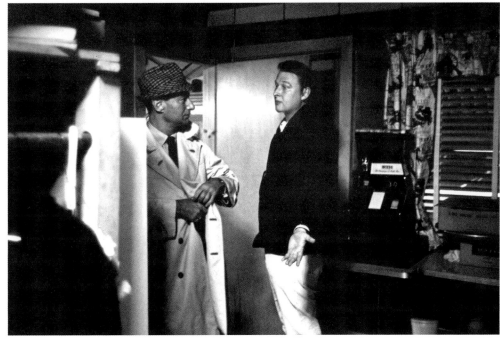

Mike Nichols

LEFT *Ultimately, in spite of all that has been written about the variety of disciplines and talents needed on a film, it's the director who's out there alone. It is he who must make all the decisions and be in control, win or lose.*

ABOVE *There were a few breaks at times: here Mike Nichols is dancing with script supervisor Meta Rebner, after wrapping the filming for the day, at his and Sam O'Steen's birthday party.*

RIGHT *Back from the location, Nichols settles into directing the final scenes in the film.*

Mike Nichols

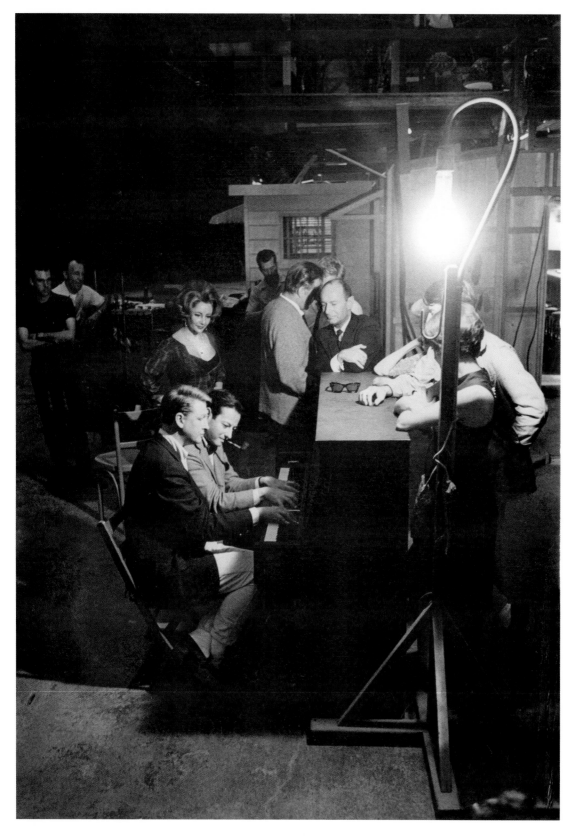

LEFT *Composer-conductor André Previn pays a visit to the set. The previous night I had heard him in a duet with Nichols, playing classical music as if it had been written as show tunes in the style of Rogers and Hammerstein … then magically they took the Broadway tunes and transposed them into a classical form à la Bach or Mozart. It was so brilliant that when André came on the set the following day, I coaxed them into a repeat performance for the cast and crew.*

LEFT *Mike Nichols lines up the last shot of the film.*

ABOVE *Elizabeth gives Nichols a huge hug and thank you, as well she might, since she and Sandy Dennis would both win Academy Awards for their performances. However, Burton and Nichols were, incredibly, passed over.*

LEFT *The cast and crew at the end-of-film party, a tradition that even brought the production head of Warner Brothers down to join in the celebration. Left to right: Jack Warner (with mustache), Elizabeth Taylor, Mike Nichols, Ernest Lehman, Richard Sylbert and his girlfriend (backs to camera), and Elizabeth's stand-in.*

BELOW *Film editor Sam O'Steen rewinds the films for Nichols in the editing bay, and the final days of putting together this multiple Academy Award-winning film lie ahead. It was Sam who told me that the first time Warner saw some of the rushes, he muttered out loud: "I'm making a five million dollar dirty movie!" When he read what the critics had to say and saw the grosses, I suspect he was glad he did.*

Clive Donner

born London, England, January 21, 1926

Donner was very easy to work with, but on *Luv* (1966, Columbia Studios; *seen on these pages*) he was given an impossible task. Black comedy may work on the stage: when a person is pushed off a bridge, and a bucket of water is splashed up—that can be funny. When translated to the comparative reality of the screen, and someone is pushed off a real bridge, well, it's hard to make killing someone funny. Mike Nichols had much the same problem on *Catch 22*.

Jack Lemmon, Elaine May, and Peter Falk did their best to make this one come alive, but they were fighting a losing battle. Donner's lovely film *Stealing Heaven* was so hauntingly beautiful that it was obvious he had a subject he was really happy with. I wish I could have worked on that one with him.

ABOVE *Jack Lemmon (left) and Clive Donner in New York City on the location of* Luv.

LEFT *Donner watches Jack Lemmon and Elaine May rehearse on the parapet overlooking Niagara Falls, New York.*

FILMS

The Secret Place *(1957)*
Heart of a Child *(1958)*
Marriage of Convenience *(1961)*
The Sinister Man *(1961)*
Some People *(1962)*
The Caretaker/The Guest *(1963)*
Nothing but the Best *(1964)*
What's New Pussycat? *(1965)*
Luv *(1967)*
Here We Go Round the Mulberry Bush *(also produced*
Alfred the Great *(1969)*
Vamira/Old Dracula *(1974)*
Rogue Male *(TV: 1976)*
Spectre *(TV: 1977)*
The Three Hostages *(TV: 1977)*
She Fell Among Thieves *(TV: 1978)*
The Thief of Baghdad *(TV: 1978)*
The Nude Bomb/The Return of Maxwell Smart *(1980*
Charlie Chan and the Curse of the Dragon Queen *(19*
Oliver Twist *(TV: 1982)*
Scarlet Pimpernel *(1982)*
A Christmas Carol *(TV: 1984)*
To Catch a King *(1984)*
Arthur the King/Merlin and the Sword *(TV: 1985)*
Dead Man's Folly *(TV: 1986)*
Babes in Toyland *(TV: 1986)*
Stealing Heaven *(1988)*
Not a Penny More, Not a Penny Less *(TV: 1990)*
Arrivederci Roma *(TV: 1992)*
Terror Stalks the Class Reunion *(TV: 1992)*
Charlemagne, le prince à cheval/Charlemagne *(TV m*

LEFT *Clive Donner reads a page*
of his script on the Columbia
Studios set of Luv.

Stanley Donen

born Columbia, South Carolina, April 13, 1924

FILMS

On the Town *(co-directed with Gene Kelly; 1949)*
Royal Wedding *(1951)*
Singin' in the Rain, *(co-directed and co-choreographed with Gene Kelly; 1952)*
Love Is Better than Ever *(1952)*
Fearless Fagan **(1952)**
Give a Girl a Break *(also co-choreographed; 1953)*
Seven Brides for Seven Brothers *(1954)*
Deep in My Heart *(1954)*
It's Always Fair Weather *(co-directed and co-choreographed with Gene Kelly; 1955)*
Kismet *(uncredited; 1955)*
Funny Face *(1957)*
The Pajama Game *(1957)*
Kiss Them for Me *(co-directed and co-produced with George Abbott; 1957)*
Indiscreet *(also produced; 1958)*

Damn Yankees *(co-directed and co-produced with George Abbott; 1958)*
Once More with Feeling *(also produced; 1960)*
Surprise Package *(also produced; 1960)*
The Grass is Greener *(also produced; 1960)*
Charade *(also produced; 1963)*
Arabesque *(also produced; 1966)*
Two for the Road *(also produced; 1967)*
Bedazzled *(also produced; 1967)*
Staircase *(also produced; 1969)*
The Little Prince *(also produced; 1974)*
Lucky Lady *(1975)*
Movie Movie *(also produced; 1978)*
Blame It on Rio *(1984)*
Moonlighting *(TV series; 1985)*
Love Letters *(TV; 1999)*

BELOW *Stanley Donen with Audrey Hepburn and Albert Finney on the set of* Two for the Road, *France, 1967 (20th Century Fox).*

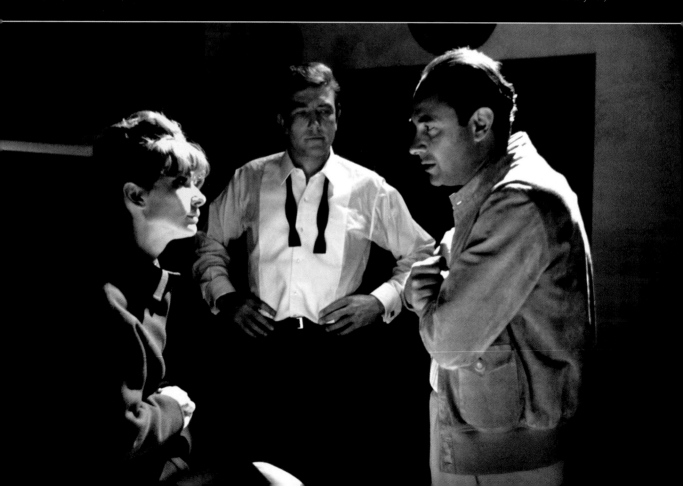

Gene Kelly

ɡene Curran Kelly; born Pittsburgh, Pennsylvania, August 23, 1912; died Beverly Hills, California, February 2, 1996

LMS

the Town (co-directed with Stanley Donen; also
reographed; 1949)
gin' in the Rain (co-directed and co-choreographed with
nley Donen; 1952)
Always Fair Weather (co-directed with Stanley Donen; 1955)
itation to the Dance (co-directed; also scripted and
reographed; 1956)
py Road (also produced; 1957)
e Tunnel of Love (1958)
ɡot (1962)
Guide for the Married Man (1967)
ck and the Beanstalk (TV; 1967)
llo, Dolly! (1969)
eyenne Social Club (also produced; 1970)
t's Entertainment (new sequence; 1976)

gured these two talents belonged together in this
ok, since they made some of the most marvelous
usicals ever produced. If they had only made one
usical and it was *Singin' in the Rain*, that would have
en enough to make them remembered for genera-
ns to come.

RIGHT *Gene Kelly on the MGM
set of* Brigadoon, *directed by
Vincente Minnelli, 1953.*

Richard Lester

born Philadelphia, Pennsylvania, January 19, 1932

FILMS

The Vise *(TV series; 1954)*
A Show Called Fred *(TV series; 1956)*
The Running Jumping Standing Still Film *(also co-photogra co-edited, and music; 1960)*
It's a Trad Dad/Ring-a-Ding Rhythm *(also produced; 1962)*
The Mouse on the Moon *(1963)*
A Hard Day's Night *(1964)*
The Knack … And How To Get It *(1965)*
Help! *(1965)*
A Funny Thing Happened on the Way to the Forum *(1966)*
Mondo Teeno/Teenage rebellion *(British sequence only; 19*
How I Won the War *(1967)*
Petulia *(1968)*
The Bed Sitting Room *(also produced; 1969)*
The Three Musketeers *(1974)*
Juggernaut *(1974)*
The Four Musketeers *(1975)*
Royal Flash *(1975)*
Robin and Marian *(1976)*
The Ritz *(1976)*
Butch and Sundance: The Early Days *(1979)*
Cuba *(1979)*
Superman II *(1980)*
Superman III *(1983)*
Finders Keepers *(1984)*
The Return of the Musketeers *(1990)*
Get Back *(1991)*

LEFT AND RIGHT *Richard Lester on the San Francisco location of Petulia, Warner Brothers, 1967*

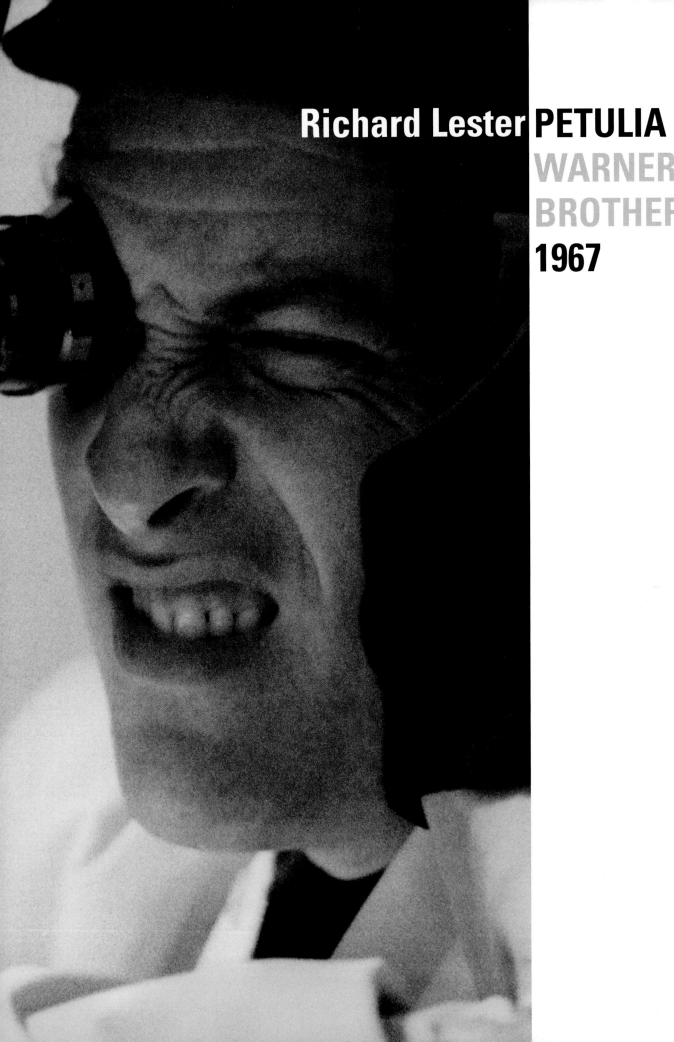

Richard Lester PETULIA

WARNER
BROTHERS
1967

Richard Lester

Warner Brothers asked me to photograph some of the scenes in Dick Lester's film *Petulia*, which I thought was terrific. Lester's *A Hard Day's Night* was great fun, and the cast of *Petulia* was also quite special, including as it did George C. Scott, Julie Christie, Richard Chamberlain, Shirley Knight, Arthur Hill, and Joseph Cotten (whom I had never had the opportunity to work with), so I was really looking forward to it.

The studio had given me a script and the shooting schedule, and I started as I normally do, selecting the best scenes to cover. When I got to the San Francisco location, however, they were filming something completely different from what was indicated in the schedule; and so it went. I never really saw anything during my visits that resembled the original script. To say the least, it was the most confusing film that I ever worked on. Lester had his own script in his head, and that was hard sometimes for even the actors to deal with. He was a great character though, and there were many laughs on the set.

RIGHT *George C. Scott and Shirley Knight rehearse for Lester, as he watches through the camera.*

BELOW *Always the entertainer, Lester knows how to keep his actors sweet. Here he shares a laugh with George C. Scott and Shirley Knight.*

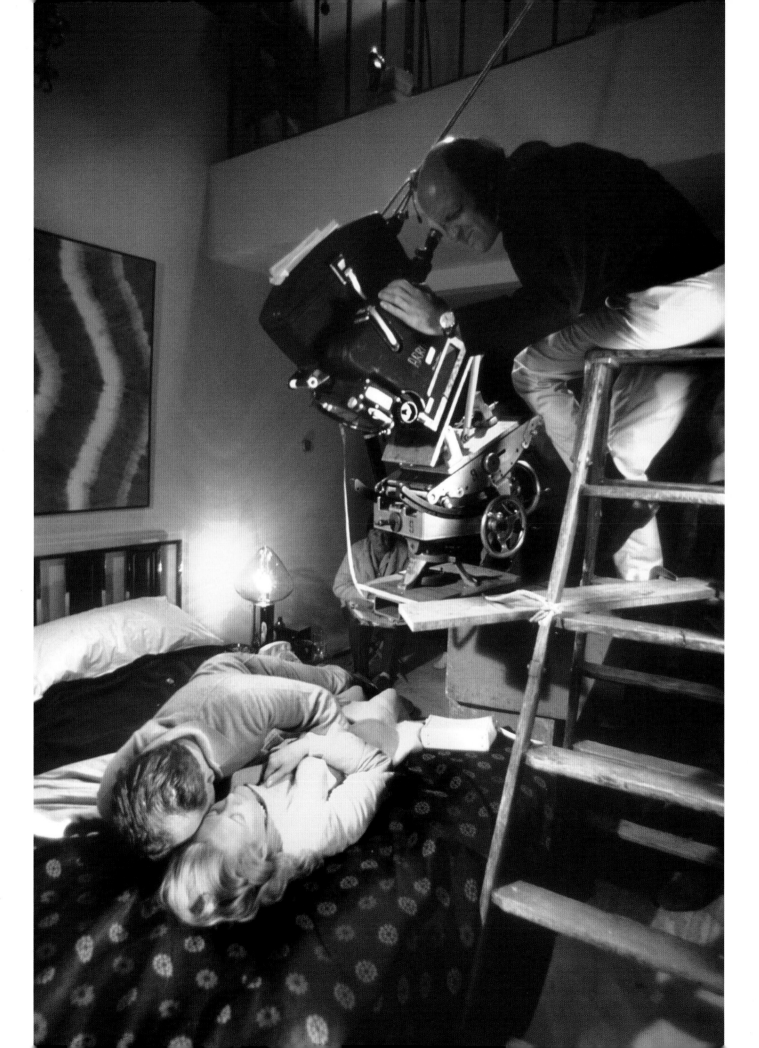

Richard Lester

Lester's famous penchant for using two or three cameras on most of the takes gave him all sorts of editing possibilities. It confused the actors at times. George C. Scott once told me that he never knew whether he was on camera, or, if he was, what part of him they were photographing.

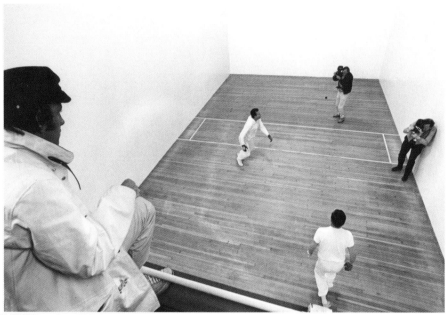

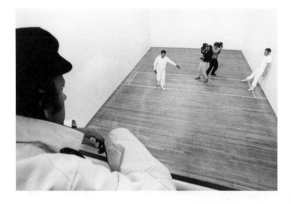

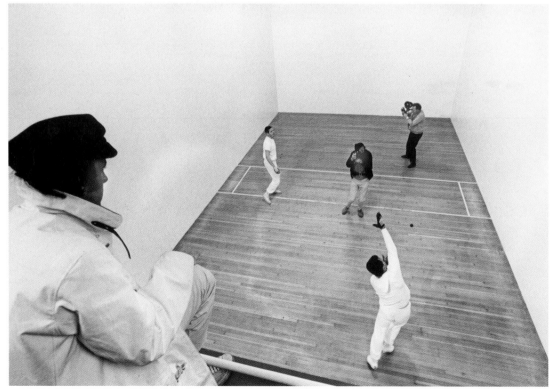

THIS PAGE *Shooting in the handball court. Lester watches as his operators Freddie Cooper and Paul Wilson photograph George C. Scott and Arthur Hill playing (and try to avoid getting hit by the ball).*

RIGHT *Lester checks the camera angle on Julie Christie lying in the bed. Cinematographer Nicholas Roeg is seen at top left. Lester was very visually oriented, and had brought Roeg, along with two of his favorite camera operators and a script supervisor, from London with him to San Francisco. This was rather unusual at the time.*

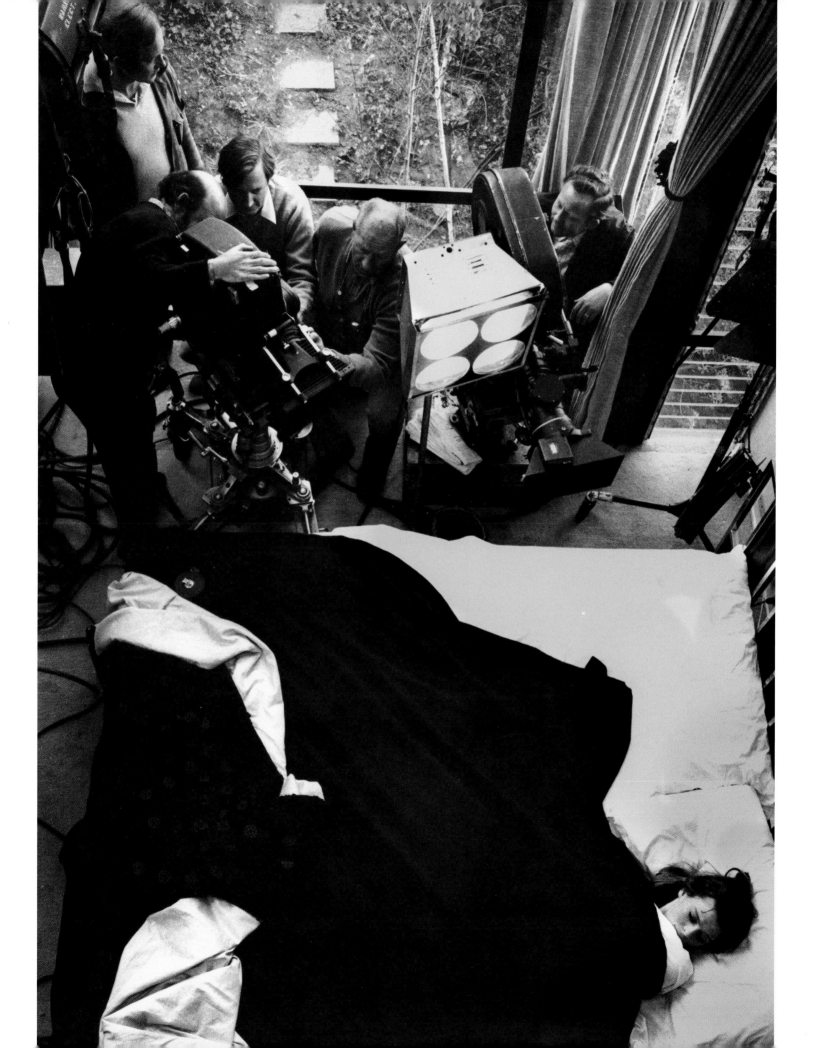

Richard Lester talks the part out with the remarkable young actress Shirley Knight. I first photographed her in 1958, and I recognized that she was a true sensitive: she could touch things deep inside herself, which reflected on her face. It had impressed me at the time, and I could see Lester tapping into this ability, creating the images for her to work with. As he quietly directed her, she responded to his words. It was a treat to watch.

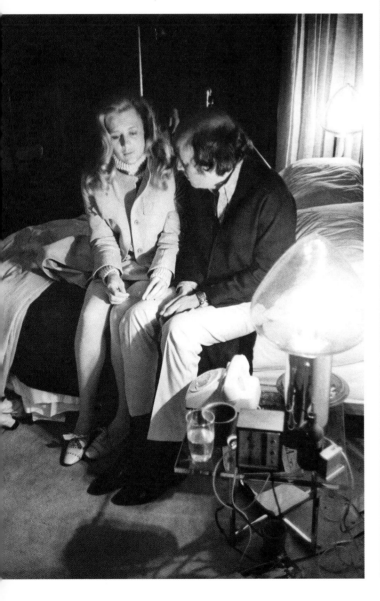

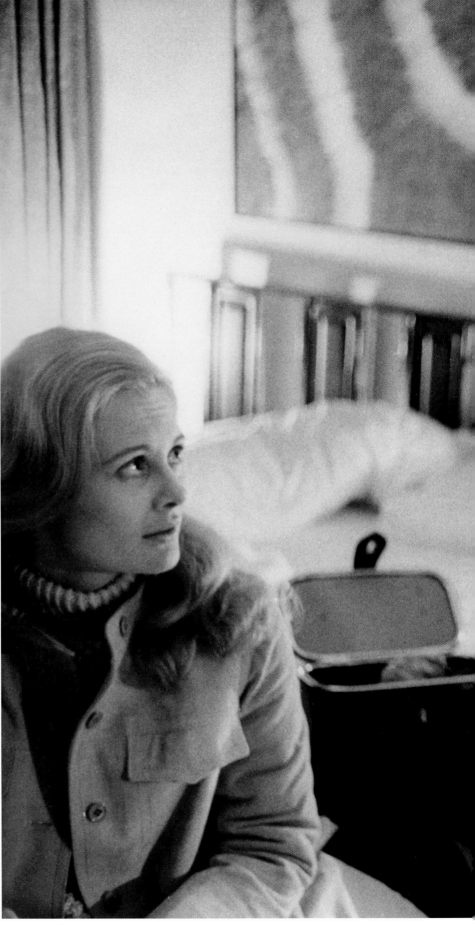

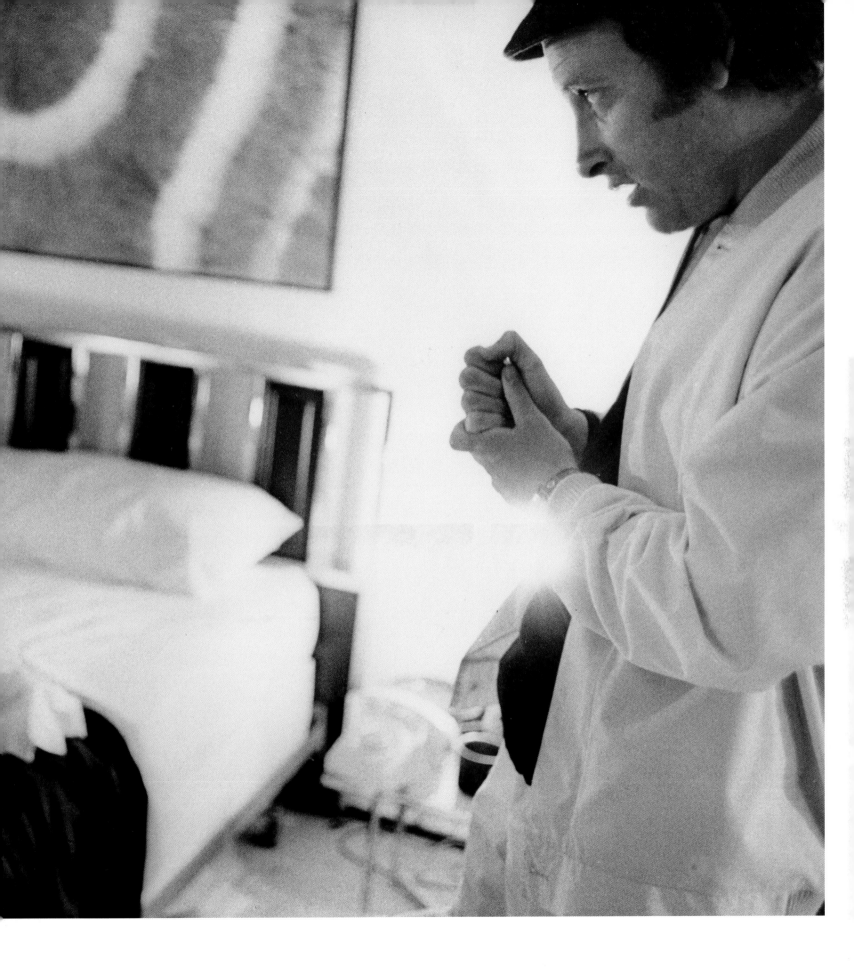

Richard Lester

Richard Lester's biography says that he was directing television shows with CBS when he was twenty. In the process he must have learned to do everything himself, as illustrated on these pages. Whether it was applying makeup to Julie Christie (*below right*) or a young actress's back (*right and far right*), checking every camera angle, or picking up the camera and shooting the sequence himself, Lester was everywhere.

In fact, for me it was more interesting to photograph Lester as he worked on the film, than the film itself. I found that it was so fragmented in the way it was shot that in the limited time I had to cover it (I was working on another film in Hollywood) I could find no continuity to do a storyline, and the script itself gave me no help.

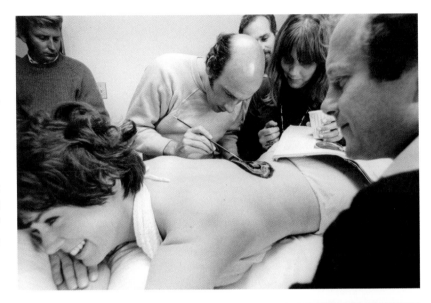

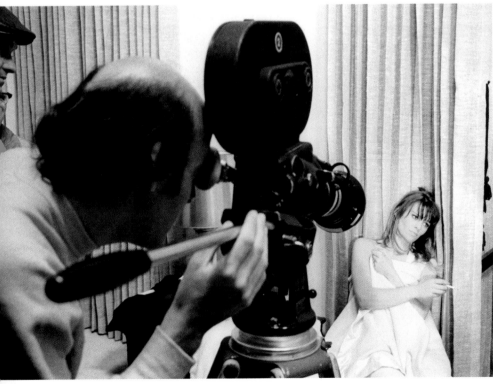

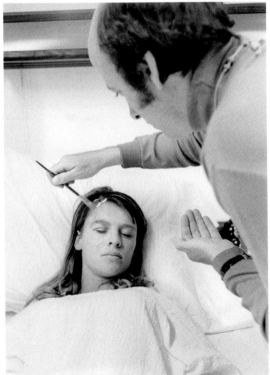

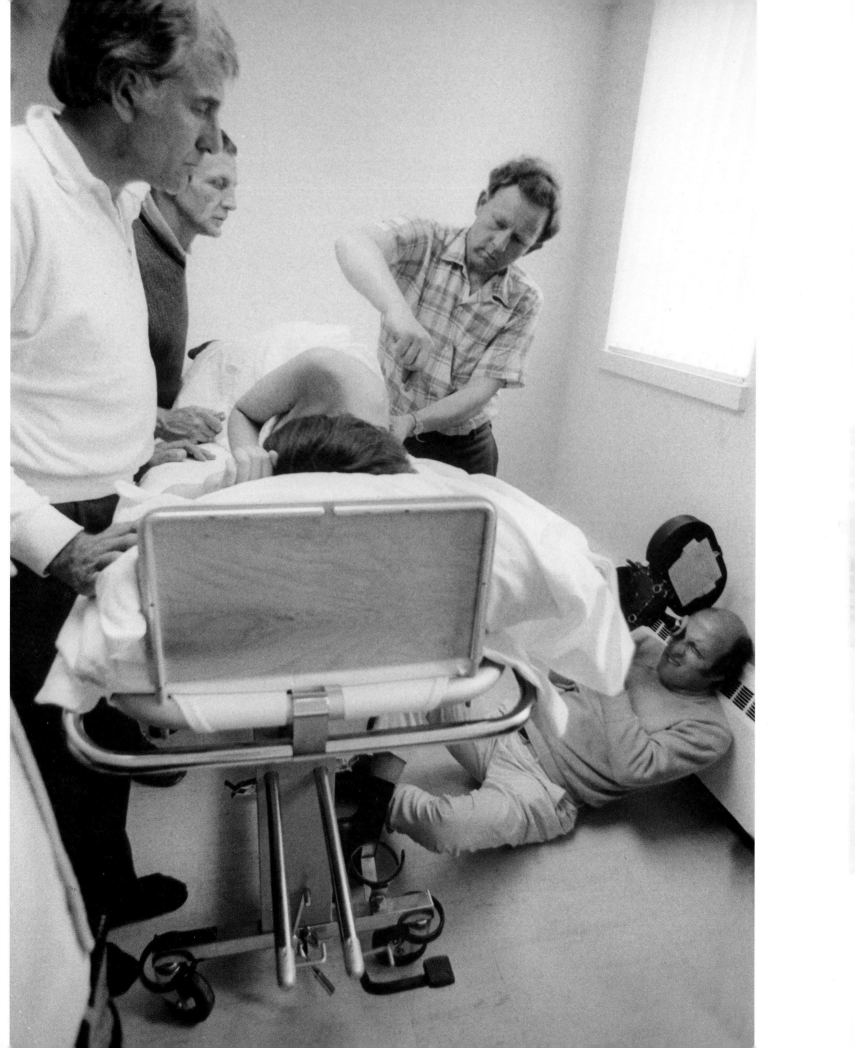

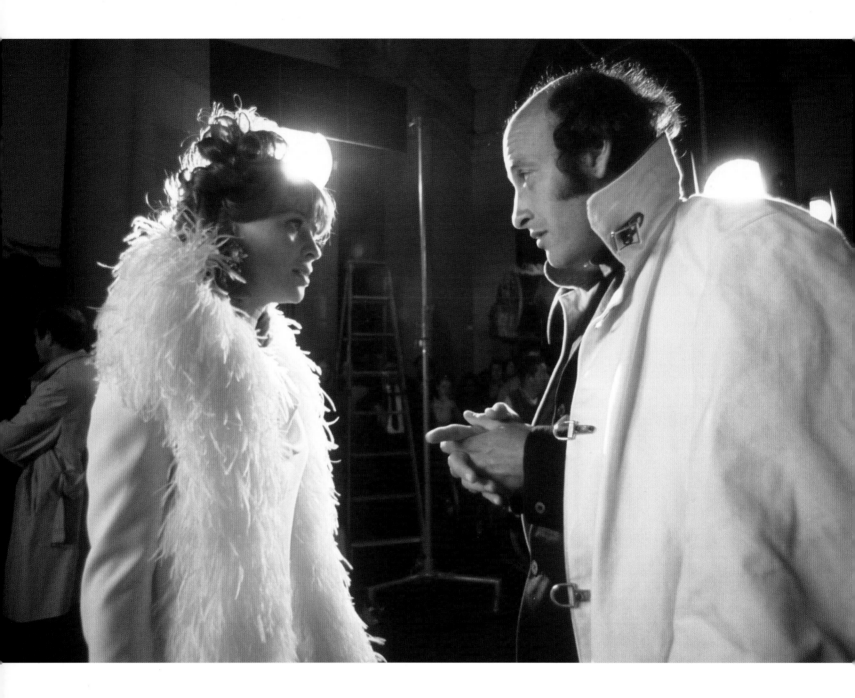

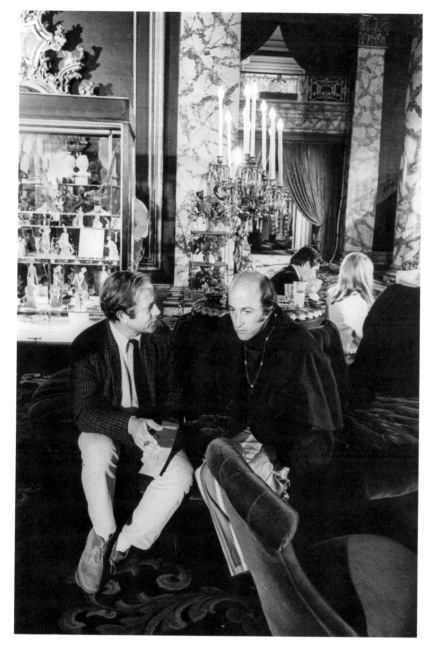

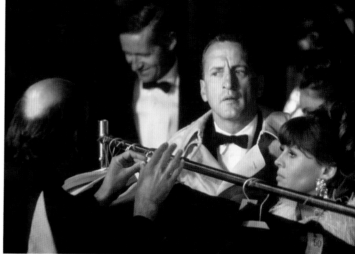

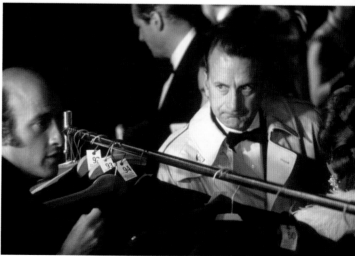

 LEFT *Filming in San Francisco's Mark Hopkins Hotel, with Julie Christie.*

ABOVE *Lester with cinematographer Nicholas Roeg, who later became a successful film director himself.*

RIGHT *Lester gives directions to George C. Scott and Julie Christie before filming begins. Scott seems not too certain where Lester is coming from. Arthur Hill is just behind*

Every angle, every position was critical to Lester. He physically demonstrates to Julie Christie where she should be and how she should hold herself, before the rehearsals even begin. He seems to think in images as a director, as opposed to in a sequenced storyline as Alfred Hitchcock did. Possibly working with him for a more extended time, one could find his wavelength and be able to see where he was going with a scene. But I confess he lost me on this one.

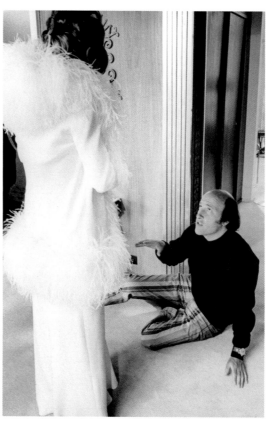

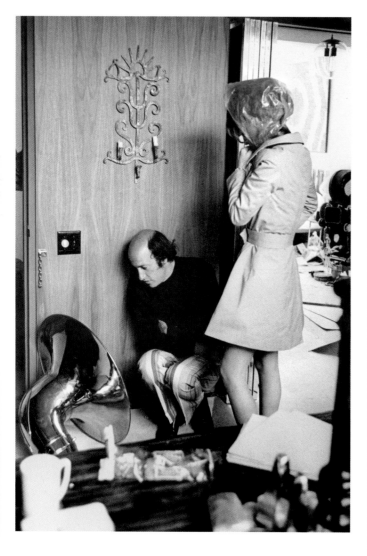

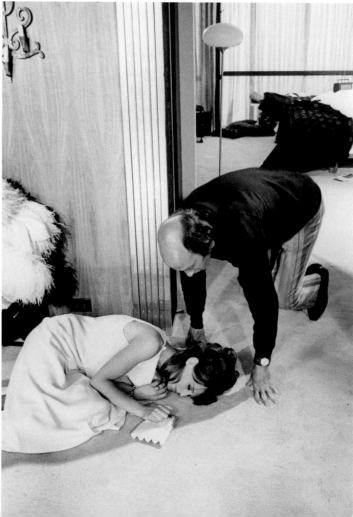

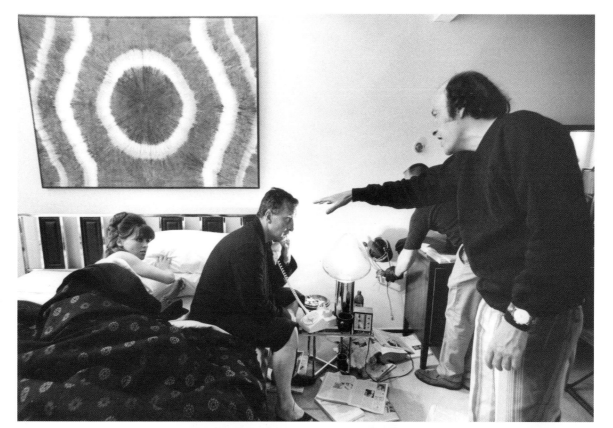

AND BELOW RIGHT *Lester
...verywhere, directing even
...y Julie Christie should lie in
...overing every detail as to
...he should sleep or awaken.*

*George C. Scott paid
...attention to the direction
...gave to the other actors.
... seemed to be trying to
... Lester's style.*

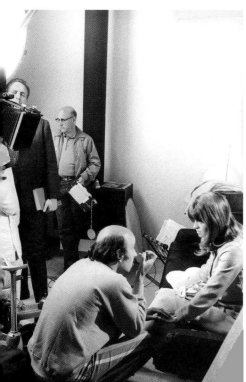

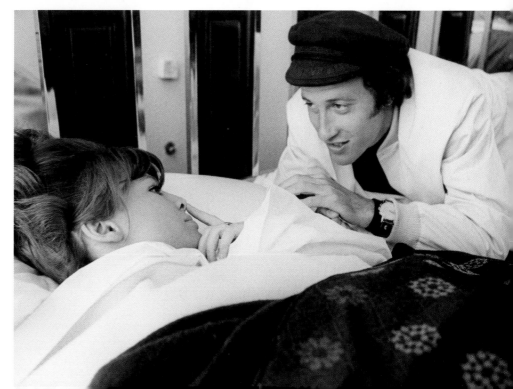

was assigned to work on *Doctor Dolittle* by 20th Century Fox and producer Arthur Jacobs, an old friend, in 1967. Working with Rex Harrison again, I thought, couldn't be bad, but there was a fly in the ointment. I cannot think of any other director I've worked with who was more arbitrary than Dick Fleischer. He frustrated me in every way. I could never figure out just what his problem was. If I mounted my radio-controlled camera on to the Panavision camera (after carefully checking with the sound people that I was not on their channel) he said he couldn't take the chance, and made me take it down. If I used a long trip wire, he said it would get in the way. It was one thing after another, until finally I created my own little company away from his, to be able to get my shots.

In the *Look* magazine color layout, there wasn't one photograph from his film, he had made it so impossible for me to do my job. When Arthur Jacobs saw my photographs, he told me that he wished his film looked like mine.

RIGHT *In Castle Combe, England, where it rained and rained, Fleischer and his assistant director share the cover of a 10K lamp.*

BELOW RIGHT *They were even forced to rehearse in the rain.*

BELOW *Anthony Newley (left) and Samantha Eggar rehearse for Fleischer. Eventually the company moved back to the States, the weather being so uncooperative in England. On a personal level Fleischer was very amiable, but to work with he was a real pain in the neck.*

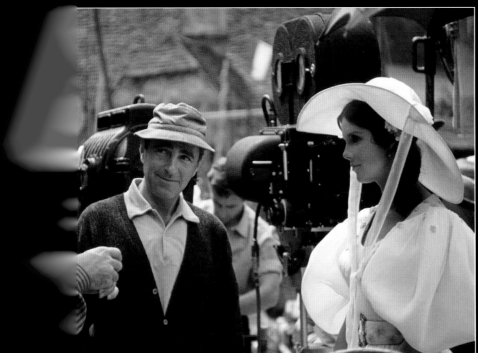

Roman Polanski

Roman Liebling; born Paris, France, August 18, 1933

Roman Polanski was nominated for an Academy Award twice for his direction, on *Chinatown* and *Tess*. He was also nominated for his screenplay for *Rosemary's Baby* (*photographs on these pages*).

BELOW *Roman Polanski watches Mia Farrow rehearse the moment when her character, Rosemary, wakes the morning following what she thinks was a terrible dream.*

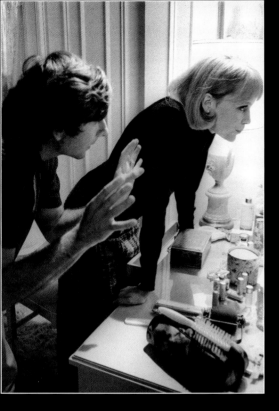

LEFT *Roman Polanski gestures to Mia Farrow, showing where he plans to place the camera for her closeup.*

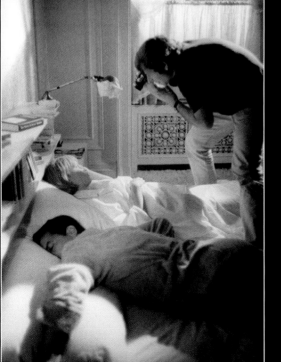

LEFT *Roman on top of the bed watches Mia through the viewfinder. John Cassavetes is in the foreground.*

FILMS

Rower/Bicycle *(unfinished short; 1955)*
Breaking up the Dance *(short; also scripted; 1959)*
Dwaj ludzie z szafa/Two Men and a Wardrobe *(short; also scripted and acted; 1959)*
Lampa *(short; also scripted; 1959)*
Gdy spadaja anioly/When Angels Fall *(short; also scripted and acted; 1959)*
Le Gros et le maigre/The Fat and the Lean *(short; also co-scripted and acted; 1960)*
Ssaki/Mammals *(short; also co-scripted and acted; 1962)*
Nóz w wodzie/Knife in the Water *(also co-scripted; 1962)*
Les Plus Belles Escroqueries du monde/The Beautiful Swindlers *("Amsterdam" episode; also co-scripted; 1964)*
Repulsion *(also co-scripted and acted; 1965)*
Cul-de-Sac *(also co-scripted; 1966)*
Dance of the Vampires/The Fearless Vampire Killers, or Pardon Me But Your Teeth Are in My Neck *(also co-scripted and acted; 1967)*
Rosemary's Baby *(also scripted; 1968)*
Macbeth *(also co-scripted; 1971)*
What? *(also co-scripted and acted; 1973)*
Chinatown *(also acted; 1974)*
Le Locataire/The Tenant *(also co-scripted and acted; 1976)*
Tess *(also co-scripted; 1980)*
Pirates *(also co-scripted; 1986)*
Frantic *(also co-scripted; 1988)*
Lunes de fiel/Bitter Moon *(also co-scripted; 1992)*
Death and the Maiden *(1994/5)*
The Ninth Gate *(also co-scripted; 1999)*
The Pianist *(2002)*

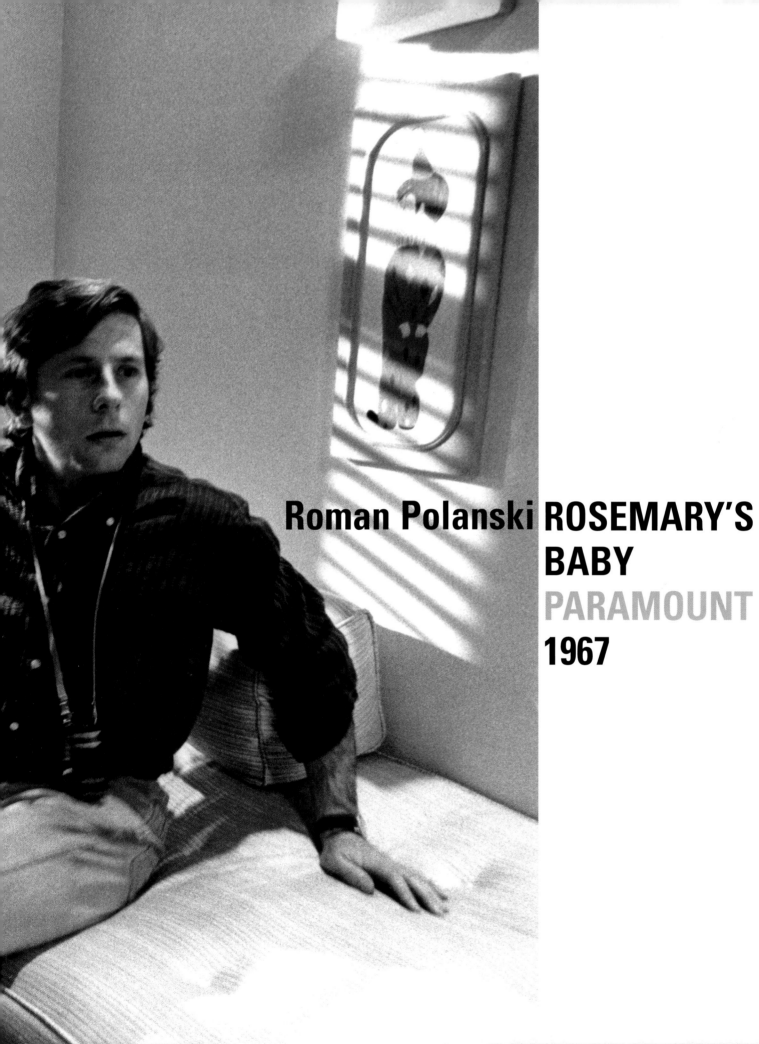

Roman Polanski ROSEMARY'S BABY PARAMOUNT 1967

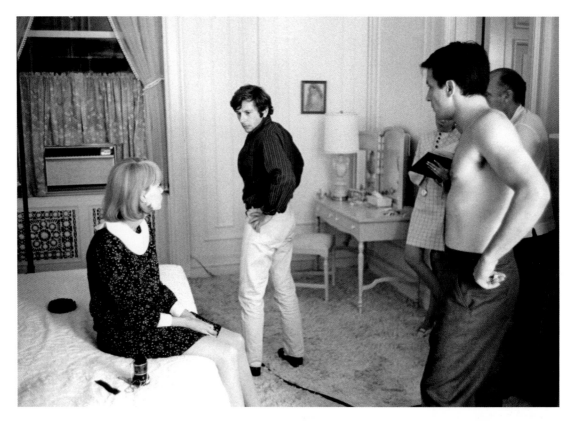

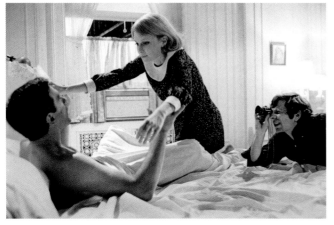

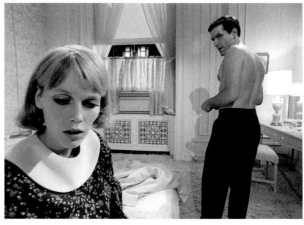

Working with Roman Polanski was an experience. There was never a dull moment on the set of *Rosemary's Baby*. The story was downbeat and rather spooky, what with Mia Farrow's character, Rosemary, having the Devil's baby, but Roman and Mia were like two kids playing. They had cowboy holsters, and practiced quick draws while waiting for production to begin. This tended to drive John Cassavetes crazy at times, since he was a very serious actor (and movie-maker) and these high jinks were not his cup of tea.

TOP AND ABOVE RIGHT *Roman Polanski shows John Cassavetes how to stand and turn around to look at Mia Farrow.*

ABOVE LEFT *John in rehearsal with Mia, as Polanski watches closely with the viewfinder.*

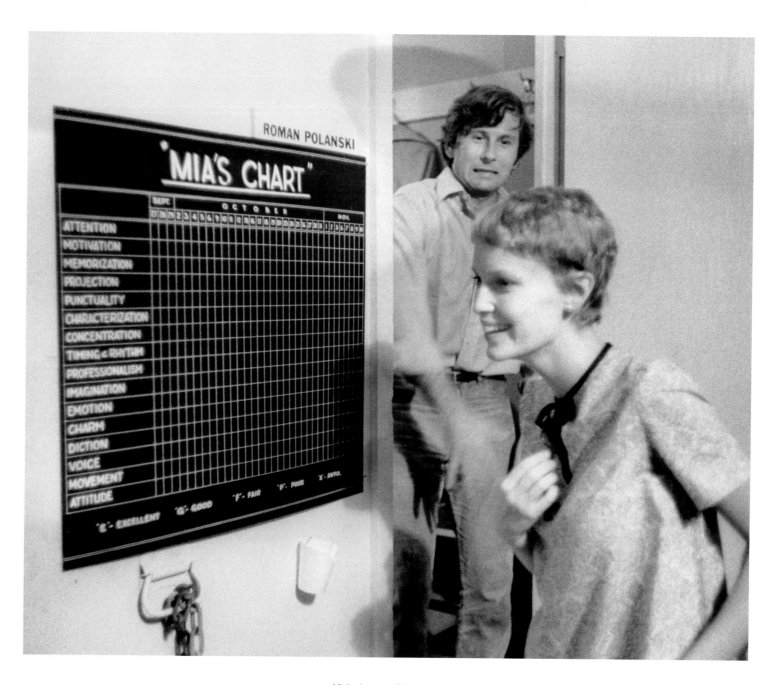

ABOVE *Mia's chart, on which
she is graded for her attention,
motivation, punctuality, and so
on. Roman had this made up
for her as a joke.*

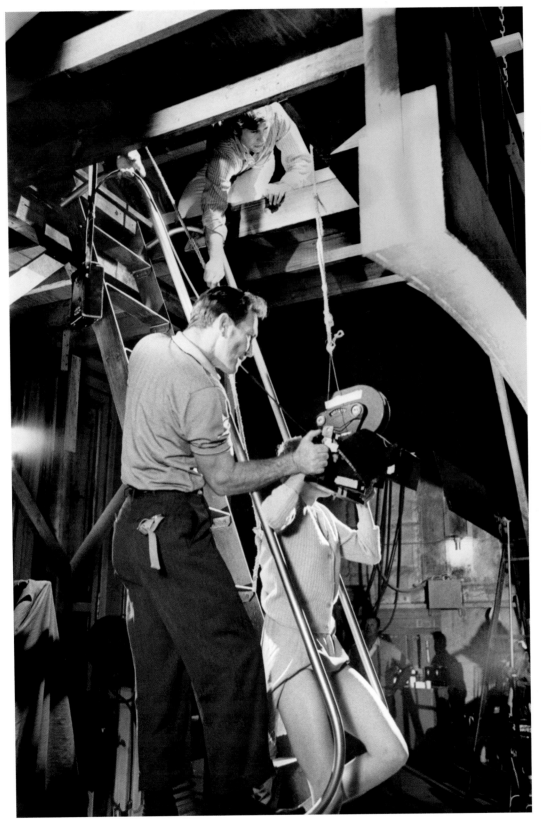

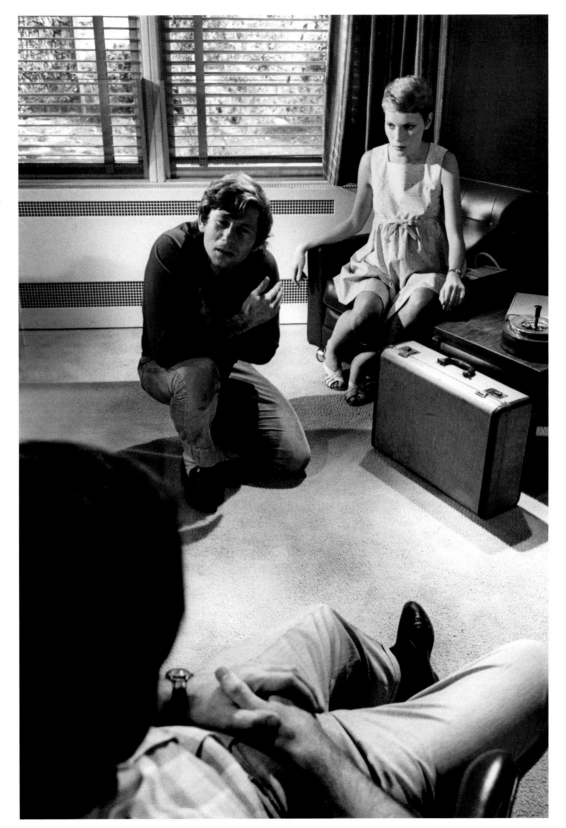

RIGHT *Polanski dramatizes the action for Mia and Charles Grodin (foreground), in the scene where Rosemary goes to him with a dread feeling of some evil conspiracy involving her and her baby. Grodin's character, of course, is part of that conspiracy*

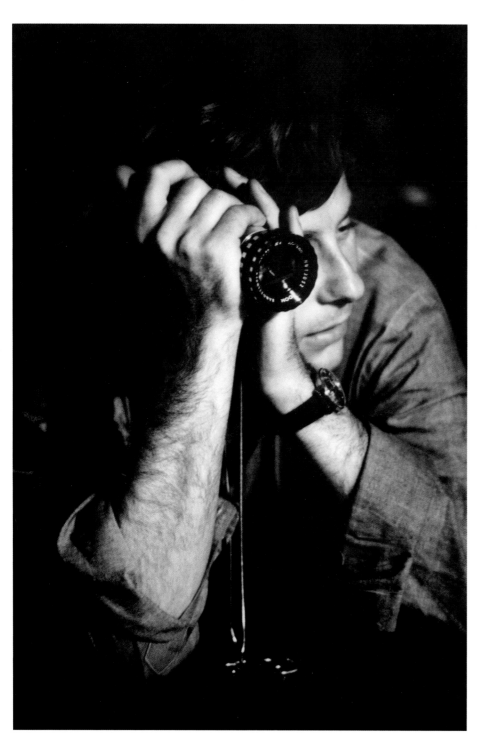

Roman Polanski was the youngest director I had worked with, and no one could accuse him of being from the "old school" in any way. Working on the set was always visually exciting, and photographing the action was no problem, but I was having trouble getting a storyline and realized he never photographed a master shot of the scene, just individual reaction shots. When I asked him about this, he pulled me aside to speak privately and said he never made a master because in that way it would be more difficult for the studio to re-cut his film. (I guess the experience of so many directors having their films ruined by studio executives had filtered down to him, and he had devised this way to subvert that possibility.)

It meant however that I had to re-stage everything for my storyline, which wasn't easy, for Roman worked very fast. I only asked for a special shot when there was no other way to get what I needed. This worked very well, and one day Roman and John Cassavetes (as very special and expensive special-effects men) even blew smoke into one of my shots, showing Mia feeling dizzy after being drugged by her neighbor's dessert (*below*).

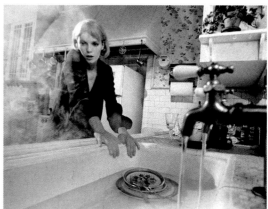

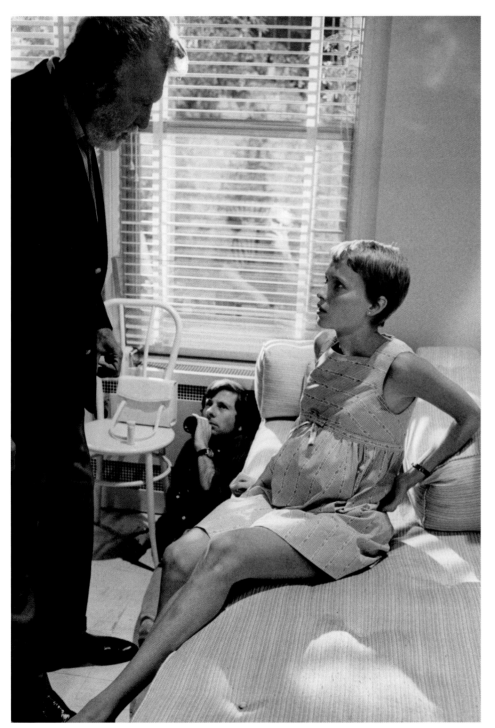

LEFT *Roman watches Ralph Bellamy rehearse with Mia.*

BELOW *Rosemary feels threatened by Dr. Saperstein and her husband Guy (Ralph Bellamy and John Cassavetes).*

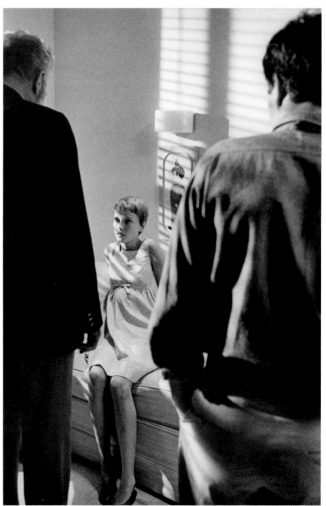

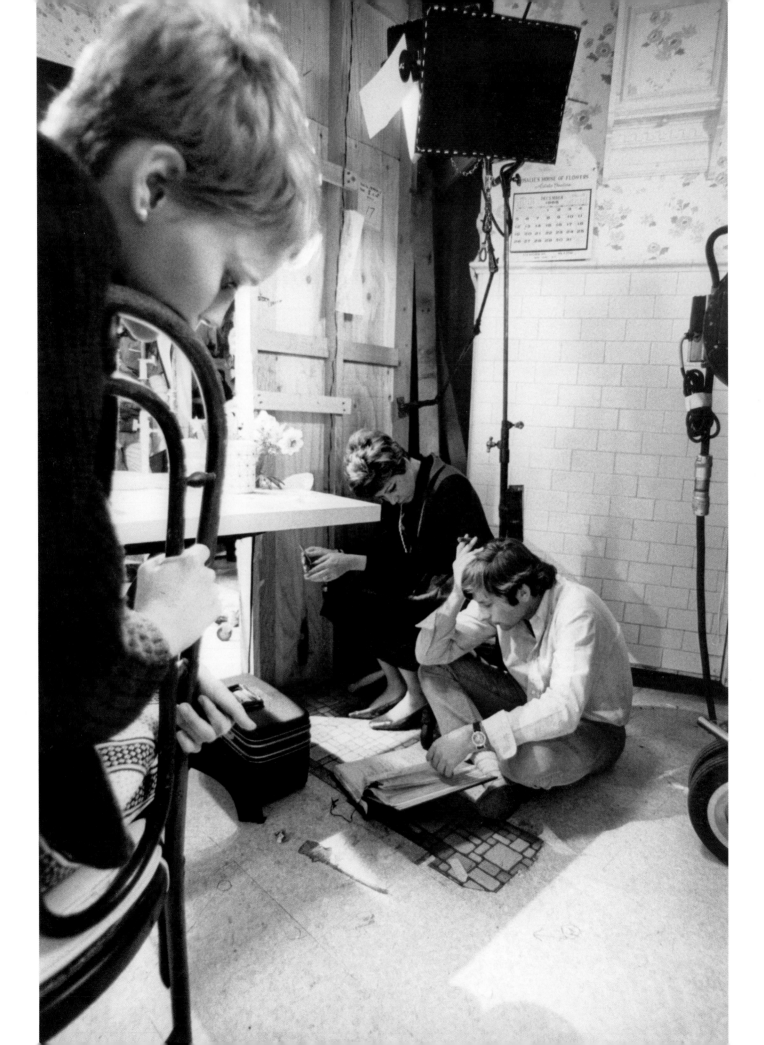

LEFT *Polanski sits with his script supervisor and tries to solve a hiccup in the shooting schedule, while Mia Farrow sits waiting for him to come out and play.*

RIGHT *Roman works out with camera operator David Walsh how to photograph the Devil raping Rosemary.*

BELOW *My image of Mia as Rosemary and her nightmare.*

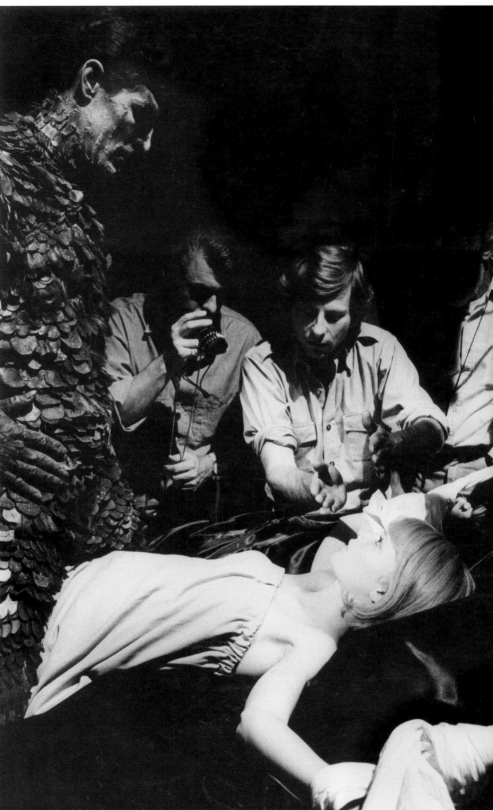

Polanski wanted the terror in Rosemary's face to show in closeup, as the witches' coven throws her on the bed and she is fighting for her and her baby's life. So Polanski and David Walsh, operating the wild camera, go right up on the bed (*right*). There is quite a crowd, with the actors and technicians. You can see the gaffer holding the light on Mia's face, the sound boom coming in. It was wild!

ABOVE *Cinematographer William Fraker laughs as he tries to support David Walsh with the camera and all the batteries around his waist.*

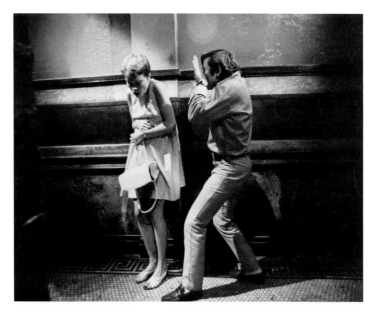

LEFT *A rehearsal in the hall outside Rosemary's apartment: Polanski follows Mia, using his hands as the camera frame.*

BELOW *Polanski isn't shy about taking the wild camera and photographing what he wants himself.*

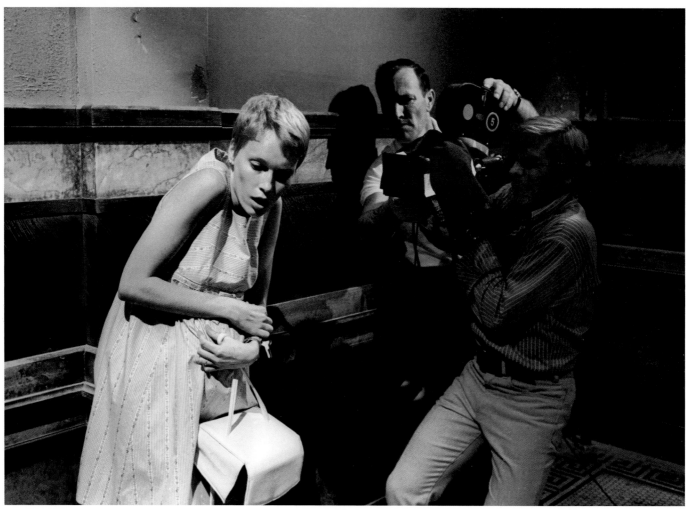

RIGHT AND BELOW *There seemed to be a good relationship between Polanski and Farrow. There was a closeness that I noticed at the time—not in the romantic sense, perhaps more like brother and sister. In the large photo, Mia has gone back to his dressing room (not hers) to rest after the emotional ordeal she has just endured in the scene with the witches' coven. One could see she was comfortable doing this. In the smaller image, you can see the way she looks at him, which said a lot to me.*

Anthony Harvey

born London, England, June 3, 1931

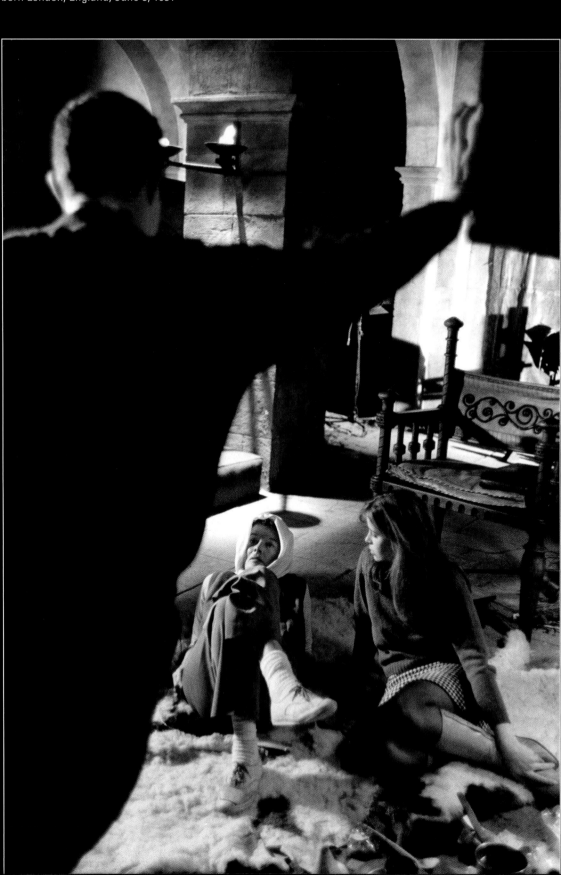

LEFT *Harvey leans on the wall talking to Katharine Hepburn and Jane Merrow on the French location (Montmajour Abbey, Provence).*

BELOW *Katharine Hepburn and Peter O'Toole are watched by Harvey during rehearsals at Montmajour.*

The Lion in Winter, 1968.

FILMS

The Dutchman *(1966)*
The Lion in Winter *(1968)*
They Might be Giants *(1971)*
The Glass Menagerie *(TV: 1973)*
The Abdication *(1974)*
The Disappearance of Aimee *(TV: 1976)*
Eagle's Wing *(1979)*
Players *(1979)*
The Patricia Neal Story *(TV: 1981)*
Richard's Things *(1981)*
Svengali *(TV:1983)*
Grace Quigley/The Ultimate Solution of Grace Quigley *(1984)*
This Can't Be Love *(TV: 1994)*

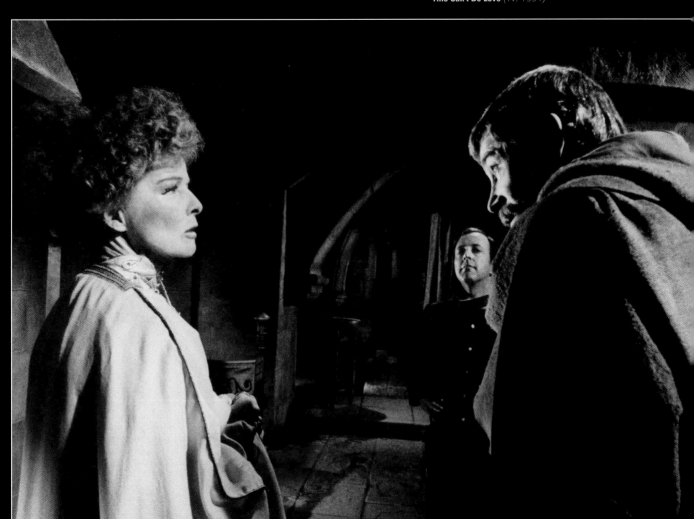

Anthony Harvey THE LION
IN WINTER
AVCO-EMBASSY
1968

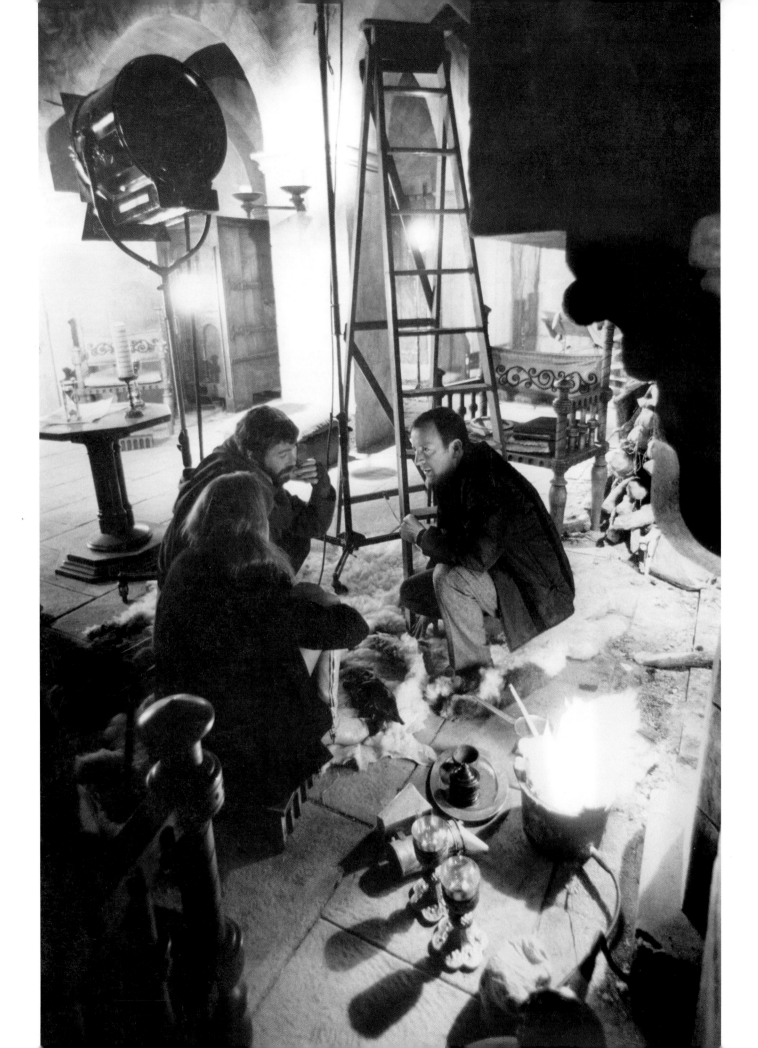

Anthony Harvey trained as an actor in London before becoming a film editor, and was credited with the editing of several important films in the 1960s, including *Dr. Strangelove*, directed by Stanley Kubrick, and *The Spy Who Came in from the Cold*, directed by Martin Ritt. His first film as a director was *The Dutchman* in 1966, which didn't make much of an impression at the time, and he must have been over the moon when Embassy dropped *The Lion in Winter* into his lap.

This was the best script I have ever read, by the very talented James Goldman, adapted from his own play. The cast was also very special: Katharine Hepburn, Peter O'Toole, Anthony Hopkins, Nigel Terry, John Castle, Timothy Dalton—it went on and on. How they selected Harvey to direct I never discovered. Producer Martin Poll told me that they had another film that fell through, and at the last minute they were able to cobble this one together. We started filming at the National Film Studio in Ireland and then moved into the golden light of Provence.

LEFT *Anthony Harvey in private rehearsals with Peter O'Toole and Jane Merrow.*

RIGHT *Harvey with Katharine Hepburn, who I think rather adopted him during the filming.*

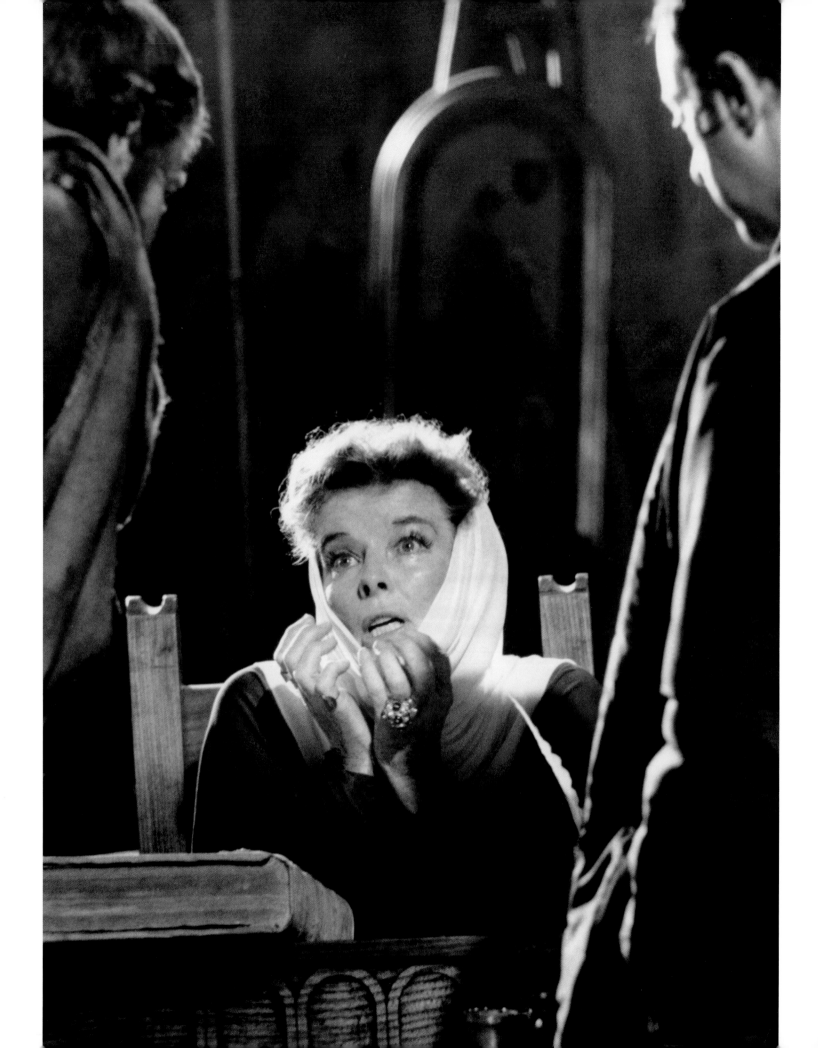

I felt that it was very difficult for Harvey to cope with the strength and experience of the two leads. He was obviously way out of his depth with such talents. He fought for control, and gained it only with the indulgence of Kate Hepburn (*left*).

Peter O'Toole was somewhat erratic at first and Monday mornings were not his great thing, but Kate took no prisoners. She told O'Toole in no uncertain terms that if he wanted to work with her he had better shape up. And shape up he did, and was bloody marvelous in the role of Henry II.

With the great script, peopled with such good actors, and with such fine photography from Douglas Slocombe, it would have been quite hard not to get a good film, no matter what Harvey did. At times the actors just ran right over him.

In France, when we were photographing in the ruins of Montmajour Abbey near Arles, for some reason we spent all our days in the cellar filming, while outside the sun shone. We emerged to eat lunch and enjoy the sun and the wonderful landscape that inspired so many French painters, and then it was back down below.

Whether it was the assistant director or Harvey who made the decision to shoot the interiors first, I don't know. On location the rule is to shoot all your exteriors while you have the weather, saving your interiors as a backup. When we finally emerged from the cellar we were inundated with rain.

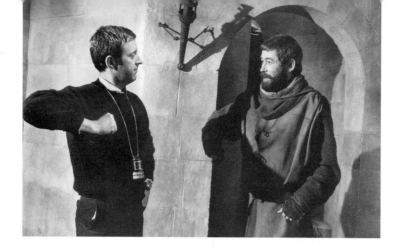

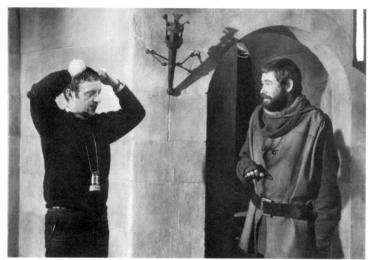

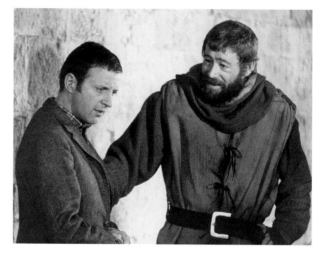

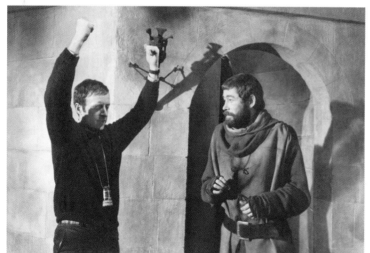

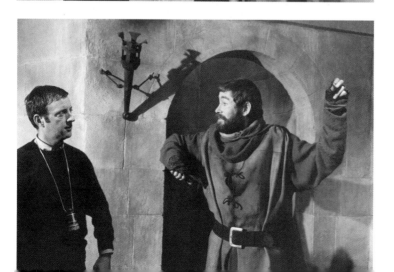

Anthony Harvey

Art director Peter Murton had serious problems with the weather. He had built a dock along the river where Eleanor of Aquitaine arrives for her visit with Henry and their boys. The storm washed it away, and the river was then so swollen that they had to build another, further up the bank. The rain persisted and the river washed that one away as well. With the constant downpour and because there were no interiors left to fall back on, all the production could do was wait it out.

ABOVE *Montmajour Abbey in France. You can see the marvelous additions that Peter Murton and his elves have added to make it look contemporary to the period of the film.*

RIGHT *Sitting on the back of the camera crane, Harvey watches O'Toole and Hepburn's exit from the castle door, as they film during a break in the weather.*

Bob Joseph was our publicity man, an old hand at the game. For some reason, Harvey took a passionate dislike to him. He forbade Bob to come on the set when we were working in France.

Obviously this made it really difficult for Bob to do his job. One day, with an important message to give me, he came down very surreptitiously to the cellar where we were filming. He caught my eye, and we went behind a studio flat that served as a false wall to talk.

Harvey somehow must have noticed him arrive, and while we were talking I saw this blur running toward us out of the corner of my eye. At full tilt he pushed the flat over on Bob, who wasn't hurt; but we just could not believe such petulant behavior coming from a supposedly mature man.

In retrospect, I guess the only explanation for such a churlish act is that he really must have been hurting under the stress of making the film.

ABOVE *Harvey and Kate Hepburn have a moment together before moving to the next set-up*

RIGHT *Harvey watches from the shadows as Peter O'Toole and Kate Hepburn begin rehearsing.*

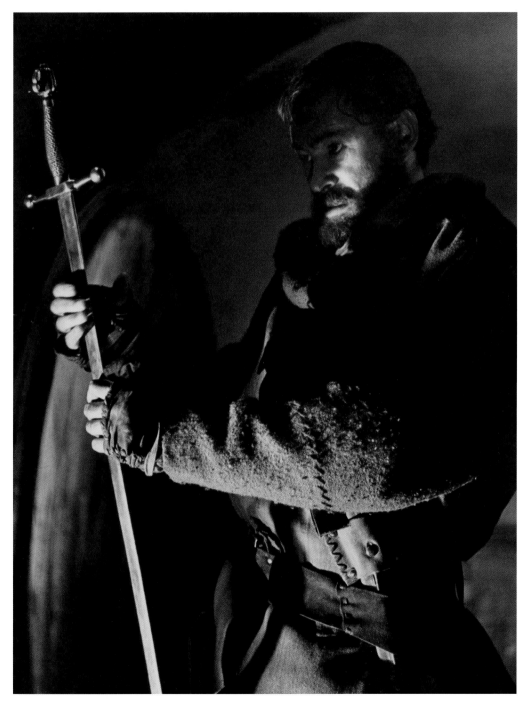

BELOW AND LEFT *Harvey demonstrates how he would like O'Toole to hold the sword in the coming scene, and then O'Toole does it his way.*

Anthony Harvey

BELOW *O'Toole's coat bears the legend "Tiger O'Toole the Paperweight Champ," while Hepburn's reads "Tiger O'Toole's Wife."*

RIGHT *Harvey, with a false mustache and beard supplied by makeup, gets a chuckle from Hepburn and O'Toole.*

There were light moments on the set, supplied mainly by the actors.

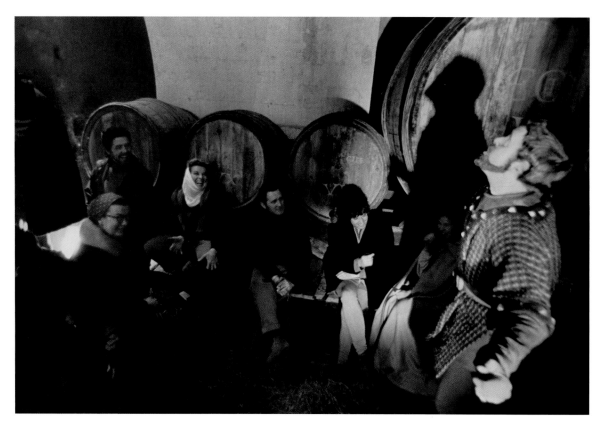

ABOVE *Hopkins threatens to run Harvey through with his sword.*

LEFT *Tony Hopkins has everyone falling about the place with his wonderful imitations, including "taking off" the crew (against the barrels, left to right: assistant director Kip Gowans, Kate Hepburn, boom man Tom Buchanan, John Castle, and Jane Merrow).*

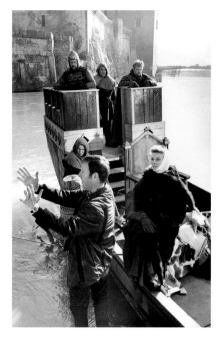

Landing on the river without a dock created problems in getting Kate ashore. Eventually, on the first sunny day, they managed to land her on the edge of the river. Henry II (*below*) greets his exiled wife, with his girl-friend Princess Allays just behind him (Jane Merrow, *below right*).

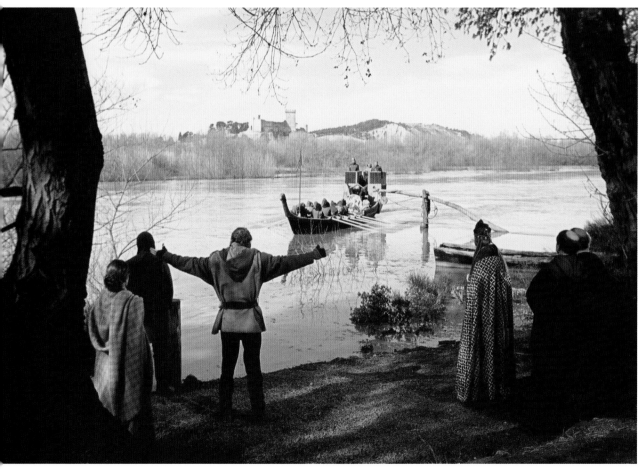

Anthony Harvey

This photograph (*right*) was taken in Carcassonne, where Anthony Hopkins, as Richard the Lionheart, takes off his helmet after the joust is over. Then he was put up on the horse in full armor, his helmet covering his face. Hopkins was afraid of horses, and told assistant director Kip Gowans this. The horse, uncomfortable with the strange armor, reared, and to everyone's horror threw Hopkins to the ground.

We thought he was gone—the crunch was horrible to hear—and everyone ran to help. Falling in full armor could easily break one's neck. Fortunately nothing that serious occurred, but he did break his arm. There was no need to put a principal player up on a horse, especially with his helmet covering his face. It was inexcusable.

The next day it actually snowed (very rare in the south-west of France) so the company broke and returned to the UK for several weeks until the arm was healed well enough to film those last shots of the jousting. When we returned to London, heading for Wales, they were having a heatwave. By the time the train arrived in Wales just hours later, it was snowing again. Was someone up there trying to tell us something?

Katharine Hepburn won an Oscar for her role as Eleanor and James Goldman also won for his brilliant screenplay, but dear Peter O'Toole was criminally passed over, as he would be time and time again.

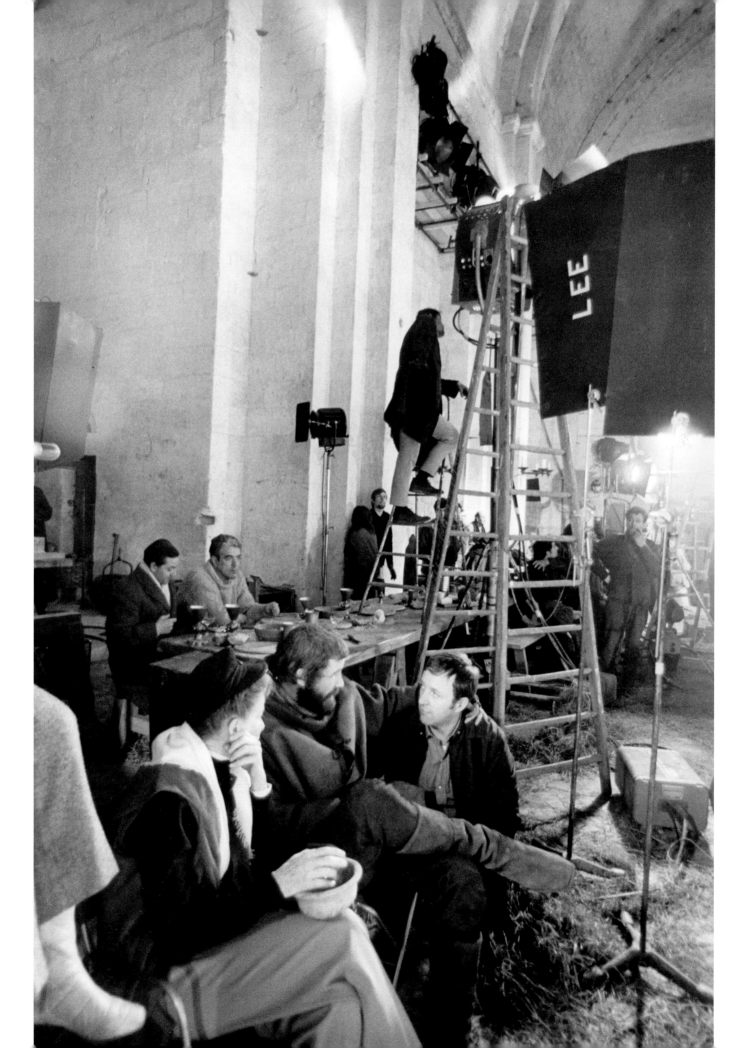

Herbert Ross

born New York City, May 13, 1927; died New York City, October 9, 2001

I worked with Herbert Ross when he was doing the choreography on *Carmen Jones* in 1954, and again on *Doctor Dolittle* in 1967. When I was assigned to the musical version of *Goodbye Mr. Chips* in 1969 it was a pleasure to see him again (*photographs on these pages*). This was his first film as a director, and if he was nervous about that, he never showed it, taking center stage (*below at Sherborne School in the UK*).

Ross has great visual style and flair, and you could see the promise of things to come in this production. His films are consistently a pleasure to watch.

BOTTOM LEFT *Ross and Peter O'Toole (who was marvelous in the part of Mr. Chips) have a moment outside the school, during a break.*

BELOW *On the Pompeii location in Italy, Ingrid Bergman came to visit (center is producer Arthur Jacobs, and far right playwright Terence Rattigan).*

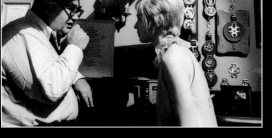

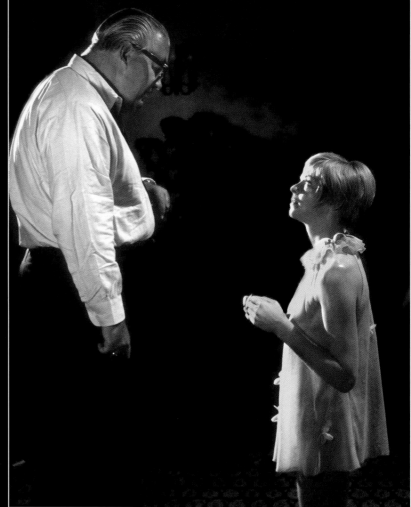

ABOVE AND RIGHT *Robert Aldrich was jovial, and serious in his direction. Here he talks to Susannah York.*

The Garment Jungle *(replaced by Vincent Sherman, who got sole credit; 1957)*
Ten Seconds to Hell *(also co-scripted; 1959)*
The Last Sunset *(1961)*
What Ever Happened to Baby Jane? *(also produced; 1962)*
Sodoma e Gomorra/Sodom and Gomorrah *(co-directed with Sergio Leone; 1962)*
4 for Texas *(also produced and co-scripted; 1963)*
Hush … Hush, Sweet Charlotte *(also produced; 1965)*

The Longest Yard *(1974)*
Hustle *(also produced; 1975)*
Twilight's Last Gleaming *(1977)*
The Choirboys *(1977)*
The Frisco Kid *(1979)*
… All the Marbles *(1981)*
The Angry Hills *(1981)*

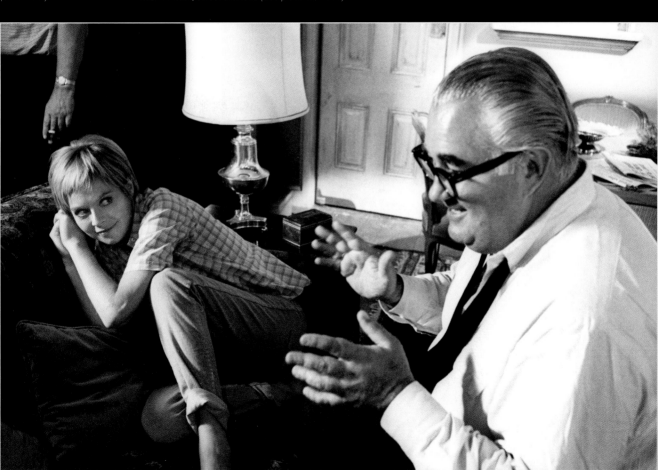

BELOW *Bob Aldrich relates some experience on one of his films to Susannah York and Beryl Reid (out of shot).*

Sydney Pollack

born Lafayette, Indiana, July 1, 1934

ABOVE *Sydney Pollack directs the traffic on the Warner Brothers sound stage from high up in the lights.*

The images on these pages are from They Shoot Horses, Don't They?, *Warner Brothers, 1969*

FILMS

(as director)

Alfred Hitchcock Presents *(TV series; 1955)*
Ben Casey *(TV series; 1961)*
The Alfred Hitchcock Hour *(TV series; 1962)*
The Fugitive *(one episode, TV series; 1963)*
The Slender Thread *(1965)*
This Property is Condemned *(1966)*
The Swimmer *(one sequence only; 1968)*
The Scalp-Hunters *(1968)*
Castle Keep *(1969)*
They Shoot Horses, Don't They? *(1969)*
Jeremiah Johnson *(1971)*
The Way We Were *(1973)*
The Yakuza *(also produced; 1975)*
Three Days of the Condor *(1975)*
Bobby Deerfield *(also produced; 1977)*
The Electric Horseman *(1979)*
Absence of Malice *(also produced; 1981)*
Tootsie *(also produced; 1982)*
Out of Africa *(also produced; 1985)*
Havana *(also produced; 1990)*
The Firm *(1993)*
Sabrina *(also produced; 1990)*
Random Hearts *(1999)*

LEFT *Pollack holds his hand over the microphone while he gives last-minute instructions to Jane Fonda.*

BELOW *Sydney Pollack with Jane Fonda and Michael Sarrazin.*

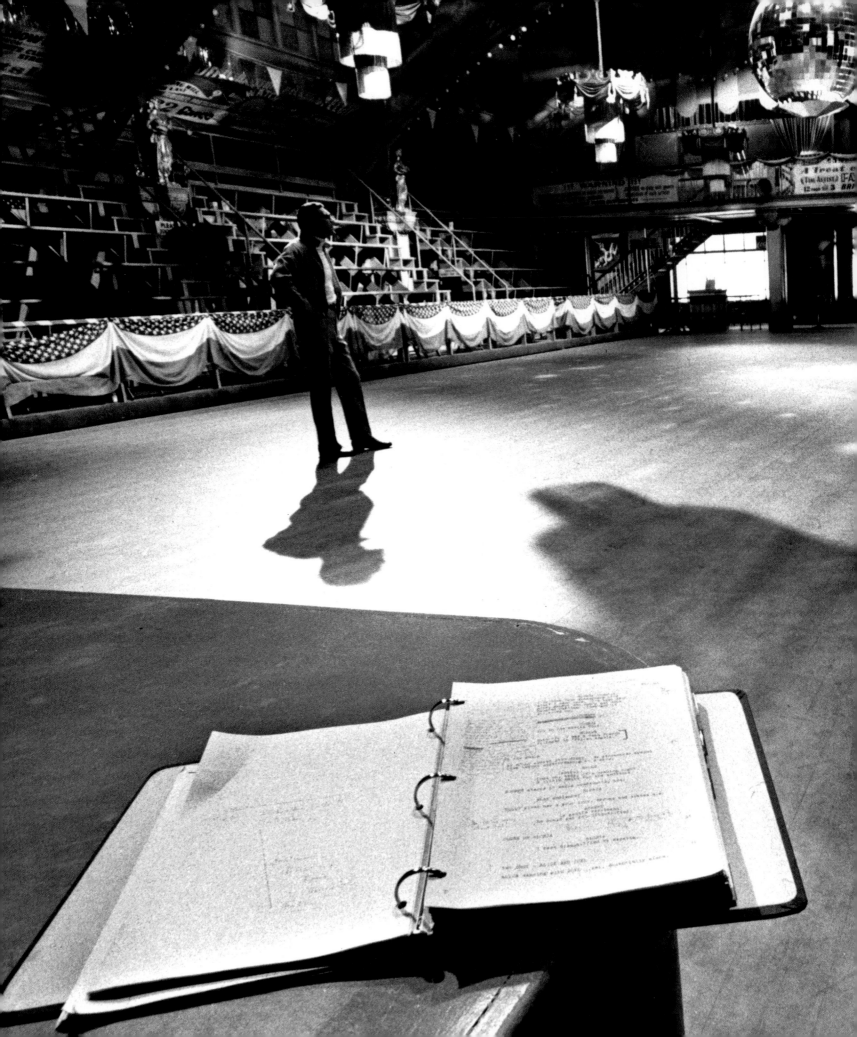

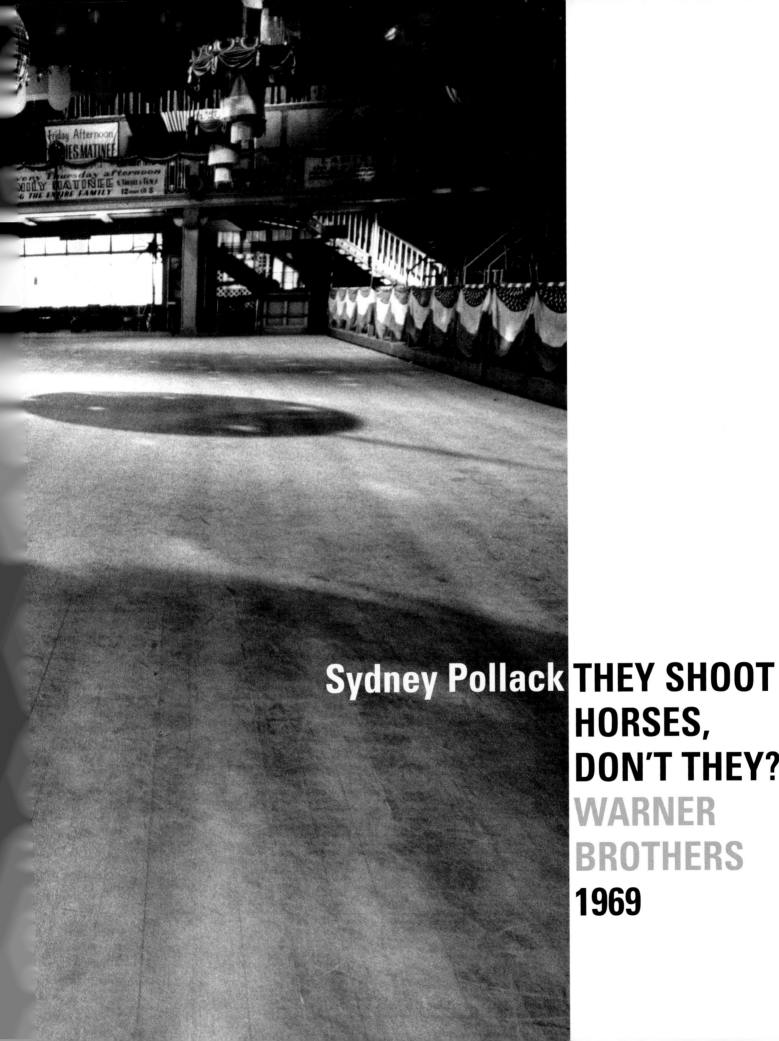

Sydney Pollack **THEY SHOOT HORSES, DON'T THEY?** WARNER BROTHERS 1969

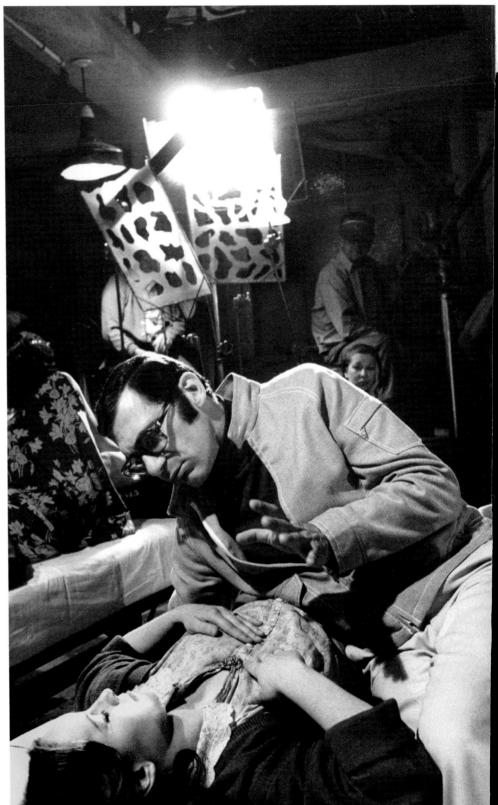

The screenplay, taken from the bestselling novel by Horace McCoy, is set in the US Depression era, when dance marathons were the rage. This surely was the most exhausting film for actors that I've ever worked on. Sydney Pollack had a good cast: Jane Fonda, Michael Sarrazin, Susannah York, Gig Young, Red Buttons, Bonnie Bedelia, Bruce Dern, and many, many others. They had not only to dance all day for the film, but also to sprint, run—you name it. It was exhausting just to watch. You could see some of the actors sleeping on the set whenever they could get a moment from the pace that Sydney set.

For me, this was a film that my radio-controlled cameras and silent blimp were made for. With a 360-degree track on the set, there was often no place for a photographer to hide. But with Sydney's help I could solve it all. Sydney was the most cooperative director with whom I have ever had the pleasure to work. He was interested in what I was doing, and wanted to be sure I was able to get my shot. He would hold the roll until my radio-controlled cameras were in place and ready to track his action. Consequently I was able to get exciting images of the main action of the film.

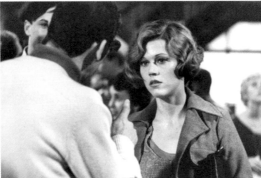

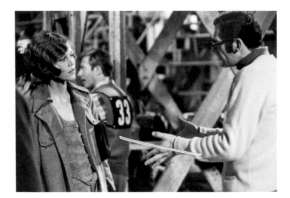

Sydney was a dynamic director. Also, as an actor himself, he was very understanding when his actors came to him about direction. Jane Fonda listens carefully as Sydney explains where he is going with her character (*above, above left, and left*). Jane was very conscientious on this. In fact everyone seemed to be, and it was amazing to see the dedication even from the extras. I give all the credit for this feeling to the way Sydney created an energy and excitement on the sound stage.

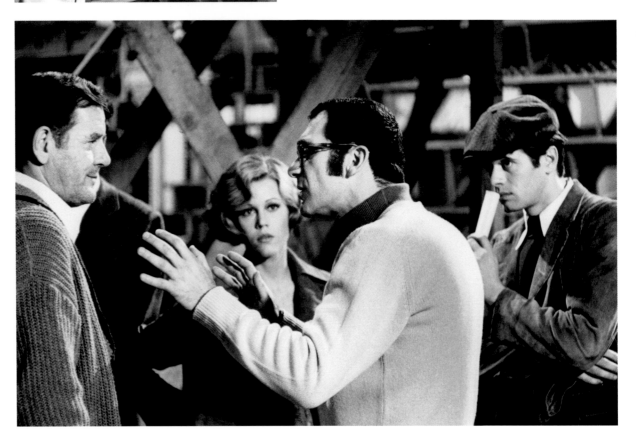

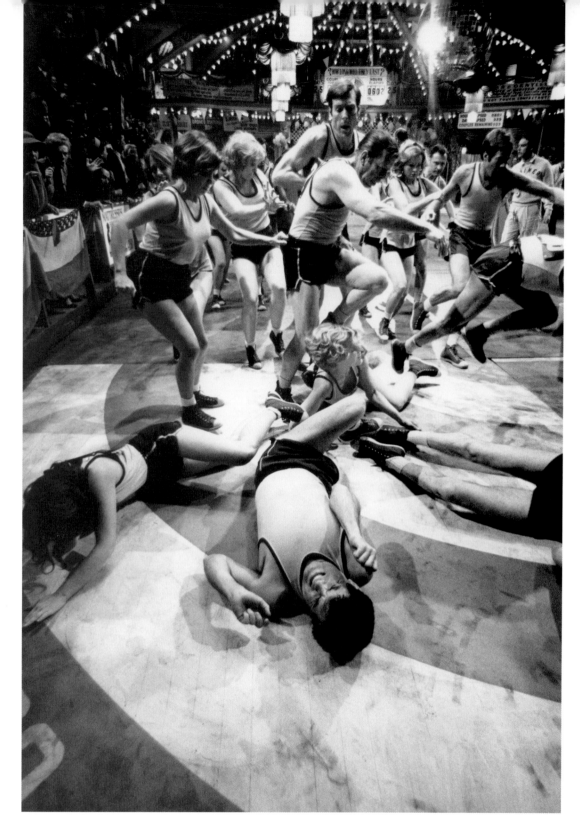

There was this air of excitement at times, and I think there was a feeling that this was going to be a "special" film. The French love it, and feel it is probably the only existential film to ever come out of Hollywood.

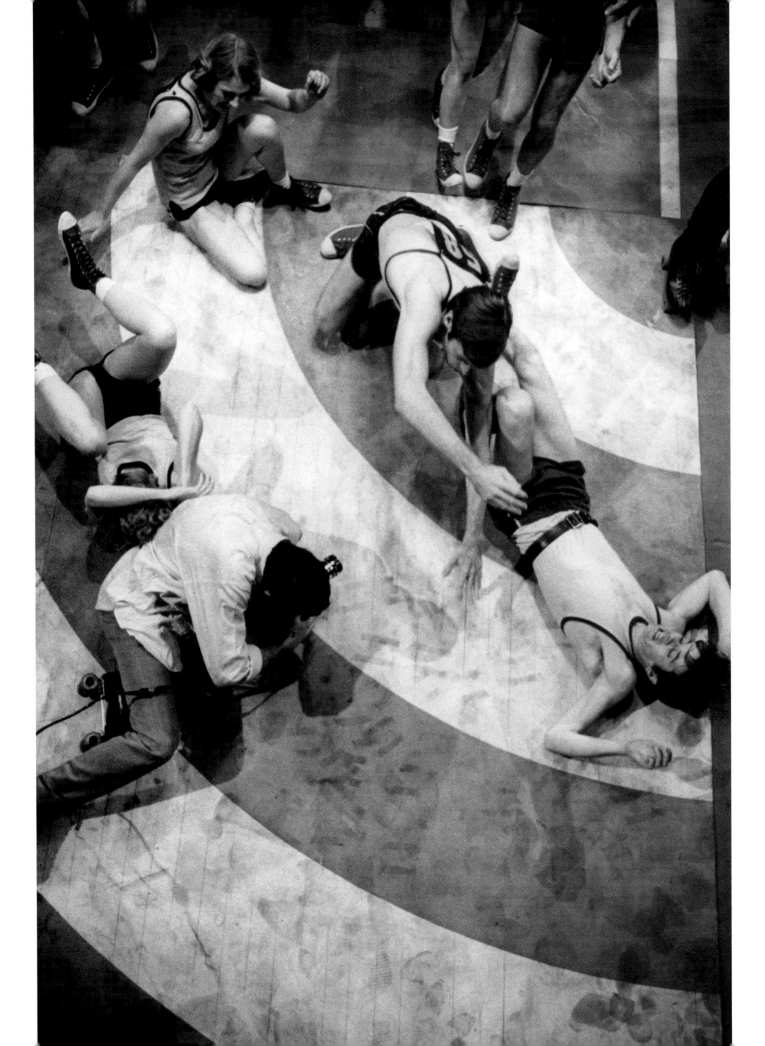

The final race was grueling for everyone. It was filmed with the grips pulling the camera dolly around the 360-degree track at top speed. Without my radio-controlled cameras it would have been impossible to photograph this exciting action.

LEFT *Bruce Dern and Bonnie Bedelia (playing his character's pregnant wife) try to thrust through the crowd, desperate to win.*

BELOW AND RIGHT *Jane Fonda and Red Buttons struggle on.*

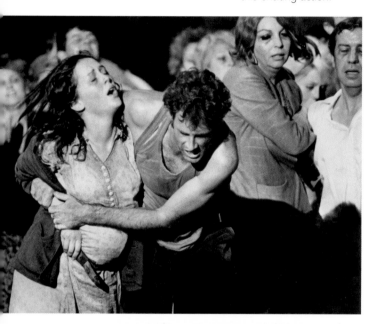

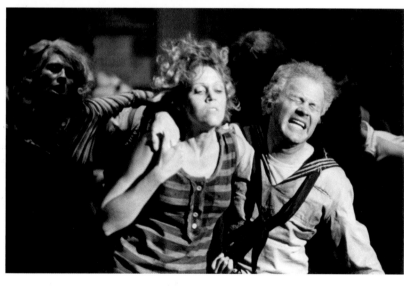

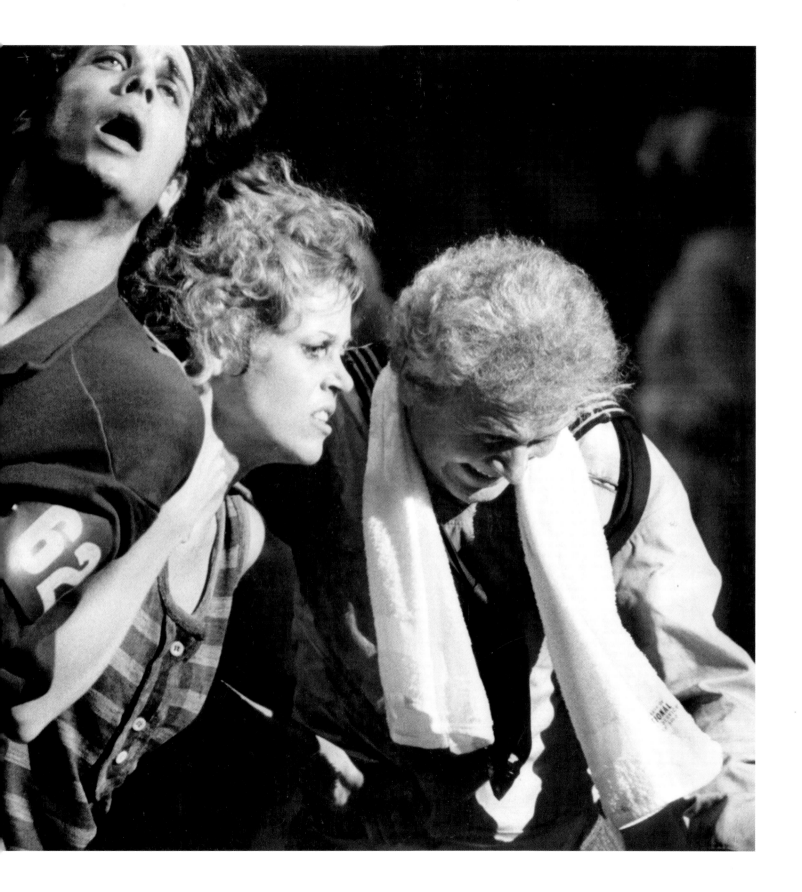

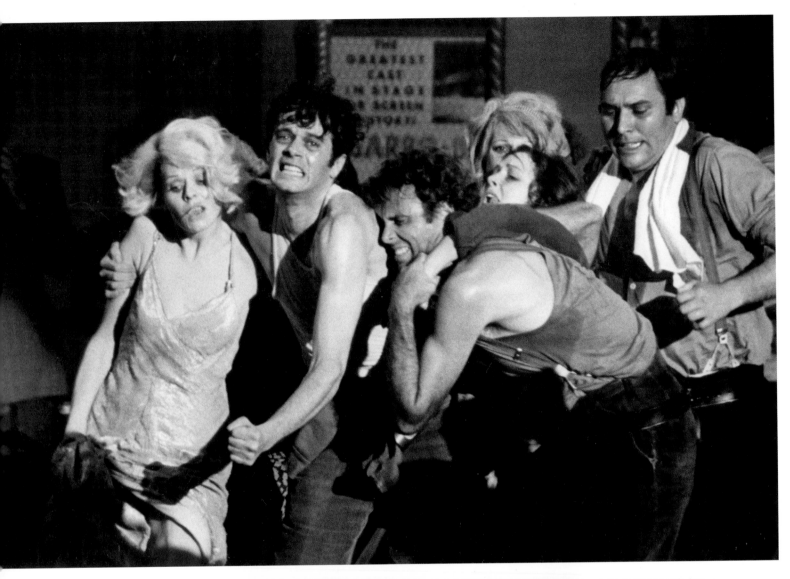

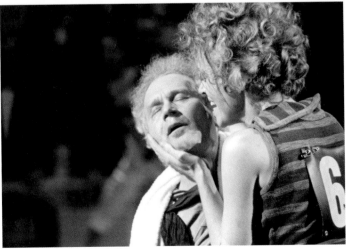

ABOVE *Susannah York and Michael Sarrazin try to keep Bruce Dern and Bonnie Bedelia from breaking through near the finish line.*

LEFT *As the race ends, Jane Fonda discovers with horror that Red Buttons has had a heart attack and died in her arms.*

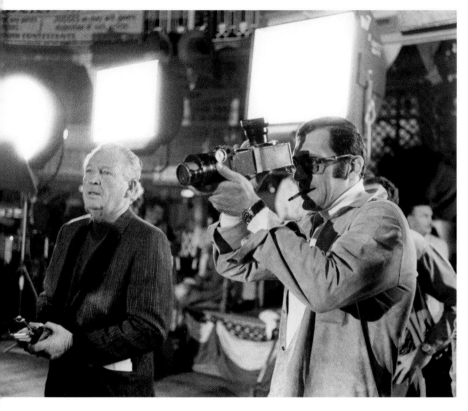

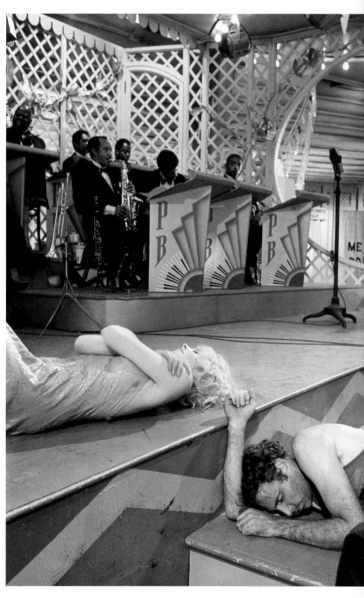

For me it was all very exciting, and a successful film to have worked on, thanks to the understanding and interest of Sydney Pollack.

Orson Welles

George Orson Welles; born Kenosha, Wisconsin, May 6, 1915; died Hollywood, California, October 10, 1985

I never had the chance to work with Orson Welles when he was directing, but our paths did cross in Guaymas, Mexico, in 1969, when he was playing General Dreedle in Mike Nichols's film of *Catch 22* (*pictured here*). One of the best things on this location was the many discussions between Welles and Nichols on how to film a scene. "If you do that shot, you don't need to pick up the other two!" Well, I almost forgot to take pictures when these two talents met head to head. It was great.

I must have seen *Citizen Kane* at least fifteen times in Los Angeles in the early 1950s. I had been taking classes at the USC Cinema Department, and I thought this was the greatest film I had ever seen, and Welles was my hero. The film world treated him shamelessly: his great directorial talents were left to wither on the vine. He fought like crazy to fund his projects, but it was like Don Quixote tilting at windmills. He was a giant with unfulfilled potential—and by the way, he's still my hero.

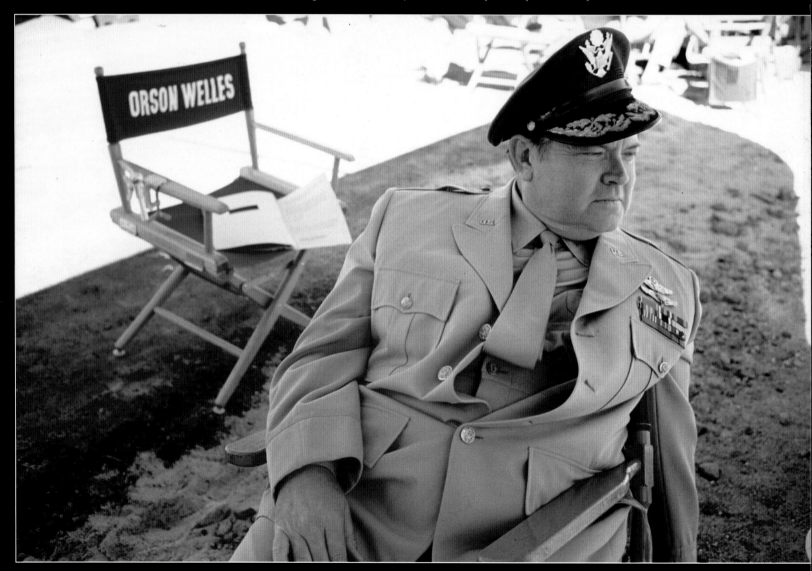

FILMS

The Hearts of Age *(short; 1934)*
Too Much Johnson *(stage insert, never shown publicly; 1938)*
Citizen Kane *(also produced, co-scripted, and acted title role; 1941)*
The Magnificent Ambersons *(also produced, scripted, and off-screen narration; 1942)*
Journey into Fear *(uncredited; also co-produced and co-scripted; 1943)*
The Strangers *(also co-scripted, uncredited, and acted; 1946)*
The Lady from Shanghai *(also scripted and acted; 1948)*
Macbeth *(also produced, scripted, and acted; 1948)*
The Tragedy of Othello: The Moor of Venice *(also produced, scripted, and acted; 1952)*

Mr. Arkadin/Confidential Report *(also story, scripted, art-directed, costumes, and acted; 1955)*
Don Quixote *(unfinished; 1955)*
Touch of Evil *(also scripted and acted; 1958)*
Le Procès/The Trial *(also scripted and acted; 1962)*
Campanadas a Medianoche/Chimes at Midnight *(also co-scripted, costumes, and acted; 1966)*
Une histoire immortelle/The Immortal Story *(1968)*
The Deep *(unfinished; 1969)*
The Other Side of the Wind *(unfinished; 1972)*
Vérités et mensonges/F for Fake *(additional footage by François Reichenbach; also co-scripted and acted; 1975)*

BELOW *Welles is interviewed by director Peter Bogdanovich (who wrote the book* The Cinema of Orson Welles*). The pretty blonde photographing the two of them is actress Candice Bergin.*

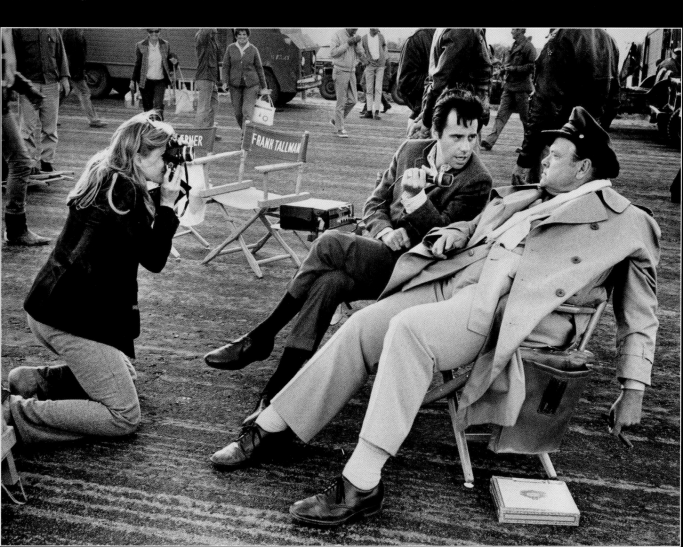

Anatole Litvak

Michael Anatol Litwak; born Kiev, Russian Empire (now Ukraine), May 10, 1902; died Neuilly, France, December 15, 1974

Anatole Litvak was sixty-eight when he made his last film, *The Lady in the Car with Glasses and a Gun*, in 1970 (Lira Film/Columbia), but one would have thought he was twenty years younger. His enthusiasm was contagious, and he was so filled with energy that after shooting all day he would make special things in the hotel kitchen for the cast (and this lucky photographer, yes; and teaching the French chefs a thing or two).

LEFT *Director Anatole Litvak watches Samantha Eggar rehearse, on the night location in the South of France.*

ABOVE *Litvak demonstrates during rehearsal just how he wants actor John McEnery to lie down next to the lovely Samantha Eggar (one of the perks of being a director).*

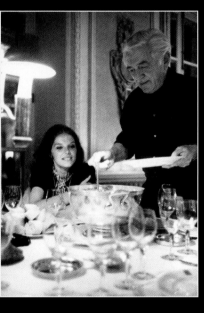

LEFT *You can see him serving his special salad to Samantha Eggar, his star in the film.*

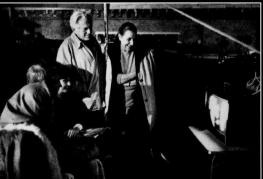

LEFT *This photograph was taken during an evening meal. The catering people had their television on, and it happened to be playing Litvak's wonderful film Anastasia, with Ingrid Bergman. The crew took their plates of food and stood around watching it. It was a very nice moment for Litvak, and the young French and British crew could see just what he was about.*

FILMS

Tatiana *(short; 1923)*
Hearts and Dollars *(short; 1924)*
(in Germany)
Dolly macht Karriere/Dolly's Way to Stardom *(1930)*
Nie wieder Liebe/No More Love/Calais–Douvres *(1931)*
Das Lied einer Nacht/The Song of Night *(1932)*
Tell Me Tonight/Be Mine Tonight *(1932)*
(in France)
Coeur de Lilas *(1932)*
(in UK)
Sleeping Car *(1932)*
(in France)
Cette vieille canaille/The Old Devil *(also co-scripted; 1933)*
L'Equipage/Flight into Darkness *(also co-scripted; 1935)*
Mayerling *(1936)*
(in US)
The Woman I Love *(remake of L'Equipage; 1937)*
Tovarich *(1937)*
The Amazing Dr. Clitterhouse *(also produced; 1938)*
The Sisters *(1938)*
Confessions of a Nazi Spy *(1939)*
Castle on the Hudson *(1940)*
All This, and Heaven Too *(also produced; 1940)*
City for Conquest *(also produced; 1940)*
'Til We Meet Again *(uncredited; 1940)*
Out of the Fog *(1941)*
Blues in the Night *(1941)*
This Above All *(1942)*
The Nazis Strike *and* **Divide and Conquer** *(WWII documentari co-directed with Frank Capra; 1942)*
Prelude to War *(uncredited; 1943)*
Operation Titanic *(WWII documentary; 1943)*
The Battle of Russia *(WWII documentary; 1943)*
The Battle of China *(WWII documentary co-directed with Fran Capra; 1944)*
War Comes to America *(WWII documentary; also co-scripted;*
The Long Night *(also co-produced; 1947)*
Sorry, Wrong Number *(also co-produced; 1948)*
The Snake Pit *(also co-produced; 1948)*
Decision before Dawn *(also co-produced; 1951)*
Act of Love *(also produced; 1954)*
The Deep Blue Sea *(also produced; 1955)*
Anastasia *(1956)*
Mayerling *(TV production; 1957)*
The Journey *(also produced; 1959)*
Goodbye Again *(also produced; 1961)*
Five Miles to Midnight *(also produced; 1962)*
The Night of the Generals *(1967)*
The Lady in the Car with Glasses and a Gun *(also co-produce*

Alan J. Pakula

born The Bronx, New York, April 7, 1928; died Melville, Long Island, New York, November 19, 1998

Alan Pakula was first known as a producer, and in partnership with director Robert Mulligan, scored successes with such films as *To Kill a Mockingbird*. In 1969 he started taking over the directing reins himself, with *The Sterile Cuckoo*. I was lucky enough to do a little work on Alan's second film, *Klute* (Warner Brothers), in 1970.

Alan was so gentle on the set, and so dedicated to what he was doing. Even with the violence in some of the scenes, the atmosphere was tranquil. Alan was so wrapped up in the film that he didn't leave the location for lunch, and had sandwiches brought in. He would sit with his script, off in a corner, going over and over the coming scenes.

One day I convinced him that it was important for him to get away, to take a break and come back fresh, and I took him to one of my favorite Italian restaurants. The following day he was right back to the sandwiches. What I imagine is that he needed to maintain his concentration, his continuity of thought. A gentle man, his talented life was cut short in a fluke accident in 1998, when a steel pipe crashed through his car's windshield, killing him instantly.

FILMS

The Sterile Cuckoo *(also produced; 1969)*
Klute *(also produced; 1971)*
Love and Pain and the Whole Damn Thing *(also produced; 1973)*
The Parallax View *(also produced; 1974)*
All the President's Men *(1976)*
Comes a Horseman *(1978)*
Starting Over *(also co-produced; 1979)*
Rollover *(1981)*
Sophie's Choice *(also co-produced and scripted; 1982)*
Dream Lover *(also co-produced; 1986)*
Orphans *(also co-produced; 1987)*
See You in the Morning *(also co-produced; 1989)*
Presumed Innocent *(also co-scripted; 1990)*
Consenting Adults *(also produced; 1992)*
The Pelican Brief *(also co-produced; 1993)*
The Devil's Own *(1997)*

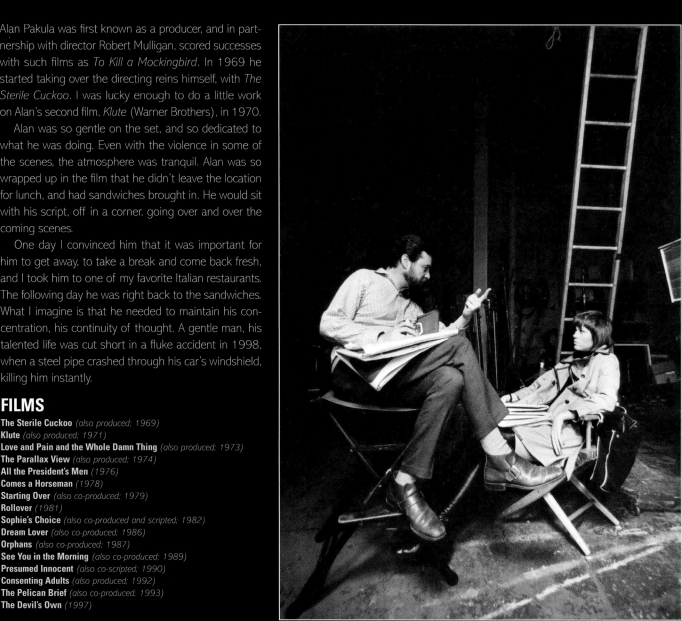

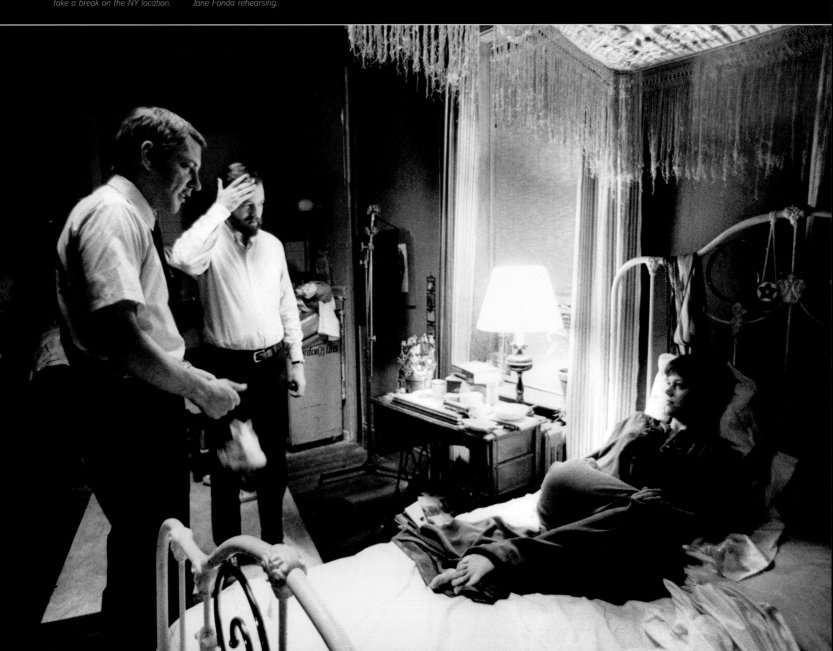

David Lean

born Croydon, England, March 25, 1908; died London, England, April 16, 1991

David Lean was a distinguished film editor in the UK, from 1935 to 1942, before he started directing.

FILMS

In Which We Serve *(co-directed with Noel Coward; 1942)*
This Happy Breed *(also co-adapted; 1944)*
Blithe Spirit *(also co-adapted; 1945)*
Brief Encounter *(also co-scripted; 1945)*
Great Expectations *(also co-scripted; 1946)*
Oliver Twist *(also co-scripted; 1948)*
The Passionate Friends/One Woman's Story *(also co-adapted; 1949)*
Madeleine *(1950)*
The Sound Barrier/Breaking Through the Sound Barrier *(also produced; 1952)*
Hobson's Choice *(also produced and co-scripted; 1954)*
Summer Madness/Summertime *(also co-scripted; 1955)*
The Bridge on the River Kwai *(1957)*
Lawrence of Arabia *(1962)*
Doctor Zhivago *(1965)*
Ryan's Daughter *(1970)*
A Passage to India *(also scripted and edited; 1984)*

BELOW *David Lean and Christopher Jones on the location of* Ryan's Daughter, *Dingle, Ireland, 1970.*

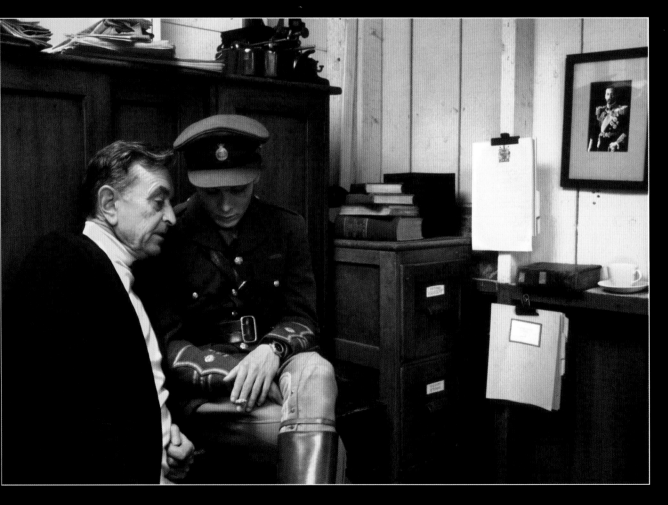

GRENADE. HAND. Nº 5. M
SCALE 8/1

SPRING

DETONATOR.

STRIKER.

HIGH EXPLOSIVE.

CAP.

CAP CHAMBER.

SAFETY FUZE.

BASE PLUG.

RETAINING PIN.

IRON BODY.

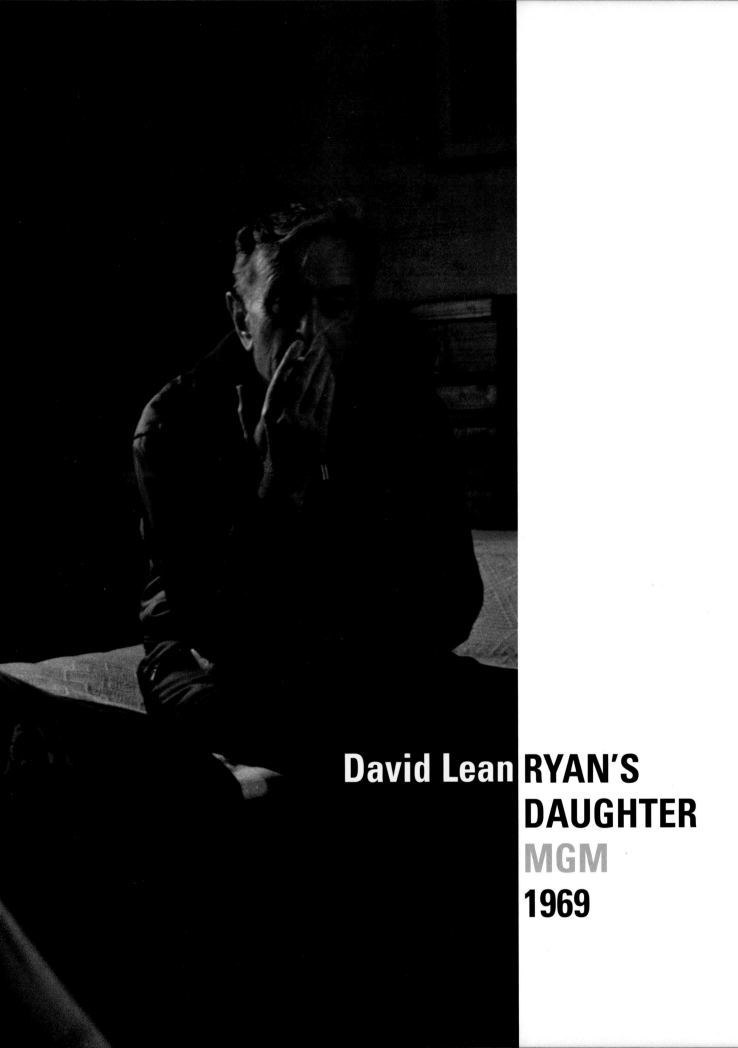

**David Lean RYAN'S
DAUGHTER
MGM
1969**

David Lean

I was working on *Catch 22* in Rome when MGM asked me to cover part of the David Lean film *Ryan's Daughter* on location on the Dingle Peninsula in the west of Ireland. MGM also asked if I could cover a bit of another film they had going near Dublin called *Brotherly Love* with Peter O'Toole. I knew a car would be necessary and made arrangements to ship mine from Rome.

I was especially delighted to get the first assignment, since Lean's early films such as *Brief Encounter* and *Great Expectations* (which is still one of my favorite films) were brilliant. He also worked with the great cinematographer Freddie Young, so as I drove out to the location from Tralee on the first day, I was really looking forward to the opportunity of seeing how they both worked.

Things started to go wrong right away. I hadn't been on the location for more than an hour when one of the assistant directors came over to ask whether that was my car with the Rome license plates. I was instructed to park it way down the lane, even though I reminded him that I had a lot of camera equipment to carry.

Well, I thought, perhaps the cars parked there would all be in the next shot; but when I returned none of the other cars had been moved, so I asked the assistant why he had made the request. He looked rather sheepish when telling me that I had made the gaffe of parking my car right next to Lean's Rolls, and as you might have guessed, he had Roman license plates. Incredible as it may seem, Lean wanted his car to maintain this exclusivity on the location.

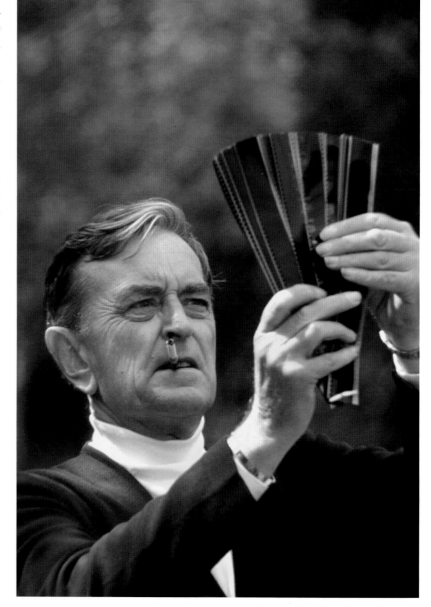

RIGHT *Lean checks the film clips to judge the printing density of the previous week's filming.*

RIGHT *Lean with young actor Christopher Jones. Peter O'Toole told me that he had wanted to play the Jones part so badly that he had someone steal a script so he could see what he might do. Lean said no.*

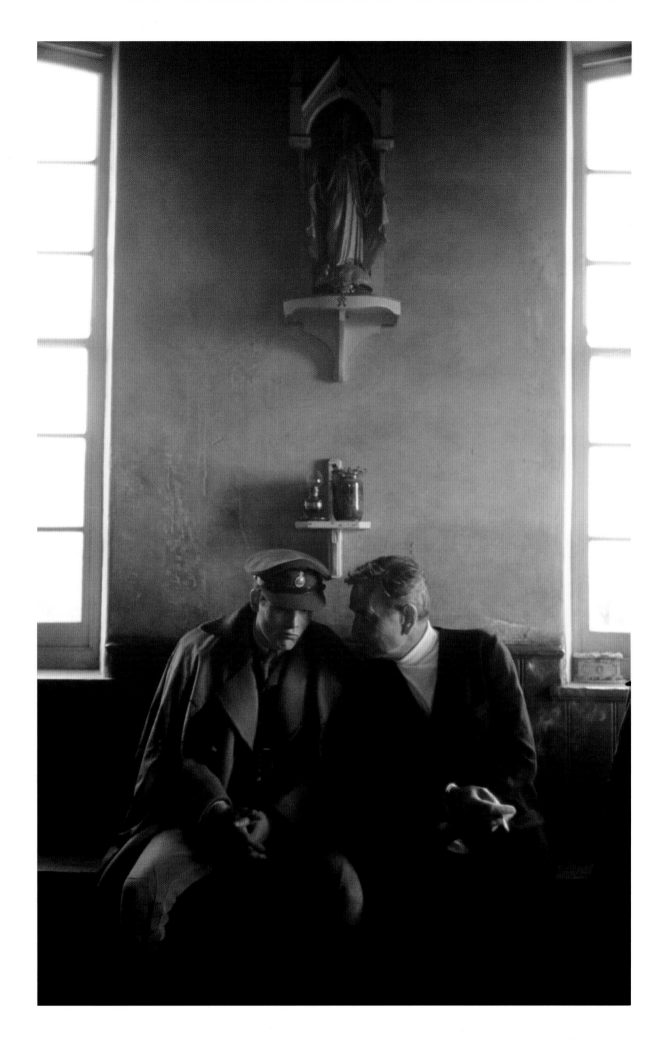

David Lean

The art directors had built an entire village out in the wilds of Dingle, in County Kerry, and it was a terrific set. It had taken about a year to construct, using local craftsmen and materials.

Whenever I start a new film, especially with a new director, I keep an extremely low profile until I get into the rhythm of the crew and I am not a distraction to the director or the actors. Things went well and by the end of the first day I had met everyone. Lean was nice enough, I had an assignment from *Life* magazine to do an essay on Christopher Jones, and there were several crew members that I had worked with before, so I thought it should all go smoothly.

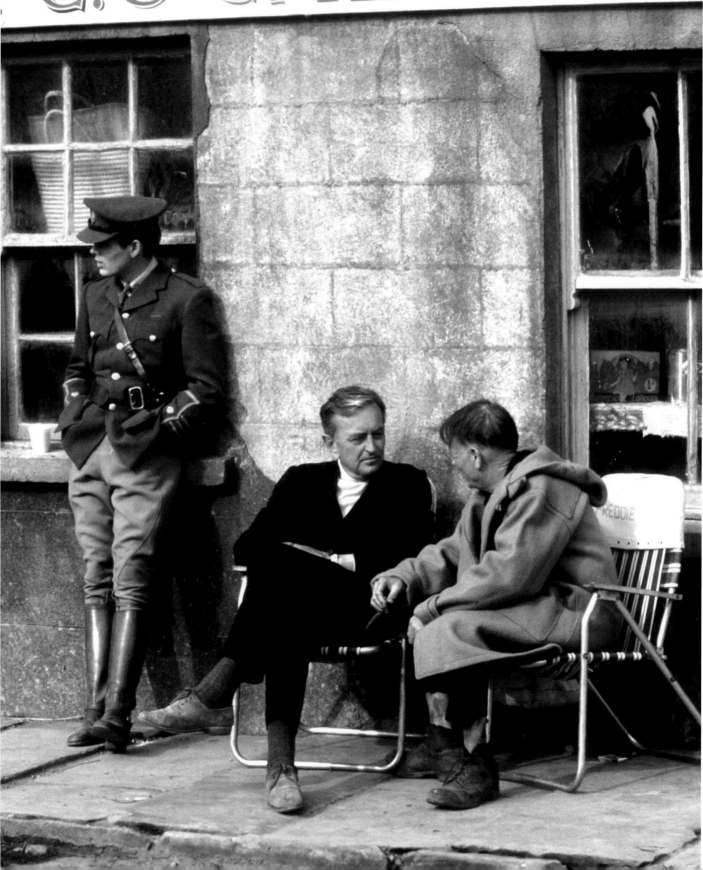

David Lean

The next morning I noticed Lean would turn to me and ask why I was taking a particular photo. I remember the huge Chapman crane in the bluebell woods seemed so out of place that I thought it an interesting image, and told him so. I had never had a director ask me why I was taking pictures, until it finally dawned on me that perhaps photographing the action behind the scenes was something he was not used to. In fact he wasn't asking me what I was taking "that" picture for, he was asking me why I wasn't taking the one that he was filming.

Something I realized too late was that he never took suggestions. I never saw the great cinematographer Freddie Young ever say the camera should be here, or tell him his opinion. He would wait until Lean said, "this is what we'll do." It hardly seems possible now, in thinking back, but Lean had set himself up as the complete authority, which many directors do, except in his case he could not accept suggestions, and no one was allowed to make them.

I saw him troop up and down hills, followed by his dedicated crew (*below*) looking for a place to put the camera. One morning in the bluebell woods, I saw Lean standing alone (*right*), walking around trying to decide where to shoot a scene with Christopher Jones and Sarah Miles. I had been looking myself and I felt I had the perfect spot, and when he caught my eye, with only the best of intentions, I made the big mistake of forming my hands in the shape of a camera frame to indicate that I thought this would be a good spot. He looked at me with such anger in his face that I just faded away, having committed the terrible sin of suggesting to the master where to put his camera.

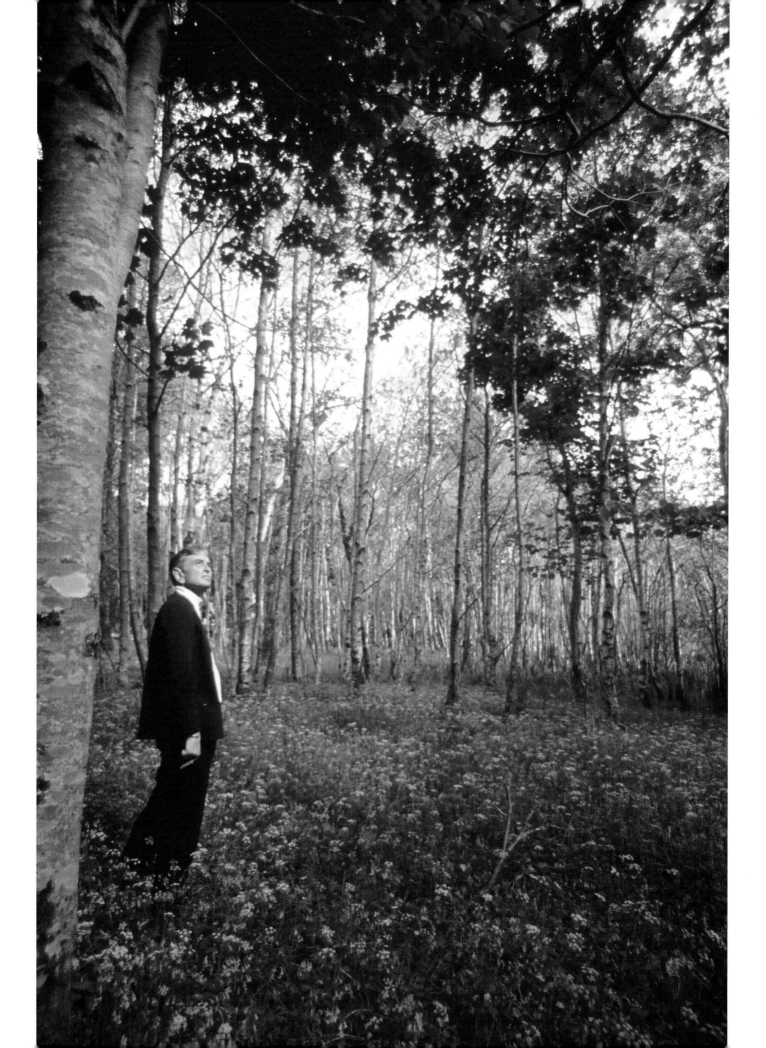

Lunch was called right then, an hour early. I realized too late just how neurotic Lean had become. When we returned from lunch, there was the camera in exactly the spot I had indicated, and Lean totally failed even to look at me for days. In fact he really prevented me from working at all. Ken Bray, the gentle MGM still photographer from London, and I sat in the rain for hours, unable to get inside where Lean was filming. The assistant director allowed us to come in and take a still after they got their print, which was pretty difficult to do never having seen the rehearsals.

I told MGM they were wasting their money on me, as I couldn't produce the magazine stories that I needed under those conditions. *Life* suggested I shoot Jones in London, which I did.

In retrospect, I cannot believe Lean was always like this, although Peter O'Toole has told me stories about some of his quirks when they were making *Lawrence of Arabia*.

Lean made some fine films, won Academy Awards, and earned critical approval, and that is enough to be said. I was just sad to see that he had isolated himself so from the very loyal people who supported him in creating his films. This was very unproductive, and possibly a factor that may have contributed to the failure of *Ryan's Daughter*.

LEFT *You can see the stress in Lean's face as he talks to Freddie Young.*

RIGHT *Lean double-checks everything as he looks through the camera for the coming scene in what was to be his "little film"—a film that went on and on and on. I went home to California, worked on a different film, and then returned to the UK on another assignment, where I met some of the Ryan's Daughter crew. They told me that they had only just returned from South Africa, where they had been filming some storm scenes that Lean had to have. They said that John Mills was nearly drowned when they had filmed them first in Ireland.*

nothing much for me to photograph, and it was only then that I realized I was only there because of O'Toole.

The shooting was in the middle of the jungle, and I was flown in by helicopter each morning. It was hot and dirty, and the water was filled with piranha fish. Peter Yates was the director, and I told him how much I had

Eventually I did photograph O'Toole and his wife Sian Phillips, who was also in the film, at Angel Falls (the highest waterfall in the world), and I was able to get permission to photograph them with the Waika tribe on the Orinoco River. It was all exciting, but not the way I like to cover a film.

FILMS

BELOW *Peter Yates looks at Peter O'Toole through the wide-angle lens of my camera.*

RIGHT *Lowering the seaplane with which Murphy (O'Toole) tries to blow up a German submarine.*

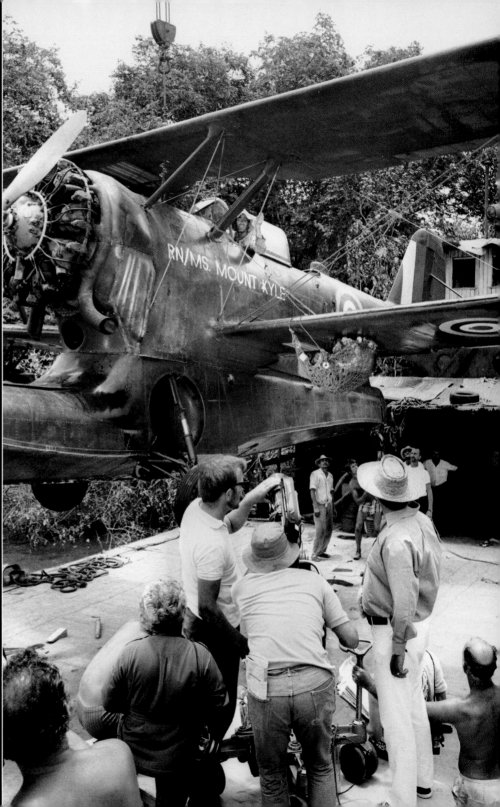

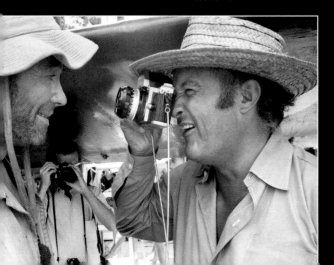

John Frankenheimer

born Malba, New York, February 19, 1930; died Los Angeles, California, July 6, 2002

I caught up with John Frankenheimer in Madrid in 1971, where he was filming *The Horsemen* (Columbia). This was a wild ride of a film with Omar Sharif playing an Afghan *chapandaz* (a rider in the wild and violent game of *buzkashi*). He was very good on horseback, a skill he had learned in the Egyptian army. The camera car following Sharif (*below*) was going at full gallop, and what with three cameras turning and everyone holding on where they could, it was all very exciting.

Frankenheimer had his plate full with the *chapandaz* riders they had brought from Afghanistan. They knew only one way to play *buzkashi*, and John was trying his best to keep them from killing Omar in their enthusiasm. They also started cooking their own food in the Madrid hotel using an open fire on the floor, which made a rather exciting situation for the production people to smooth over.

John was up to it all, and he lived for the action. He was enthusiastic about the project, and it was great to see how he dealt with everyone. He also knew my role, and helped me get what I needed. So for me this film was a pleasure.

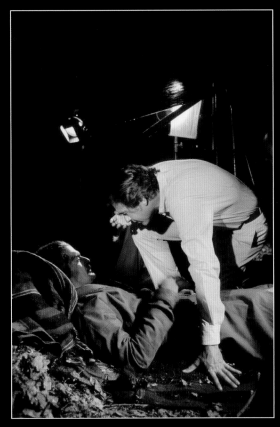

LEFT *Frankenheimer confers with Omar Sharif before a take.*

BELOW *John with Omar and Jack Palance on the location near Madrid.*

FILMS

The Young Stranger *(1957)*
The Young Savages *(1961)*
All Fall Down *(1962)*
Birdman of Alcatraz *(1962)*
The Manchurian Candidate *(also co-produced; 1962)*
Seven Days in May *(1964)*
The Train *(1964)*
Seconds *(1966)*
Grand Prix *(1966)*
The Fixer *(1968)*
The Extraordinary Seaman *(1969)*
The Gypsy Moths *(1969)*
I Walk the Line *(1970)*
The Horsemen *(1971)*
Story of a Love Story *(1973)*
The Iceman Cometh *(1973)*
99 and 44/100 Per Cent Dead *(1974)*
The French Connection II *(1975)*
Black Sunday *(1977)*
Prophecy *(1979)*
The Challenge *(1982)*
The Holcroft Covenant *(1985)*
52 Pick-Up *(1986)*
Dead-Bang *(1989)*
The Fourth War *(1990)*
Year of the Gun *(1991)*
The Island of Dr. Moreau *(1996)*
Andersonville *(TV; 1996)*
George Wallace *(TV; 1997)*
Ronin *(1998)*
Reindeer Games *(2000)*
Ambush *(2001)*
Path to War *(TV; 2002)*

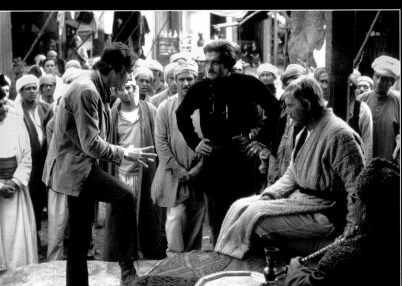

When Warner Brothers assigned me to cover *The Cowboys* (1972), I was surprised to meet Mark Rydell, and I wondered how John Wayne would take to this young New Yorker directing a Western. Wayne had become by then the living expert on Western films. (I didn't know at the time that Rydell had made so many Westerns for television.) There was a tentative testing of each other, but Rydell came through, and Wayne soon settled in. Rydell went on to be nominated for an Academy Award as best director for his film *On Golden Pond* (1981), which was also nominated for best film.

LEFT *Rydell (left) and Wayne in Colorado.*

BELOW *John Wayne rehearses a fight with Bruce Dern, making the hit look good for the camera, a technique that he really perfected in his earlier films. Watching at the far right is director Mark Rydell, and to his right cinematographer Bob Surtees.*

FILMS

Gunsmoke *(1955; TV series 1964–66)*
Ben Casey *(TV series; 1961)*
I Spy *(TV series; 1965)*
The Wild, Wild West *(TV series; 1965)*
The Fox *(1968)*
The Reivers *(1969)*
The Cowboys *(also produced; 1972)*
Cinderella Liberty *(also produced; 1973)*
Family *(TV series; 1976)*
Harry and Walter Go to New York *(1976)*
The Rose *(1979)*
On Golden Pond *(1981)*
The River *(1984)*
For the Boys *(also executive-produced; 1991)*
Intersection *(also co-produced; 1994)*
Crime of the Century *(TV; 1996)*
James Dean: An Invented Life *(TV; 2001)*

ABOVE AND RIGHT *Rydell energizes the young actors for a scene in the schoolroom, where Wayne's character, short of men to do a cattle drive, recruits the young boys from the class (above: Wayne top left, Slim Pickens seated next to him).*

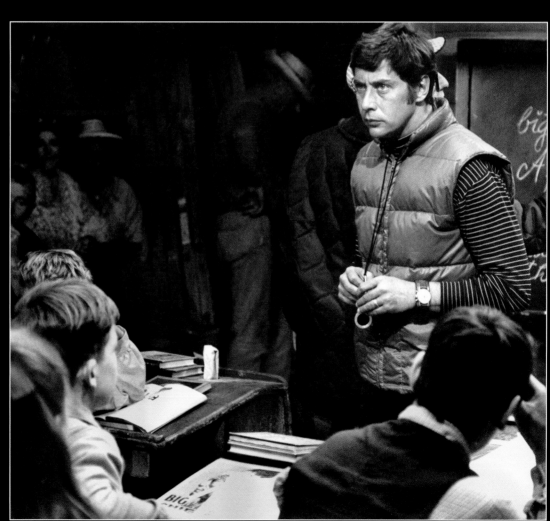

Sam Peckinpah

born Fresno, California, February 21, 1925; died Inglewood, California, December 28, 1984

Sam Peckinpah was a lean, crusty character. He could have been one of the cowboys in *Junior Bonner* when I met him in Prescott, Arizona, in 1971, on the shooting of that film (*pictured here*). I never cared for his films, with all of their gratuitous violence. My assignment was to shoot an ad for ABC, do a few days, and I was away.

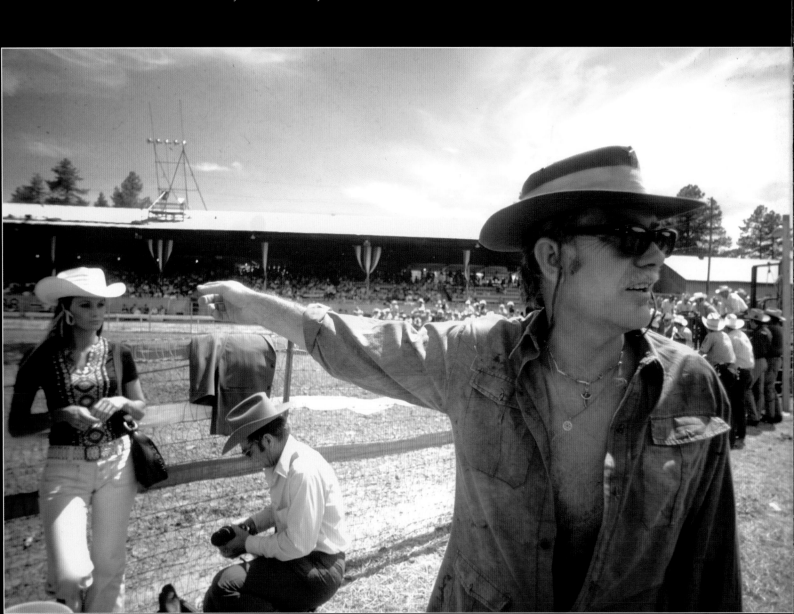

FILMS

Zane Grey Theatre *(TV series; 1956)*
Broken Arrow *(TV series; 1956)*
Trackdown *(TV series; 1957)*
The Rifleman *(TV series; 1958)*
The Westerner *(TV series; 1960)*
The Dick Powell Show *(TV, several episodes; 1961–63)*
The Deadly Companions/Trigger Happy *(1961)*
Ride the High Country *(also co-scripted, uncredited; 1962)*
Major Dundee *(also co-scripted; 1965)*
Noon Wine *(TV; 1966)*
The Wild Bunch *(also co-scripted; 1969)*
The Ballad of Cable Hogue *(1970)*
Straw Dogs *(also co-scripted; 1971)*
Junior Bonner *(1972)*
The Getaway *(1972)*
Pat Garrett and Billy the Kid *(1973)*
Bring Me the Head of Alfredo Garcia *(also co-scripted; 19*
The Killer Elite *(1975)*
Cross of Iron *(1977)*
Convoy *(1978)*
Jinxed *(uncredited; 1982)*
The Osterman Weekend *(1983)*

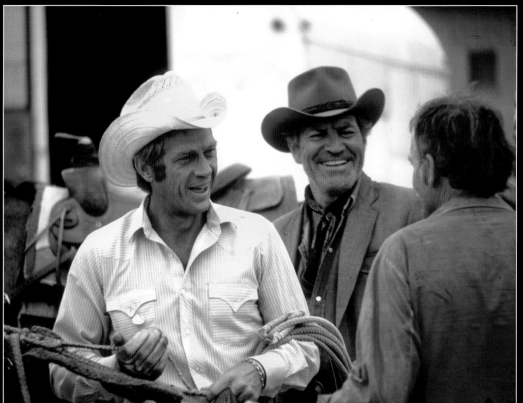

ABOVE LEFT *Sam Peckinpah the gravel pits they were usi in one of the scenes.*

LEFT *Steve McQueen and B Preston enjoy a joke with Sa Peckinpah in the stadium wh they were filming the rodeo sequences.*

John Landis

born Chicago, Illinois, August 3, 1950

Working with John Landis on *An American Werewolf in London* (Polygram/Lycanthrope, 1981) was rather like being in the *Twilight Zone* myself. Filming was zany and fast, and the set was never boring. I think John's ability to combine horror with humor must be quite unique.

FILMS

Schlock/The Banana Monster *(also scripted and stunts; 1972)*
The Kentucky Fried Movie *(also acted; 1977)*
National Lampoon's Animal House *(1979)*
The Blues Brothers *(also co-scripted and acted; 1980)*
An American Werewolf in London *(also scripted and acted; 1981)*
Twilight Zone – The Movie *(prologue and "Back There" segment; also scripted; 1981)*

Trading Places *(1983)*
Michael Jackson's "Thriller" *(TV: 1983)*
Into the Night *(also acted; 1985)*
Spies Like Us *(1985)*
Three Amigos! *(1986)*
Amazon Women on the Moon *(also co-executive-produced; 1987)*
Coming To America *(1988)*
Oscar *(1991)*
Innocent Blood *(1992)*
Beverly Hills Cop III *(1994)*
The Stupids *(1996)*
Blues Brothers 2000 *(1998)*
Susan's Plan *(1998)*

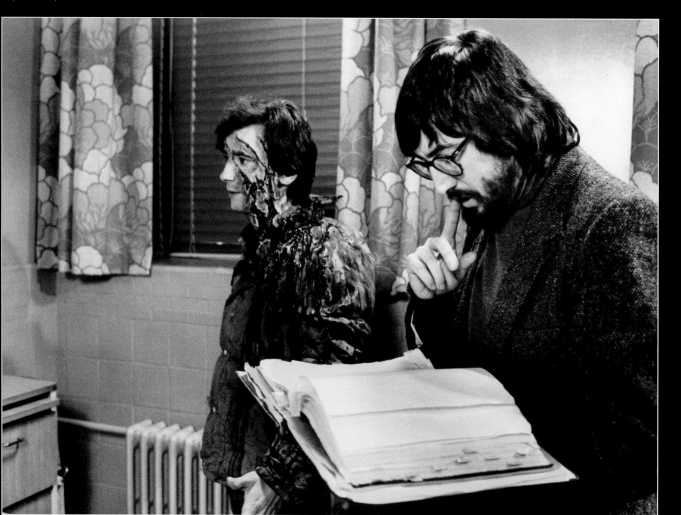

FAR LEFT *John Landis checks his script while Griffin Dunne, one of the many werewolf victims, stands unnoticed.*

LEFT *Landis at home amidst the "Kensington Gore"—the UK name for artificial blood. "More blood!" he would call, and the assistant would be back on the phone.*

Jean-Jacques Annaud

Born Draveil, France, October 1, 1943

When I arrived at the Rome location of *The Name of the Rose* (20th Century Fox, 1986) I discovered a brilliantly done exterior set. There was a Romanesque church that you would swear was real, until you went through the door. The other buildings in the complex, from the same period, were just marvelous.

I had come with an assignment from *Life* magazine, but every time I asked to get a shot, or to shoot something special, director Annaud interrupted. He had no time or he was too rushed, and he made it literally impossible for me to get the kind of images that I knew *Life* would use. It was all very frustrating. I shot what I could in the short time I was allotted, but there was zero cooperation. There were, however, at least half a dozen television crews visiting during my stay, and they *did* get the cooperation. I realized then that the magazine photographer on the set was a thing of the past: and it was the last film I ever covered.

Annaud received French César Awards for best film and best director for *Quest for Fire* and *The Name of the Rose*, and for best director with *The Bear*. He was honored with the French Academy's Cinema Prize for his cumulative work. He also won the Academy Award for best foreign film for *Black and White in Color*.

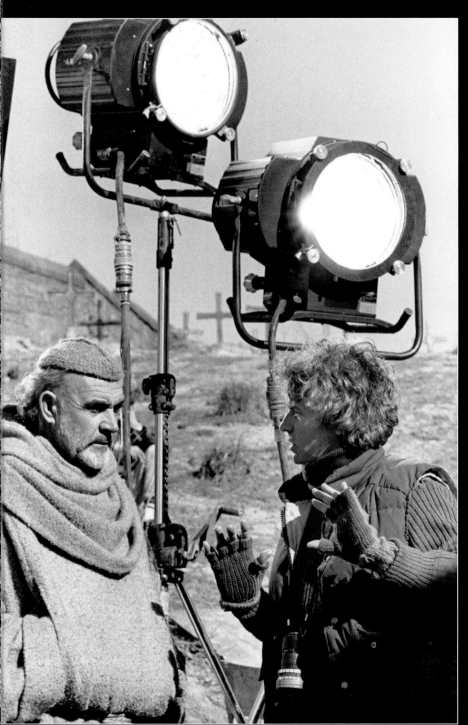

FILMS

Noirs et blancs en couleur/Black and White in
screenplay; 1977)
Coup de tête/Hothead *(1979)*
La Guerre du feu/Quest for Fire *(1982)*
The Name of the Rose *(1986)*
L'Ours/The Bear *(also co-scripted; 1988)*
L'Amant/The Lover *(also scripted; 1992)*
Wings of Courage *(also produced and scripted;*
Seven Years in Tibet *(1997)*
Enemy at the Gates *(2000)*

LEFT *Jean-Jacques Annaud talks
to Sean Connery on the set of*
The Name of The Rose, *a
medieval detective story, on
location in Italy.*

Index